DATE DUE

NO 1 7 '04			
DE 7 '04			

PAPER MUSEUM

PAPER MUSEUM

Writings About Painting, Mostly

ANDREW GRAHAM-DIXON

Alfred A. Knopf *New York* 1997

THIS IS A BORZOI BOOK
PUBLISHED BY ALFRED A. KNOPF, INC.

http://www.randomhouse.com/

Originally published in Great Britain by HarperCollins
Publishers, London, in 1996.

Library of Congress Cataloging-in-Publication Data
Graham-Dixon, Andrew.
Paper museum : writings about painting, mostly /
by Andrew Graham-Dixon.
p. cm.
Originally published: London : HarperCollins, 1996.
Includes index.
ISBN 0-679-45520-5 (hc)
1. Art appreciation. 2. Painting—Appreciation. I. Title.
N7445.2.G7 1997
750'.1'18—dc21 97-2812 CIP

Manufactured in the United States of America
First American Edition

For my mother and father, with love

Acknowledgements

MY THANKS TO Stuart Proffitt at HarperCollins, whose idea this anthology was and who did a great deal of work in assisting me to make the final selection of pieces. My thanks also to Arabella Quin, who has worked so hard proof-reading the copy and who has been invaluably helpful in helping me to arrange the pieces in an order I could bear to contemplate.

Many thanks to my old friend, Charles West, with whose elegant, intelligent cover design for this book I am more than delighted.

I owe a great debt to Thomas Sutcliffe, who first invited me to write on art for the *Independent*, and who was a forbiddingly exacting and exemplary Arts Editor during the many years we worked together. I owe much also to Tristan Davies, Tom's successor; to the *Independent*'s first editor, Andreas Whittam-Smith, whose great love of the visual arts was always apparent, both in his conversation, and in his newspaper; and to all those who staffed the library of the *Independent* when it occupied its former premises at 40 City Road, for whom no query was ever too small, and without whom the task of writing many of the pieces reprinted here would have been much more onerous and stressful.

My greatest debt by far, though, is to my wife Sabine, who has been, throughout, the most constant, persistent, perceptive, intelligent, emotionally honest, unforgiving and direct an editor any writer could possibly hope to have.

Contents

Introduction

NEARLY ALL THE PIECES in this book were written between nine o'clock in the morning and six o'clock in the evening, on Mondays, in the former offices of the *Independent* at 40 City Road. They were not written for posterity but for tomorrow's newspaper. I am of course pleased to see them resurrected from the grave of daily journalism, but cannot help fearing for them a little as they lurch and stagger into this new literary existence.

Having let some of these essays out into the world in the first place with less than complete care, I have, like an anxious parent combing his children's hair or dusting off their clothes, made certain minor adjustments to punctuation and syntax. But the large majority appear exactly as they were originally written. Readers familiar with my most foolhardily ambitious work to date, *A History of British Art*, will notice that certain passages in that book (notably those which concern Hans Holbein and Rachel Whiteread) were adapted almost verbatim from articles that are now reprinted here. My only excuse, and I hope it is not too devious, is that painters often repeat elements of one composition in another. Since this is, after all, predominently a book about painting, please think of me as a writer who has learned a trick or two from those he has written about.

'My work is like a diary, it's even dated like a diary,' Picasso once said. In this respect (only in this respect) my work is comparable to his. I was mildly shocked when going through my cuttings books to finalize the selection of pieces which appear below, to discover the extent to which re-reading my past words was like re-reading my past itself. Each and every article was like a marker in time, a buoy attached to all sorts of feelings and memories. For instance, looking over a piece about Richard Long (not reprinted here) I remembered that I had written it on the day that my eldest child, Eleanor, learned to walk – but it took the reading of the words I had written during the course of that day to

recall its most important and moving event. I finished the process of picking over my past with the distinct if slightly uneasy impression that I have, perhaps, measured out too much of my life in art reviews.

I had not quite realized, until required to go over my own work so thoroughly, how lacking in objectivity, how ruled by my own concerns, moods, passions and dislikes I have been. Writing about art has been, increasingly rather than decreasingly over the years, my way of expressing myself. I am not sure whether this is a weakness or a strength. But because there seems to me to be little point in attempting to disguise this feature of my writing, I have made a deliberate decision not to arrange this anthology according to any conventional art historical or chronological scheme. The chosen articles appear, instead, arranged under a variety of rubrics which, together, amount to a collage or kaleidoscope of my own preoccupations. I also prefer this slightly playful and arbitrary arrangement because I think it is truer to the newspaper medium – itself an often eccentric assemblage of information and views – to which each of these pieces of prose owes its origin.

The writers on art whom I most admire are Lawrence Gowing, Robert Harbison and William Hazlitt – above all Hazlitt, whose clarity, insight, gusto and pugilistic resistance, both to his own habitual responses and to received opinion, have been a continual, inspiring rebuke to me. Habit, Hazlitt once wrote, is the enemy of life, because it deadens us to the infinite variety of experience. For that same reason art is one of the great revitalizing forces at work in the world. It makes us see as though with the eyes of others. It allows us a way (many ways) out of our own egotism and, in the process, it makes better and larger selves of us all. That is why it matters; and that is why I have spent so much of my life writing about it.

ANDREW GRAHAM-DIXON
May 1996

I

'THIS IS NOT ART –
BUT LIFE PERPETUATED'

Ortega y Gasset

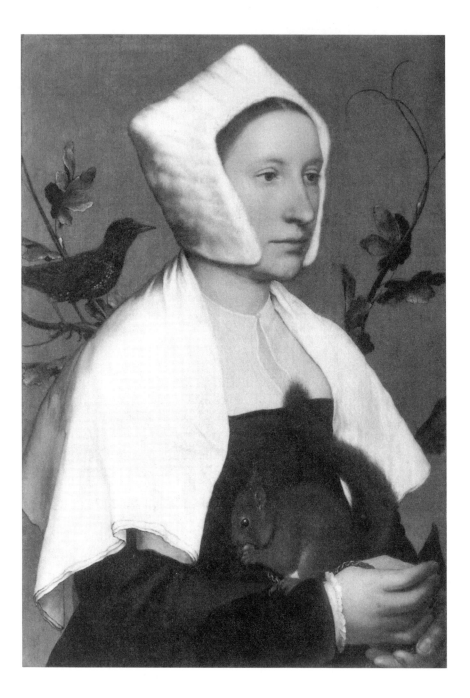

Holbein

THE LADY IN THE WHITE FUR HAT sat for her portrait in a quiet, well lit room somewhere in London one day in 1526 or 1527. There may have been little conversation between her and the artist. She was a lady of the court of Henry VIII and he, as a painter, would in those days have been regarded as a craftsman. He may have occasionally instructed her to move her head or hands, but the main sound in the room was probably that of his physical activity: the busy scratching of chalk on paper; the intermittent whisper of fingers rubbing the image to establish tone. She would have had plenty of time to wonder how the likeness would turn out.

The drawing Holbein made that day has not survived, although the painting for which it was the essential preparatory work has. He added certain things: the blue background, on which he has inscribed a delicate, almost abstract tracery of vine leaves and tendrils; the squirrel that the sitter holds; the starling perched on a branch next to her. The squirrel and bird may once have held some significance, perhaps heraldic, but the information might not add much to the picture, the strength of which lies in its dedication to a particular ideal of truthfulness. Holbein's portrait is not one of those paintings of a person that encourage you to admire the artist's inventiveness, his flattering transformation (as in the case, say, of a Van Dyck) of his subject. A young woman, neither particularly beautiful nor ugly, gazes away to her left. She seems withdrawn, a touch melancholic. The immediacy of the painting is, still, startling.

The woman's name is no longer known, so she has become *A Lady with a Squirrel and a Starling*. It is one of the ironies of history that the painter's aristocratic subject should have become anonymous, her distinction subsumed within the fame of her former employee. These days, she is 'a Holbein'.

The National Gallery's two other Holbeins depict foreign sitters

and do so with fairly unusual intentions. *The Ambassadors*, that world-famous image of two French envoys set among allegorical bric-à-brac, is a complex masterpiece whose precise meaning may never be unravelled. The prominent lute with its broken string, ancient symbol of discord, combines with the presence of Lutheran texts and the renowned anamorphically indistinct skull to suggest the doctrinal leanings and religious concerns of Holbein's sitters. It records a moment of religious crisis in the West – a moment when man's salvation from death through faith seemed to be threatened by rifts within the church. And while Holbein's *Christina of Denmark*, which was painted to show Henry VIII what one of his potential brides looked like, is a female portrait, it has little else in common with *A Lady with a Squirrel and a Starling*. Queen Christina colludes with the fact of her own display. The painting lacks the modesty and the sense of involuntary self-revelation you find in the portrait of the anonymous Englishwoman.

It is an odd fact that no British museum should have owned, until now, an example of the relatively small-scale portraits which constituted the large majority of Holbein's output during the half of his life that he spent in this country. It is hard to understate the impact these paintings must have had on the English court in the second quarter of the sixteenth century. Before Holbein there existed no tradition, in England, of portraits painted from the life. Then, suddenly, this German artist appeared who not only painted from the life but did so more faithfully and minutely than any other artist in history. By the time he died, he had painted roughly a fifth of Henry VIII's entire court circle. No wonder he was in demand. Holbein was the artist who showed the English what they looked like. He showed them the difference between the self seen by the self in the mirror, and the self seen by another.

The distant, reticent gaze of Holbein's *Lady with a Squirrel* may partly be explained by etiquette. But there may be more to the lady's reticence than the courtly requirements of female modesty. She looks frozen as well as distant, as if she is holding her breath. Her immobility seems charged with something almost like apprehension. Holbein has painted her awareness of being painted. In doing so, he has registered the uneasiness of an entire generation to whom the sensation of having a likeness taken was a new and not entirely comfortable experience. You still sense here the old occult power of the image.

Holbein's realism is of a different order to that of every other artist before or since his time, although when people express their sense of this they tend to sound rather like Erasmus writing to Sir Thomas More about Holbein's portrait of him: 'I should scarcely be able to see you better if I were with you.' In the case of Holbein, such remarks have been repeated with such frequency that they have acquired a more than conventional force. And it is true that you do feel, as the cliché goes, as if you are in the same room with Holbein's lady with a squirrel; she seems to be *there* in a way that the subjects of other great Renaissance portraitists like Titian do not.

Holbein does not seem to have idealized his sitter in any way, although that is not to say that he has been purely objective. His realism is a rhetoric of honesty. Holbein made a deliberate choice when he decided not to make her conform to any of the established canons of female beauty. It may not be entirely fanciful to find, in the slightly protuberant nose, unpronounced mouth and small chin of his sitter, a certain type of face which is, still, peculiarly English.

Holbein's persuasiveness is inseparable from his technique, which has something in common with that of the miniaturist, but also tends to fluctuate between hard minuteness and subtle generalization. His brush-strokes are so closely adapted to what they depict that you can get extremely close to his paintings and still read them, totally coherently, as description. A Titian, once you get close to it, invites you to read it, instead, as a *painting*. It discloses the visual mechanics – the brushstrokes – that make it so convincing from a certain distance. So as you get closer to the painting, there is a sense in which you retreat from its subject. But Holbein almost abolishes this dialogue between subject and image, which means that getting closer to a Holbein is very like getting closer to a person. To inspect his *Lady with a Squirrel* from as close as six inches away is, extraordinarily, to receive more not less information about her: it is to note the degree of moistness of the skin, the barely perceptible bluishness of the temples. How this was done remains unclear.

There is nothing flashy about the *Lady with a Squirrel* but it does display a form of subtle exhibitionism. Holbein has deliberately made things difficult for himself and, in overcoming self-imposed problems, has revealed his virtuosity. The painting incorporates a striking breadth

5

of visual effects. The different forms of reflection depicted range from the dull sheen of a grey metal chain and the muted lights in the sitter's fingernails to the delicate limpidity of her gaze and the twinkle in the squirrel's eye. A similar range is to be found in the painting's handling of textures, from the fine translucency of thin silk to the creamy opacity of the linen shawl and the modulated darks of dress and sleeve.

Within this broader play on texture there is a play on varieties of hair and fur. The lady's fur hat is painted in a blend of tiny, discrete marks and more general tonal passages; her hair is painted, with the finest brushes, as a multitude of single strands; the squirrel's fur is painted just a little more coarsely. Holbein has also created a clever visual pun by making the end of the squirrel's tail protrude slightly above the line of the lady's bodice. Silhouetted, it assumes the shape of the rounded tip of a paint-brush: a symbol, perhaps, of the act of painting that created this image; a witty reminder, from Holbein, that this apparent miracle of verisimilitude is in truth the product of his craft.

The squirrel's tail/paint-brush is, also, somewhat suggestively placed. There is something slightly irreverent about this detail, with its suggestion of what Frank Auerbach once termed 'the haptic nature' of painting – the sense in which to paint someone is to touch them, if only with your eyes. Holbein was aware that to take someone's likeness is to assume a certain power over them. It is to create them over again, to preserve your reinvention of them for posterity. The employee knew that he was, secretly, the master.

28th April 1992

This piece was written in April 1992 to mark the acquisition by the National Gallery of Holbein's *A Lady with a Squirrel and a Starling* for a net price of £10 million.

Poussin

THE YOUNG MAN at the centre of the procession has brought some-
thing very unusual with him, something he wants to share with
everyone present. It is a huge decapitated head on a pole. He holds it up
for all to see like an athlete holding up a trophy as he runs a lap of
honour. Trumpeters blowing a fanfare precede him, while the people
in the crowd exhibit what can only be called the full gamut of human
response.

Some hold their hands up in horror and relief. Some thank the Lord.
Some shake their fists. Some embrace one another, or raise their arms
in acclaim like sports fans celebrating a score by their team. Some
wonder what on earth is happening and need to have it explained to
them. Some debate the morality of it all. Some, babies and young
children, laugh or cry or just burble and carry on doing not very much
in particular. Some think the young man is rather attractive.

This is David shortly after slaying Goliath as painted by Nicolas
Poussin, *circa* 1632. *The Triumph of David* is worth dwelling on
because it is one of those masterpieces into which a great painter
appears to have squeezed almost every part of himself. An ancient
myth, reimagined, has mutated into an entire and thronged world.
Poussin's view of the world in general is also implicit within it:
generous, excitable, perceptive, easily roused to sensual enthusiasm
(the colours in the painting are as alive as the people) as well as more
than a little morbid.

Poussin's David is not Michelangelo's boy giant, nor is he Donatello's
self-conscious and flirtatious teenager. He is ordinary. He is fit and
healthy, slightly chubby, too, and not particularly intelligent. His skin
(flushed pink by his exertions) is made to seem still pinker and more
rudely healthy by the nasty green that has begun to tinge the head on
the stick. Goliath, who looks just like David but older and bearded,

chuckles in death, as if he might have died seeing a part of himself in his nemesis.

This great image of a victory for the forces of light contains Poussin's most profoundly felt and painfully acquired piece of wisdom: the knowledge that light itself easily turns to darkness and that bright-faced young Davids are always turning into Goliaths, just as day is always turning into night. The crowd in the painting is endlessly fascinating. But its fervency is also slightly repellent.

Metamorphosis was Poussin's great theme: change for better or worse, but always change. Many of his paintings are set at dawn or dusk, when light is draining in or out of the world: moments when the world's eternal changeability is both most manifest and most poignant. In his first and most bloodily crepuscular pictures, Poussin confronts change like a man still so moved by it, so profoundly affected by its inevitability, that he can hardly bear to face it.

Echo turns amazingly and terrifyingly to stone while Narcissus indifferently begins to undergo his own transformation: his hair has begun to become flower stems and blossom.

Two shepherds and a shepherdess in Arcadia discover that death exists even in paradise, by bending over to read the inscription on a tomb: the composition of this picture is structured around the declining shape their three bodies make, the acquisition of knowledge painted as a fall.

The first painting seen in the exhibition is one of Poussin's most violent pictures of change, in this case the change wrought on one man's body by other men. A saint, pinioned face-up and naked over a workbench, is having his guts meticulously removed. The executioner, who has made a neat incission in the victim's body just below the breastbone, is gently easing out the intestines. He does it with the care of a butcher used to handling strings of sausages without rupturing the skin. The gentleness of his inhumanity is horrifying. Behind him an assistant turns the large wooden roller to which the pink strings have been attached. This misery will be spun out. An old man draped in white, some pagan high priest, points to the obscure brazen god on whose behalf this punitive act is being carried out, but the victim is too far gone to care.

Nobility, heroism, in fact all good or grand things are always on the verge, in Poussin, of turning into their opposites. He lived all his mature

POUSSIN *The Triumph of David*

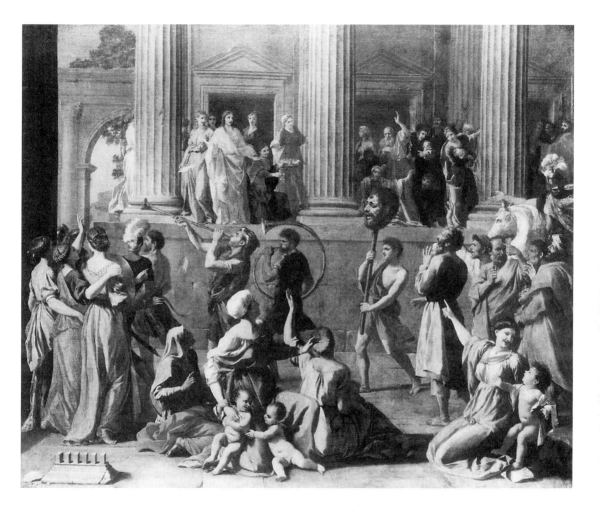

life in Rome – the only city in the world rich enough to sustain his imagination – but he didn't sentimentalize the place or its history. He painted its mythical origins in his *The Rape of the Sabines*. A crowned man stands in elegant profile on the steps of a temple before a plaza, and incites his men to carry off every woman they can find. His soldiers scurry about grabbing women; the women bite and scratch. The crowned man is Romulus, the soldiers are the first ancient Romans and the women belong to the tribe of the Sabines, but it is best not to know too much about Poussin's subject matter. This is an image of abduction and pillage and rape as it has always been and will always be.

No wonder the greatest painter of the French Revolution, Jacques Louis David – a man who lived his life at the eye of the storm, who saw the power of crowds turn so rapidly from good to evil, who saw idealism torn to dust and victory turn to defeat – was enthralled by Poussin. Among other things, he learned from him the tremendous poignancy that a still-life detail can impart to a narrative painting. The heap of useless armour that Poussin painted under the dead man's bed in *The Death of Germanicus*, a bright reminder of triumphs past and never to be re-enacted, like a pair of football boots hung up never to be used again – this is a brilliant invention, which predicts the useless quill which David placed in the dying Marat's limp grasp, and the sewing basket on the table in his painting of Brutus and his wife grieving over their dead sons.

Poussin's influence on the artists who came after him, particularly the French artists, has been immense. He was one of the first great narrative painters to invent his own subjects rather than paint to commission. He invented himself and to a great extent he may be said to have invented French painting. The storms and deluges of his last years anticipate the tarnished copper seats and leaden skies of Théodore Géricault. His voluptuous, statuesque women, the soft but chiselled dancers and orgiasts of his bacchanalia would preoccupy the imagination of Ingres for more than fifty years. His vivid dancing colours, bright shapes laid on dark grounds as freely as the elements in a collage, must have been at the back (or the front) of Matisse's mind when he invented the great jazzy compositions of his last years.

But Poussin's formal inventiveness, so fruitful for later paintings, had nothing of the spirit of formalism about it. He painted as only a great

and perceptive voyeur, living in a turbulent century, could paint. In 1649, commenting on the beheading of England's unlikely Goliath, Charles I, Poussin wrote to a friend: 'It is a great pleasure to live in a century in which such great events take place, provided one can take shelter in some little corner and watch the play in comfort.' His painting fed off the world but it was also his way of making sense of the world, of distancing himself from it, of producing order out of its ceaseless flux.

Perhaps, too, it was one of his ways of disciplining himself. This great moralizer of change seems to have been a most changeable man. In his youth, it was said, he was a boisterous, rebellious character, a street brawler and an ardent, hopeless lover. In his maturity he became well-known for his asceticism and his adherence to the strict, temperate resigned philosophy of the Stoics. His painting style also changed. His Venetian melancholia became Roman fortitude as he stopped painting like Titian and started painting like Raphael. Colour became line. Feeling became reason. Instinct became geometry. That, at least, is how one theory of Poussin's development goes. He contributed to it himself, declaring in a letter to a friend: 'My nature compels me to seek and love things that are well ordered, fleeing confusion, which is as contrary and inimical to me as is day to the deepest night.'

This is one of the older Poussin's most well-known statements, but it is not entirely truthful; his nature was more humane, inventive and generous than the remark implies. The kinds of structure and order which he devises are open, not closed, and he is constantly breaking with decorum in ways that are more often associated with other and more patently anarchic geniuses like Rembrandt or Shakespeare.

A tremendously bold and affecting instance of this occurs in the picture of *Extreme Unction*, which he painted as part of his first series devoted to the subject of the Seven Sacraments. The dying man and those watching him die absorb the viewer's attention, but not entirely. To the extreme right of the picture a beautiful girl is running out of the room. She is running, and looking straight at us, in a way that makes it quite plain that she is going to meet her lover. Death often leads people to think of sex, which is natural enough, if not something polite people notice. But Poussin saw the world clearly enough, and accepted what he saw there sufficiently, to paint one of the few masterpieces – maybe the only one – to observe this.

His unruliness was inseparable from his love of life and his Stoicism cannot have been at all the conventional kind: a check placed on his enormous appetites and humanity, but one that could not restrain or mute it.

Poussin never stopped exploding until he died and he kept reinventing himself in ways that only modern artists are, according to some, supposed to do. Painting a *Lamentation* in 1658, he displaced all the feeling in the tragic subject out of the figures and into the colours. Purple and red and pink and blue shriek a discord that makes the picture as effective seen from fifty yards away through half-closed eyes as it is from close to.

In his valedictory late landscapes, Poussin invented Surrealism (making the invention of it, in fact, unnecessary). He painted among other things an odd dream of a giant, guided by a man standing on his shoulder like a parrot, walking through beautiful countryside past a woman standing in clouds that looked like backlit coal smoke. His hand shook terribly as he painted, but Poussin worked with the constraint and made the handicap of an old man into a form of pictorial originality; a distant dreamed blurriness. Sir Joshua Reynolds, of all people, owned this picture, the *Landscape with Orion*. It must have been a perpetual reproof to him.

Poussin died in 1665, having been forced at last to put away his brushes, as Germanicus had had to put away his armour. Perhaps he kept them under the bed. Almost his last recorded remark was his definition of painting as 'an imitation in lines and colours of all that is under the sun.'

24th January 1995

Velázquez

THE YOUNG PAINTER Diego Rodriguez de Silva y Velázquez painted Mother Jerónima de la Fuente in 1620, the year of her departure from the convent of Santa Isabel de los Reyes, in Toledo, for the wilder shores of the Philippines. She left, the inscription that runs along the bottom half of the painting informs you, with missionary intent, her goal the establishment of 'the convent of Santa Clara de la Concepción of the first rule of the city of Manila'. She was sixty-six years old when she decided to take this leap into the territory of the unconverted, but frailty was not a characteristic the painter chose to note.

Her gaze is unavoidable, a sour, accusatory glare, her mouth a study in set, stubborn sullenness. In one gnarled, prominently veined hand she clutches a bible. In the other she grips a long wooden crucifix as if it were a club. She is no pushover, this wizened but doughty figure in her coal-black robes, the frontierswoman of missionary Catholicism.

Mother Jerónima stands near the entrance to 'Velázquez', an exhibition of thirty-eight works by his hand at the Metropolitan Museum of Art in New York. Velázquez, deemed 'le peintre des peintres' by Manet, is unusual among artists in that his was a career virtually without setbacks. In 1623, at the age of twenty-four, this young painter from Seville was – to the not inconsiderable annoyance of older court painters – officially appointed painter to the king, Philip IV of Spain.

It is not hard to see why the king chose Velázquez over his elders. The early An Old Woman Cooking Eggs, is a painting that doubles as a list of Velázquez's areas of competence. He can paint the tough but reflective skin of a melon, can capture the areas of light and shade that succeed each other along its ridged surface. He can render the contrast between the shiny inside of an earthenware dish and its dull, unglazed exterior. He can paint a white porcelain saucer and – he makes things hard for himself – the shadow of the knife that has been balanced on

BONVM EST PRESTOLARI CVM SILENTIO SALVTARE DEI·

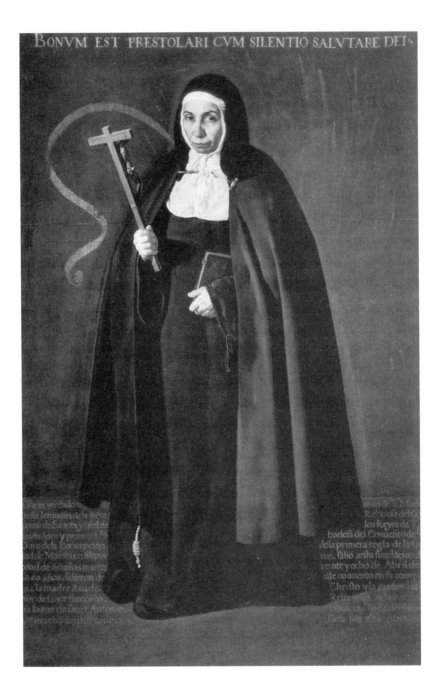

it, a shadow bent by the saucer's curved recess. The result is faintly disturbing, a painting that seems to fall apart as you look, riven by the artist's intense, dispassionate observation of each and every thing in it.

Later, Velázquez would learn to vary the degree of his attention, much of the force of his painting coming from the tension between hard precision and looser, sketchier handling. In his late portrait of *Queen Mariana*, the disparity between the painting of her face, free and immediate, and the fetishistic treatment of her vast, ballooning dress suggests the crushing formality of Spanish court etiquette.

It has become customary to consider Velázquez as one of art's consummate realists, a painter who leapt the boundaries of his time and anticipated the optical truths of much later art. He can paint a still life as if he were Manet arriving on the scene two centuries early; he can paint a landscape as if he were Corot. How, you wonder, is it possible for the eye and the hand to collaborate in this way? How does the eye know, for instance, that a nondescript blob of white paint, placed just *here*, will conjure at a stroke both the rounded form *of* and reflection of light *in* the vase on the table in his portrait of the *Infanta Margarita*? How has the hand managed that strange blurring of the face of *The Dwarf Francisco Lezcano, called 'El Niño de Vallecas'*, to convey the impression of a head actually wheeling through space to confront you?

The myth of Velázquez as a god among painters, an artist so skilled that his creations might be confused with those of the Creator himself, began early. But it is a myth that is partly blind to Velázquez's achievement. He was far more than the mirror of nature. There is in Velázquez the subtlest of plays between illusion and artifice, between the painter's ability to fool the eye and the willingness to disclose his own trickery. His works are filled with pictures-within-pictures – *Las Meninas* being the most famous example, a picture that takes its own making as subject – making you constantly aware of the conventions at work on the surface of his paintings, aware that every image is an illusion, a trick.

Velázquez's style has its counterpart in the critical intelligence he brought to bear on the broader question of what it is, exactly, that an image represents. His court portraiture is enriched by the sense he so often creates that his subjects are at odds with their elaborate costume, the iconographic paraphernalia they carry around with them or the symbolic poses they strike. The Count-Duke of Olivares sits, rather

heavily, on a rearing horse, pointing his baton imperiously at the battle-field towards which he is evidently about to charge. His armour, and the splendid folds of drapery that enfold him, announce his grandeur, his quasi-regal potency – the painting was commissioned to mark a rare Spanish military success, the battle of Fuenterrabía – but something is almost indefinably amiss.

There is something ludicrous about Olivares' pudgy, venal counte-nance, as he stares so arrogantly from his steed. Olivares would almost certainly have devised the pose himself and it is, in fact, based on an equestrian portrait of Philip IV, majesty in charge of an unruly beast – but Velázquez has subtly made him a *parody* of kingship, has engineered a failure of fit between sitter and self-image.

Velázquez turned the world he found on its head, but he did it so cleverly, with such lightness of touch, that he got away with it. His art operates through tension, through the collision of contradictory visual codes. It is there from the beginning, in that portrait of Mother Jeró-nima. Velázquez has not broken with the commemorative convention of this type of portraiture, but he has exceeded his brief, has provided all sorts of additional information about his sitter – her pent-up aggres-sion, her sour, violent spirit – that are surplus to official requirements. Velázquez's most subversive official portrait remains his punishing image of Pope Innocent X, squinting out from the canvas with that famous malign, suspicious expression. The Pope is said to have remarked that the painting was '*troppo vero*', but he was only half right. It is not that it is too true, but that it dares to combine two *kinds* of information; Velázquez paints the gap between the Pope as man and the Pope as institution.

It was Goya who would seize on this aspect of Velázquez and take it to the caricatural extremes of his own court portraiture. But Goya lacked Velázquez's capacity for generosity. Velázquez could also suggest the sadder aspects of the court's image-fixation, as he did, particularly, in painting the children of the royal family, stiff and vulnerable dolls swaddled by their couture. He could, too, suggest the nobility or dignity of those who had no official title to them. He painted the slave *Juan de Pareja* erect and level-gazed against a plain background, as the proudest of aristocrats; he painted the dwarfs and buffoons of Philip IV's court not – as their courtly function suggested he should have done – as

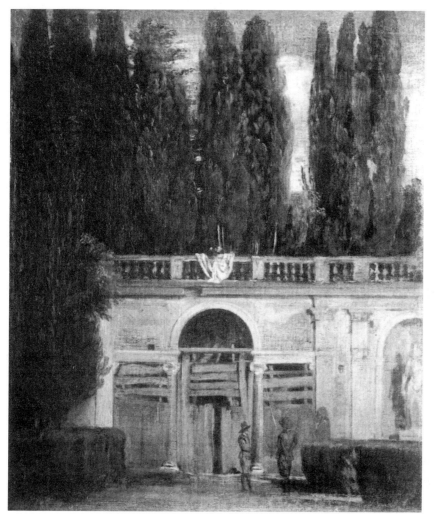

VELÁZQUEZ *Garden of the Villa Medici*

ignoble foils to their noble masters, but as poignant figures imprisoned by deformity.

Velázquez could be most audacious when least apparently so. *The Garden of the Villa Medici* seems innocuous. Cypress trees sprout above a classical portico which, boarded up with a ramshackle arrangement

17

of planks, seems to be *in restauro*. Someone has hung their laundry on the balustrade. Its ordinariness is precisely what makes it so extraordinary. There had not been another landscape painting like it, and there would be no more like it for 200 years. Gardens are places where nature is made to turn allegorical, where nature has, literally, a construction placed upon it – but Velázquez has chosen to paint no notable monument, no vista, no allegorical scheme. Velázquez's subject – it is, perhaps, the theme of his art – is the world's refusal to conform to meaning. Here, in a corner of a garden in Italy, away from the formalities of one of the most hierarchical, ritualized societies in the history of Western civilization, he dares to paint something that is, simply, of no consequence.

Velázquez is perhaps not quite as inexplicable or anachronistic as he is sometimes made out to be. He lived at a time and in a place where the myths enshrined in the image of kingship were under severe threat: in Spain, Philip IV lurched from one economic or military crisis to the next; in England, the unthinkable occurred when Charles I was executed by his own people. Velázquez may have alluded to the military vulnerability of Spain when he painted his strange mythological caricature, a *Mars* disarmed who slumps, nude bar a loincloth and helmet, on a rumpled bed. He never challenged Philip IV's authority directly (his paintings of the king are his least interesting works) but he did so obliquely, perhaps, in this picture and in his masterpiece *Las Meninas*. *Las Meninas* has not travelled, but it is here that you find Velázquez's last and greatest meditation on the nature of painting. Painting *himself* painting the king. Velázquez suggests a momentous shift of priorities. The sovereignty of kings is replaced by the sovereignty of vision, a new and radical dispensation where anything, indeed, is possible.

7th November 1989

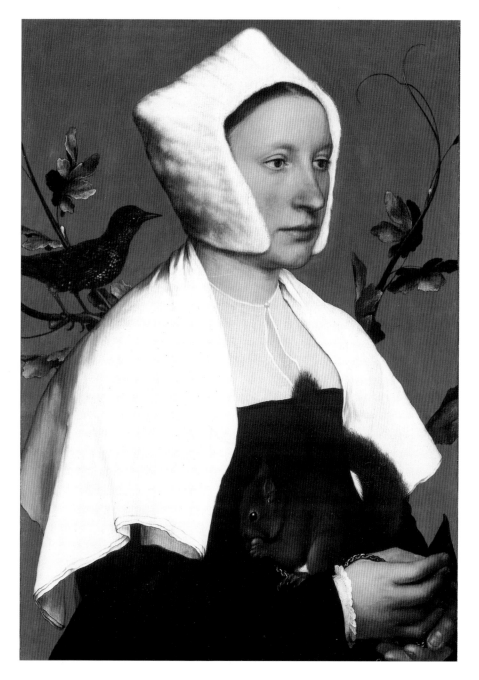

HOLBEIN *A Lady with a Squirrel and a Starling*

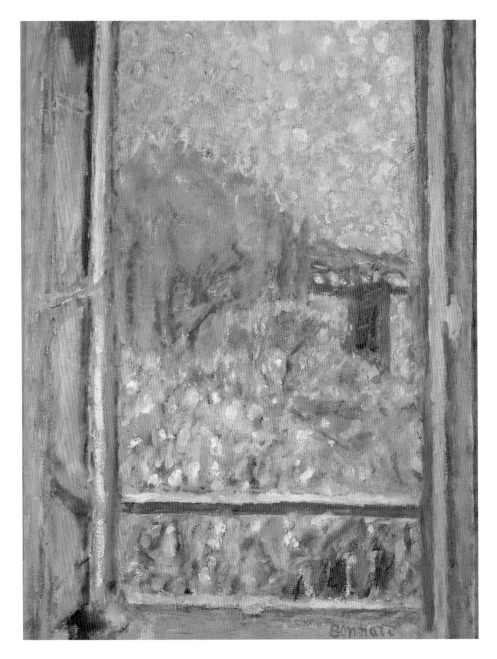

BONNARD *The Little Window*

Opposite: VUILLARD *L'Elégante*

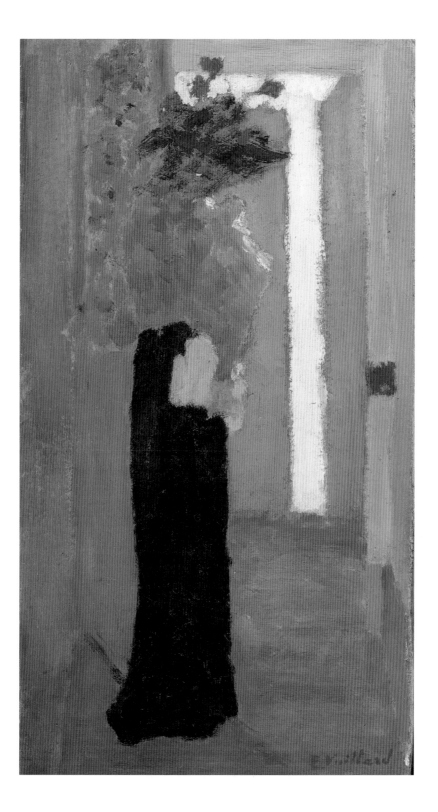

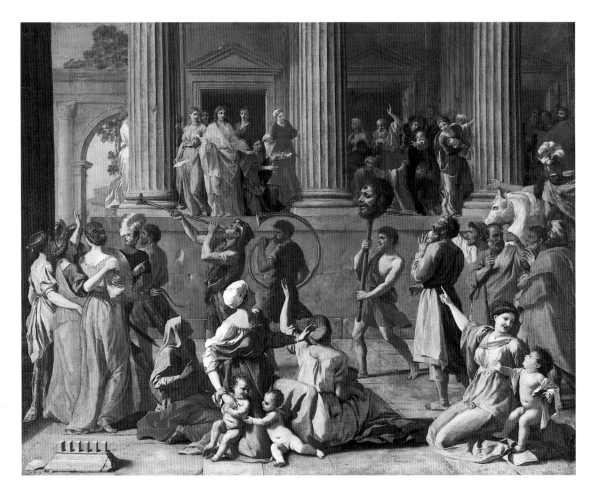

POUSSIN *The Triumph of David*

Rembrandt

REMBRANDT WAS thoroughly inconsistent and frequently inept artist. He often got things wrong in his paintings, treating the human form with a strange disregard for anatomical truth. He was for ever smudging, omitting and leaving indistinct. Sometimes whole areas of a painting appear to have bored him, so he handled them with a disconcerting, cursory sketchiness. He often seems a different artist from one painting to the next, and the field of his concerns is so large as to seem almost indefinable.

These are the most common complaints about Rembrandt, but there is also a sense in which they are not really criticisms at all. Rembrandt's inconsistency, his troubling variousness, are an integral part of his genius. They are built into his greatness.

This is a source of irritation to many people, not least, perhaps, to the professional Rembrandt scholars responsible for 'Rembrandt: The Master and His Workshop', at the National Gallery. The exhibition was brought into being by a group of art historians, led by the Amsterdam-based Rembrandt Research Project, in the hope that it might justify their attempts to tidy up Rembrandt, to smooth out his rough edges and make him a more manageable and discreet artist.

The results of the Rembrandt Research Project's investigations are, by now, well known: the deattribution of large numbers of so-called 'Rembrandts', and their re-assignment to artists employed in his workshop; the removal, from the presumed corpus of Rembrandt paintings, of such masterpieces as the Frick Collection's *The Polish Rider*. The National Gallery's exhibition was intended to demonstrate the solidity of the art-historical reasoning that lies behind the curious saga of the incredible shrinking Rembrandt *oeuvre*. It fails, but the nature of its failure is not without interest and even a certain drama. In trying to reveal a leaner and more consistent Rembrandt, the scholars have merely

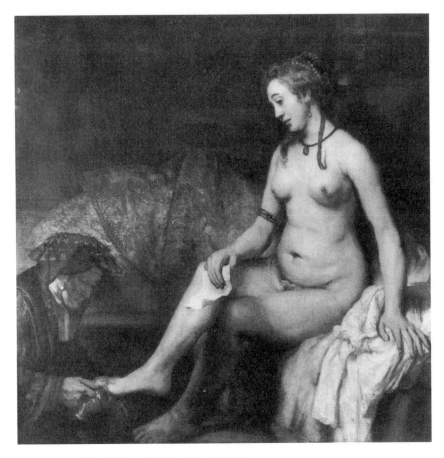

REMBRANDT *Bathsheba with King David's Letter*

reaffirmed his uncontrollable vitality, his resistance to the taxonomies of the art historian.

The exhibition is predicated on a notional chasm between the paintings of Rembrandt himself and those executed in his workshop under his supervision. Its first four galleries contain some fifty indubitable Rembrandts, arranged in chronological order. These are succeeded by three galleries containing works once thought to have been by Rembrandt but now given to his assistants, juxtaposed with other paintings

definitely known to be by those same assistants. This part of the show is rather like a public accountability exercise. 'See for yourself,' the exhibition says. 'The scholars have got it right.'

In fact, the scholars' confidence in explicit, demonstrable differences between 'Rembrandt' and 'Workshop of Rembrandt' comes to seem a little suspect. It may be significant that the RRP's various reattributions seem most watertight in the case of dull or evidently lifeless works that have long been believed to show minimal evidence of Rembrandt's own involvement. Jan Lievens' inert *The Feast of Esther*, or Carel Fabritius's workmanlike *Portrait of a Seated Woman*, are ex-Rembrandts that few people are likely to get particularly worked up about. But when you come to the borderline cases, the nearly-but-not-quite Rembrandts, it is a different matter.

To argue that Gerrit Dou painted the version of *Anna and the Blind Tobit* attributed to him in this exhibition seems only marginally more sensible than to argue that Walt Disney painted the Sistine ceiling. The faces and the hands of the two figures are painted in a register that seems far more congruent with the Rembrandts in the preceding galleries than with the other Dous on show; the whole tenor of the scene, its presentation of sacred legend in terms of the everyday, also seems thoroughly Rembrandtian. The National Gallery's Chief Curator Christopher Brown, in a guide written to accompany the London showing of the exhibition, hints that the painting may well be 'given back' to Rembrandt. This is a tribute of sorts to the slipperiness of the artist, and it contains a lesson for the Rembrandt scholars.

Rembrandt's stubborn, persistent refusal to paint the expected means that you can never be sure what to expect of him. There is a very fine line, in his art, between magnificent clumsiness and outright failure. This is why many of the traditional tools of art-historical analysis are peculiarly blunt when applied to Rembrandt.

One of the standard reasons given by art historians when they deattribute a work is that some passages are too ineptly or cursorily painted for the painting to be autograph. But this is a dangerous stratagem in the case of Rembrandt, precisely because he *is* an artist whose expressiveness is inseparable from a certain unevenness of attention to detail. Consider, by way of illustration, Rembrandt's painting of hands in three works attributed to him in this exhibition: *Abraham's Sacrifice* from the

Hermitage, *Bathsheba with King David's Letter*, from the Louvre, and the late *Self-Portrait* from Kenwood House.

In the first painting, the whole drama of the scene, the tension of that moment when the angel intervenes in the father's sacrifice of his son, is concentrated in Abraham's vast, meaty left hand, clamped over Isaac's face. It is a small part of a single painting that seems to contain, within it, a vast area of Rembrandt's concerns: his disdain for that classicizing, mostly Italianate tradition of painting within which certain proprieties of pose or gesture are always observed; his profound recognition of man's capacity for brutishness, and his ability to invest painted forms with a kind of sublime terror of this fact.

Then look at Bathsheba's left hand in the second of these paintings. It is like a dead crab, contributing nothing to the painting as a whole. Painted with almost incomprehensible cursoriness, it does not even come close to anatomical accuracy. It sticks out like a sore thumb. This may seem surprising when you consider the careful attention Rembrandt has paid to the rest of Bathsheba's nude body, to her face and the expression it registers – but is not at all surprising when you consider his creative habits. Rembrandt gives importance to what is important to him, and he is simply not interested in incidentals.

The *Bathsheba* may be the painting in which Rembrandt's sympathy for a certain type of specifically female predicament is most apparent. He manages to imply that Bathsheba's beauty is, also, her tragic fate. The awkward quality of the painting, which is the sign of Rembrandt's compassion, is hard to pin down but has much to do with the sense that this body, while being presented to your view, is also being withheld: the poignant inwardness of Bathsheba's expression dignifies her nakedness, armours her against the usual vulnerability of the nude in art. Bathsheba's left hand (unlike her right hand, which holds the fateful letter and which is beautifully painted) has no role to play in any of this. Rembrandt's indifference to it signals that other things are to be looked at.

Finally, look at the hands in the Kenwood *Self-Portrait*. In fact, you cannot, because they are not there. They *ought* to be there – they are not behind the painter's back, and he appears to be holding his palette and mahl-stick in one of them – but they are, simply, not. He has left them out. Yet this seems entirely natural, because the painting is so

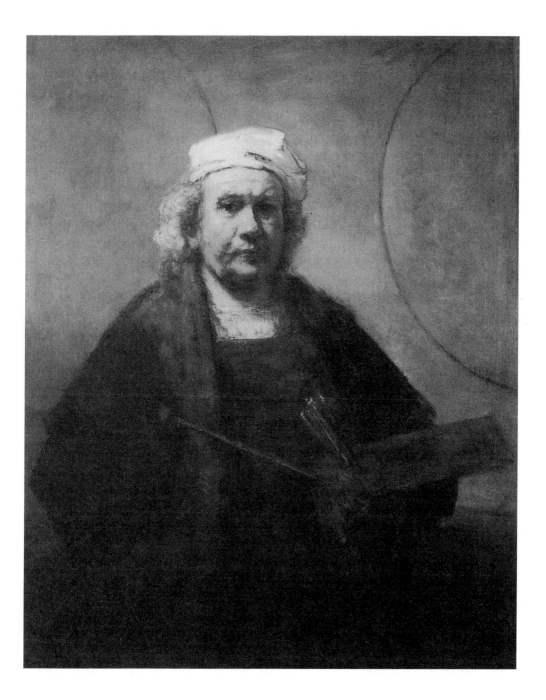

strongly focused on Rembrandt's face, with its mixed expression of resignation, weariness, wry pride and humility. The absence of the hands is a way of telling you what the painting is about: a man, alone, staring the fact of his own mortality straight in the face.

There is something strangely childish, and certainly undeveloped, about the notion that artistic integrity is necessarily manifest in some supposed stylistic consistency obtaining across the different periods of an entire *oeuvre* – and this is exposed with cruel clarity by Rembrandt. Which leads, in a roundabout way, to the strange case of Willem Drost.

Drost is the member of Rembrandt's workshop said to have been responsible for one of the few indubitable masterpieces in the later galleries of this exhibition, *The Vision of Daniel*. The RRP also considers him to have painted *The Polish Rider* and *The Man with a Gilt Helmet* in Berlin, once described by Jacob Rosenberg as the most affecting Rembrandt in the world. This means that Drost is either one of the great unacknowledged artists in history, or the beneficiary of one of the greatest art-historical mistakes in history.

But if Drost, in Rembrandt's workshop and under his instruction, actually did execute the paintings now claimed for him, does that necessarily make him their sole author? It is certain that those paintings could not have come into existence had Rembrandt never lived. This raises another possibility concerning Rembrandt and his workshop practice: that Rembrandt encouraged those artists whom he employed to, in a sense, *become* him.

Other artists had used the workshop system to produce works of art painted in their style but executed by assistants. But in Rembrandt's case this does not seem to have operated in nearly so straightforward a manner as it did, say, in that of Rubens. Rembrandt's style, which is so shot through with strange, sudden touches of observation for which there is no precedent, is not really a style in the same sense as that of Rubens. Rembrandt never worked from preparatory sketches in the way that Rubens did, except in the loosest and most improvisatory way: X-rays indicate that the compositions of most of his greatest works were worked out by the artist in the process of painting them. So Rembrandt's assistants, unlike those of Rubens, could not simply transfer his sketches to canvas and proceed, so to speak, to fill them in. What they had to do was to learn to *think* like him.

In other words, even if Drost is considered to have invented *The Polish Rider*, Rembrandt may be considered to have invented Drost. This is not completely far-fetched. Rembrandt was an artist who decisively altered the course of painting. Looking at the National Gallery exhibition, it is impossible not to be struck by the gulf that separates his works from just about all previous paintings. It also seems inconceivable that Rembrandt, himself, was not aware of just how revolutionary and singular he was.

This leads back, finally, to the real reason to visit this show. It is to experience and to celebrate the achievement and vision of an individual, and to remember why Rembrandt occupies a place at the top of hierarchy of Western art. This should not need restating, but perhaps it does. Rembrandt matters because he realized that to paint according to preconceived rules of decorum was to tell a lie about the world. He matters because – as his *Bathsheba* shows – he was the most forbearing and least sentimental painter of people to have lived. He matters because he was the greatest painter, simply, of what it is to be human, to be alive and to have to die.

The scholars might have set out to shrink Rembrandt, to make him more manageable and less unruly, but they are fighting a losing battle. He grows rather than diminishes. His art seems fuller and broader and deeper, more mysteriously charged with human significance, every time you experience it.

31st March 1992

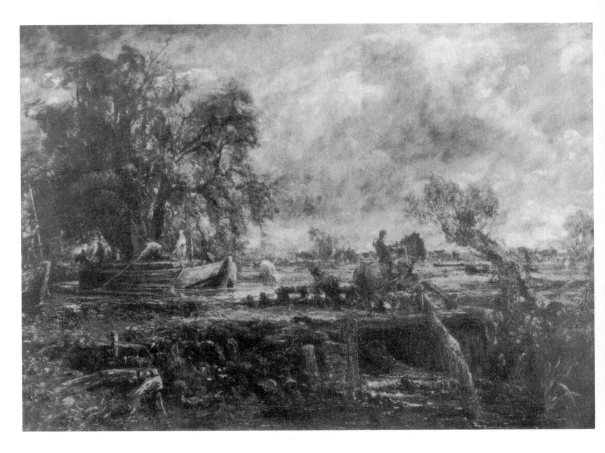

Constable

WHAT IS A GREAT CONSTABLE? Not just a pretty piece of landscape painting by a talented observer of English scenery; not just a picture of trees and water and weather. It is a vivid and emotionally complicated thing, a dark eruption of memory and longing. The Tate Gallery's Constable exhibition gathers together some 344 paintings, drawings and prints. His works have never been seen in such quantity before, but at no point do they begin to pall. They are fierce and wonderful objects.

The Hay-Wain is his most famous picture but the high point of this show is another pair of works: *The Leaping Horse* and the full-scale oil sketch for it. They are encountered about halfway through the Tate show, which is appropriate because they are the hub of his painting, the centre around which everything else that he did seems to revolve.

The painter's subject, as usual, is nothing much: 'Scene in Suffolk,' as Constable described it to a prospective buyer in 1825, 'banks of a navigable river – barge horse leaping on an old bridge under which is a flood-gate.' This flat description is entirely belied by the grandeur of the paintings themselves, and particularly the oil sketch, which Constable has painted with such intensity.

Look at the way the figures on the left in the foremost barge are modelled, as dark, almost inchoate silhouettes struggling out of the murk of the trees gathered behind them. Look at that windswept sky, paint whipped up into a turmoil of cloud. Look at the horse, that image of arrested striving, hindquarters rooted to the ground (Constable was, in both senses, a painter of tremendous gravity). Constable's use of paint demands the kind of comparisons that are rarely made with regard to his work. It suggests, not other landscape painters, but Velázquez, late Titian, or the dark Rembrandt of the late self-portraits – echoes that are amplified by the central detail of the horse and rider, which evokes the equestrian subjects of those artists.

Both versions of the painting are large, which is another of the ways in which Constable demands parity with the masters of the grand narrative tradition in Western painting. This is a fundamental part of what made the exhibited picture – which is only a little more cautious in handling than the sketch – both so revolutionary and so puzzling to the artist's contemporaries. Constable's grand bravura landscape, with its writhing trees and stormy sky, is fit for a martyrdom or crucifixion – but he has, apparently, *left out the subject*. There is no martyrdom, no crucifixion: no grand theme, apparently. In fact, Constable did have such a theme, but he expressed it in a quite unprecedented way.

Constable's works add up, as his biographer, C. R. Leslie, once put it, to 'a history of the painter's affections'. That is not a platitude. Constable reinvented landscape painting, complicated its old topographical or classical associations and made it the vehicle for a new kind of story: a story of the self.

'I should paint my own places best,' Constable wrote to his friend and patron John Fisher. 'Painting is but another word for feeling. I associate my "careless boyhood" to all that lies on the banks of the Stour. They made me a painter (and I am grateful).' Painting the landscape of his youth – which he continued to do long after he had moved away from that landscape – became for Constable an enterprise akin to Wordsworth's in *writing* about his childhood. It was an attempt – although to simplify it like this is to make Constable sound more lachrymose than he ever was – to recapture the immediacy, the freshness of experience of his 'careless boyhood'.

There is nothing in previous landscape art like the series of small sketches of *Flatford Mill from the Lock* which Constable painted in approximately 1811. Already, you find a sense of tension, between the painting as record – these are sudden, lightning sketches which convey the slightest atmospheric changes with wonderful subtlety – and the painting as an independent object, with its own immutable logic of form and shape and colour. And already there is something about the passion and attack with which Constable paints that suggests, in a barely definable way, a sense of loss, of charged (but not sentimental) nostalgia. Loss is Constable's theme.

The sense of tension, so strong in Constable, between the work of art and what it represents, comes to assume the force of a tragic

revelation. To paint a place can never be to relive the experiences had there. Pictures cannot supply the scenes they imperfectly evoke. This is the sadness of all mimetic painting, and in his darker moments Constable came to feel that he was engaged in an inherently futile activity: 'Good God,' he wrote in 1833, 'what a sad thing it is that this lovely art – is so wrested to its own destruction – only used to blind our eyes and senses from seeing the sun shine, the fields bloom, the trees blossom, and to hear the foliage rustle – and old rubbed out dirty bits of canvas, to take the place of God's own works.'

Both versions of *The Leaping Horse* are central to Constable's work because they state, with a compelling combination of grandeur and urgency, the painter's conception of art as an act of charged remembrance; and because they are paintings salvaged from the consciousness of inevitable failure. This is particularly true of the full-scale sketch, which is heavy with a sense of distance and obstruction; like so many of Constable's mature works, it is built around a composition that opposes a dense foreground of dark, wet or rotten forms to a distant, Arcadian prospect of calm and sunlit meadows.

It is a picture of physical struggle – embodied by horse and rider, who strive to get from one place to another, up and away from this dark foreground to that becalmed background – that becomes an analogue for the painter's own imaginative struggle: to get from one *time* to another, from tainted adulthood to innocent childhood. (The open field was, too, redolent in Constable's time of an idealized communal past, evocative of an England before the Acts of Enclosure.)

Constable developed a pictorial language rich in metaphors for feeling. Distance acquires a massive emotional charge in Constable's art – beginning perhaps in 1813, when he paints, again and again, the house of Maria Bicknell, the woman whom he loves but is forbidden from wooing, across the fields from his own house in East Bergholt. These are landscapes that suggest blocked affection, frustrated longing. But Constable's landscape structures cannot be explained by the painter's unhappy relationship with Maria Bicknell, since they are developed most eloquently in works (like *The Leaping Horse*, or *The Lock*) painted after their marriage.

If it is possible to talk of anything like a simple progression in Constable's painting, it is from open compositions – the frankly Arcadian

Dedham Vale: Morning of 1811 is a radiant example – to increasingly closed and occluded compositions. (This makes the pictures sound simpler than they are, since Constable's characteristically dark, dank foregrounds are painted so freshly, are so vigorously spotted with his famous 'dew', that they hint at further emotional complication: images of age and decay, perhaps, redeemed by the vitality of art.) *The Hay-Wain* is unusual, not typical: a painting in which the open meadow, the blooming field lit by the sun, seems within touching distance.

Constable's later paintings – like *The Lock*, with its heroic, straining barge-hand – are more troubling. The sketch for *Hadleigh Castle*, with its Gothic ruin presiding over a vast and empty sea, is almost unbearable. This is Constable encroaching on the territory of Turner, but with a weight of desolation unparalleled in the art of his contemporary; the only other Romantic work of art to approach its mood of desolation is Wordsworth's *Elegiac Stanzas*. Constable's problem – it was the problem of all the Romantics – was how to give private feelings public speech. He solved it by finding, in his own emotional predicaments, a larger human significance. He painted the gap between facts and aspirations, between what is real and what is yearned for.

18th June 1991

II

HEAVEN AND HELL –

AND IN BETWEEN

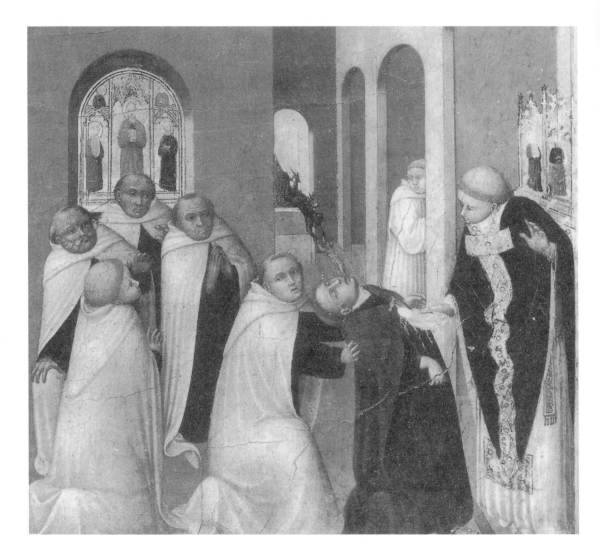

Sassetta

RELIGIOUS PAINTINGS ARE usually denatured when they end up in museums, places that inevitably turn them into things which they were not originally intended to be. The museum tacitly transforms the religious painting into an object of aesthetic contemplation and art-historical classification, rather than an injunction to the faithful. It becomes something to be admired for its formal qualities, to be retro-spectively slotted into a school or a movement. It becomes a link in the chain of art history, too easily seen as an echo or a prophecy of other paintings, rather than a thing made to move, stun or astonish particular people in a particular place at a particular time.

According to the catalogue to 'European paintings from the Bowes Museum', an early fifteenth-century predella painting of *A Miracle of the Eucharist* by Sassetta, demonstrates that 'his contribution to Sienese art lies principally in his convincing, though mathematically imperfect, construction of inner space' and in a 'unity of composition created by the skilful grouping of the figures'. This does less than justice to the ferocious piety of Sassetta's painting, its extraordinary marriage of righteousness and violence, and what must once have been the terrify-ing nature of its appeal to the lay Catholic imagination. This is a painting that is too fierce to be tamed, to be domesticated or secularized, and its message is unambiguous. Forget art history, forget composition and perspective and the skilful grouping of figures. Sassetta's picture is not even a work of art, in the museum sense. It is a threat: believe, or burn in hell for ever.

A Miracle of the Eucharist is about the consequences of sinfulness, the perils of feigning faith, and the power of God. An unbeliever, clothed (probably symbolically) in black, has been found out in the act of receiv-ing Communion. The Host, offered to him on a plate by the officiating priest, miraculously spurts blood and the unbeliever falls backwards,

SASSETTA *A Miracle of the Eucharist (detail)*

struck dead instantaneously, while a tiny black devil swoops down to snatch his soul as it emerges from his mouth. The priest looks down in amazement at the bloody wafer, the poleaxed communicant and the predatory winged devil reaching into his mouth. A group of thick-set Carmelite monks, heavy men with shaven heads and austere expressions, reel and fall to their knees in prayer, one of them uneasily supporting the dead man – with a gesture of succour that also looks like one of revulsion – as he topples. The queuing laity, waiting their turn to receive Communion, look at each other uneasily: amazed by the miracle, or perhaps newly daunted by the prospect of going, themselves, to the priest with open mouths. They have just become fully acquainted with their vengeful and savage God.

Sassetta's painting is a stern reproof to the very idea of placing such an object in a museum – a picture that makes you feel more than a little uneasy about looking at it somewhere other than in a church. Perhaps it is a great painting, in part at least, precisely because it continues so strenuously to resist categorization as one. It makes that sort of aesthetic judgement seem thoroughly irrelevant – rather like admiring the dress sense of someone who has just sentenced you to death. *A Miracle of the Eucharist* implicitly damns anyone with the temerity to regard it as, merely, a painting, a quaint fiction. This really happened, is the message behind this carefully staged, meticulously created illusion (the picture commemorates the Miracle of Bolsena, said to have taken place in 1263). And if you are not careful, it will happen to you.

A Miracle of the Eucharist is designed to inspire fear and faith in equal measure. Every representational image creates its own world, but Sassetta's also gives the impression of taking you back to one. Modern Catholics are enjoined to believe in the miracle of transubstantiation as a literal truth, but the anthropophagous nature of the act of taking Communion is scarcely insisted on with Sassetta's fierce literalness, his absolute insistence on the connection between salvation and digestion. Eat God, his picture says (and really believe that it is the actual flesh and blood of Christ that you are swallowing), or get ready to puke your soul into blackness and hellfire.

Catholicism is often said to be a religion of ornament and artifice, whose ceremonies and churches are tainted with theatricality: one of the oldest traditions of Protestant thought links the theatre with the

decadence of Popish Rome, and finds acting morally disreputable if not actually irreligious. But Sassetta's painting is, among other things, a diatribe against mere show, against ritual gone through without true faith. It is not enough to seem to believe: omniscient God will find you out; he will know, as you lower your doubting lips to receive him into your mouth, that your faith is not true. *A Miracle of the Eucharist* is a painting of an actor being found out in performance (the victim of God's rage is himself a Carmelite monk), an image designed to inspire all doubters with a positive terror of being discovered in their dissembling. God knows the true self, and it is naked and defenceless before him: as naked and defenceless as this human soul, a pitiful homunculus blindly stretching its arms out and emerging from the mouth of the stricken man like a new-born baby emerging from the womb. To die is to be reborn: another article of faith which the painting makes uncomfortably literal, while reminding those who look at it that their conduct here on earth will decide whether the midwives turn out to be devils or angels.

Perspective, in Sassetta's painting, performs as much of a rhetorical, persuasive purpose as it does a mimetic one. The space within which the artist contains his narrative is painted with supreme confidence, a lucid straightforwardness that makes the supernatural event taking place within seem doubly disturbing, emphatically other-worldly. Sassetta creates an entirely structured world, but it is also a world the harmonics of which – those three, perfectly realized vistas through to architectural spaces beyond, the subordination of the entire design to the simple rhythms of arch and void – exist to be shockingly disrupted. The calm orderliness of Sassetta's painting, its lucid, confident creation of space, light, distance, give the appalling events of the miracle itself even more force: something terrible is happening, and it seems still more terrible and affecting because it is happening within this pictorial structure of perfect, measured spatial illusionism.

A Miracle of the Eucharist, seen in the National Gallery (or any modern museum), is a picture triply out of context. It is no longer in a church; the world and the people for whom it was produced have vanished into the past; and it has been cut from the far larger altarpiece by Sassetta of which it was once simply one element. At the last count, Sassetta's *Altarpiece of the Eucharist* was divided between three museums (British, Hungarian and Italian), the Vatican and a private collection. But this

piece of it defies its displacement from its original setting by supplying, from within, an image of the world from which it has been torn. The picture's narrative is enacted in a church whose chapels conspicuously contain altarpieces (painted, by Sassetta, with a blurrily impressionistic touch that predicts Vermeer's paintings of images within images) like the one to which the painting itself once belonged.

The painted paintings in Sassetta's painted church – which may represent *The Virgin and Child Enthroned* and *Christ in Majesty* – also serve as reminders of the higher reality in which the sinful unbeliever has failed to believe. In Sassetta's world pictures are not, strictly speaking, art, but truth – and to consider them otherwise is a blasphemy that will be punished. The effect of all this is a form of sealing, an insulation of the picture from whatever modern setting it occupies, since it itself provides an image of its own original home, of the kind of place in which it once hung; and it also tells you precisely how it should be regarded, with unquestioning belief in the truths which it proclaims. It can never be entirely displaced from the world that brought it into being, because it carries that world, so whole and intact, inside itself.

11th May 1993

Goya

THE MAN IN BED does not look well. His whole body has gone into a violent and, it is to be assumed, terminal spasm. He clenches a fist involuntarily and his right leg, knotted with cramp, sticks out from under disarranged bedclothes at an unnatural angle. His face is twisted into a scream.

He is not alone although he might prefer to be. He shares his bed with a horned demon, a monster with the head of a goat, a red-eyed ghoul and a thing with bat's wings. Help may or may not be at hand. By the side of the bed there is a priest, dressed in black, who holds up a crucifix in benediction and looks on, half amazed, half horrified, as a miracle takes place. The figurine of Christ which he clutches, gingerly, has raised a tiny wooden arm to fling a rain of blood across the dying man. It arches through the air to spatter him with thick red gobbets, a blessed and horrible shower.

Goya painted *St Francis Borgia Attending a Dying Impenitent*, one of about eighty pictures in the Royal Academy's 'Goya: The Small Paintings', in 1787 or 1788. The image is full of omens, a dark fantasy portending the still darker and more fantastical world of the painter's later and better known creations: a picture which has its roots in the violent and superstitious Catholic faith of old Spain, but which still manages to strike a new, dissident and nearly atheistic note.

This is not the sort of painting which seems calculated to cure those of little faith of their doubts. It is hard to say which is more distressing: Goya's appalling vision of hell or his equally gruesome vision of potential salvation; the menagerie of mediaeval demons in the bed or the haemorrhaging wooden homunculus in the priest's hand. Perhaps, the painting seems to imply, in its contrast between the reality of a dying and convulsive man and the mad extravagance of the phantoms that beset him from all sides, there are no other worlds, either better or

worse than this one. Perhaps there is only death, and the consoling or terrifying fantasies that we have invented about what lies beyond it are merely figments of the imagination.

The RA's exhibition confirms that Goya was constitutionally unsuited to the expression of uplifting or enlightening themes. Goya was always inevitably himself, and there was always something disconcerting and disturbed about the nature of his imagination. The show contains many of his sketches for religious pictures, executed, when he was a relatively young man, in a style derived from Spanish Baroque and Italian Rococo art. They are unfamiliar and besettingly odd, these images of airborne saints and *putti*, floating heavenwards on the brightly coloured, overlit stage-prop clouds of stock eighteenth-century religious art. A false note is always struck. Goya's heaven is always too much like a hell.

There is a strong sense, in these works, that Goya himself does not believe in the religious fictions which he is painting. He responds distractedly to his subjects, like someone with his mind on other and more sinister things. The cherubs that hover in mid-air in his very early *Virgin of the Pillar* are nasty, mischievous imps with sour faces and flushed, livid bodies: not the standard flying toddlers of Rococo religious painting but fat worms with wings and babies' faces. Goya's oil sketch for *The Appearance of St Isidore to St Fernando*, an obscure and opaque picture of one of those thousands of obscure and opaque minor miracles still celebrated annually in small towns all over Spain, is stranger still. The saintly apparition looms, sudden and enormous, swooping through the air in his great outstretched yellow cloak and bishop's mitre, banking up and around the edge of a tent to astound the assembled devout with his appearance.

There is something of the cartoon character about him, a caped crusader saint, flying low – and he will reappear, in a slightly different form, as one of the flying clerics in Goya's *Los Caprichos*, more openly satirized and made to look like a witch on a broomstick. But even when Goya was, apparently, trying to paint such subjects with a straight face, he could not quite manage it. His religious pictures are clearly the work of an irreligious man.

The RA's show, with its preponderance of minor and little known works, is fascinating despite its limitations. It presents the spectacle of an artist working against the grain of his own temperament, but it also

GOYA *Saint Francis Borgia Attending a Dying Impenitent*

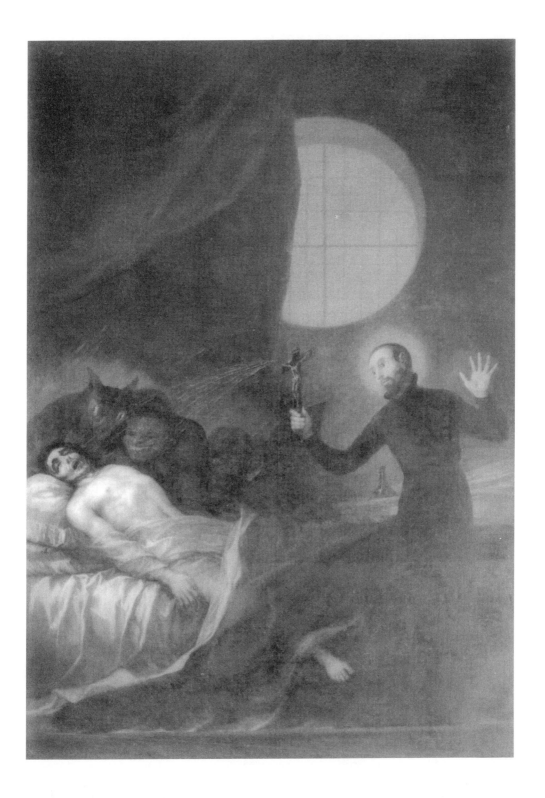

shows how Goyaesque Goya always was. The light, decorative tapestry designs that he made in the 1780s and 1790s deserve to be better known because they are so surreally and incongruously unpleasant. They are not light and decorative at all, beneath their bright surfaces and un-complicated subjects, but strange and alienated and incorrigibly weird, pictures of pastoral idylls where things always seem slightly but nastily awry. To look at these pictures is to see how Goya was incapable of painting an ideal world, and incapable of adopting the styles and subjects of artists who could without turning them to his own obscure purposes: this is Watteau's Isle of Cythera, painted in the loose and bright and insouciant manner of Boucher, but still filtered through a dark and morbid imagination that is entirely Goya's own.

There is something black and blank about the eyes of the frolicking and rustic peasants, a disquiet in the souls of the leisured aristocrats having a picnic. A game of blind man's buff, played under blue skies and beside a placid lake, seems sinister and allegorical, a torture inflicted, inexplicably, on someone who thought he was in paradise. *The Straw Manikin*, tossed in a blanket, becomes more than a prop in an innocent game and turns oddly human: a disjointed, sad-faced dummy, he is an inscrutable victim who flops and jerks and turns, in mid-air, to fix you with dead eyes.

Goya, it might be said, was a disillusioned artist made great by histori-cal circumstance. He lived during one of the great ages of disillusion-ment, and was perfectly adapted to create the emblems of a new and saddened sense of what it means to be human and live. In the later stages of this show, he finally becomes the Goya of legend and one of the first modern painters: a painter of madness and despair, of folly run wild, of a universe ruled, not by God but by violence and pointlessness and death. Goya's pictures of bullfights and insane asylums, of frenzied flagellants, of the dark and hellish councils of the Inquisition – these have become, with the passage of time, among the great symbolic images of the unregenerate, tormented modern world, and of a certain kind of pained, modern self-consciousness.

But what gives these later paintings such force and such potency, and what makes them so inimitable, is the fact that they did indeed spring from disillusionment and were created out of the wreckage and death of an older kind of culture and another kind of painting. They draw

their strength and tension from the painter's own sense of their newness and dissidence and from the knowledge that his way of seeing is not the old way of seeing. Goya often plays this up, through pastiche, as if he has learned to use and adapt the involuntary pastiche of his earlier work and make of it a tactic. The carnival lunacy of *Procession of Flagellants* is a disaffected, jaundiced parody of an old and discredited form of devoutness. *The Madhouse*, where crowded loons enact the roles dictated to them by their diseased fantasies, is also a sort of religious parody: an image of the old and frenzied imagination of the Catholic faithful redefined as a literally mad credulousness.

The paradox of Goya's imagination, so vivid and inventive, so swarming, is that it expresses a profound distrust of the claims made *for* the imagination. The imagination is what Goya finds most dangerous and suspect in human beings: it is responsible for the delusions and fantasies that lead to war, the myths that lead to religious servitude, the ingenuities of torture. He painted the terrors of the mind, perhaps, to release himself from them and he died, like the man with the clenched fist and outstretched foot that he painted back in 1787 or 1788, impenitent: grimly proud of his own faithlessness.

22nd March 1994

Van Gogh

IT IS LATE. The candle, which has burned down almost to its wick, has been extinguished. Shadows encroach, but there is just enough light to illumine the pages of the large family bible propped open on the table. Today's reading, you can just make out, is Isaiah Chapter 53. The prophet announces the coming of the servant of the Lord: 'He is despised and rejected of men; a man of sorrows and acquainted with grief; and we hid as it were our faces from him; he was despised, and we esteemed him not.'

Still Life with Bible is signed, in a red scrawl at bottom left, 'Vincent'. An early painting, from his Nuenen years, it is a reminder that Van Gogh always had a keen sense of his own destiny. 'He was despised, and we esteemed him not.' It was written, and it came to pass.

How little time he had. It has become a cliché, but Amsterdam's centenary exhibition reminds you, with peculiar force, of the tragically short span of Van Gogh's career. *Still Life with Bible* is one of the first pictures you see, exhibit 10 of around 130. It was painted in 1885, three or four years after he had decided to be an artist, but already he had less than five years to live.

No surprise, perhaps, that Van Gogh identified so strongly with the sunflower. He painted its sudden, fantastic radiance, and its equally sudden collapse, with the pathos of one who sensed in its extremes an emblem of his own life. The *Still Life with Two Sunflowers* that he painted in Paris in the autumn of 1887 was done at a time when he was nervously absorbing the impact of Impressionist art – yet this fanatically close observation of the dried-up husks of their blooms, the droop of their stems, is entirely alien to the Impressionists' world of generalized effects.

The flowers, which are past their best, have his full and undivided attention. Monet, for instance, would have placed them *in* a vase, *on* a

table, *in* a room, whereas Van Gogh enlarges and isolates them, which has the effect of intensifying the enigma he found embodied in stark botanical fact. They were alive; they are dead. He paints them, as he paints all the manifestations of nature, as if he is attempting to get *beyond* appearances, to penetrate, somehow, the mysteries of life and death. The weight of his attention turns them into more than only flowers, painted with a transforming intensity that makes every petal a dying flame, every bloom a toppled head. Van Gogh paints the sunflower as earlier artists painted the dead Christ.

'I see in nature,' he wrote in 1882, 'for example in trees, expression and as it were a soul.' Van Gogh combined close scrutiny of the natural world with a passionate sympathy for its every manifestation. This showed itself early in an 1882 sketch of *Tree Roots in Sandy Soil*. Studying this knotty complex of branch and root, clinging desperately to life in unpromising circumstances, Van Gogh finds an unmistakable metaphor for human struggle and desperation. That he thought of the drawing in such emblematic terms is revealed by the pendant he devised for it, *Sorrow*, in which a despondent nude buries her head in her arms.

He had been, it should be remembered, an evangelist, a lay preacher who had unsuccessfully attempted to spread the word among Belgian coalminers and peasants before renouncing his faith. Van Gogh's life and art revolved around his religious apostasy. In the early years, you sense his strenuous attempts to define the new and narrower world of the lapsed believer. He makes countless drawings of peasants, bent virtually parallel to the low Dutch horizon by their tasks of digging, ploughing, carrying. He paints the decayed church tower of Nuenen, surrounded by the simple wooden crosses of innumerable peasant burials and provides a memorable gloss on the picture in a letter to Theo: 'now these ruins tell me how a faith and a religion smouldered away – strongly founded though they were – but how the life and death of the peasants remain for ever the same, budding and withering regularly, like the grass and the flowers growing there in that church-yard.'

Biological fact, the unchanging realities of life and death, were all that Van Gogh, the lapsed Protestant, had left. What counts is the recklessness of his abandonment to nature – that, and the terrible weight of transferred spiritual need that he brought to bear on it.

Van Gogh's art is as unstable, as mercurial as weather. It is his determination to find pictorial equivalents for the strength of his feelings that makes him more than an interesting proto-Symbolist or an Expressionist *avant la lettre* and one of painting's great innovators. He painted rain, for example, as no one had – there is nothing like the incredible, disfiguring slashes of paint that virtually obliterate his late *Landscape, Auvers-Sur-Oise* until the art of Pollock. He invented a new way of painting wind, not merely registering its influence on field and foliage but making empty space itself writhe and gyrate, in those churning skies of his. Cézanne is usually credited with laying the foundations for Cubism, but it is hard not to suspect Van Gogh's boiling, turbulent spaces of having exerted at least as significant an influence on the Cubist Braque and Picasso.

He was an apostate, but he nevertheless painted a world ordered on biblical principles. Van Gogh's heaven takes many forms but it is always, and unmistakably, a heaven, a place loaded with a spiritual significance that you simply do not find elsewhere in Impressionist and Post-Impressionist art. Every tree, in his flowering orchards, is a flaming candelabrum; the sun that casts its incandescent glow over the landscape of *The Sower* is placed, hieratically, at the dead centre of the horizon and modelled in thick, palette-knifed layers of paint that make it resemble the golden haloes of much earlier and more conventionally religious painting.

Then, of course, there is Van Gogh's hell. It is, by now, a familiar place; its most famous *mise-en-scène The Night Café*, that sickly green bar-room filled with slouched despondents, whose tutelary demon is the white-coated waiter who manages to look (not surprising, maybe) like the admissions clerk of a lunatic asylum.

Hell, everyone knows, won out over heaven. Nature had usually provided Van Gogh with a kind of solace, but it began to turn ugly. Cypresses tower above the land like funereal monuments; skies boil over. It is at its worst in his last painting, the *Wheatfield with Crows* – 'fields of wheat under troubled skies', as Van Gogh wrote to Theo, 'and I did not have to go out of my way to express sadness and extreme loneliness.' The wheatfield is split, like the Red Sea parting before Moses, by a winding path that rushes you to the horizon with its breakneck perspectival plunge. There the sun, sick and muffled, awaits. The

crows that rise and surge through the middle distance are reminiscent of another famous swarm in art, the bats that flutter around the troubled dreamer in the most famous of Goya's *Caprichos*. The sleep of reason breeds monsters.

3rd April 1990

Reinhardt

'NICKNAMED 'THE BLACK MONK' on account of his sparse, purely black abstract paintings, Ad Reinhardt was a rarity: an ascetic with a sense of humour. The Museum of Modern Art's retrospective of his grand, solemn, withdrawn pictures opens with a sequence of the satirical cartoons which he drew from the 1940s until his death in 1967. A grinning New York *bourgeois*, in one of the best of them, points at an abstract painting and says 'Ha! Ha! What does this represent?' The painting proceeds to sprout legs and an accusatory arm, which it points at its startled interlocutor and demands 'What do *you* represent?'

Still, quite what Reinhardt's abstract paintings can be said to represent remains an open question. The exhibition starts with a sequence of works that look like student exercises in composition along Bauhaus lines: examples of what Frank Stella would call, disparagingly, 'the you-do-something-in-one-corner-and-you-balance-it-with-something-in-the-other-corner thing'. These are succeeded by works that look like dissolved Monet waterlily paintings, by paintings that resemble subjectless Cézannes, and by pictures that approximate increasingly to brick walls. At this point things begin to get interesting. Reinhardt reduces his range of colours, painting red and then blue abstracts which become harder and harder to make out, since their grounds and the colours of the forms contained within them are so close-toned that considerable effort is required to separate them. Then, in the last room in the show, you encounter Reinhardt's last and by some distance his most extraordinary works.

Reinhardt referred to the black paintings he made in the final twelve years of his life as 'free, unmanipulated and unmanipulatable, useless, unmarketable, irreducible, unphotographable, unreproducible, inexplicable icons'. This begins to suggest the difficulty of describing them – an important characteristic, since they represent one of the most radical

enactments of the perennial abstract painter's ambition, to make a work of art that cannot be translated into worlds or reproductions. MOMA's catalogue to the Reinhardt show is a comical object, with its succession of unreadable illustrations: and it would be possible to walk past the works themselves, at the pace of an average museum visitor, and assume that this is all there is to them – that they are absolutely unrelieved monochromes, as mute and unrewarding as any paintings in the world. But they are not, or at least not quite.

Looking at a late Reinhardt is an intriguing and – if you are patient enough – intense experience. You need to stare into one for several minutes (literally) to perceive that what had seemed monochrome is, in fact, nothing of the kind. There are shapes in there, lurking in the gloom, but it takes the eye a long time to adjust to the minuteness of nuance in Reinhardt's blacks so that these forms can be picked out. Even when they are identified – Reinhardt's shapes are invariably straightforward once detected, simple hard-edged horizontals and verticals – they can easily slip out of focus and are lost altogether if looked away from even for an instant.

Late Reinhardts are both odd and challenging: pictures of almost nothing at all, but almost-nothings that require such endurance and concentration merely to be *seen* that they acquire a distinct, if indefinable, sense of consequence. If you are going to experience a black Reinhardt, you are going to have to devote yourself to it: it becomes a secular altarpiece, although of a peculiarly opaque, obscure kind.

Reinhardt himself preferred to talk about what his paintings did *not* mean. He was christened Ad, but his credo was Subtract, and he put it most succinctly in a text called 'Abstract Art Refuses': 'In painting, for me no fooling-the-eye, window-hole-in-the-wall, no illusions, no representations, no associations, no distortions, no paint-caricaturings, no cream pictures or drippings, no delirium trimmings, no sadism or slashings . . . no confusing painting with everything that is not painting.' Reinhardt's taciturn pictures were conceived as objects of resistance, as rebuttals of the shams and posturings he detected in most art.

This would subsequently make Reinhardt into something of a father-figure to the Minimalists – who saw their own absolute literalism prefigured in his black paintings – although he never shared their cool,

affectless attitude. Reinhardt believed in art as an antidote to the chaos of the later twentieth century – or at least a contemplative pause from it – whereas the Minimalists were more interested in making art that offered equivalents to the dumbness they saw in the world around them.

Reinhardt despised the Abstract Expressionists because he felt they made unjustifiable claims for their art – 'I am nature, I am fate, I sell my paintings' ran his damning parody of Jackson Pollock. He made works which still seem to yearn for the retrieval of significance from the vast, dark cosmos inhabited by modern man. His black paintings could be said to depict the absence of God – this is not as fanciful as it sounds: in an undated manuscript, Reinhardt jotted down one of the first astronauts' descriptions of space as 'hostile, void and very black' – but they also, in those glimmerings of pure geometry that appear and then disappear within their blackness, materializing at the margins of consciousness, hint at the possibility of spiritual or mystical transcendence.

Reinhardt was the Savonarola of the New York art world, a vigorous damner of corruption and proselytizer for the abstract faith. He liked to think of his paintings, whose matt surfaces are easily and irrevocably damaged by the slightest touch of a human hand, as surrogate Christs sent out into a hostile world: 'The painting leaves the studio,' he noted, 'as a purist, abstract, non-objective object of art and returns as a record of everyday experience', bearing the 'scratches' and 'marks' of its martyrdom. His favourite poem is said to have been Auden's 'The More Loving One', and its final stanza is probably the most eloquent text that can be appended to Reinhardt's black paintings:

> Were all the stars to disappear or die,
> I should learn to look at an empty sky
> And feel its total dark sublime
> Though this might take me a little time.

Often what seems most like idealism, in modern art, stems from the attempt to come to terms with lapsed faith. Reinhardt's idealism is grim and stoical. It is the product of acceptance, of capitulation just barely shadowed with optimism.

6 August 1991

On a wing and a prayer

THERE MIGHT BE as many as a hundred of them on your mantelpiece and there is, almost certainly, one on top of your tree, but the chances are you have not taken the time to look at them – to note their differences, their quirks and habits. Angels are just part of the festive scenery: airy, anonymous, almost abstract embellishments to the modern Christmas.

Almost, but not entirely abstract. Angels have a past. To follow the evolution of the angel in art, its various metamorphoses and eventual extinction, is to see in miniature the fluctuations of the Christian faith, and its gradual decline in the West. Angels may have been denatured as God's messengers, but they are, still, carriers of fascinating information.

The history of the angel in art is partly a history of the humanization – the imaginative materialization – of the supernatural. The idea that divine will requires these intermediaries, winged beings whose forms are half mortal, half supernatural, goes too far back to trace. The word 'angel' is ancient, derived via Old French and Latin from the Greek 'aggelos', itself a translation of the Hebrew 'mal'akh', meaning messenger. The angels we know from art galleries and Christmas cards are descendants of Mercury, the envoy of Jupiter, and of the innumerable winged deities to have preceded him. They demonstrate the close links between pre-Christian and Christian imagery, although, for many people now, even their Christian significance is much diminished.

Nowadays, for instance, we tend to think of angels as being, more or less, all the same. We might be able to tell the difference between an archangel and a cherub – but the finer distinctions between various kinds of angel that might have been recognized by, say, a fourteenth-century churchgoer, tend to be lost on us. The nine kinds (or choirs) of angel, first listed in the fifth century AD by a convert of St Paul called Dionysius the Areopagite are categorized as follows: Seraphim,

Cherubim, Thrones; Dominions, Virtues, Powers; Princedoms, Arch-angels, Angels. The last choir of the last hierarchy has the title 'Angels', but the generic term 'angel' applies to the others too. Angels (who are all, incidentally, male) demonstrate that heaven is not quite the classless society it is sometimes made out to be.

Different angels have different jobs. The Cherubim and Seraphim, absorbed in perpetual love and adoration of the Almighty, do not leave His side. (God, in Titian's famous *Assumption of the Virgin* in the Frari, Venice, should be surrounded by a multitude of Seraphim and Cherubim who bathe in the glow of His divinity.) The lowest orders of angels, by contrast, the Angels and Archangels, are constantly scurrying off to earth to do His bidding. This is reflected in art, although over the centuries artists seem to have become less and less respectful of, and knowledgeable about, the distinctions within the angelic host.

The early angels of Byzantine art have a stiff, intimidating, almost martial bearing. They are not adolescent (like most angels of the early Renaissance), nor childish (like most angels of the Baroque and after), but fully grown. They are impressive but impassive, having the character of emblems. Something of the distant solemnity of the Byzantine angel survives in the figure of Gabriel in Duccio's panel of *The Annunciation*. By contrast, Filippo Lippi's Gabriel, in his *Annunciation* of almost 150 years later, seems a courtly, courteous, and far more worldly messenger from heaven. Gabriel had only begun to kneel in versions of *The Annunciation* in the fourteenth century, and later artists like Lippi painted him as a kind of respectful knight from heaven, adopting the stance of courtship popularized by the code of chivalry. A temporary innovation acquired the permanence of a convention.

Angels first became touchingly human in the art of Giotto. Giotto's angels, in the great *Lamentation* which he painted for the Scrovegni Chapel in Padua, seem shocking because they react to the death of Christ with such painfully human emotions: they scream, they weep, they wring their hands in anguish. Yet they also retain something of the nature of the old, emblematic angels: it is as if they have been driven beyond the limits of the artistic conventions that framed them, by pain.

Artists have, in general, tended to concentrate on the first and last pair of choirs: the Cherubim and Seraphim; the Archangels and Angels. Why they should have chosen to abbreviate the heavenly host may be

RAPHAEL *Sistine Madonna (detail)*

deduced from one of the few paintings in which all the choirs of angels *are* present: Francesco Botticini's *Assumption of the Virgin*, of around 1475, in the National Gallery. Botticini pictures heaven, here, as a vast architectural dome in the sky, with God just below where a cupola might be, its sides banded with the nine choirs of angels. It is an awful lot to fit into a painting. Heaven, in Botticini's image, ends up occupying nearly the whole canvas.

Relatively early on during the Renaissance, five of Dionysius's choirs – the Thrones, Dominions, Virtues, Powers and Princedoms – had been dropped by most artists. These were, after all, the least *interesting* of the angels, being neither those closest to God, nor those closest to man.

The angels in Masaccio's *Virgin and Child* in the National Gallery are sharply individuated and begin to invite those kinds of questions (which two boys sat for the painter? where did he find them?) that tend to complicate perception of them *as* angels. When angels become more and more palpable, more and more like people, but with wings, it

sometimes seems as if they run the risk of forfeiting their angelic stature as a result – and as if Renaissance artists themselves sense that, by painting their angelic models with the same empirical attention which they devote to landscape or architecture, they are in danger of creating heavenly beings that no longer have the sense of heavenly mystery about them.

There is a kind of uneasiness in much later Renaissance sacred art, a creeping doubt about the narrowing gap in representation between the holy and the mundane. It may be detected in the art of Raphael. In *The Sistine Madonna*, he negotiated this problem by pitting one kind of angel against another. In the painting's foreground, propping themselves on their elbows on its stagy parapet, you find a pair of those distinctively urchin-like, mischievous child angels which the Victorians so admired Raphael for. Above them, in the centre of the picture, the Madonna and child are framed against a glowing backdrop, a radiance peopled by innumerable, tiny cherubs' heads – a kind of backlit angelic cloud, an almost abstract device. It is as if the artist has recognized that some form of retreat from his own accomplished realism is necessary to create a sense of holy transcendence. The paradox of the image is that the artist himself seems much more interested in the angels below, with their naughty altar-boy demeanour, than he is in those above. You can imagine him leaving all those tiny heads to an assistant: 'Gone for lunch. Please do the cherubs.'

Titian's baby-thronged mist, in his *Annunciation*, or the endless fricassees of angelic infants served up by Baroque and Rococo artists, may be said to to demonstrate a similar recognition of the limits of a literal, descriptive language of art when it comes to the depiction of beings as ethereal, as charged with holiness, as angels.

Angels in art are never just the intermediaries of God, but also of artists – the messengers of their originality. To compare the angels in Mantegna's *Agony in the Garden* with the angel in Bellini's version of the same subject is to measure the gap between the two artists. Mantegna's angels are fitting occupants of his hard, mineral world, a row of stonily realized winged babies perched on a cloud the texture of rock. Bellini's angel, on the other hand, is a radiant, floating being – a creature who seems fashioned from Venetian blown glass, as if the artist has attempted to translate, into the forms of art, that mystical Christian

tradition of thought in which the angel is held to be a transparent medium of God's light. Nearly two centuries later, Rembrandt would attempt something similar, omitting the angels altogether from his *Adoration* and putting in their place, simply, a beam of yellow light.

Every artist has his own angels – Piero della Francesca's are solemn, watching presences, indefinably ambiguous; Caravaggio's are lithe, streetwise, earthbound adolescents – yet for all the variety within it, the history of angels does have a certain consistency. The evolution of the species might be haphazard but it has a direction.

What happens to angels is that they get younger. In fact, they get much younger. They regress constantly, over time, so that from (say) Duccio to Murillo their average age drops from about twenty-five to about two. This cannot merely be explained by the earlier suggestion that artists sought, in the Cherubic mist, an escape from their own literalness. What seems to happen, in Western art during and after the Renaissance, might be described as a peculiar *rapprochement* between sacred and secular painting which results in an altogether new *kind* of angel. To put it simply, angels start to look like Cupid. And angels start to look like *putti*, the winged assistants of Cupid. Artists, collapsing the gap between one sort of painting and another, between the profane and the religious, devise a multi-purpose otherworldly figure equally suited to either. The evidence for this is everywhere, in those rooms of the National Gallery given over to the seventeenth century: on one wall you may see Velázquez's *Rokeby Venus*, attended by Cupid, on another a Murillo saint having visions of tiny winged infants, but the Cupid and the angels look *exactly the same*. The old hierarchy of angels has almost completely disappeared, to be replaced by a new and uniform type. Angels are gradually homogenized, so that by the period of the Baroque they have acquired the character of a virtually invisible convention – a development in art which may itself mark a dilution of the old Christian faith in heaven as a *reality*, since it presents angels as beings no longer really known and differentiated between.

The implications of this development are large. Walking through the National Gallery in search of angels, you notice a gradual diminution of their symbolic power. Their meaning, as divine messengers, seems to leak from them and seep into other, more secular kinds of imagery.

When angels became Cupoids, a new kind of religious art was born.

It could be spectacular, but it could also be profoundly ambiguous in a way that (for instance) the art of Giotto could not be. A perfect example of this ambiguity might be the High Baroque sculpture of Bernini, where (typically) the angel-cum-Cupid assists a swooning female saint to attain a condition of visionary ecstasy that looks remarkably like orgasm. When angels begin to turn pagan, saints and Madonnas can seem like Venuses and heaven like one vast orgy. After Bernini, the secularization of the angel gathers pace and can be said to culminate in the jokily profane, semi-sacrilegious mythologies of Boucher and Fragonard. It is not exactly that angels cannot be angels any more, but they cannot be (even in religious art) *only and unambiguously* angels. They have been soiled by association. Their origins, in heathen mythology and iconography, have come back to haunt them.

This may be why William Blake, one of the last artists to create a new, distinctive and sacred-seeming version of the angelic form, should have avoided the Cupid-*putto* stereotype. In the V&A's drawing of *Angels Hovering over the Body of Christ in the Sepulchre*, Blake reinvented the old, distant Byzantine angel in a new form. His mysterious beings, who seem made of liquid or light, are removed both from the mundane world and from the dangerous, sexually charged world of classical mythology. They are quite sexless, these hovering beings, and are doubly armoured by the symmetry of Blake's composition. Their wings touch, forming a Gothic arch. The angel recovers, for a moment, its holiness.

Turner painted an angel too, although his *Angel Standing in the Sun* really marks the angel's disappearance from art. The standing angel (the Archangel Michael, announcing the Last Judgement) is overwhelmed and almost obliterated by the whirling vortex of light and heat that is Turner's late style. After Turner, in this century, artists with a spiritual bent (like Mark Rothko) have created trembling voids of pure, saturated colour, emptied of figurative reference. These gaping emptinesses are ambiguous, lucid pools in which we see reflected our own religious doubt. They may picture The Void, or simply nothing. Look hard into them, and you might just see an angel. But probably not.

28th December 1991

III

EROS

Michelangelo

FEW GREAT PAINTINGS can have come quite as close to destruction, and survived, as Michelangelo's *Entombment*. The story of its narrow rescue, by the Scottish painter and photographer Robert Macpherson deserves to be better known, not only because it is so curious and romantic, but also because it records one of the most eloquent compliments ever paid to the power of a picture.

Macpherson, we know from the autobiography of his close friend James Freeman, first came across *The Entombment* while looking through a job lot of pictures which had just been sold cheaply at auction in Rome in 1846. 'Mac had carefully observed among these paintings,' Freeman tells us, 'a large panel over which dust, varnish and smoke had accumulated to such a degree as to make it difficult to distinguish what it represented. There was, however, something in its obscured outlines which made an impression on him, and haunted his recollections of it. Knowing the dealer who had bought the pictures, he went a few weeks later to his shop, and, while looking at some other things, asked carelessly, "What is that old dark panel there?" "Oh, that," replied the dealer, "is good for nothing, beyond the wood on which the daub is painted. I am going to sell it to a cabinet-maker who wants to make tables out of it."' Macpherson bought it for a little more than £1, smuggled it out of the country and sold it, years later, to the National Gallery.

'There was something in its obscured outlines which made an impression on him, and haunted his recollections' – a fine tribute, not only to Macpherson's perceptiveness but also to Michelangelo's draftsmanship. 'Making and Meaning: The Young Michelangelo', at the National Gallery is above all an occasion to reconsider *The Entombment*, his only altarpiece. Bernard Berenson once and without ulterior motive described the picture as 'the quintessence of Michelangelo'. Perhaps no other of his works provides quite so stark a demonstration of the intense

sensuality and spirituality that were so strongly and uniquely combined in him.

The oddity of the picture's composition has often been noted. The dead Christ, coiled round with winding sheets, has been hoisted into a slumped but upright position facing the viewer of the picture. Saint John (on the left), along with a figure thought to be one of the three Marys (on the right) and Joseph of Arimathea (behind) are carrying the body backwards up a flight of stairs to the tomb. The balletic symmetry of the two figures flanking Christ introduces a somewhat incongruous elegance to an extremely sombre scene. (There is a portent of the future here, perhaps; Leonardo da Vinci, when he saw Michelangelo's now lost cartoon for *The Battle of Cascina*, not far distant in date from *The Entombment*, detected in its ingenious variety of poses the seeds of Mannerism.)

All this is less than convincing, if judged by the criterion of realism. *The Entombment*, however, is not a narrative painting but an iconic one, the job of which is to present, as matter for contemplation, the image of the body of the dead Saviour. The fact that it was intended as an altarpiece, with the Eucharistic significance which that implies, requires emphasis. This is a picture designed to be looked up at by the kneeling faithful during the celebration of Mass: a hushed, sacred image of the redeeming body of Christ, that same body which shall be ritually eaten and drunk in the form of bread and wine.

Only if you kneel before the picture and look up at it does its otherwise peculiar perspective make sense. The figure of Christ, seen from this angle, becomes both more monumental and more ethereal, a weightless spirit only just contained in flesh, who looks as though He may float effortlessly up into the heavens away from those who bear Him. His feet hover just above the ground. This entombment has something of the ascension about it.

It is a relatively early work, but already Michelangelo is himself. He has disdainfully abandoned the fussiness and genteel *horror vacui* of his master, that painter of materialistic Nativities, Domenico Ghirlandaio. Although it belongs to a well-established genre, the *Ostensio Christi* or showing of the body of Christ, *The Entombment* is really an *Ostensio Michelangelo*: a showing of the painter, a revelation of his overriding preoccupation, the male nude.

The naked figure of Christ is so much its *raison d'être* that it may explain why Michelangelo never finished *The Entombment*. It is difficult to see how he *could* have finished the painting without diluting its concentration on that single, sublime body. The system of checks and balances which he presumably intended to contain the other figures has clearly proven ineffective, and he has left off rather than elaborate them into the fatal distractions which they were fast becoming.

It has become customary to dismiss Benvenuto Cellini's assertion that Michelangelo never drew the male anatomy more beautifully than when he was a young man. But the figure of Christ in *The Entombment* suggests that Cellini may have been right: here is a body of tremendous sensual immediacy, painted with a delicacy and a strength of feeling beyond description, yet also one that is somehow abstracted and unreal. By comparison with it there is not another figure in Michelangelo's painted *oeuvre* which does not seem (however slightly) heavy or coarse.

It may be argued that by painting a figure who seems both so palpably human and so mysteriously divine, Michelangelo was only responding to theology and incarnating the most beautiful paradox of the Christian faith. But this is to ignore what it is, in Michelangelo's painting, that continues to move those of us who do not share that faith – the sheer weight of feeling that seems lodged within it, which in turn produces the conviction that it expresses a profound personal struggle.

Kenneth Clark wrote one of the subtlest descriptions of the tensions which may have formed Michelangelo, which also serves to describe the effect of *The Entombment*. 'Michelangelo, like the Greeks, was passionately stirred by male beauty . . . The passage of violent sensuous attachment into the realm of non-attachment, where nothing of the first compulsion is lost but much gained of purposeful harmony, makes his nudes unique.'

The distanced eroticism of Michelangelo's art showed itself, above all, in the rapt emphasis he placed on parts of the body which were not usually the conventional foci of sexual interest. Think of the outsize hand his *David* hangs by his side or the fingers of Adam, that lazy reclining river god reaching out to be animated by the sparking finger of the Almighty on the Sistine ceiling. He was also deeply affected by the line traced by the curve of the calf just underneath the knee. The eye is unaccountably drawn to this part of the body in his *Bacchus* and

his *Pietà* and in the figure of the standing angel in the 'Manchester Madonna' – and it may not be entirely eccentric to find in the use of that same line, with its generous suggestion of pendulous flesh, an explanation of the mysteriously sensual character of the bulging stone steps in his great late architectural project, the staircase for the Laurentian Library.

Maybe the best clues to *The Entombment*'s private significance are found in those two great sculptures which he carved shortly before he undertook the altarpiece: the slight, floppy-legged child-cum-Saviour, lying limply in the arms of his mother, that is his Vatican *Pietà*; and the dangerous giddily drunk, cheap little rent-boy that is his *Bacchus*, the most vividly real and sexually vital creation in Michelangelo's entire *oeuvre*.

The Entombment seems to resolve the two sides of Michelangelo represented by the two sculptural masterpieces of his youth. Aside from the figure of Christ, the eye is only drawn for long to one other member of *The Entombment*'s incomplete cast: the slightly louche, androgynous figure of St John, with his plump young voluptuary's face, who has the air of a Dionysus reluctantly brought to order. What might this indicate? A victory, perhaps, for the pious Michelangelo over the sensualist; for the religious, ascetic Michelangelo over the Michelangelo who was drawn to the pagan world of antiquity like a moth to a flame; for the pure Michelangelo over the erotic Michelangelo. In *The Entombment*, he subordinated the Bacchus of his fantasies to the Christ of his dreams.

25th October 1994

Poussin

TO THOSE WHO HAVE NOT READ the Renaissance poet Tasso, Poussin's two paintings of *Tancred and Erminia* may seem initially mystifying. Who exactly is that man lying on the ground, and what is the matter with him? Who is the girl in blue and why is she trying to give herself a haircut with a blunt sword? Thoughtfully, curator Richard Verdi's catalogue to the small Poussin exhibition at the Birmingham City Art Gallery gives you the potted version of Poussin's source, Canto XIX of Tasso's verse epic *Jerusalem Delivered* – which certainly takes some potting.

The story so far: Erminia, a Saracen princess, has fallen secretly in love with Tancred, a Christian knight crusading in foreign lands, despite having accidentally killed her best friend, the Amazon Clorinda (with whom he was secretly in love). Meanwhile Tancred goes into combat with the pagan giant, Argantes, slays him but is severely wounded and collapses on the battlefield next to the body of his victim. Erminia goes in search of Tancred accompanied by his trusty squire Vafrino and, finding him close to death, confesses her love for him and attempts to bind his wounds using her hair as a makeshift bandage.

Poussin knew how to cut a long story short. His first version of *Tancred and Erminia*, loaned to Birmingham from the Hermitage in St Petersburg, condenses several hundred lines of poetry into a single image tense with emotional conflict. Erminia, suspended between desire and anguish, looks raptly at the prone figure of Tancred in Vafrino's arms and takes his sword to her long golden hair. The rest of the story is consigned to the background, treated through circumstantial detail: the body of the giant, to the right; Tancred's strewn armour, gleaming dully.

Erminia's white horse, painted by Poussin with wonderful attentiveness, is a subtly anthropomorphized animal. It acts as a stand-in for the

viewer of the painting, a cue for his or her own emotional responses. Will Erminia save Tancred? Will he return her love? The horse gazes at her and seems worried, uncertain, just as the whole picture seems poised uncertainly between a happy and a tragic ending. The glowing sky in the background casts a muted golden light that could be dawn or dusk, coming day or encroaching darkness.

Even an audience familiar with Tasso would not have been able to supply the story's ending from their knowledge of the poem – or at least not all of it. They would have known that Tancred did, indeed, recover, but at the end of *Jerusalem Delivered* Erminia's love for him remains unfinished business. There is a small hint, in Poussin's first *Tancred and Erminia*, that all will end well for Tancred. The barren ground to the right of his body has begun to sprout anemones, a symbol of regeneration. But this detail is not altogether convincing. It looks like an intrusive element of allegory brought into a painting whose subject will not be easily moralized or resolved. Erminia's fate remains unclear, and the whole register of the painting, which revolves around her romantic, reckless figure, seems to declare the dangers and uncertainties of passion.

Poussin has earned a reputation as one of the most rigorously intellectual, detached, learned painters in history. 'My nature constrains me to seek and to love well-ordered things, and to flee confusion, which is as much my antithesis and my enemy as light is to dark,' he wrote in his mid-forties. But Poussin in his forties was a cooler and more resolved artist than the Poussin of ten years before. The Poussin who painted the Hermitage *Tancred and Erminia* is preserved in the British Museum's wonderful red chalk self-portrait drawing: he is a tousled prototype of the romantic artist-as-bohemian, gazing truculently out at whoever cares to meet his eye.

This is the figure often conveniently forgotten by Poussin's later mythologizers: the unruly, dissolute, syphilitic Poussin who was arrested in a street fight in the early 1630s in Rome; the painter of subjects which almost invariably seem charged with dangerous, conflicting emotions. The Birmingham exhibition includes his *Rinaldo and Armida*, another subject from Tasso, where Poussin chooses the moment when the wicked witch, about to stab her sleeping victim, finds her hand stayed by Cupid. And it includes his *Venus and Adonis*, goddess

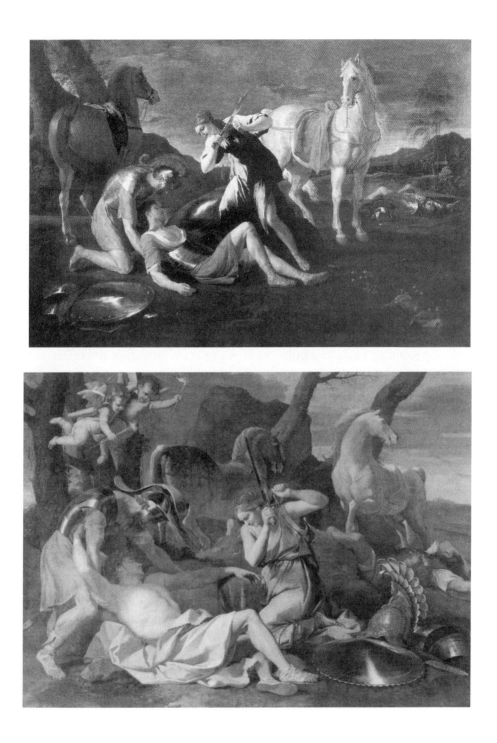

mourning over the corpse of her lover: love and death, in both paintings, held in a fine tension.

It is not just Poussin's subject matter in these earlier works, that seems to conflict so strongly with the later myth of him, but also his style. Poussin came to be revered by later generations of artists (notably Ingres) as the great classicist of French seventeenth-century art, a man who preferred the probity of line to the seductions of colour. Yet the Poussin who painted the Hermitage version of *Tancred and Erminia* seems anything but a cool exponent of the values of tight, linear composition and intellectual control: the keynote of the painting is abandonment, to passion and to colour, and it is painted in a free style and a rich palette redolent of Titian and the other great Venetian colourists. It is a reminder, too, that Poussin in his youth was (look at that flash of Erminia's leg) an extremely *sexy* painter.

Poussin's second *Tancred and Erminia*, owned by Birmingham's Barber Institute, is dated to within two or three years of the Hermitage painting but a vast gulf – in terms of style, intention and effect – seems to separate the two works. They could almost have been painted by two different artists, and in a sense they were.

Poussin was no self-copyist, and he seems to have painted his second version of *Tancred and Erminia* in a spirit, rather, of self-criticism. This is painting as recantation. He reasserts sense over sensibility and moralizes the disturbing emotions, the passionate excesses of the Hermitage picture by confining them within the narrow bounds of an overtly Christian allegory. Second time around, Poussin paints *Tancred and Erminia* as, in effect, a Lamentation over the Dead Christ. Tancred, now clothed not for battle but wearing the vague drapery of countless Renaissance Saviours, has fallen into a *Pietà* pose; Vafrino, who cradles him, wears red, the colour of St John the Evangelist; while Erminia has become a weeping Magdalene. Poussin has even included a pair of *putti* in the upper left corner of his picture, one final dig in the ribs for anyone in his audience too dumb to get the point.

The main thrust of Poussin's second version had always been implicit in Tasso, the subject of whose poem was the conquest of the pagan world by a militant Christianity. Tancred-as-Christ was part of the allegorical fabric of *Jerusalem Delivered*, one of whose messages was that Christ's battle must always continue, for His death means our life. You

note, in *Tancred and Erminia II*, that even Poussin's landscape has been moralized into a vignette of death and resurrection, dusk on the left giving way to the cool blue of dawn on the right. But you can read this personally too: one Poussin has died, and another has been born, in this picture.

The second *Tancred and Erminia* reverses the priorities of the first almost completely: no longer about love, its passion and anguish, it shifts the focus of attention subtly away from Erminia and towards Tancred; the very fact that he looks like a Christ makes you read him (even if you only register the iconography subconsciously) as the chief protagonist and still centre of the work. The painting is no longer, either, about abandonment and this is reflected in Poussin's shift of stylistic allegiances. The landscape is no longer deeply recessive, charged with mystery and fervour; it is flat, planar, like a sequence of stage flats, before which the figures themselves seem modelled as a frieze. Seeking clarity, which he comes to equate with the hard, almost sculptural use of line, Poussin abandons Titian as a model and turns, instead, to Michelangelo; he forsakes Venice for Rome. His draperies seem hewn from stone, and their bright acid colours, so different from the mistier, richer colours of the Hermitage picture, suggest he had been looking at the Sistine Chapel; he pays even more explicit homage to Michelangelo in the outstretched arm of Tancred, the same arm that Adam reaches out to God on the Sistine ceiling.

This is not to say that biblical references are entirely absent from Poussin's first version of *Tancred and Erminia*. They are present there too, but they have a different and more erotic flavour. Poussin's first Tancred and Erminia are not Christ and the Magdalene. They are Samson and Delilah, although subtly reversed. He is not the strongman whom she will enfeeble by shaving, but the weakened hero whom she will make strong again by the cutting of her own hair. The Samson and Delilah story is one of the most sexually suggestive of all biblical myths and the *locus classicus*, in Western culture, of male castration anxiety. The younger Poussin, secularizing the myth and putting it in reverse, seems to dream of sexual consummation as a form of restorative. He responds to a strain of erotically suggestive symbolism also present in Tasso: 'For with her amber locks cut off, each wound/She tied: O happy man, so cured so bound!'

67

All this is purged, with a sort of summary violence, from the second version of the picture, although to see the paintings together is to see that an artist cannot entirely rewrite his past. There is something mean and guilty about the second *Tancred and Erminia*. It is virtuous, but plain, and lacking in generosity.

3rd November 1992

Manet

A SOMEWHAT TUBBY American tourist sidles up to one of the more famous paintings in the Musée d'Orsay and beams at his wife who faces him, camera at the ready. 'Okay, honey, I'm ready.' She depresses the shutter button, the flash flashes ('No flash' it says on the walls of the museum), and they're gone.

The painted lady who has provided the backdrop for this exercise in souvenir-snatching remains unmoved. She has seen stranger things in her time. Nevertheless, there is something slightly unreal about the scene that has just been played out. It is tempting to wonder whether that busy, overweight gentleman realizes the nature of the company he has been keeping. The French have a lot of words for what she is: *une impure*; *une amazone*; *une fille de marbre*; *une mangeuse d'homme; une horizontale*. Edouard Manet, who painted her, called her *Olympia*.

Olympia continues to regard those who come within her orbit with that unsettling gaze – a mixture of impertinence, business acumen and sadness – which made so many of the people who witnessed her first public appearance feel so profoundly uncomfortable. She was painted in 1863 but, for reasons that remain mysterious, her creator did not see fit to place her on view until the summer of 1865. *Olympia* was exhibited at the annual Paris salon in that year, and within days Manet's painting had received the most hostile reviews in the annals of French art criticism.

'An epidemic of crazy laughter prevails before the canvas of Manet,' reported *Le Moniteur des Arts*. '*Olympia* is a nude, recumbent woman to whom some sort of Negress offers a bouquet voluminously wrapped in paper. At the foot of the bed crouches a black cat, its hair on end, which probably doesn't like flowers since it cuts such a pathetic figure.' The critic for *Le Grand Journal* claimed to see only 'a sort of female gorilla, a grotesque in India rubber outlined in black'.

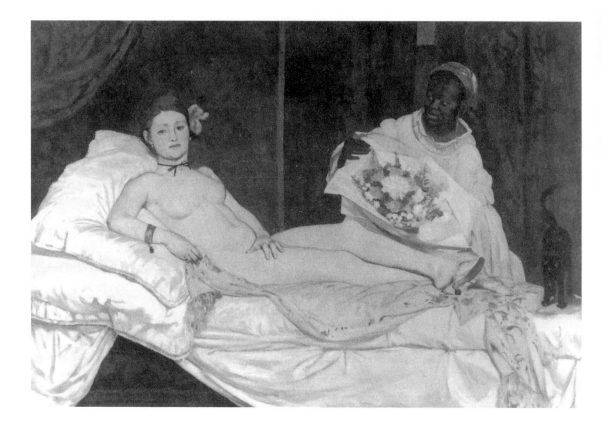

After the brickbats and the insults, the apotheosis. It is a hundred years since Manet's *Olympia* was acquired for the French nation, and first hung, as part of the national collections, in the Musée du Luxembourg. The Musée d'Orsay, which is now the painting's permanent home, is celebrating the centenary in solemn style. *Olympia* hangs, alone, behind a massive sheet of protective glass in one of the museum's more impressive galleries. A number of seats have been arranged in front of the painting, encouraging visitors to give Manet's work the lengthy, sustained attention that pictures deserve (but so seldom get) and suggesting, too, in their odd resemblance to a church pew, the gallery's temporary transformation into a place of worship.

Anne Distel, the museum's chief curator, says half-jokingly that they have built '*une chapelle pour Olympia*'. The joke contains a truth. It would be hard to find a more striking demonstration of a work of art's metamorphosis: from object of universal scorn to venerated icon; from public laughing stock to hallowed relic.

Manet, a dandyish and reserved man, was prompted to a rare outburst of feeling by the furore that engulfed *Olympia* in 1865. He wrote plaintively to his friend Charles Baudelaire a week after the salon opened that 'I really would like you here . . . they are raining insults on me, I've never been led such a dance.' The poet was not entirely sympathetic. 'So once again I am obliged to speak to you about yourself,' he replied. 'People are making fun of you; pleasantries set you on edge; no one does you justice, etc, etc. Do you think you are the first to be placed in this position? Have you more genius than Chateaubriand and Wagner? And did people make fun of them? They did not die of it.' Manet may have been aggrieved, but – as Baudelaire hinted – he had little right to feel surprised. *Olympia* broke just about every rule in the book.

Olympia's profession is not always immediately apparent to the modern viewer, who may simply experience Manet's painting as a slightly enigmatic portrayal of a naked woman. But visitors to the Paris salon of 1865 would certainly have identified her as a prostitute – even though there is nothing to suggest that the artist's model, Victorine Meurent (who also appears as the enigmatic nude on the grass beside her clothed male companions in Manet's *Déjeuner sur l'Herbe*) was one.

Little is known of the real-life Olympia, save that the painter had met her outside the Palais de Justice and been 'struck by her unusual

appearance', that she lived in the rue Maître-Albert in the fifth *arrondisse-ment* and that her hobbies were playing the guitar and sketching. It was Manet's title, as much as his choice of pose or setting, that established the profession of the woman in his painting.

Olympia was a favoured pseudonym of *horizontales* in mid-nineteenth-century France, but even those Parisians who knew nothing of such ladies would have been aware of the name's less than proper associations. When Manet titled his painting, he must have had in mind one of the most famous courtesans in the literature of the period: Dumas's Olympia, main rival of Marguerite in *La Dame aux Camélias*.

The overt, discomfiting nature of Olympia's sexuality was under-scored, too, by the pictorial attributes Manet gave her: the orchid she wears in her hair, symbol of *luxe*, vanity; the Negress, tut-tuttingly regarded as an emblem of exotic pleasures and primitive urgings; the black cat, traditional emblem of female sexuality unleashed and, as first cousin to the numerous cats that appeared within the pages of Baude-laire's *Fleurs du Mal*, the carrier of many erotic associations.

Prostitution was the subject of heated debate in France in the mid-nineteenth century. Looking back on Second Empire Paris in 1872, the writer Paul de Saint-Victor expressed the peculiar social anxiety surrounding the subject. 'Courtesans exist in all times and places,' he wrote, 'but has there ever been an epoch in which they made the noise and held the place they have usurped in the past few years? They figured in novels, appeared on stage, reigned in the Bois, at the races, at the theatre, everywhere crowds gathered.'

The prostitute, as the art historian T. J. Clark has argued in the most penetrating recent study of Manet and his milieu, *The Painting of Modern Life*, was perceived as a threat to the smooth functioning of society – not primarily because of what she did, but because of the way in which she seemed to blur the accepted social categories of the time. It was no longer possible, numerous writers of the time complained, to tell the difference between the wealthy, sought-after prostitute and the well-bred lady, the *petite dame* and the *grande dame*.

Manet's Olympia, as both the opulence of her boudoir and her demeanour suggest, was a distinctly high-class prostitute. In painting

such a woman, regarding her client with such poise and *sang-froid*, Manet gave the new power and self-assurance of the prostitute visible form. Moreover, there was nothing in Manet's painting to suggest that he, the artist, disapproved of this threatening figure. That, more than anything else, was Manet's sin, and the source of the scandal that surrounded his painting.

Manet's work was also a full-frontal assault on the aesthetic conventions of its day. *Olympia* was a calculated pastiche of Titian's *Venus of Urbino* – and, therefore, a portrayal of a prostitute made doubly scandalous by the venerability of its pictorial source. One way of measuring the gulf that separated Manet from his contemporaries is to compare *Olympia* with those paintings of the nude that *were* sanctioned by Second Empire taste: Alexandre Cabanel's *The Birth of Venus*, for instance, also in the Musée d'Orsay, also painted in 1863, and deemed sufficiently respectable for purchase by Emperor Napoleon III. Cushioned unrealistically on a foaming wave, attended by a quintet of hovering *putti*, Cabanel's Venus adopts the sprawling, wantonly abandoned pose of countless nudes painted by countless artists from the Renaissance onwards.

What Cabanel's painting brings home, with a jolt, is the thoroughness with which Manet set out to expose and dismantle this vision of the ideal woman. The nude, in Manet's hands, is no longer the passive, dreamily abandoned creature of male sexual fantasy handed down by centuries of artistic precedent. Everything in his painting declares the self-possession of this cool, more than slightly intimidating, naked woman.

The point is made in Olympia's left hand, clenched over her genitals, which revises the gesture of pudic modesty of a thousand past Venuses and replaces it with one that seems, rather, proprietorial. This can be yours, Olympia seems to be saying – but I'll name the price. Her most famous attribute – that beady, businesslike expression – is itself a pictorial fact the revolutionary nature of which is easily overlooked. The male viewer, to whom pictures of the female nude had always been implicitly addressed, is no longer the voyeur at liberty to exercise his fantasies on the image. Rather, he becomes the object of the nude's gaze, subject to *her* power.

This is not to say that *Olympia* signals anything as simple as the

liberation of women in art. Manet's painting has its own pathos, both in the melancholy that seems to blend with Olympia's hardheadedness and in the notice served that her power is, in the end, a small thing: the power only to sell her body on her own terms.

The passage of *Olympia* from notoriety to celebrity has been a troubled one, in which another famous French painter, Claude Monet, played a key part. Monet took almost the whole of 1889 off to organize a public subscription to buy Manet's *Olympia* for France.

The price set on *Olympia* by Manet's widow (the artist had died in 1883) was FFr25,000 – about £25,000 in today's money. This may seem cheap by comparison with current estimates of the painting's value (*Olympia*, in the unlikely event that it should ever be sold, would be expected to fetch between £30m and £60m) but, considering that most of the people whom Monet knew were artists or writers, it must have taken some getting. Monet, who persuaded even the then penniless Pissarro and Renoir to make donations (each gave the equivalent of £50), somehow managed it.

Having done so, he was faced with a difficulty: how to persuade the government to accept the picture. The painter Berthe Morisot met the director of the French National Museums in late 1889, and noted that he went into a mad rage at the very mention of *Olympia*, 'insisting that as long as he was there Manet would never enter the Louvre'.

On 7 February 1890, Monet wrote a steelily diplomatic letter to the Minister of Public Instruction, Armand Fallières. 'The discussions that swirled around Manet's paintings, the hostilities that they provoked,' Monet asserted, 'have now subsided . . . We have wanted to retain one of Edouard Manet's most characteristic canvases, one in which he appeared victorious in the fight, master of his vision and of his craft. It is the *Olympia* that we put back in your hands, Monsieur Minister.'

Monet sent a copy of the letter to *Le Figaro*, which published it in full. He had been more than a little disingenuous in claiming that the controversy around *Olympia* had died down – soon after, *La Liberté*, a right-wing newspaper, published a ringing denunciation of 'this bizarre *Olympia* . . . this creature advertising vice' – but his letter proved decisive.

Monet's motives for ensuring Manet's painting was hung alongside the masterpieces of French art were not, perhaps, entirely disinterested.

Paul Hayes Tucker, curator of the Royal Academy's current Monet exhibition, 'The Series Paintings' notes in its catalogue that 'he was, in effect, forcing the State to endorse an avant-garde tradition that it had fervently opposed and obliging it to enthrone a particular brand of modernism to which Monet was the heir.' Monet may be said to have set the radical painting of later nineteenth-century France on the path to respectability.

It would be hard to overstate the influence *Olympia* has exerted on generations of artists. Picasso, for one, was virtually obsessed by the painting, and he may well have been inspired to paint *The Demoiselles d'Avignon* (also set in a brothel, also notable for the hard, intimidating gaze its angular women direct towards the viewer) by its example.

But, despite its current incarnation as icon, its status as, indubitably, one of the key works in the development of modern art, the whiff of scandal still hangs about *Olympia*.

3rd November 1990

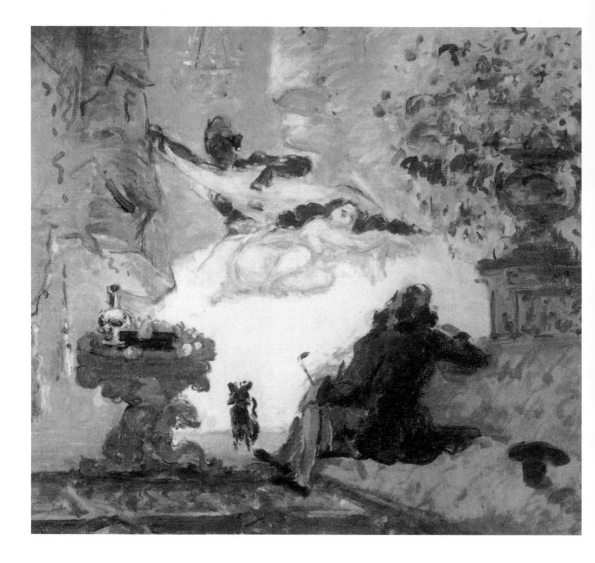

Cézanne

WHEN EMILE ZOLA PUBLISHED his novel, *L'Oeuvre*, he included a barely disguised portrait of the young Cézanne, in the person of Claude Lentier – a disturbed artist riven by his 'passion for the flesh of a woman, a foolish love of nudity desired and never possessed, an impotence to satisfy himself, to create this flesh so much that he dreamed of holding it in his two bewildered arms. These women whom he drove away from his atelier, he adored in his paintings – there he caressed them and violated them, desperate that through his tears he would not have the power to make them as beautiful and vibrant as he desired.'

Zola and Cézanne had been inseparable friends in their youth, when they were brought up together in the small provincial town of Aix-en-Provence. But after the publication of *L'Oeuvre*, their friendship was abruptly terminated. Cézanne curtly acknowledged receipt of the copy of the novel that Zola sent to him, and hardly spoke to him again.

'Cézanne: The Early Years', at the Royal Academy, sheds much light on the little-known, darkly obsessive beginnings of this great artist. There is little in it to suggest the future patriarch of modernism, the painter who would counsel Emile Bernard, in a famous letter of 1904, to 'treat nature through the sphere, the cone, the cylinder'. Instead, you encounter an art whose violence and whose misogynistic sadism – scenes of rape, murder and orgiastic sex abound – border on the psychotic. Coming to this exhibition, as most people will, from the perspective of his great, becalmed later work, it seems barely credible.

Near the start of the show, you are brought up short by an early self-portrait, painted when Cézanne was twenty-two. It is a demonic self-image, a portrait of the artist as a young devil. Cézanne glares out at you with startling, mysterious intensity, from a dark featureless ground (one of the most remarkable and unexpected things about the young Cézanne is his colour sense, which seems almost nordically

gloomy in contrast with the lucid, heat-struck colours of his maturity). His lips, set in a scowl, are a liverish red; more of the same colour has been dabbed into the corner of each eye, heightening his unearthly aspect. The only thing missing is a pair of horns.

Shortly after this you find a very early *Lot and his Daughters*. A muddy little panel, painted in heated, reddish tonalities which suggest that Cézanne had been looking at Venetian painting or perhaps the lurid Delacroix of *The Death of Sardanapalus*, it is overtly pornographic. A bearded Lot, seated, is straddled by one of his daughters, while the other looks raptly on. Lot and his daughter kiss, faces blurred in a rapid flurry of brushstrokes, and he clasps her buttocks with awkward passion. It is sheer sexual fantasy, scantily clad in the iconographic language of tradition.

In later life, Cézanne is said to have declared that 'My method, if I have one, is based on hatred of the imaginative.' Yet his earlier works are almost fanatically imaginative, unleashing the painter's fantasies on the world.

The Rape features a bronzed he-man bearing off a pallid, swooning maiden against the backdrop of a tempestuous, blasted landscape. It was painted for Zola in 1867, the same year that the writer published his own, lurid work, *Thérèse Raquin*, a grim novel of adultery and murder.

The Murder, which was probably painted around 1870, strikes the most sinister note of all in the young Cézanne's chamber of horrors: in another of his dark, brooding landscapes, a thick-set blonde writhes on the ground, her arms stretched out in grotesque parody of the Cruci-fixion. She is pinioned to the earth by one of her two assailants, a lumpen female, head bent in concentration, while the other, a man whose face remains hidden from view, raises the dagger which he is about to plunge into her heart. The whole scene, rendered in wriggling, feverish lines and lit with the harsh glare of a lightning strike, is charged with a kind of furtive, over-excited energy.

No artist creates his work in a void, and to see Cézanne's early paint-ings simply as painfully honest, spontaneously blurted confessions is to ignore the cultural circumstances that helped bring them into being. Depictions of orgiastic excess or violence were not, after all, uncommon in Cézanne's day. John Rewald, in his monograph on Cézanne, quotes the titles of several such pictures from contemporary Salon catalogues

– a choice representative example is a work (presumably lost, or buried in some provincial French museum) called, cheerily, *Woman Tied to the Tree from Which Her Husband Had Been Hanged by Order of the Bastard of Vanves, Governor of Meaux in the XVth Century, Devoured by Wolves.*

But while such paintings generally came dressed up as 'history' pictures, allegories or mythologies, and while they would have been painted in a style with recognizable roots in classical or genre traditions, a work like *The Murder* would have been almost incomprehensible to the Salon-going public of the time. This violent fantasy is equipped with no alibi; its subject matter and style – owing a surprising debt, as much of early Cézanne does, to Daumier – suggest an uneasy elision of caricature and gutter press sensationalism. The young Cézanne was a deliberately wild, ill-mannered painter, who prided himself on the unexhibitability of his art, the annual refusals that it met from the Parisian Salon jury. It is as much in the handling as the subject matter. He works with paint in a gloomy, fevered way, using it almost as slime; he uses the palette knife alone, in many of his early portraits, conjuring craggy visions of people that are physical structures as much as conventional likenesses; he turns descriptive elements into vigorously independent abstract motifs – the wriggling patterns of the wallpaper, in a scene of a young girl at the piano, playing the overture to *Tannhäuser*, virtually predict the art of the Fauves, and certainly go as far in unsettling conventional hierarchies of looking as anything painted by Degas or Manet.

The young Cézanne was obsessed with Manet (as, indeed, was the young Zola, who was Manet's most vocal early champion), and particularly with two paintings: the *Déjeuner sur l'Herbe* and *Olympia*, both of which were notorious *succès de scandale* in Paris in the 1860s. Cézanne painted his own versions of each painting. The pointedly titled *A Modern Olympia* sets out to shock, just as Manet's *Olympia* had done, to *épater les bourgeois*, only more so.

But where Manet had left himself out of *Olympia*, Cézanne is bulkily present, beard and all, in the foreground of his version. He is at once the painter of the courtesan and her client – a still more overt development of the implications in Manet's work.

The critics hated Cézanne's early paintings. One, on seeing *A Modern Olympia*, found in it 'weird shapes generated by hashish, taken from a swarm of lascivious dreams', and characterized its creator as 'a kind of

79

madman who paints in delirium tremens'. But for all the oddity of these pictures, they do have a kind of coherence. There is an implicit criticism of Manet's absence, in Cézanne's self-inclusion. Cézanne's openly confessional art, that admits its own nature as sexual fantasy or autobiography, represents a kind of manifesto: it recalls Zola's famous definition of a work of art as a corner of the world distorted through the temperament of the artist. You could just about make a case for Cézanne, on the strength of these pictures, as the first Expressionist.

Cézanne was to leave all this art behind, ushered into the presence of nature, as he would later express it, by his mentor Pissarro. But an increased understanding of the early work goes a long way towards explaining the impact of late Cézanne, notoriously hard to formulate in words. Cézanne's later art, for all its classical feel, does possess an extraordinary intensity, bringing an immense weight of perceptions to bear on apparently ordinary subject matter and raising it above its station – a plate of apples, painted by the late Cézanne, may be as compelling as a Rembrandt self-portrait or a Titian altarpiece.

The development is hinted at in a pair of the early still lifes at the Royal Academy. There is a barely suppressed violence in his *Still Life with Bread and Eggs*, with its arrangement of phallic baguette, restless drapery, ominous knife and a glass that teeters on the edge of a table; *The Black Clock*, painted for Zola, features a conch shell whose red, moist mouth is painted with a striking, suggestive sense of bodily intimacy. In Cézanne's later art, such tensions would almost, but never entirely, disappear. It is as if all the emotion, all the anxiety, the sexual urges and the violence had been poured into landscape and still life.

26th April 1988

Schiele

KNEELING A LITTLE AWKWARDLY, the girl leans forward on her elbows. She is almost naked, wearing only black stockings, a corset and a skirt which is hitched up to reveal her bare, raised bottom. This is not (although it certainly could be) a description of Egon Schiele's 1917 drawing *Girl Kneeling, Resting on Both Elbows*, currently on display at the Royal Academy. It is a description of 'Donna', as she appears on page 92 of the November ('Huge Dynamic Taut Thrusting Wobblesome Winter Warmerama Packed with Big Friendly Girls for Dark Steamy Nights') issue of *Men Only*.

Context has a lot to do with the way in which we receive images. We know that 'Donna' is Pornography because she is on the top shelf at the newsagent. Because she is in the Royal Academy, we know – or at least we think we do – that Schiele's naked woman is Art. But not everyone sees it that way.

Much has been made of the fact, widely reported, that the Royal Academy had great difficulty finding sponsors for 'Egon Schiele and His Contemporaries'. You can imagine the tone of boardroom apology. Schiele, not quite right for our image. He is a bit, er, well, too explicit for us. But while AmEx, ICI, Barclays *et al.* have been widely condemned for their faintheartedness, it can also be argued that their reluctance to be associated with this exhibition represents an honest and appropriate response to its contents. Schiele's art is indeed, er, well, explicit. The foot-dragging sponsors, like the nineteenth-century critics who reviled Manet's *Olympia*, at least acknowledged the potency of the art in question.

More interesting is the need Schiele's work seems to arouse in the modern liberal critic to make a distinction between art and pornography – and, having done so, to insist on the security of those categories. 'Are the embraces of Schiele's couples really that different from the poses in

Penthouse?' asked Henry Porter rhetorically in *The Independent on Sunday.* 'Does not "erotic" broadly mean the same as "pornographic"? The answer is no.' But the answer is not, when you look at the evidence, nearly so categorical.

'Schiele's purpose was not the same as Paul Raymond's,' added Porter. 'He did not seek to profit from the distribution of his drawings, he did not hope to titillate a large audience and he did not exploit his subjects.' But this sits uneasily with the known facts. At times, Schiele made his living solely from private sales of his more explicit erotic drawings. He planned, at one point, to publish a folder of erotic prints in a limited edition of 100 copies. It is, moreover, hard to imagine the parents of the subject of Schiele's 1911 watercolour *Black-Haired Girl with Skirt Turned Up* – her enflamed genitals are painted to resemble a split, overripe plum – sharing Porter's confidence that the artist never exploited his subjects.

This is not to say that there are no differences between a Schiele nude and 'Donna'. There are, but they are not differences that can be accounted for by anything as blunt as a distinction between art and pornography. Erotic art, when it is as compelling (and compelled) as Schiele's, exposes some of the more interesting contradictions that lie at the heart of much contemporary thinking about art in general.

During the last two centuries, art has gradually usurped religion's role as witness to the extraordinary, supramundane aspects of human existence. Like the seer, ascetic or flagellant of earlier times, the artist has exposed himself to the extremes of human experience – pain, poverty, starvation, madness – in order to report back to his audience on what lies beyond the ordinariness of their daily lives. This is why Van Gogh has become the archetype of the great artist in a secular age. Yet the radical notion of art and of the role of the artist embodied by Van Gogh also poses major problems to the freethinking, liberal tradition of critical thought that has done so much to promote it – and erotic art puts those problems into focus.

The modern cult of radicalism has given the artist sanction to explore, imaginatively at least, *all* areas of human experience. It is hardly surprising, therefore, that some artists, trawling the seabed of consciousness, should have dredged up evidence of man's darker impulses. The results

SCHIELE *Girl kneeling, resting on both elbows*

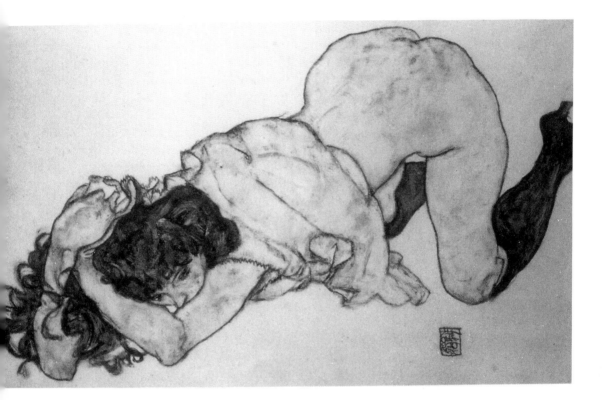

can be – and Schiele's genitally fixated drawings of young girls are a good example – extremely disturbing.

Erotic art troubles the liberal mind because while taking to an extreme its ideas about the radical, exploratory nature of great art, it also punctures one of its fonder delusions. This is the received idea that the contemplation of art is necessarily *good* for people. Works of erotic art demonstrate, in a blatant and troubling way, that this is simply not true. They have what might be termed cultural significance; they are important, in a sense that photographs in *Men Only* are not – but they are hardly edifying or improving.

Fuseli's drawings of contorted men submitting to the sadistic attentions of fantastically coiffured harpies; Degas's brothel-scene monotypes, ushering you into gloomy interiors where gentlemen in dark suits engage in lonely acts of voyeurism; Schiele's painfully observed drawings of young girls whose protuberant bones make them look virtually arthritic – the history of erotic art is not enlightening or liberating but, if anything, dispiriting, a catalogue of obsessions exorcized. It is, also, a history of guilty recantations (Aubrey Beardsley's deathbed request that his illustrations to Aristophanes' *Lysistrata* be destroyed) – and, therefore, a history of a genre that has provoked as much unease in its practitioners as in its audience.

Liberal thought signals the anxiety caused it by the most powerful and singular erotic art when it tries to distinguish it from pornography. But the distinction cannot be made without falling into all kinds of self-contradiction. Art is commonly said to be more 'affecting' and 'profound' than pornography – but, if that is so, those are merely qualities that would seem to qualify it as a yet more effective and persuasive catalyst for socially unacceptable sexual behaviour (rape, child abuse, sadism) than the often gauche, hastily produced texts and images of commercial pornography.

The desire to distinguish art from pornography stems largely from anxiety. The hope is that works like Schiele's drawings might somehow be *made safe* if they could be shown to have crossed an imaginary line dividing one, unacceptable category from its opposite. But the fact is that erotic art cannot be made safe or acceptable, simply because its subject is human sexuality.

Sex, as almost all the artists who have treated the theme have

suggested, represents instinct's tyranny over man. It is nature's way of imprisoning us in obsession and fantasy (as its victims in literature and music, too, testify: Othello, Tristan and Isolde, Don Giovanni), of condemning us to a solitude that love may alleviate but never entirely cure.

If there is a difference between Schiele's nude and *Men Only*'s 'Donna', it is not the difference between art and pornography. What makes Schiele's erotic art better, or more significant, is its engaging complexity – the fact that it, unlike the photographs in *Men Only*, aspires to be (and is) more than a straightforward aid to masturbation. Cumulatively, Schiele's frail creatures, painfully isolated or locked in clinging, desperate embrace, suggest a metaphor, even something as grand as a vision, of the human condition: a condition, as perceived by Schiele, of absolute solitariness and vulnerability.

Good erotic art, unlike bad erotic art, finds significance in its subject matter; it speaks of more than sexuality. But sexuality is its first language, and the prime source of its power. The corporate sponsors who refused to underwrite the Schiele exhibition have made a useful contribution to aesthetic debate in this country. They have reminded us that we should not lightly surrender our capacity to be shocked by art. Once we lose that, we also lose the ability to be moved by it.

27th November 1990

85

Masson

THE RULES WERE SIMPLE. 'A) Entry into a state similar to a trance. B) Abandonment to interior tumult. C) Rapidity of writing.' It sounds like a correspondence course: Write a Romantic Novel and Make Your Fortune, Here's How . . . It was, in fact, André Masson's formula for bona fide Surrealist art. The point of the game? To produce 'automatic' drawings that would meet the first Surrealist *Manifesto*'s call for 'Pure psychic automatism', i.e. 'The dictation of thought in the absence of any control exerted by reason, and outside any aesthetic or moral pre-occupation'. Doodle and be enlightened; find emblems of your repressed subconscious in the undergrowth of free-form calligraphy.

Masson's drawings suggest, at first sight, ink-dipped spiders given the run of the sketchpad. On close inspection, their linear flicks and swirls resolve themselves into serpentine landscapes, cascades and orgies – mostly orgies, since even his landscapes throng with phallic protuberances and gynaecological orifices, hands that grope and fondle, and boulders that cleave suggestively into buttocks.

Masson meant these willed spontaneities to lead straight to his true, instinctual self. *Line Unleashed*, the title of the Hayward Gallery's exhibition of drawings by Masson, is something of a misnomer. Masson's line is intended, metaphorically, as an umbilical cord, reaching from the artist's subconscious out and on to the paper. When André Breton, the godfather of the Surrealist movement, wrote his plea for automatism, *The Automatic Message*, he talked of the man who, 'lighting his cigar, is unaware that he is smoking visions'. Masson's automatic drawings coil like random smoke formations, but he always seems to catch the smoke in erotic freeze-frames. Through all the windings of his spaghetti draughtsmanship, the sheer consistency of his imagery begs the question: just how 'automatic', and just how premeditated, is this sexually obsessed art?

Virtually all the noteworthy Surrealists, Masson among them, originated in Catholic territory. Most of them were men. Setting out to liberate the psyche, and to *épater les bourgeois*, they discovered sex – or rather, male sexual fantasy, most of it pretty unpleasant. Judging by fifty years of Masson's artistic output, he never seems to have got over the discovery. Like a young boy lifting stones, he seems ceaselessly amazed by the creepy-crawlies of his lurid imagination.

Masson's non-automatic compositions contain as much, if not more material for the sexual counsellor. 1928 finds him illustrating one of the Surrealists' Ur-texts, the Marquis de Sade's *Justine*, with a handcuffed nude swinging from a rope; 1933 renders a series of stylized 'Massacres' in which brusquely crystalline men rape and decapitate their female victims; dating from the later 1930s and the 1940s, you get drawings titled *Terre Erotique*, where the world itself becomes a throng of embattled genitalia, masquerading as plants, grottoes, clouds or tumescent volcanoes. Later, Lilliputian invaders rape Mother Earth, a hilly landscape of gushing mammaries and cavernous womb. Turning to the world of interiors, Masson imagines kitchen furniture coming dryadically to life and dismembering the cook.

David Sylvester has selected the works and written an introduction for the catalogue, in which he claims that 'what makes Masson a great draughtsman is not his invention as an image-maker but the vitality and sensuality of his line'. There is something dubious about this argument – in which all the artist's fantasies of carnal violence are subsumed in appreciation of technique – but it does contain an important truth. Masson was a pictorial innovator. He described his desire, early on, 'to seize at last the knife, immobilized upon the Cubist table', and that is exactly what he did (he animated the table too). Masson disarranged Analytic Cubism's frozen surfaces, and his liberation of line into associative freedom was critically important for younger artists. The labyrinthine, congested surfaces of Jackson Pollock's drip paintings owed a lot to Masson (who lived and worked in New York during the Second World War); there are frequent hints too, at the Hayward, of his influence on Willem de Kooning, a similar excavator of erotic imagery from heaving metamorphic landscapes.

Masson's formal innovations imply, in the words of the catalogue, 'a Heraclitean flux where everything is turning into everything . . . a

jungle of irrepressible growth and irresistible annihilation and new growth'. In other words, what poses as inadvertency has rather more ambition. Masson is not just laying bare his soul, fantasizing about sexual aggression. He is saying that this is what the whole world is like.

20th July 1987

Picasso

SHORTLY AFTER PICASSO'S DEATH, in 1973, his long-time friend Douglas Cooper delivered the most famous verdict on the artist's later work: 'These are incoherent doodles done by a frenetic dotard in the anteroom of death.' 'Late Picasso', at the Tate, allows the greatest painter of the twentieth century several anterooms through which to approach the inevitable, unpalatable truth of his own mortality. The exhibition comprehensively demolishes Cooper's bitter and shallow one-liner. It also overturns just about every existing preconception about the way in which great artists are supposed to grow old.

Late Picasso is graceless, scurrilous, irreverent. He is frankly obsessed with violence, with sex, and with the carnally suggestive capacities of line, colour and texture. His paintings are ugly, awkward, brutal. Late Picasso rages, fantasizes, caresses and disturbs, cultivating a style that flouts all notions of aesthetic propriety and teeters constantly on the brink of slapdash.

The overriding theme of Picasso's later art is – as it had been in the first decade of the century, with *Les Demoiselles d'Avignon* – the female nude. Picasso's late nudes are monumental, intimidating harpies, who fix you with a wonky, basilisk glare. Near the start of this show, you are confronted by a *Seated Nude* of 1959, which predicts much of the art to follow. Subjected to extreme pictorial violence, refracted through the geometries of what seems like a late, late version of the Cubist kaleidoscope, her body has been monstrously dislocated. Her right breast emerges from underneath one armpit, neighboured by a thick, brushy patch of underarm hair. Following the arm that jack-knifes up and back behind her head, you notice that it elides with the line of her right cheek, stretching it into a long needle of flesh the central feature of which is an elongated sphinx's eye.

Her legs, severed from her torso in another of Picasso's customary

reinventions of human anatomy, end in huge, wedge-shaped hooves. Picasso has included, to one side, a pair of ludicrously minuscule pumps into which her elephantine feet could never hope to squeeze – his jokey way of calling attention to the impossible, extravagantly imaginary nature of the image.

Picasso's distortions of the female (and, on occasion, male) anatomy do not seek to abolish the body, but to intensify it, to make the most of its carnal, fleshly aspect. Rocket-launcher bosoms, or breasts that roll and swell and seem to turn, indeterminately, into buttocks; splodged navels, pubic undergrowths and slashing, one-line vaginas – these abound in late Picasso. Faces tend to be masks. The body itself does most of the expressive work, and what it expresses is Sex. Even still lifes, like the 1969 *Vase of Flowers on a Table*, Picasso turns erotic, a cluster of phallically burgeoning, tumescent stalks and blooms.

Moving forward, from that early seated nude, you find nudes whose sheer, overwhelming sexuality has finally untethered them from the last vestiges of Cubist geometry. There are frequent couplings, messy embraces and arbitrary trails of white paint, congealed in semen-like gobbets on the surface of the canvas. Alone, a single body becomes its own orgy, great arms and legs flailing, breasts wheeling, the whole anatomy star-fished around that central, salient feature, the solitary gash of paint that was late Picasso's graphic shorthand for the vulva.

Picasso explained such visual abbreviations in late life: 'I don't want to do the nude as nude. I want only to say breast, say foot, say hand or belly.' His shorthand is a calculated ploy, designed to remove the nude from the arena of high art and return it to the world of the senses. As early as 1914, John Richardson writes in an excellent catalogue essay, Picasso and Braque had proposed a criterion by which to judge paintings of the nude. 'Is this woman *real*?' Picasso would ask. 'Could she go out in the street? Is she a woman or a picture? Do her armpits smell?'

Picasso's late paintings pass the armpit test with flying colours. This is art that is unashamedly, intentionally puerile in the narrowness of its focus. Its achievement lies in the way Picasso manages to raise puerility, sexual obsessiveness, to the level of a philosophical stance. 'Late Picasso' reveals, among other things, the artist's consistency. It is no coincidence that Picasso's original, preferred title for *Les Demoiselles d'Avignon* was

Le Bordel Philosophique, 'The Philosophical Brothel', which could stand as the subtitle for the Tate exhibition.

Picasso's crude subject matter is matched by the technical devices that he has chosen to deploy – patchy, unevenly brushed fields of bright, raucous colour or dishwatery monochrome, a scribbled, hastily gestural line. Picasso deliberately courted misreadings of the late work, like Cooper's accusations of senile doodling, by boasting that *'chaque jour je fais pire'*, 'every day, I get worse'. What he meant was that every day he was getting better. He wanted to rid his art of the aura and appearance of 'fine art' – 'the less art, the more painting,' he used to say – and to root it, instead, in base fact.

Picasso's late work, in its stubborn calculated clumsiness, its cack-handed, quasi-pornographic dwelling on bodily realities, lives up to the artist's dictum that 'You have to know how to be vulgar. Paint with four-letter words.' It adds up to a last, grand reminder that for Picasso the prime function of art was, and always had been, to shock into recognition. The greatness of late Picasso lies in his intransigence, the sheer bloodymindedness with which he refuses to go quietly.

Late Picasso was not only obsessed with sex, but with art – which, it can be argued (and has been, *ad nauseam*, by the duller section of the Picasso biography industry) became a surrogate form of intercourse as the ageing artist's sexual powers waned. Numerous paintings at the Tate depict the artist and his model. The artist's phallic brush and the swelling, testicular shape of his palette, generally held at groin level, make the sexual analogy inevitable. It is made still more so by the fact that in reality Picasso did not even use a palette, but painted directly on to a canvas which was laid out flat. But these paintings are more than footnotes to Picasso's sexual decline. They read as final, persuasive statements of his relationship to the Western art traditions.

Picasso's artist is a lascivious, lecherous figure, using his brush to lick or caress the object of his attention, invariably a female nude. This, Picasso must be suggesting, is how he wants to be remembered – as the artist who, more than any other, brought sex out of the shadows of the fine art tradition and fixed it in the limelight.

Late Picasso is full of references to the art of the past. In this show alone – which contains, after all, a tiny fraction of Picasso's vast output in the last twenty years of his life – you find reworkings of masterpieces

by Rembrandt (*The Night Watch*), Poussin and David (*The Rape of the Sabines*), Delacroix (*Les Femmes d'Algers*), Manet (*Le Déjeuner sur l'Herbe*), Degas (the brothel-scene monotypes) and Matisse (the *Odalisques* which, Picasso joked, Matisse had 'bequeathed' to him on his death). It is less of a dialogue than a contest – Picasso versus The Rest of the World.

Late Picasso is not out to learn from the masters of the past but to supersede them, to rewrite art history in Picassian terms. 'That bastard, he's really good,' Picasso is reported to have said of Delacroix, but that does not deter him from competition. Delacroix's sullen, harem-bound *Femmes d'Algers*, heavy with their own lassitude, become sharp-angled, blank-faced *Demoiselles d'Avignon*, totems fraught with sexual threat. Manet's enigmatic *Déjeuner* becomes a pastoral idyll for sexually motivated biomorphs – although, in the finished paintings at the Tate there is nothing quite as obvious as Picasso's notebook solutions to Manet's pictorial mystery, seen in *'Je Suis le Cahier'* at the Royal Academy in 1986, where he turned the *Déjeuner* into a gang-banging free-for-all.

Likewise, Picasso purges Poussin's or David's *Rape of the Sabines* of their classical or neo-classical moralities, turning them into orgies of violence in which death-dealing Romans on horseback terrorize a bevy of flailing, supplicant maidens. The late nudes can be read as Picasso's Dionysian riposte to the Apollonian clarity, the formal perfection and calmness of Matisse's odalisques. Picasso made no secret of the fact that he regarded Matisse as the only other contender for the laurel of Greatest Twentieth-Century Artist.

It is the same everywhere you look. In his prints, where he comes closest to sheer pornography (they have been consigned to a basement at the Tate, which enhances their peep-show qualities) Picasso imagines Degas as a seedy voyeur, telescoping the gap between art and life that the older French artist was so careful to preserve. In other prints, Picasso imagines Raphael – whom he depicts simultaneously painting and making love to the Fornarina with *kama sutra*-like ingenuity – as a virtuoso sexual gymnast.

There is, doubtless, some form of Oedipal motivation behind Picasso's multiple appropriations of past art and artists. Creating his forefathers in his own image, Picasso is also, symbolically, killing them. It is apparent, too, in the surrounds Picasso chose. He particularly liked

his pictures to be hung in antique frames; their physical occupancy of Old Master territory reads metaphorically – Picasso's way of reminding us that he, Pablo, has displaced the Renaissance.

'Late Picasso' explodes the stereotyped idea of late great art. Not for him the darkling shades of Rembrandt's final self-portraits, the accepted epitome of twilit genius. There, the encroaching darkness and the painter's wry, pitiless observation of his own physical decay read as a wise acceptance of mortality. There is no wisdom, no resignation, and precious little morality in late Picasso. Instead, there are the same old sexual neuroses, the same violent yearnings, expressed with a brutality and honesty that spits in the face of approaching death. Picasso remains the same, unregenerate anarchist who burst on the world in the early years of this century. Perhaps it was inevitable. He was never the type to go gently into that good night.

5th July 1988

Willem de Kooning

THE TATE GALLERY'S RETROSPECTIVE of the work of Willem de Kooning, the last surviving Abstract Expressionist painter, is no ordinary art exhibition. It is a canonization, with the most senior of its organizers, David Sylvester, playing the part of the Pope. De Kooning, to quote Sylvester's benediction written for the exhibition catalogue, is not only 'the supreme painterly painter of the second half of the century and the greatest painter of the human figure since Picasso' but he also belongs 'in the middle of the map of this century's art like a great railway junction'. Sylvester is a distinguished man, but he may on this occasion have caught the wrong train.

The elevation of De Kooning to some notional first division in some notional league table of twentieth-century artistic merit can only serve to mislead. The fact is that De Kooning is an intriguing artist but he is certainly not A Figure of Major Cultural Significance. He is especially ill-served by the inflationary rhetoric that would seek to puff him up into one, because he has always been the opposite of a pretentious painter. His art has spoken, always and only, of his own obsessions, and they are not complicated ones.

At his best he is a robust and vulgar painter, with some of Rubens' crudeness but never quite his generosity of spirit. A Dutchman who has spent most of his life living on Long Island, he has always belonged as much to Holland and Flanders as to America – a painter of bawds and scenes of tavern ribaldry in Abstract Expressionist disguise.

De Kooning is not a terribly various artist, although he is an extremely uneven one. As the Tate retrospective proves, sometimes monotonously and sometimes exhilaratingly, he has only ever been truly moved by two subjects, food and sex. It seems to have taken him a long time to realize this.

His early paintings are low-toned murks haunted by staring,

anatomically incomplete ghosts: the artist's first attempts, it may be presumed, to extricate himself from the tight academic drawing style he had learned as an art student in Holland. Then, in 1946, he paid a brief but revealing homage to Francis Bacon's *Three Figures at the Base of a Crucifixion* in the form of a painting called *Fire Island*. Bacon's horrid anatomies of threat and revulsion have become internalized and intimate in De Kooning's painting: no longer monsters screaming at the outside world, they have become organs nestling inside a body.

Through the late 1940s he painted a series of rather depressing monochrome paintings, black and white or the colour of grey dirt, which look like attempts to conjure effects of weather – to render, abstractly, the movement of air through landscapes or cityscapes. They do so, but with an inevitable dullness, since their subjects clearly did not engage the man who painted them. For De Kooning to begin truly to become De Kooning, he needed to excavate something alive from these turgid surfaces. He did. In 1952 he finished painting the boss-eyed, big-breasted, cartoon maenad that he called (conscious, no doubt, that she was just the start of something) *Woman I*.

De Kooning's first series of Woman paintings, painted, nearly all of them, in the first half of the 1950s, are ferocious totems that have become laughable. Their huge grinning mouths and huge grinning vulvas, their spreading flesh and staring eyes make them hilarious rather than disturbing. Their laughter and the laughter they provoke is impeachment enough of that school of psychoanalytical art criticism which finds in these works of art evidence of their creator's unquiet relationship with his mother.

These pictures are, among other things, an act of sustained homage to Picasso's *Demoiselles d'Avignon*, but Picasso's intimidatory whores have become much friendlier in De Kooning's hands – more lovable because softer, more luscious. In transforming Picasso's goddesses into his own kind of goddesses, De Kooning suddenly discovered the nature of his fantasy – a fantasy that would sustain him as an artist for the rest of his career. He had dreamed of a woman you could not only touch but eat as well.

This picture established what would become a habit or compulsion in De Kooning, who has always been an artist ruled by his appetites. A very large proportion of his paintings have been attempts to inter-

nalize the things that he likes. They are attempts to eat the objects of his affection. His best paintings are the ones where this gustatory spirit has been carried into the paint itself, so that it assumes the properties of comestible substances like cheese or butter or fruit pulp.

But he also paints like a man perpetually shocked by the nature of his own character, as if he cannot quite accept his own hedonistic flippancy and feels the need to prove himself respectable and substantial. There is a guilty edge to De Kooning's art always, as if no matter how close he comes to liberating himself and his dreams, a little trace of dour Calvinistic guilt never quite leaves him. This might explain why it was that he stopped painting his huge edible women in the second half of the 1950s and began painting abstracted landscapes instead: pictures of something safer and less overtly onanistic – pictures of something not inside but outside the painter.

What they prove, however, was that De Kooning has always been simply unable to paint what was outside himself with conviction. His hagiographers have tended to refer to these works as moving evocations of the vastness and sublimity of the American landscape. In fact, they are dull and mostly inept pictures, misconceived in scale and handling, in which the surprisingly frequent lapses in De Kooning's colour-sense are most glaringly revealed.

Part of the problem may lie in the fact that the colours in which most of them are painted – yellows, umbers, blues and greens – are incapable of exciting De Kooning. His imagination has only ever been inflamed by the colours of the body, which is why all of his best pictures are essentially the colours of blood or flesh or viscera. His landscapes by contrast are merely dutiful. They are depressing in the way that so many abstractions of the St Ives school, painted at roughly the same date, are depressing. They even look as if they could have been painted by a St Ives artist.

De Kooning is more often a promising artist than a fulfilled one. His better pictures are so much better than the others that they virtually nullify them. The gallery containing the works he painted in a concerted burst of activity in 1977 might just as well have only contained one, *Untitled I*, so thoroughly does it outperform the rest. It is a picture that looks as though it is concocted of human flesh and flowers and ice-cream, a wonderfully obscene and riotous dream of pleasure translated

into paint. Everything close to it is rendered instantly forgettable, like mess.

By the time he painted that picture, De Kooning had begun to run out of steam as a painter. His late work is becalmed, but not in any interesting way because it consists merely of arrangements of nothing much in particular. The onset of Alzheimer's disease, which has afflicted him for several years now, may or may not have affected these pictures. There is a faint, faint memory of the excitement that touching another's body once gave him, in their abstract jostlings and abuttals – but it is terribly faint, a sighing, dying fall, not a last radiant outburst of creativity.

De Kooning's *annus mirabilis* was 1966, when he painted his most seductive pictures. One of them is in the Tate exhibition and it is by a distance the best painting in the show. It is called *Woman Accabonac* and it is the achievement, in paint, of De Kooning's crude, unruly being. It is a wonderful, mad, joyful thing, much more exuberant and un-leashed than the earliest Woman paintings because painted (at last and for once) in bright and radiant colour – pink and orange and yellow. Its subject is a woman made out of bubblegum, cheese, ice-cream and egg yolks, and De Kooning has even lent his paint the sheen and the elasticity of bubblegum in the painting of it. It is a masterpiece, for the simple reason that, in it, its creator expressed himself fully.

De Kooning used to laugh at American artists for being grim and serious and altogether too pompous in their ambitions – for behaving (in his words) as if they were members of 'a team writing American history'. The false modesty of artists is often beguiling, but this is a piece of genuine modesty. De Kooning has not been a rewriter of art history. He has not been a great innovator, as he himself has always been the first to admit. His technique, a slippery, fluid handling of paint much influenced by the French painter of charnel houses, Chaïm Soutine, contains nothing substantially new to art. His attempt to con-vey life as a succession of 'slipping glimpses' is plainly (and confessedly) derived from Cubism. His influence on the artists to come after him has not been entirely negligible, but neither has it been fruitful. De Kooning at his best has proved inimitable, while De Kooning at his worst seems to have spawned a world of imitators. Much of the worst (overscaled, confused, sloppily abstract, semi-figurative) painting to

have emerged from Europe and America during the past 10 or 20 years has resembled the distillation of his greatest faults.

De Kooning's achievement is a small but uplifting one. He clearly had great difficulty in giving rein to his witty, greedy, erotic character, but he did manage it a few times and that is what he deserves to be remembered for. His best pictures are not major contributions to Western visual culture, or anything else as abstract and high-sounding as that. They are evocations of strange, dreamed orgies – attempts to evoke, in painting, something like the experience of having sex with someone gorgeous in a bath filled with maple syrup and milk while eating a fried egg and bacon sandwich. De Kooning's genius was inseparable from his essential indecency.

21st February 1995

IV

SCHOLARS, COLLECTORS,
ART CRITICS AND
OTHER DISTORTERS
OF THE TRUTH

Cassiano dal Pozzo

'THE PAPER MUSEUM of Cassiano dal Pozzo', a small part of which is currently on exhibition in the British Museum's department of prints and drawings, brings a dead world to life with sudden and unexpected vividness. This is an unusual museum: not a real one, but a notional one; the idea of a museum, one of the earliest ancestors of André Malraux's *musée imaginaire*. It exists only on paper. It is a museum that takes the form of upwards of 1,500 drawings and water-colours and that contains, in reproduction, each shrunk to the manageable dimensions of an image on a single sheet of paper, an apparent infinitude of weird bits and pieces: it is full of fragments, odds and ends, peculiar visual bric-à-brac ranging from a drawing of *The Sarcophagus of Alexander Severus* to a drawing of the largest broccoli plant ever grown. But it adds up to more than the sum of its parts and its chief exhibit might be said to be itself. Much of it is devoted to recording the relics of the ancient world, but it is most fascinating as a relic of its own time, and of a culture in which the curious idea of a paper museum could have taken root and grown such strange fruit.

Cassiano dal Pozzo was once generally accepted to be one of the most extraordinary men of his time but these days he requires introduction. Born in Turin in 1588, he was brought up in Pisa and spent his adult life in Rome, where under the patronage of Pope Urban VIII he was appointed to a position in the household of the pontiff's nephew, Cardinal Francesco Barberini. His official activities were fairly undemanding, if the range of his unofficial activities is anything to go by. Cassiano is known to have commissioned some forty paintings by Poussin, including one of the two great sets of *Seven Sacraments*. He was also an archaeologist, a botanist, a zoologist, a geologist and the leading ornithologist of his age. He played a vital role in the publication of Galileo's *The Assayer* of 1623, a book that changed the accepted picture of the known

universe by finally demolishing the old Ptolemaic cosmology. Without Cassiano, the idea that the earth revolves around the sun, rather than the other way around, might have caught on rather later than it did.

Cassiano was also a driving force behind the Accademia dei Lincei, a scientific academy that was one of the least characteristic but most important institutions of Counter-Reformation Rome – in the days of the Inquisition, scientists tended to be thought of as a good way to start a bonfire – and as such he played an important part in both aspects of the seventeenth century's scientific revolution. He contributed to the dismantling of old Aristotelian approaches to the study of flora and fauna and the forging of a new, empirically based natural history. If they had played football in seventeenth-century Italy he probably would have been player-manager of AC Milan.

There is something more than slightly daunting, to the modern mind, about the diversity of Cassiano's interests and talents. To consider his career is to realize with renewed force that we live in an age of extreme specialization and distinctly partial individual competence. How many ornithologists, these days, are also expert in art history? (And how many art historians are familiar with the migratory behaviour of the citron-crested cockatoo?) To Cassiano, the notion that aesthetic and scientific inquiry represented two different forms of endeavour would have seemed alien, since in his day the arts and the sciences went under the same name, both being referred to as 'art'.

Visitors to the renovated sixteenth-century palace where Cassiano lived in Rome would have passed through the courtyard, where the live birds that he kept for the purpose of study could be seen perching on his collection of classical sculptures. Inside, they would have passed the laboratory which he had had constructed to carry out animal dissections and, proceeding through corridors lined with maps, they would have met their host upstairs, on the *piano nobile*, surrounded by paintings on sacred and pagan themes by Poussin. Cassiano's house was a microcosm of his interests and, also, the image of Western civilization on the verge of enormous change, being transformed by new knowledge and new approaches to the getting of knowledge. The house cannot be revisited, but one of the things that it contained can: Cassiano's Paper Museum, which in its own way is also a model of his mind and of the seventeenth century's fast-turning world.

The origins of the Paper Museum lay in a desire to make sense of what, to a cultured seventeenth-century Italian, would have represented both heritage and competition: the vast but shattered legacy of the classical world. Cassiano conceived his Paper Museum as a pictorial encyclopaedia that would one day (he hoped) contain a record of the appearance of every single existing trace of the great Greek and Roman civilizations of the distant past. He commissioned those whom he considered to be the most promising artists of the day (they included, besides Poussin, Pietra Testa and Pietro da Cortona) to make drawn copies of every such relic that he knew of. The Paper Museum found room for the works of classical antiquity, monumental marble friezes, grand reliefs sketched in minute detail by Cassiano's army of copyists; but also for all kinds of other arcana. It contained images of antique brooches and weighing and measuring devices, of Roman boxing gloves, of plates and dishes and jugs and of all kinds of votive objects including at least one large stone phallus.

Looking, today, at the drawings that must have been delivered almost daily to the Dal Pozzo household for cataloguing and entry into the Paper Museum, what is most striking about them – especially given that the artists responsible for them included some of the masters of seventeenth-century painting in Rome – is their peculiar artlessness. They are not just pictures of objects, but pictures of an attitude to objects. The drawings almost invariably attempt to include the maximum of visual information about the things drawn. The light is uniform and even, the viewpoint chosen absolutely straightforward; no attempt is made – and this is where these drawings of the remains of classical antiquity differ so radically from those of later centuries, particularly the eighteenth and nineteenth – to impart mood or drama through composition or effects of chiaroscuro.

A neo-classical artist, drawing the *Marble Statue of a Man Wearing a Toga* which Pietro da Cortona drew for Cassiano sometime in the 1620s or 1630s, would almost certainly have attempted to make something of the pathos of the figure's headless state, would have dwelt on the deep carving of the drapery and would have modelled it in much greater tonal contrast. But Pietro da Cortona's two drawings have the matter-of-factness of a fashion plate: this, they say, is how Romans might have been wearing their togas *circa* AD 100. They suggest a culture fascinated

by the minutiae of the past, one that viewed the relics of Roman civiliz-ation not ever as great art but as vital keys to an understanding of its social habits and customs. The Paper Museum is full of drawings – Vincenzo Leonardi's study of a *Samnite Triple Breast-Plate* is another beautiful keen-eyed example – that take more than one view of a single object and whose aim appears to be to impart something like the know-ledge that might be derived from handling a thing. These images are attempts to piece the past together, to reconstruct it in order to under-stand it. The only artful, overtly imaginative drawings of classical sub-ject matter in the Paper Museum take the form of reconstructions: a Roman meal, imaginary diners gathered round reclining, reconstructed from the evidence of classical literature or a theatrical performance, reconstructed from the evidence of a crumbling, ruined amphitheatre.

Cassiano dal Pozzo's Paper Museum sheds much light on the paintings of Poussin, explaining among other things what can, occasionally, seem to be that artist's excessive devotion to archaeological fidelity. The Paper Museum also suggests, like Poussin's paintings of bacchanalia poised between order and discord, a world attempting but not entirely suc-ceeding in squaring its knowledge of antique civilization and customs with its own sense of civilization and of what constitutes acceptable behaviour – a world potentially troubled as well as inspired by antiquity, by its violence and pagan religious practices. Cassiano's encyclopaedic attempt to gather together all the visual evidence of antiquity was bound to turn up evidence not only of the great intellectual and architectural and organizational achievements of Roman civilization, but also of its savagery. The Paper Museum contains drawings of gladiators being mauled by wild beasts, of arcane religious rites and strange obscure objects of worship.

Cassiano lived at a time when knowledge must have seemed particu-larly fraught with worrying possibilities. The letters of his contempor-aries suggest the doubts and anxieties that coexisted, in them, with an insatiable thirst for knowledge: Galileo's discoveries did not merely redefine the world, they also turned it upside down.

The Accademia dei Lincei, the Academy of Lynxes, named itself knowingly after that small and extremely sharp-eyed animal, and the natural history drawings assembled in the Paper Museum testify both to the lynx-eyed nature of Cassiano and to his determination to forge

a new method of scientific inquiry based on close observation. The drawings of fruit and birds and stones in the Paper Museum show that Cassiano wanted to understand and tabulate nature just as exhaustively as he wanted to reconstruct and comprehend classical antiquity. Cassiano lived in the same period that saw the invention of both the microscope and the telescope, and he commissioned the first ever microscopic drawings of natural objects. The natural history drawings in the Paper Museum, drawings in close focus of oranges, tomatoes, herons, quartz stones, are remarkable because the nature of their realism sets them apart from virtually any other image made before them (although they have something of Leonardo's curiosity about them: Leonardo understandably fascinated Cassiano). This is not the moralized realism of Dutch still-life painting, objects caressed and renounced at the same time, but the neutral realism of analysis. The kind of precise observation that Cassiano encouraged in his draughtsmen would, eventually, make the taxonomic rigour of Linnaeus possible.

There is even, in a few microscopically realized drawings of ammonites, a sense that Darwin is there, waiting in the wings. Such apparent freaks of nature fascinated Cassiano because they did not fit any known explanation of the origins of life, because they simply did not tally with biblical accounts of the creation. To visit the Paper Museum is, above all, to see the world being seen differently. Through the eyes of science, perhaps; or as Cassiano dal Pozzo would have said, 'through the eyes of the lynx'.

25th May 1993

The Badminton Cabinet

TO MOST PEOPLE, the Badminton Cabinet may well just look like a large and fantastically ornamental chest-of-drawers. The most splendid eighteenth-century cabinet in existence, the most ostentatious reposi-tory of ducal socks ever made – but is it really an object of national significance?

There are clearly those who believe that it is. The Badminton Cabinet is the first object of a National Art Collections Fund National Appeal for almost thirty years. £8,697,000 is needed to prevent it from becoming a conspicuous topic of conversation in the New Jersey mansion of Mrs Barbara Piasecka Johnson, the Johnson & Johnson's baby powder heiress who bought it at Christie's last July. The last export-threatened object that the NACF deemed to be of equivalent worth was the Leonardo Cartoon which the nation acquired in 1962. Few would contest the desirability of saving the Leonardo, but the Badminton Cabinet? Until it was sold, hardly anyone had even heard of it. The world's most expensive piece of furniture goes on display at the British Library today.

A reasonable case can be made for its acquisition. It is an object as heavily freighted with political, intellectual and aesthetic significance as it is with gilt, ormolu and lapis lazuli. The trouble is that the audience for art has largely lost the means to decipher the statements made by such an object. What follows is an attempt to unlock it.

More than one key will be required. The first is some knowledge of the man who commissioned it. He was Henry, the third Duke of Beaufort, a wealthy English aristocrat. In 1726, when he was nineteen, he left England on the young nobleman's obligatory trip to mainland Europe, the Grand Tour. In Rome he bought enough paintings to furnish entire galleries at Badminton, his ancestral home. In Florence he commissioned what would come to be known as the Badminton Cabinet.

Osbert Sitwell once said of it with wry understatement, that 'it will not be liked by those who care only for old oak'. It is certainly not an object calculated to appeal to English tastes. Its overwhelming ornateness seems distinctly Mediterranean. There is something popish about it, something redolent of the theatricality and glitter of Catholicism. The Badminton Cabinet – with its elaborate clock-face, its crowning gilt-bronze statuary and coat-of-arms, its fantastical illusionistic panels inlaid with *pietra dura* – is supercharged with detail.

Yet for all its intricacy it does not seem gaudy but, rather, stately. Nothing *feels* superfluous. We know from existing letters that the Duke played a large part in its design. He requested many alterations and additions to it during the two years that it took the Florentine artists and craftsmen involved – some thirty people or more – to make it. The Duke was a student of architecture and had, while in Italy, worked on designs for what would have been (it was never built) one of the grandest Baroque palaces in Europe. It is presumably no coincidence that the design of the cabinet is essentially architectural, taking the form of a Baroque triumphal arch.

It is, if such a thing is possible, a triumphal piece of furniture. It is the product of its time, that brief moment in British eighteenth-century history when a communal mood of self-confidence resulted in a sequence of grand aristocratic commissions. Its scale is daunting: at around twelve feet tall, it is the equivalent, in the decorative arts, of Vanbrugh's Blenheim or the grand neo-Palladian architecture of William Kent. When in Florence, the Duke of Beaufort set out, brazenly, to out-do the Florentines: he commissioned, from the Medicis' own workshop, the Opificio delle Pietre Dure, a grander, more intricate and expensive object than any made for the Medicis themselves. The Badminton Cabinet is clearly a statement of princely ambition.

The collections kept in royal cabinets throughout Europe symbolized their owners' comprehension and mastery of their world. The cabinet form, which seems to have developed in Spain around 1500, was the first furniture type to possess a complex internal anatomy of pigeon-holes, drawers and secret compartments. During the course of the seventeenth century, the cabinet evolved from a piece of furniture into what was, in effect, a physical encyclopaedia. Here you would find Greek and Roman coins and cameos, emblems of the desire to recapture the glory

of the ancients, but also far odder things: desiccated frogs, misshapen stones or curious fossils, 'wonders' of nature believed to confer potency of various kinds on their owners. The cabinet came to represent an entire mythology of regal power and knowledge.

The Mannerist cabinet was an article of furniture the significance of which owed much to the survival of primitive beliefs – a testament to the fact that royalty was still invested with an aura of occult power. (This aura still survives, as a faint etymological memory, in the modern use of the word 'Cabinet' to designate an inner circle of governing politicians.) But the Duke of Beaufort's cabinet is not Mannerist, but Baroque, and the distinction is important. The Baroque cabinet might be said to represent a contradiction in terms. What happened to the cabinet, when it became Baroque, was that it was, almost literally, turned inside out.

The Badminton Cabinet was never designed to contain a collection of objects. Its interior is bathetically rudimentary, virtually rustic, in comparison to the richness of its outside. It is all façade, no content – but its façade *is* its content. Much that might look, initially, merely like decoration, turns out to have additional significance. The chalcedony lion masks that are fixed to the Badminton Cabinet, for example, make symbolic reference to the type of ancient glyptic objects that would have formed part of the older princely cabinet collection. They have become symbols rather than facts – but that is not to say that this is a cabinet that no longer wants to impress the viewer with its owner's occult knowledge. That is precisely the message carried by the cabinet's most striking decorative elements: the virtuoso *pietra dura* panels that cover much of its surface.

Pietra dura is a fiendishly complicated process laying together thin slices of hard, often semi-precious stone to form a design. The panels on the Badminton Cabinet are among the finest existing examples of a technique that would later become debased by the third-rate examples turned out by the Florentine tourist trade. The illusion, here, is of an extremely subtle and complex nature. The slices of stone that have been chosen, or 'edited', from the original blocks from which they were cut, actually seem to *model* the objects which they have been made to represent.

Take the central panel of the cabinet: the cherries, each formed by a

single circular slice of semi-precious stone whose colour shifts from red to pink, seem rounded by light and shade. The illusion of volume is conjured from mineralogical accidents. Other elements are still more remarkable and ingenious. The bird's plumage is made from at least five types of marble, the patterns of which suggest the different types of feather required. But the carnation is perhaps the most breathtaking of all, its complex foliage realized by a slice of fortuitously rippled red marble.

All this might seem merely like a form of clever but somewhat pointless trickery. Yet it too carries its weight of meaning. The wonders of *pietra dura* were, once, seen as precisely that. This was not just craftsmanship, but revelation. The owner of the Badminton Cabinet, it is implied, has become privy to the hidden correspondences of nature, the magical echoes from the inanimate to the animate part of God's creation. He has uncovered worlds within worlds, has seen the universe in a grain of sand. (The metamorphic, hallucinatory quality of *pietra dura* illusionism looks forward to the art of the Surrealists, who also invested such 'found' correspondences with mystical significance.)

The symbolism of the cabinet's *pietra dura* has another dimension. Rendering birds and butterflies and flowers in the hard, unchanging colours of stone, these panels are emblems of an astonishing – to the modern viewer, anyway – princely hubris. Fragile, evanescent Nature, assisted by Art, has conquered Time. The Badminton Cabinet is a piece of furniture, but it is a fantasy embodied. It dreams of omnipotence, invulnerability, immortality. This becomes still more explicit in the clock and the gilt-bronze figures of Flora, Ceres, Bacchus and Saturn (symbols of the four seasons) which are surmounted by the Beaufort coat-of-arms at the apex of the cabinet. Beaufort is literally *above* Time.

All the complexities of the Badminton Cabinet resolve themselves into this overriding statement, this fantastic proposal. The fantasy in question is not personal but dynastic. It is the name of Beaufort, not the third Duke himself, that shall triumph over Time. The entire cabinet could be said to illustrate the Beaufort family motto, inscribed on the gilt-bronze ribbon that scrolls around the base of the coat-of-arms: '*Mutare vel timere sporno*', 'I scorn change or fear'.

The Badminton Cabinet is, as they say, an object fit for a king – or,

at least, for a king-maker. This may be the last key needed to unlock its meaning. When the third Duke of Beaufort arrived in Italy, the Hanoverian dynasty had only been on the throne of England for twelve years. Its future was still uncertain. The Beauforts, who had lost much of their wealth in a disastrous attempt to support Charles I, had always been particularly devoted to the Stuarts. We know that the third Duke met the Old Pretender while in Italy, and that one of his major agents there was Cardinal Alberoni, a prominent agitator on behalf of the Stuart cause. Perhaps the Duke dreamed of playing a chief part in some future Stuart restoration. His cabinet certainly suggests that he saw himself as a man of destiny.

His hopes were unfulfilled. The Stuart restoration remained a dream and the third Duke of Beaufort died, at the age of thirty-eight, in 1745, 'worn out by a complication of disorders'. The Badminton Cabinet remains. It is an object that represents a unique confluence of aesthetic and philosophical beliefs, dynastic ideals and political interests. It is a piece of furniture, but it is also a piece of history.

26th February 1991

The NACF Campaign to purchase the Badminton Cabinet failed.

Ruskin

'HAVE YOU NOT FLATTERED HIM?' John Ruskin's doting parents asked George Richmond when they saw his drawing of their twenty-four-year-old son. 'No,' he replied, 'it is only the truth, lovingly told.' Richmond's portrait is one of the first images you come across in the Whitworth Gallery's fresh and compelling exhibition, 'Ruskin and the English Watercolour'. The young Ruskin gazes out with quiet intensity, hair swept back from a noble forehead, a half-smile frozen on his lips. On balance, the artist probably did flatter his subject. Richmond's son described Ruskin at around this time as a gaunt young man 'with a profusion of reddish hair' and 'shaggy eyebrows like to a scotch terrier'.

Richmond's Ruskin might be an idealization, but if so it is a salutary one – a reminder that Ruskin was not always the slightly stuffy Victorian of his later years but was, also, the last of the Romantics, who happened to write his poetry in the form of art criticism. When Richmond drew him, Ruskin was secretly writing his remarkable, idiosyncratic defence of J. M. W. Turner, the first volume of *Modern Painters*, with its virtually biblical purple passages: 'Turner – glorious in conception – unfathomable in knowledge – solitary in power – with the elements waiting upon his will, and the night and the morning obedient to his call, sent as a prophet of God to reveal to men the mysteries of His universe, standing, like the great angel of the Apocalypse, clothed with a cloud, and with a rainbow upon his head, and with the sun and the stars given into his hand.'

'Ruskin and the English Watercolour' has you constantly scurrying back to Ruskin's texts. It is an exhibition turned inside-out, where the images on the walls are there to illustrate the critic's comments on them. Much of the art in this show is of little interest in itself, but it is made interesting by the revelation of what it could mean to Ruskin. David Cox's *Bolton Abbey, North Yorkshire* is a relatively pedestrian watercolour

along stereotypically picturesque lines – cattle graze in a riverside meadow, while the abbey ranges itself against cloud-capped hills in the distance – yet images such as these spoke volumes to Ruskin, who wrote volumes about them: 'David Cox, whose pencil never falls but in dew – simple-minded as a child, gentle, and loving all things that are pure and lowly – content to be quiet among the rustling leaves, and sparkling grass, and purple-cushioned heather, only to watch the soft white clouds melting with their own motion, and the dewy blue dropping through them like rain, so that he may but cast from him as pollution all that is proud, and artificial, and unquiet, and possess his spirit in humility and peace.'

Ruskin was never, merely, an art critic. Art mattered to him in a way that now seems virtually inconceivable, since its function as he saw it was to unveil the workings of God. The English watercolour tradition always had a peculiar importance for him. Watercolourists specialized in capturing the most fugitive and beautiful of natural phenomena – the sudden apparition of a rainbow within an alpine waterfall, the radiance of a sunset – in which Ruskin felt he could perceive divine presence in the world.

Raised in the evangelical traditions of Protestantism, Ruskin expected artists themselves to evangelize, to reveal God's second book, nature, in all its redemptive glory. He so admired Turner's small watercolour of *The Falls of Terni* that he paid 500 guineas for it (then a small fortune) at Christie's. With its glorious, sunlit wall of water, it presumably excited him because it portrayed a world that seemed to have been literally ignited by the grace of God. 'For pure painting of light and mist,' Ruskin commented, 'I know nothing like it.'

Where the earlier Romantics tried to capture the world's sudden, uplifting emissions of radiance in words, Ruskin collected watercolours. The activity of collecting and writing about art was his version of Wordsworth's *Prelude*, an attempt to regiment, to order, a lifetime spent communing with the natural world. Although Ruskin was as fascinated by alpine scenery as Wordsworth ever was, he tended to prefer its representations in art to the real thing. Art edited the natural refractoriness of experience, distilled its purer beauties.

Where Wordsworth tried to recover his childhood sense of blessedness by writing about nature, Ruskin wrote about *pictures* of nature. But

Anthony Vandyke Copley Fielding's *View of Lancaster* is scarcely great art, and the intensity of Ruskin's response to works such as this suggests that what he was really writing about was himself, his own yearnings: 'Copley Fielding, casting his whole soul into space – exulting like a wild deer in the motion of the swift mists, and the free far surfaces of the untrodden hills . . . always with the passion for nature burning in his heart.'

Ruskin's extreme solicitude for the correct conservation of fragile works of art – a section of the Whitworth show is given over to 'Ruskin and the Conservation of Watercolours' – is more than the connoisseur's desire to protect his investments. Behind it lurks that old spectre of the Romantic sensibility, the nagging awareness that even the most magnificent, spiritually uplifting experiences are subject to the erosions of time and forgetfulness. Where Wordsworth might lament the gulf that separated the writing adult from the feeling child, the natural fading of memories, Ruskin worried over the fading of his watercolours. 'Each drawing with its own golden case and closing doors,' ran his proposals for a Turner museum, 'with guardians in every room to see that these were always closed when no one was looking at them.' Turner's *The Falls of Terni* still occupies the frame Ruskin had made for it, complete with pull-down blind.

Ruskin could be remarkably wrongheaded. Turner's *Upnor Castle*, a gloomy meditation on the decline of Britain's naval might, sun setting over a seascape, men-o'-war at half-mast, was interpreted by Ruskin as a cheering sunrise. One of the minor comedies of nineteenth-century art history was Turner's resistance to Ruskin's interpretation of him. 'Criticism is useless', he told his young admirer, and when Ruskin commissioned the artist to make a watercolour depicting the Pass of St Gothard in Switzerland, concentrating on pine forests, Turner painted everything bar the pines, a neat gesture of independence from his would-be interpreter.

Ruskin was always obsessed with colour. The radiance of Turner's art seemed God-given, was what made him a 'great angel of the Apocalypse . . . with the sun and the stars given into his hand.' As he grew older and less certain in his faith, Ruskin became gloomily preoccupied with what he saw as a draining of colour from the world, for which – in *The Storm Cloud of the Nineteenth Century* – he blamed the pollutants

of the industrial revolution. He complained frequently in his diaries and letters of the increasing 'blackness' of the weather, and wrote nostalgically of 'the heaven that one used to have a father in, not a raging enemy'. Ruskin's admiration for the Pre-Raphaelites, initially so hard to square with his youthful worship of Turner, actually demonstrates his consistency. Looking, in particular, at the dense, jewelled Rossetti watercolours in this show, it seems plain that Ruskin found solace, precisely, in their polychrome intensity of colour.

You take your leave of Ruskin, at the Whitworth, in William Gershom Collingwood's memorable portrait of the writer at work in his study at Brantwood in the Lake District, circa 1882. Bent and greyed, he continues still to write, an image of persevering old age; the floor is strewn with waste-paper, presumably rejected drafts. Ruskin is in his retreat, the house in which he became a virtual recluse for the last decade of his life. Collingwood's portrait suggests the gradual loss of vitality and faith that was, also, the fate of the first British Romantics. The fervent twenty-four-year-old has become the eminent Victorian, but at a cost.

11th April 1989

Rembrandt

ON GUY FAWKES DAY, 1822, William Hazlitt visited the Dulwich Picture Gallery. He admired many of the pictures in this new, 'large gallery, built for the purpose,' particularly the Cuyps, but only one painting inspired him – 'the *Jacob's Dream*, by Rembrandt, with that sleeping figure, thrown like a bundle of clothes in one corner of the picture, by the side of some stunted bushes, and with those winged shapes, not human, nor angelical, but birdlike, dreamlike, treading clouds, ascending, descending through realms of endless light, that loses itself in infinite space! No one else could ever grapple with this subject, or stamp it on the willing canvas in its gorgeous obscurity but Rembrandt!'

In fact, someone else could, and did. *Jacob's Dream* was cleaned in 1946, revealing the signature of Aert de Gelder, one of Rembrandt's pupils.

Re-attribution is the most devastating blow an art historian can deal to his predecessors. If proven, it allows no comeback. The rug is pulled; the victim falls. Re-attribution of Rembrandt paintings tends to be particularly embarrassing since Rembrandt, one of the archetypal objects of cultural hagiography, has excited some of the most garishly purple prose in the annals of art criticism.

Hazlitt is not the only writer to have effused over the essentially Rembrandtesque qualities of a picture that Rembrandt probably never painted. This is Jacob Rosenberg, from *Rembrandt: Life and Work*, published in 1949 but still one of the standard works on the artist: 'The *Man with the Gilt Helmet*, in Berlin, rightly deserves its fame . . . As in all Rembrandt's greatest works, one feels here a fusion of the real with the visionary, and this painting, through its inner glow and deep harmonies, comes closer to the effect of music than to that of the plastic arts.' Virtually all Rembrandt scholars now agree that *The Man with the Gilt Helmet* was not painted by Rembrandt.

A number of experts had doubted the work for many years, but because it is a world-famous 'great Rembrandt', their reservations had been widely ignored. A process known as Neutron-Activation Auto-Radiography – an extremely expensive and specialized exercise, which involves irradiating the tested picture and requires the use of an atomic reactor – finally tipped the balance of opinion against the painting. It revealed certain technical irregularities that do not square with the known patterns of Rembrandt's studio practice. 'By' became 'School of'.

The twentieth century has witnessed what you could call a Rembrandt drain. Christopher Brown, Curator of Dutch Paintings in the National Gallery, lists some striking statistics in the catalogue to its forthcoming exhibition, 'Art in the Making: Rembrandt'. In 1913, when Hofstede de Groot published his catalogue of Rembrandt's works, he listed 988 pictures. Bredius's 1935 catalogue whittled that number down to 630; Bauch's 1966 catalogue rejected around seventy of those; Gerson's 1969 revision of Bredius brought the figure down to about 500.

But the real cat among the art-historical pigeons has proved to be the Rembrandt Research Project, an independent group of seven Dutch scholars who have embarked on by far the most ambitious attempt to write the Rembrandt catalogue to end all catalogues. After twenty years, they have published two volumes, covering all paintings by or attributed to the artist during the period 1625–1634. By the time they (or more likely their protégés: Rembrandt died in 1669) finish their *magnum opus*, the number of unassailable Rembrandts will almost certainly have dwindled to less than 300.

A Corpus of Rembrandt Paintings proposes three clear categories of picture, an ABC of his art. The As are 'definites'; the Bs are 'don't knows'; the Cs are rejects. As the catalogue crawls down the years, museum staff, private owners and auctioneers wait anxiously while their 'Rembrandts' sit their examinations.

The decisions of the Rembrandt Research Project carry immense weight. The difference between an A and a C can mean, among other things, a great deal of money. Last January Sotheby's sold the *Portrait of a Bearded Man Standing in a Doorway*, once in the Thyssen Collection and long considered to be by Rembrandt. Since the Project had not yet published on the painting, which dates from the 1640s, Sotheby's invited them to give their verdict and published it in the auction catalogue. The

REMBRANDT *Portrait of an Eighty-Three-Year-Old Woman*

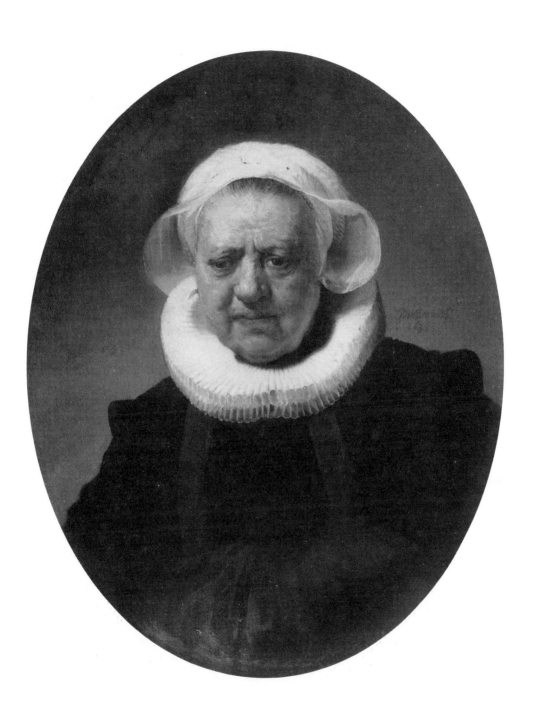

picture got the thumbs down. According to a letter from Josua Bruyn of the Project, it 'comes from Rembrandt's workshop but was not executed by the artist himself'. Although several other Rembrandt experts, including the National Gallery's Christopher Brown, gave the opinion that it *is* an autograph painting, it sold for just $800,000. If the Project's decision had gone the other way, that figure would have been closer to $14 million.

Attributional expertise is the cornerstone of art history, yet it remains – at least for the majority of those who visit museums and exhibitions – an unknown quantity. If a label on the wall of a museum tells us that a particular painting is by Rembrandt, or Titian, or Delacroix, we tend to believe it and get on with the business of looking. The connoisseurship of individual scholars, the extensive range of analytical techniques employed in conservation departments in art galleries all over the world – these are the unacknowledged legislators of museum culture. It is easy to forget the long history of research, the frequent differences of opinion, the uncertainties that can lie behind the label.

The majority of such work rarely comes to public attention. But when it affects such an artist as Rembrandt it tends to make the news. Late last year the Project delivered its opinion that large areas of two Rembrandts in the National Gallery are by a different, 'much inferior' hand. Christopher Brown defended the pictures on the basis of his own connoisseurship. 'Art World Rivals in Row over Rembrandts' screamed one newspaper headline, suggesting an intriguing confrontation: the Project 'confiscating' a curator's masterpieces by re-attribution, versus the curator himself, hanging on to them for all he's worth.

It is not quite that simple. If a museum's Rembrandt is clearly not an autograph work, its curators would be foolish to maintain its authenticity because they would seriously damage their own credibility. Several years ago, the Project cast doubts over another supposed Rembrandt in the National Gallery, the *Scholar in a Lofty Room*. Brown, who recently finished bringing the gallery's catalogue of its own Rembrandts up to date, is satisfied that the painting is not by Rembrandt but an imitator. The arguments that have arisen over the Project's methods and decisions are more complex. They go to the heart of attributional science (if it *is* a science), of *how* one should go about the

business of defining authenticity. What gives a painting its essential Rembrandtness? What makes it an A rather than a C?

Some paintings are relatively easy to attribute to Rembrandt himself. They are documented. *Judas and the Thirty Pieces of Silver* falls into this category: it is discussed, as being by Rembrandt, in a manuscript written within a year of its being painted.

The majority of paintings are less straightforward. Distinguishing Rembrandt's work from those of his followers or pupils is complicated by the very nature of the apprenticeship system in seventeenth-century Holland. Rembrandt was an extremely successful, famous artist; he had a large number of pupils, who worked in his studio, used very similar materials and had every opportunity to watch and learn from Rembrandt himself. It is significant that very few rejected paintings are actual fakes – doubtful works tend to come from within the original Rembrandt circle, although when the Project began their catalogue they expected to uncover hordes of nineteenth-century forgeries.

Learning to distinguish between Rembrandt's work and that of his followers, according to Christopher Brown, is 'very largely a question of experience and spending a lot of time looking at the artist's work. You start from the rock solid, definite Rembrandts and work out. You have a general idea of his development from those paintings, and you try to fit others into it. We pay a lot of attention to the results of scientific analysis, but they are rarely conclusive. In the end, a lot of it comes down to old-fashioned connoisseurship, inevitably subjective judgements about the quality of draughtsmanship or handling of paint – the *way* something is painted, which can be hard to put into words. It's not at all an objective matter, and in many ways I think one should be fairly suspicious of Berenson-type connoisseurship. Great connoisseurs have been wrong in the past; great connoisseurs will be wrong in the future.'

Partly no doubt because they have devoted so much of their lives to Rembrandt attribution, the members of the Project are less equivocal. Out of around 200 paintings classified so far, only eight or so have been categorized as 'don't knows'. Near the start of Volume I of *A Corpus of Rembrandt Paintings*, the team spells out its belief in critical objectivity. 'In our catalogue entries,' they write, 'the reader will find no poetry. We positively mistrust poetic evocations of Rembrandtish qualities.

Deeply felt songs of praise have been written about highly suspect paintings in which no one believes today.'

Away with the old woolliness, the wordy obfuscations of old-fashioned connoisseurship ('verbalization,' they write in clipped tones, 'is a rather questionable necessity'). This is the age of the Neutron-Activation Auto-Radiograph. Within their tombstone-like volumes, you will find scores of X-ray and infra-red photographs. Microscopic paint samples have been blown up and photographed in cross-section; a graph records 'Thread density of canvases used by seventeenth-century

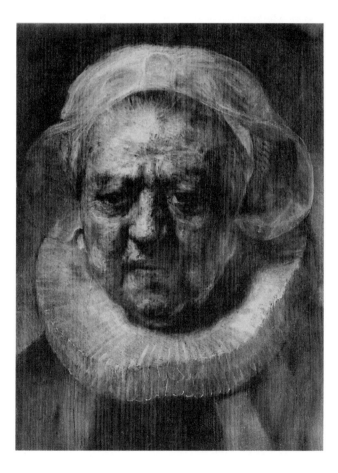

REMBRANDT *Portrait of an Eighty-Three-Year-Old Woman (X-Ray)*

painters other than Rembrandt, the extremities indicating the average ratios of warp and woof threads respectively.'

Yet there are notes of doubt too. The Project was conceived, you learn, at a time when 'Increasing activity in the field of scientific examination of works of art warranted the hope that the results of such research might help in forming an opinion as to authenticity.' Now, they write, after many years of study, they have decided that scientific methods of analysis are much less conclusive than they had once hoped. 'One need hardly say,' they confess, with some poignancy, 'that coming to terms with this experience was a painful process.'

Christopher Brown feels that, whether they care to admit it or not, the scholars of the Project have increasingly come to rely on 'traditional principles of connoisseurship'. Reading their catalogue, it is hard not to agree. They write (supporting rejection of the famous Berestijn portraits in the Metropolitan Museum of Art) that 'The eyes, in themselves painted with suggestive power, betray (for example in the lower edge to the right-hand eyelid and the switch of colour within the eyelid itself) a preference for a colouristic effect that seems almost coquettish.' This comes dangerously close to the kind of 'poetical' language they profess to despise in the introduction.

Similarly, Bruyn's letter to Sotheby's about the *Portrait of a Bearded Gentleman*, is an undisguised example of old-fashioned connoisseurship, necessarily subjective: 'While the picture's treatment does show all the stylistic and technical ingredients Rembrandt used, they are applied here with a notable tendency toward a linear description of forms or even an illusionistic rendering of them.' These are questionable grounds for disqualification.

Brown clearly feels that the Project's scholars have been far too rigorous in their rejections. His argument is simple: by defining the parameters of Rembrandtishness too tightly, the Project have not allowed the artist enough variety; although he does add that they have done 'invaluable work and haven't just thrown out paintings but added some too, especially in Rembrandt's early period'. But for the most part, works that don't precisely match or live up to unassailable Rembrandts tend to be rejected (even when signed – the Project places very little faith in signatures).

For Brown, the Berestijn portraits, while not of the highest quality,

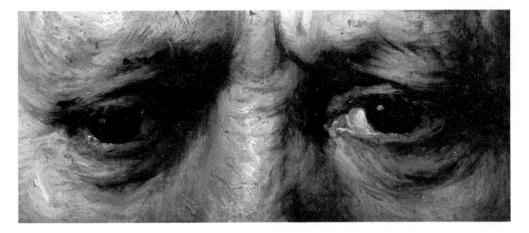

REMBRANDT *Portrait of an Eighty-Three-Year-Old Woman (detail)*

are perfectly acceptable Rembrandts. 'You have to remember that at the time when these portraits were painted, Rembrandt had attracted a lot of interest as a portrait painter, and was painting a lot of portraits to meet the demand. Now, some of these are less good than others, and the traditional view has always been that he worked very hard, very intensively in the years 1632–6, while he was establishing himself in Amsterdam, and that this is reflected in the varying quality of the pictures.'

Brown gives similar reasons for not agreeing with the Project's decision to attribute a large area of the National Gallery *Portrait of Philips Lucasz* to a different hand. The area in question is the sitter's lace ruff, which he admits has been 'somewhat cursorily painted. Certainly it bears no comparison with the quite brilliant lace painting in Rembrandt's famous *Portrait of Nicholaes Ruts* in the Frick Collection – but again, you have to remember that that painting was very important to Rembrandt and he clearly took an unusual amount of trouble over it. He painted it while he was still in Leyden, and it was virtually his calling-card in Amsterdam; he knew that Ruts was a very prominent merchant, whose friends would be in a position to offer him further commissions, and he painted it accordingly. It is very time-consuming to paint lace that beautifully; inevitably, in other works it's more perfunctory.

'There's a good analogy with the splendid Van Dycks we have in the gallery at the moment. Look at the wonderful painting of Henrietta Maria, which was to be sent to Cardinal Barberini in Rome, one of the greatest connoisseurs of the time; then look at the painting hung above it, a portrait of Lady Andover and Lady Thimbelby, which was sent to Lincolnshire. The Barberini painting is immeasurably better and more sophisticated – but both paintings are autograph Van Dycks.'

The Rembrandt Research Project began, in part, because its members were irritated by the post-nineteenth-century Romantic deification of Rembrandt. They wanted to get back to facts. It would be a curious paradox if they should have ended by turning him into a different kind of god, a painter who painted no failures.

Nevertheless, despite their deep differences of opinion, there are some elements of Rembrandtness, manifest in some Rembrandts, which seem agreed. The National Gallery's *Portrait of an Eighty-Three-Year-Old Woman* is an instructive example. Brown is certain that it is by Rembrandt, although undocumented; the Project's scholars agree, placing it with the As. They talk of 'the great directness and freedom of the treatment'. Brown lists his reasons: 'The format, first of all, the oval format. It was very fashionable when Rembrandt came to Amsterdam, and he quickly picked it up. Secondly, the lighting. This idea of giving the figure volume by having a fall of light on the back wall is entirely characteristic of his procedure at the time. The treatment of the face is entirely characteristic, the way that he puts in certain highlights, throws the shadow across it.'

Pushed for specific details, Brown displays the archetypal caution of the connoisseur. 'What you're asking me to do is move towards a kind of Morellian connoisseurship. What Morelli did was look for what you could call automatic details, the idea being that if you look at the ear, say – the ear not being a very important part of the head – then the artist will almost always do it in an unconsciously unique way. I'm not sure that that is particularly useful: if you look at such supposedly unconscious details in definite, agreed Rembrandts, they often seem to differ.'

Brown prefers to concentrate, instead, on areas of evident virtuosity, the passages that could only have been painted by Rembrandt because only he was that *good*. 'Look at the eyes, which are magnificently painted

– the underlid, for example, where the glistening white highlight is very characteristic, which gives it a very subtle wetness. That was imitated, but no one else could do it this well.'

Scientific methods of analysis have played an increasingly important role in attribution, but they have never – as the Project once hoped they would – offered independent grounds for positive attribution or rejection. David Bomford, a restorer at the National Gallery who has worked extensively on the forthcoming Rembrandt exhibition, says that 'The classic case, where you get an anachronistic pigment, or a material that wasn't available in Holland in the seventeenth century, just doesn't occur. Those cases are almost always so glaringly obvious that they've been thrown out long ago, on the basis of connoisseurship.'

Ashok Roy, a scientist in the Conservation Department, has done important work with microscopic paint samples taken from the gallery's Rembrandts, and has managed to establish two distinct categories of ground (the priming layer) used by Rembrandt. When a ground differs, however, it does not provide categorical evidence for rejection; artists do not always stick to their usual routine. The painting will simply be questioned rather more rigorously in other ways. If enough other elements exhibit peculiarities, it may be rejected. Brown and his fellow members of staff remain undecided over the National's smaller *Portrait of Margaretha de Geer*, which is painted on an untypical ground.

But much 'scientific' analysis of Rembrandt's paintings itself simply requires the old skills of connoisseurship. David Bomford 'reads' an X-ray photograph of the *Portrait of an Eighty-Three-Year-Old Woman* in much the same way that Brown reads the surface of the painting: 'What you're looking at is still brushstrokes, just a different layer of brush-strokes, primarily the lead white foundation that Rembrandt used to sketch in the broad structure of the face. It shows up so clearly because lead is impervious to X-rays. The X-ray image of the face is absolutely characteristic of undisputed Rembrandts of the 1630s: these great broad bones of structure, this incredibly confident, rapid laying-in. It was done very quickly in perhaps an hour or so. Rembrandt's pupils were always much more tentative when they layed in faces. You may get a superficially similar look at the end of it, but at this stage you would see these little tiny tentative brushstrokes altering and correcting. That nose was just done in ten strokes, and he's had the courage and confi-

dence to sweep round the form. A pupil would probably have done a long shape to define it and then worked around that.

'Only in Rembrandt of this period do you find this incredible panache in handling paint. Nobody else could have painted it – but that's not science, it's just something you develop a feeling for. It's not always a question of judging him by his strengths, either. Rembrandt was absolutely brilliant at faces, he studied the human face mercilessly, but he wasn't very good at painting hands. His hands fail over and over again.'

The *Portrait of an Eighty-Three-Year-Old Woman* is a great Rembrandt, a definite A. But there will always be, Bomford insists, 'a lot of border-line cases, where the paint isn't quite as nicely handled as that, but where it's still maybe a little better than if a pupil had done it. There are cases where you simply can't be sure. The more we look into it, the more we realize that you cannot divorce connoisseurship from scientific analysis. There will always be unchallengeable Rembrandts; there are always going to be firm rejects. But there will also always be a grey area. No one is ever going to change that: not us, not the Project. A lot of people feel they would have been better advised to include a lot more Bs, to be a little less dogmatic. But they have set themselves up to decide; that's what they're *there* for. You have to feel some sympathy for them.'

Even when the Project finally does grind its way through to 1669, its catalogue will never be 'complete'. It will always be subject to revision, to change. Every generation has its own Rembrandt. The Romantics had theirs, a melancholic, wistful poet of the brush. Rosenberg's generation inherited his soulful meditator on the transience of worldly glory. Ours is a slightly harder figure, perhaps, closer to Bomford's 'merciless observer of the human face'. Paintings live through argument; great paintings adapt to the passage of time. Besides, it is in the nature of art historians to challenge other art historians. Rembrandt will always keep at least a little of Hazlitt's 'gorgeous obscurity'.

10th September 1988

Gombrich and Baxandall

THE PALE, PLUMP, YOUTHFUL FACE of the risen Christ in Caravaggio's *The Supper at Emmaus* is lit by a source outside the painting and, by implication, outside this world. We see him in an obscure simple inn, the Redeemer quietly making his presence known at a table spread with a plain white cloth, in a dark room, over a meal of boiled fowl, loaves of bread and fresh fruit. He reaches out to bless and break the bread and, in doing so, he blesses all with potential salvation. His companions, who have only now, at this precise instant, discovered his identity, are dumbstruck by the revelation. One, his back to us, prepares to rise from the table, hands on the arms of his chair, paralyzed for ever by awe. The other spreads his arms as wide as he can, trying to measure astonishment like a fisherman demonstrating the size of a fish that got away – and miming, with unconscious poignancy, the ordeal of crucifixion.

Caravaggio's subject is the terror and wonder of God made flesh; the miracle of the impalpable and unknowable making itself palpable and known and here in the room. The picture is its own miracle, a work of art with seemingly occult powers of persuasion. The outspread hands of Saviour and disciple reach out of another world and into this one, as if our fingers might touch theirs across the membrane separating illusion and reality. The compelling believability of these painted arms is worked, by Caravaggio, through cunning foreshortening. From the tip of Christ's thumb, back along the dappled sleeve of his red shirt to his shoulder, his arm is a piece of art that measures distance, in graded lights and darks with such illusory precision that it is impossible to look at the painting and truly believe it flat.

But illumination and shadow do not only convince. They tell a story. In this drama of shadows, darkness has been made to pay reluctant tribute to light. The innkeeper, whose expression suggests that he may

still have doubts about his holier-than-thou clientele, unknowingly casts a shadow on the wall behind Christ which furnishes Him with a black but unmistakable halo. The table-top in the picture presents a world of flux and change in miniature. Caravaggio's fruit bowl, where light flickers on shiny grapes, on peaches and pears, and where darkness lurks like a threat in black pools, teeters on the edge of the larger darkness that starts at the lower edge of the table. This is a place in which fickle light gives every thing its mocking double in the caricature form of a shadow; a place of illusory substances and as illusory shades which figures the vivid, dangerous world itself. This is the world that the bright Christ may redeem for us all.

The Supper at Emmaus is exhibit number one in Ernst Gombrich's 'Shadows: the depiction of cast shadows in Western Art', at the National Gallery, the moral of which is that the inclusion of great paintings is no guarantee of greatness in an exhibition. 'Shadows' is a salutary oddity, an aridly playful enterprise the title of which promises more than what turns out to be a disjointed gathering of pictures in the service of a half-formed thesis. The impression given throughout is of great works of art commandeered peremptorily to illustrate a sequence of rather flat observations about the representation of reality in painting.

There is a persistent, bathetic relationship between word and image in the show; the viewer turns from Caravaggio's masterpiece, invigorated by its genius and splendour and dark magic, to read a wall label which indicates that it is here simply to demonstrate the range of realistic effects which the artist's *tenebroso* style of painting was capable of communicating. Later, Holbein's *Queen Christina of Denmark* is accompanied by a caption highlighting the self-evident fact that the shadow which she casts on the green void behind situates her in space.

Gombrich's remarks are simple-minded but inoffensive enough, for the most part. However, the trouble that has been gone to in order to illustrate such slightness lends the entire project a flavour of silliness and donnish self-indulgence. It requires a peculiar combination of hubris and eccentricity to take down and rehang the National Gallery's wonderful *School of Rembrandt Scholar in a Lofty Room*, only to affix to it a caption remarking how often seventeenth-century artists showed an interest in extreme tonal contrast and suggesting that the picture 'illustrates this effect to perfection'. This is interpretation of such banality

that it amounts to an insult. The painting's subject is the lot of man, however learned, to live his life in shadows. It is a picture which resolutely refuses to perform the simple pirouette of a *trompe-l'oeil* effect demanded by the narrow focus of this show. It is a painting rooted not in appearances but in feeling, a work of art that uses light and shadow to express sadness – and, incidentally, to suggest the humility proper to the professional scholar.

Gombrich, who has spent as much of his life pondering perception as he has studying painting, is well aware that perceptible reality is not the only subject of art. But his views on painting appear to have become increasingly limited, with time. 'Shadows' suggests that he has fallen into the trap of his own enthusiasm for perceptualist problem-solving art criticism and has come to regard far too many pictures as mere machines for the conveyance of realistic effects. There is a fearful lack of poetry in what he has to say about the paintings he has selected, which he tends to judge solely on the grounds of their mimetic ingenuity.

In a brief acknowledgement at the beginning of the exhibition booklet, Gombrich regrets that Michael Baxandall's *Shadows and Enlightenment* appeared too late for him 'to profit by its insights'. The regret may well have been tinged by relief: Baxandall's book, while brief, is one of the most remarkably difficult essays in academic obscurantism ever published. For all that, there is something endearing about its opacity, because it seems to spring from genuine obsession with the phenomenon of shadow, a desire to wrestle the subject out of darkness and into light.

Quite what that subject is remains, for the most part, obscure. The bulk of his book is taken up with a discussion of the peculiar interest in shadow-watching that developed during the Enlightenment, largely as a result of John Locke's arguments about the nature of human perception. To cut an intricate story short, Enlightenment belief in the perfectibility of man depended in certain essential respects on Locke's conviction that our knowledge of the world is not instinctual, but learnt – one key example being the way in which we learn to distinguish the shapes of objects by an empirical process of shadow-interpretation. This resulted in quite extraordinary longueurs of shadow description. To read that amateur of early Enlightenment physics, Abbé Millot, on the shadows cast by sunshine in his bedroom in Lyons on a day in 1753, is

to realize with renewed force how perfunctory are the observations made by Gombrich.

Baxandall's book becomes interesting when he himself begins to set down his own impressions of shadows, mainly it would seem sitting outside in bright sunlight with a glass of wine in one hand and notebook in the other. The result is some wonderfully serio-comic writing, as the full attention of a trained art historic eye is brought to bear on nothing more than a table, a white rough-cast wall and some paving stones seen in early morning light somewhere near Santa Barbara. His main conclusion? That shadow tells us less about the properties of solid objects than much modern science would seem to argue – and that shadow tells us, paradoxically, much more about the properties of light.

Sitting and thinking about the nature of shadow, which Baxandall helpfully defines as interruption to the photon flux of existence, or 'a hole in the light', he occasionally becomes almost poetical. His moment of Damascene revelation occurs on page 76: 'I cannot see the structure of cross-fire and ricochet in the photon flux I am sitting within, or at least I cannot see it directly as light in the air, only as the cause of surface illuminations here and there.' Shadow, he explains, has enabled him to sense the most vital principle of the universe, because shadow is what reveals the ceaseless, endless play of light that is nature.

Another way to have reached the same conclusion might have been to spend an hour or two looking at the shadows in Caravaggio's *The Supper at Emmaus*.

23rd May 1995

Géricault

I WAS FIFTEEN WHEN I first went, reluctantly, to the Louvre, and I didn't much like old pictures. I remember countless dark and obscure religious paintings, time-smoked martyrdoms and baptisms and visitations and annunciations; I remember murky brown landscapes and shadowy Dutch still lifes, full of skulls and gleaming pewter and pendulous spirals of lemon peel; I remember wanting to leave and buy a chocolate éclair from one of the pâtisseries on the rue de Rivoli.

But then I saw one old picture that seemed, somehow, different from the rest. It was by Théodore Géricault, it was called *The Raft of the Medusa*, and it had something to say (or at least I thought it did) about me and my life. I thought I understood it, this enormous painting (and it is truly enormous: no shrunken reproduction can remotely do justice to its intimidatory scale) of men abandoned at sea, on a makeshift raft, desperately trying to attract the attention of a far-off ship.

Géricault's painting was based on a true story, but I knew that it was not really about a group of early nineteenth-century castaways. It was a metaphor. It was about wanting something, or someone that will almost certainly prove to be beyond your grasp – in my case it was the unattainable nineteen-year-old sister of the Parisian boy with whose family I was then staying to improve my halting French. It was about longing.

That, anyway, was my romantic adolescent reading of *The Raft of the Medusa*. Since then, I have changed my mind about the picture more times than I like to remember, but I have never quite grown out of my obsession with it. Last autumn the BBC gave me the chance to change my mind again when they commissioned me to write and present a film about *The Raft of the Medusa*. Having spent an embarrassingly large proportion of the last six months looking at the picture, reading books about it and talking to other people about it (a remarkable number of

whom shared my preoccupation: *The Raft of the Medusa* seems to have a strange effect on those who come within its orbit), I finally know where I stand. I think I understand, at least just a little bit, the nature of its power; and what happens when a painting transcends its own time to leap the barrier of history.

Géricault's masterpiece is one of the great pictures of human aspiration. It is so powerful because it is at once so intensely, physically present – no artist has ever made the painted human form seem more palpable than Géricault did: the bodies in his turbulent painting spill out into the space of the viewer; the enormous hands of the dead and dying men in the foreground seem almost touchable – and yet also so thoroughly abstract. You do not need to have been lost at sea to respond to it, to identify with those frantically signalling men at the apex of its composition. We have all yearned for things that seem as out of reach as the distant speck of that painted ship on the painted horizon. Perhaps Géricault's painting has lasted so long, has become one of those pictures that are for ever denying conclusive interpretation, because it can be the image of whatever secret desperation, whatever hope or disappointment, you want it to be. Géricault put us all on his raft.

The Raft of the Medusa has inspired numerous tributes, countless subtle and not so subtle reinterpretations of its themes of subdued violence and yearning, in art, music and literature. It is a painting that has launched a thousand cartoons, especially in France, where caricaturists have adapted its composition on many occasions to attack parties of both left and right: it is easily enough remade into an image of political aspiration gone terribly wrong, of rudderless politicians on course for national catastrophe. It made a sudden guest appearance in Goscinny and Uderzo's *Asterix the Legionary*, in which the eternally hapless pirates, whose ship has been sunk (yet again) by those indomitable Gauls, Asterix and Obelix, mimic the poses of Géricault's castaways. It was also a key if unacknowledged influence on Picasso's *Guernica*: Picasso borrowed Géricault's composition, the tension between ascending and descending energies, structured across a scything diagonal, directly from Géricault's painting.

But none of the reinterpretations or reworkings of *The Raft of the Medusa* has diminished the mystery of the original. Before Géricault, no artist had painted a picture about a current event on such an

enormous, heroic scale – the picture was based on the most scandalous news story of the artist's time, the wreck of the French frigate *Medusa* and its catastrophic aftermath. The simple fact is that no one knows why Géricault chose to do so; nor why he painted the particular moment in the story that he did – the moment when the last few survivors, having sighted the ship that would eventually rescue them, are suspended between hope and despair; nor what he intended his picture to signify.

Julian Barnes included a wonderful, elegant homage to *The Raft of the Medusa* in his *A History of the World in 10(1/2) Chapters*, which is hard to better as an account of the compelling ambiguity of a great work of art: 'All that straining – to what end? There is no formal response to the painting's main surge, just as there is no response to most human feelings. Not merely hope, but any burdensome yearning: ambition, hatred, love (especially love) – how rarely do our emotions meet the object they seem to deserve? How hopelessly we signal; how dark the sky; how big the waves. We are all lost at sea, washed between hope and despair, hailing something that may never come to rescue us.'

Barnes's chapter gave me and my director a lot of trouble when we were working on the BBC documentary about the *Medusa*. Our problem was simple. It was so good, such a convincing account of the process by which Géricault turned a true, ephemeral story into a timeless work of art. Barnes seemed to have thought himself so completely into Géricault's skin that there was no room for anyone else's imagination to go to work. Part of the brilliance of what he had written lay in the fact that it seemed to cut so cleanly through the Gordian knot of art-historical doubt that has always surrounded *The Raft of the Medusa*. Barnes argued that Géricault had willed that doubt into being – that he had painted an *intentionally* ambiguous painting.

Barnes looked exhaustively at the primary evidence, the hundred or so preparatory sketches that Géricault produced during his months of work on the picture. Pursuing an argument first advanced by Lorenz Eitner in his Géricault monograph, he noted that Géricault had chosen the moment of maximum uncertainty in the *Medusa* story, and showed how Géricault gradually heightened that uncertainty as he worked up his sketches into his finished painting: stretching the distance that separated the men on the raft from the rescue vessel until it became a bare

speck in the distance; cropping and adjusting his image until it became what it still is today, a universal image of longing.

But still I wasn't absolutely sure that I believed in Barnes's Géricault, this canny coverer of his own traces, this premeditated seeker after artistic immortality, this careful, careful painter of a deliberately impenetrable, mysterious masterpiece. And I wasn't sure that Barnes had said all there was to say about *The Raft of the Medusa*. Our problem was how to find an alternative to the Barnes version, to find another way of imagining ourselves back into Géricault's life.

Richard Holmes's book *Footsteps: Adventures of a Romantic Biographer*, suggested a possible approach: 'a kind of pursuit,' as Holmes there describes his approach to biography, 'a tracking of the physical trail of someone's path through the past, a following of footsteps'. We went to France on Géricault's trail, more in hope than expectation. And we did find, almost everywhere he had once lived, peculiar, unpredictable traces of the man who painted *The Raft of the Medusa*. In each of Géricault's different milieus, it seemed, someone was keeping the flame of his memory alight. We met a group of enthusiasts who call themselves *Les Fous de Géricault*, 'Géricault's madmen' – some of them experts, some of them amateurs. We met historians, doctors and the deputy mayors of two small provincial towns which Géricault had visited, and found that each had different stories to tell – about Géricault's politics, about his private life – which cast *The Raft of the Medusa* in an entirely new light. At various times during the making of the film, I became convinced that Géricault's painting was (in no particular order): entirely unambiguous political propaganda; the disguised autobiographical confession of a man hopelessly in love with a woman forbidden to him; a picture about Géricault's subconscious desire for God. Somewhere along the way I might have found out the truth about Géricault's painting, but I'm not sure.

The fact is that none of the interpretations which I heard could be backed up by anything as substantial as factual evidence. Géricault died young, leaving virtually no letters behind him, and it seems impossible to separate the real man from the myths that have subsequently grown up around him. We don't even know what Géricault looked like. The most famous portrait of him, the statue on his tomb in Père Lachaise cemetery, shows him as a monk-like ascetic, a gaunt-faced man with a

shaven head. But the portrait was sculpted years after Géricault's death and its most striking feature, that shaven head, was based on a legend: the apocryphal story that Géricault shaved off all his hair before he began work on *The Raft of the Medusa*, put into circulation by wishful-thinking biographers with a vested interest in turning him into the prototype of the tortured Romantic artist.

But interpretation, too, is always a form of myth-making. When we try to decipher any work of art, and discover the true intentions of its creator, what we are really doing itself amounts to a form of creative (or at least fictional) activity. We like to think we are being objective, so we say that the meanings we invent aren't ours, they were the artist's. We say we didn't make it up, he put it there. But perhaps we make him up too; and perhaps we always make him up in our own image.

Re-reading Julian Barnes's chapter recently, it occurred to me that I was not really reading about Géricault at all. Barnes's careful, fastidious artist, this habitual modifier and adjuster – he sounded suspiciously like everything I imagined Julian Barnes himself to be. We can attempt to imagine ourselves into a dead man's shoes, but we take our own feet with us. The great works of art are the ones that force us to make that attempt – but the truth is that when we talk about the art and the artists that truly move us we are always, in the end, talking about ourselves.

6th April 1993

V

'ABOUT SUFFERING
THEY WERE NEVER WRONG,
THE OLD MASTERS . . .'

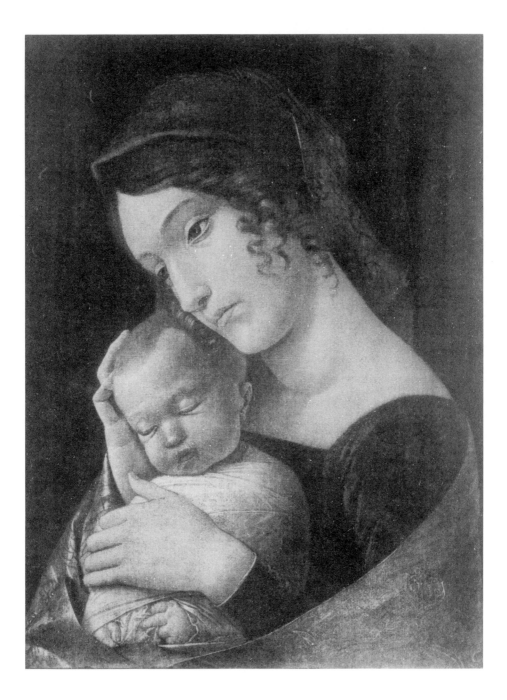

Mantegna

VASARI TELLS US that Andrea Mantegna 'was so kind and lovable that he will always be remembered', but not everyone found him memorable for those reasons. Certainly not Simone Ardizzone da Reggio, a printmaker briefly under Mantegna's direction who made the mistake of taking on some additional work without his consent. First, Mantegna had him threatened; then the *capo di tutti capi* of the Mantuan art world sent a dozen armed men to assassinate him; when they failed, he attempted to have him arrested on trumped-up charges of sodomy. Simone fled to Verona and subsequently kept a safe distance between himself and the first painter to the court of the Gonzagas.

Mantegna left his own, memorable image of himself in the form of the bronze bust that adorns his mausoleum in Mantua. A painted plaster cast of it is the first thing that you see in the Royal Academy's marvellous exhibition of Mantegna's paintings, prints and drawings. Wreathed with laurel, the painter confronts you in the guise of a Republican senator or Stoic philosopher, although there is also something disturbing in the stern twist of his features.

Mantegna was a hard man and he painted a hard, hard world. No painter of sacred subjects, before or since, has created a vision of man and nature so thoroughly devoid of optimism. In the earliest attributed picture in this show, the panel of *St Jerome in the Wilderness* of around 1448–9, the landscape that surrounds the saint in his cave is punctuated by sharp rocky extrusions like knives thrust up through the skin of the earth. Violence lurks in this petrified world: Mantegna, whose obsession with stone and stoniness seems to have reflected something of his own, flinty temperament, developed the fantastic mineralogy of his paintings as a metaphor for threat, risk and danger. There are few gentle declivities, few rolling hills, in his art. But there are always these jagged mountains, these broken crags and sudden, sickening precipices.

They are there, too, in his *Adoration of the Shepherds*, of 1450–1, from the Metropolitan Museum of Art in New York. The holy family is, temporarily, at rest. Joseph sleeps; Mary kneels in prayer; the infant Christ lies in the fallen folds of her cloak. A pair of rude peasants, as craggy as Mantegna's landscape, arrive to pay their devotions. But even this scene of apparent repose is freighted with suggestions of menace. The shepherds tending their flocks on the mountainside in the distance stand and chat on the edge of a vertiginous drop. The infant Christ lies perilously close to one of the many ledges formed by the splintery, unstable nature of the ledge on which He lies, while a barren, cruciform tree hints at His trial to come.

It was characteristic of Mantegna, an artist constantly alive to the tragic dimension of Christian story, that he should have been a great painter of sorrow. This has not always been recognized. Bernard Berenson found the expression on Christ's face in his late *Man of Sorrows* to be 'inane', and remarked on the 'perfunctory grimaces' of the two angels who attend Him. These are unfair comments, but they suggest something about the nature of Mantegna's achievement. He did not idealize grief, here, but made it appallingly present. The painting's ugliness, its awkwardness, is also responsible for its power.

Mantegna painted several versions of *The Holy Family* that look as though carved from stone, like the bas-reliefs of Roman funerary art. Yet the effect is not of an artist straining to evoke an archaeological memory but of one adapting the forms of past art to his own pressing requirements. What Mantegna gets from this close-cropped, frieze-like arrangement of figures is something the artist of antiquity is quite uninterested in – a sense of intimacy, of complete, cloistered aloneness. This is why there is no more moving painting of the most common theme in Western art than the Berlin Mantegna *Madonna and Child*.

The mother and her baby are isolated against a dark ground, leaving nothing else to reflect on but their closeness. The child is asleep, his mother's gaze vacant, maternally abstracted, as if her whole soul is absorbed in the act of nurture. Her great hands hold him close to her, one wrapped around his midriff, the other curved around his cheek. There is no better or more poignant painting of the warm weight, the vital inertness, of a sleeping baby's head. It may be significant that Mantegna saw Mary's affection for the infant Christ as something

that could only be given issue to in the dark, protected from the harsh glare of his daylit world. To love, in Mantegna's world, is to be a refugee.

The fascination which classical art held for Mantegna, manifest not only in his compositional sense but, too, in the lapidary quality of his line, is well documented. His paintings frequently include fragments of classical statuary and he is said to have been peculiarly attracted to subjects which require the recreation of scenes from antiquity. The roots of Mantegna's classicism lie in the romantic antiquarianism of the humanist circles in Padua and Mantua in which he moved, and this has given rise to a common view of the artist, reflected in many of the comments passed in the catalogue to the show: 'For Mantegna,' it is said, 'the visible remains of antiquity conjured up a grander, more ordered world than the one in which he lived.'

But is this actually true? And was Mantegna really, in his preoccupation with the ancient world, the harbinger of the gradual secularization of painting that may be detected in the art of the High Renaissance – and that can be said to culminate in the neo-classical art of David and Ingres? These are not unimportant questions, since on the answers to them depends the established notion of Mantegna's role in the development of European art.

The issue is complicated by the fact that the most important examples of Mantegna's classicizing art are in ruins. The frescoes that he completed for the Eremitani in Padua early in his career survive only in the form of black and white photographs, because an Allied bomb scored a direct hit on the church during the Second World War. *The Triumphs of Caesar*, Mantegna's most famous cycle of paintings, are now ghosts of what they must once have been, the victims of so many botched attempts at restoration that hardly any of their original surface survives.

Still, there is enough evidence to suggest that Mantegna's attitudes to the ancient world were considerably less naïve than those imputed to him by so many of his commentators. The photographs of the Eremitani fresco cycle include a famous scene of *St James Led to Execution* which indicates that Mantegna was fully alive to the brutality, the summary cruelty of the Roman military state. A wall of soldiery bars the way of an anonymous man who would witness St James's progress to execution: this is an image of the impersonal, murderous efficiency of

Rome, but hardly a vision of 'a grander, more ordered world than the one in which he lived'.

The RA show itself includes much that jars with the notion of Mantegna as an artist romantically besotted with the classical past, one itching for the benevolent patronage of the Gonzagas to release him from the tiresome burden of religious commissions. Mantegna's prints of bacchanalia are stern indictments of paganism, their classical manner – again, these are two-dimensional images conceived as sculptural friezes – actually serving a disapproving Christian message concerning the perils of drunkenness.

The more time you spend with Mantegna's art, the less he seems a harbinger of the High Renaissance (let alone of neo-classicism) than a ferocious, late Gothic moralist. Indeed, one of the chief lessons of this show lies in its demonstration of how clumsy and falsifying such generic terms at 'Gothic' and 'Renaissance' really are. Mantegna's innovative adaptations of classical sources were a new development in art, but the attitudes that lay behind them were rooted in a fierce and entirely traditional Christian piety. This is true, too, of his innovations in perspective, although the best example of this is not present in London: it is the *Dead Christ* in Milan, where Mantegna's extraordinary foreshortening exists, not to call attention to the artist's virtuosity, but to force the eye to crawl, inch by inch, along the body of the Saviour, and to meditate on the tragic physical evidence of man's betrayal of the Son of God.

Mantegna's is essentially an art of renunciation. It sets its face against facility and even against beauty because such things are both inimical and irrelevant to its true intentions – which are, always, to convey the significance of the story told. His cast of mind becomes more and more sternly allegorical and allegory always demands the suppression of that which is incidental or superfluous to interpretation. Nowhere is this more evident than in Mantegna's most sculptural paintings, the *grisailles*.

These are unusual pictures, because they so openly declare their alienation from their own medium. They are paintings designed, literally, to look like sculptures. They do not read, however, as an antiquarian's wistful homages to classical statuary. Rather, the hard monochrome forms presented in a work like the *grisaille* of *Judith and Holofernes* convey the artist's determination to transform images into *emblems*. No refuge

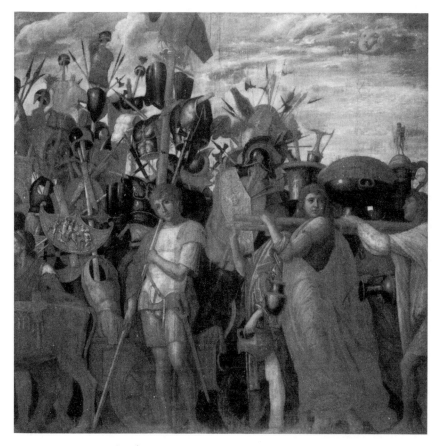

MANTEGNA *Triumphs of Caesar*

from their Christian significance can be taken in their presumed likeness to real people, real scenes. They are frozen symbols, petrified representations of representations. Mantegna probably despised the misty loveliness of Leonardo's figures and landscapes, and he would certainly have been intensely suspicious of Titian's sensuality. For his own part, he willingly forgoes the potential seductiveness of paint, its juice and colour. They are distractions.

So where does this leave his most famous, most seductive and most classically inspired paintings, the nine *Triumphs of Caesar*? Are they, as

Kenneth Clark once argued, the conclusive evidence that to Mantegna 'Roman grandeur was one with Roman *gravitas*. Roman triumph with Roman justice?' It is hard to say, because they are so wrecked, but that is not – at least in the context of this exhibition – the impression they give. What you see is a vast triumphal procession, a victorious Roman horde bearing its trophies with it, Julius Caesar bringing up the rear.

These paintings of Roman grandeur (if that is what they are) seem peculiarly double-edged. In them, Mantegna dwells on the fruits of that pointless savagery, that human will to conquest and domination, that is the eternal rule in his hard, sad world: he pictures a vast array of possessions that do not matter, a grand accumulation of all the things that Christianity teaches us to renounce. *The Triumphs of Caesar* might once have demonstrated that a capacity for irony was present in Mantegna's extreme and ascetic sensibility. Their ruination may not be entirely inappropriate. They amount to the grandest, the most ambitious, the most splendid *vanitas* in the history of art.

21st January 1992

Claude Lorrain

ON A STILL SUMMER EVENING, beside a pool where plump cattle have gathered, above a spreading landscape of fields and shining lakes and the silhouette of far-off mountains, someone is about to be skinned alive.

A man has been tied to a tree-trunk, but not tightly, and he responds with elegant dismay. His struggles have the quality of ballet. Perhaps he does not yet fully believe that what is about to happen to him, will indeed happen to him. Almost lost in shadow, a pair of rustically dressed onlookers can hardly bear to watch as the torturer, at the command of a handsome and effete youth seated on a tree-stump, prepares to begin his slow work. The victim seems drugged by the anomaly of his predicament. It is too beautiful a world, too beautiful a day, for such violence. Two cows stumble up a bank and birds wheel indifferently in the sky.

Claude Lorrain, whose radiant, melancholy art is the subject of a new exhibition at the National Gallery, painted *Landscape with the Flaying of Marsyas* in about 1645. The title of the painting is drawn from Ovid's *Metamorphoses*. Marsyas, a satyr, discovers an enchanted lute abandoned by the goddess Minerva and challenges Apollo to a musical contest. The Muses declare Apollo the victor, and Marsyas is sentenced to his dreadful, bloody punishment.

But whether Ovid's tale was truly Claude's theme, or merely his pretext, remains open to debate. There is an ambiguity in that title – *Landscape with the Flaying of Marsyas* – which may be, too, the ambiguity on which all Claude's painting turns. The conjunction, 'with', is slippery. Is this primarily a landscape painting, primarily a narrative painting, or are both things held, here, in balance? What are we to make of a work of art that mingles gruesome story and glorious dreamlike setting in such an apparently incongruous manner?

The National Gallery's exhibition, which concentrates on the

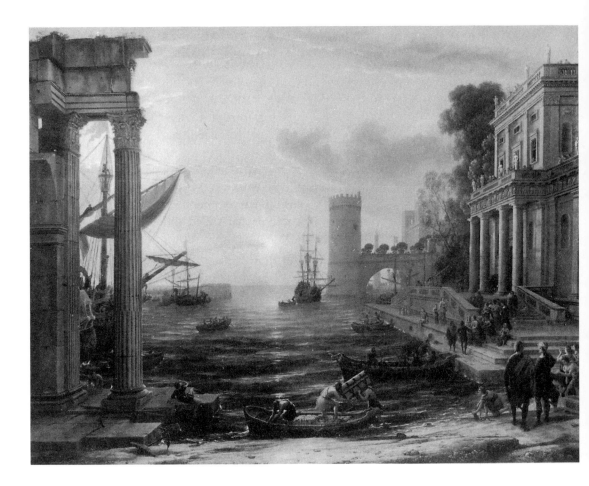

narrative dimensions of Claude's art, asks these questions while aiming to correct an habitually cavalier attitude to the subjects of his pictures. The paintings are exhibited alongside captions explaining the myths being enacted by the generally small and often overlooked figures that people Claude's art. The implication throughout is that Claude has been loved imprecisely for too long: admired too freely by those who, ignoring the stories that the painter tells, have allowed themselves to be completely seduced by his virtuosity as a creator of ideal landscapes. The exhibition aims, it might be said, to restore to Claude his intelligence and his complexity.

'In Claude's landscape all is lovely – all amiable – all is amenity and repose; the calm sunshine of the heart,' John Constable wrote. He was not entirely right. Claude's becalmed landscapes may amount to the most enduring and affecting vision of Arcadia, that stilled and sylvan paradise of the pastoral imagination, in Western painting. But Claude's Arcadia is not all amiability and calm sunshine. There is, often, trouble in paradise. It is present in the form of subtle suggestions, dim lurking potentialities of death or ruin or fatal disappointment. The hunted stag and the crumbling castle are carefully placed, objects of contemplation there to be teased, by the thoughtful or feeling observer, into metaphorical significance.

Story was Claude's way of suggesting certain forms of response to his pictures. It was how he enriched, complicated and deepened his art, weaving together vision and myth. His *Landscape with Narcissus and Echo* pictures Narcissus, lost in self-contemplation, rapt by his own still reflection in a still pool of water while Echo and a companion watch from their hiding places in a nearby tree. A mysterious water-nymph slumbers, naked, in the foreground, while behind Narcissus Claude has conjured one of his most compellingly golden distances. Above, a great tree overhangs like an arboreal threat.

What might Claude's patrons and contemporaries, infinitely more learned in the interpretation of the classics than most modern viewers, have made of the picture? They might have seen in it an allusive combination of landscape, classical subject matter and Christian allegory: Narcissus, the image of self-regard, blind to the glory of God's creation (the landscape behind him), deaf to God's Word (the fruitlessly calling Echo), indifferent to intellectual beauty (the idealized water-nymph). It

CLAUDE *The Embarkation of the Queen of Sheba*

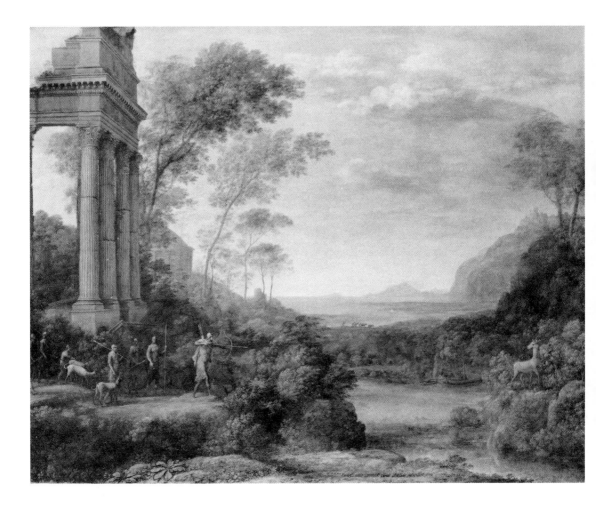

may be objected that these are no longer reasons to admire a picture. But Claude's paintings are above such an objection, because they are not to be exhausted in the mere enumeration and elucidation of emblems.

It is a relief to be told the stories behind the pictures because to know them is, in the end, to have their essential unimportance confirmed. The pictures remain mysterious and urgent, despite all the beetle-browed attentions of the iconographer. They are transformations of old myths into new ones. They have left words behind to become strange and soundless visual dramas with their own capacity for self-renewal. They are not objects that tell stories, but objects to make stories up about. *Landscape with Narcissus and Echo* need not, for us, be a merely Christian allegory, the symbols of which have atrophied. It can be a picture of egotism and all the beauty that is lost to it. Or another and less solemnly moralizing picture: the image of a man's total absorption in an image, which in turn invites you to become as absorbed in Claude's world of dreams as Narcissus is in his.

The artist takes pride in the wonderful unreality of his world, which in many of his details becomes almost playful, a virtuoso artificiality. The impossibly elongated figures, the strange menagerie of beasts quite unlike their real counterparts, the trees like vastly enlarged sprigs of feathery dill, may have been Claude's way of flaunting the artifice of his world. A way, too, of insisting that he is not, really, attempting to flesh out true stories but to reincarnate myths and therefore make images which (like myths themselves) are really equivalents for states of mind or eternal human impulses. *Landscape with Erminia and the Shepherd*, with its sweet, improbable horse and disproportionate heroine in her fantastical armour, embodies the fascinations of the pastoral ideal perhaps more perfectly than any other Claude. The painter has chosen to depict the least eventful episode in all of Tasso, from whose poem *Gerusalemme Liberata* he has drawn his subject. The result is a picture less of an action than of a moment of inaction prolonged: a painting in which, for ever, nothing is about to happen.

Claude's narrative subjects, complex and easily forgettable, have fallen away from his pictures, at least in their precise detail, and survive instead in the vestigial but stronger form of a feeling lodged in paint itself. *The Embarkation of the Queen of Sheba* is no longer about that but, instead, about the terror and beauty of the unknown: the gold void of

the sun, the seductive loveliness but also the threat of the ocean, its surface beauty and the implacability of its deeper rhythms. *Landscape with the Flaying of Marsyas* is not really about Marsyas, whose fate is transmuted, by the painting, into a nearly abstract idea of cruelty. As a result, the picture is more than the sum of what it discordantly combines, a savage story and a beautiful landscape. It is a fantasy that pictures a sad fact: implicit within it is the knowledge that, no matter how much like an Eden the world may occasionally feel, somewhere in some murky corner something terrible is happening.

The picture's liveliness, the fascination that it continues to exert, is the product of precisely that peculiar combination of landscape and narrative which Claude made the basis of his art. Its story is as much in the landscape as it is in the figures. Marsyas, tied up, is echoed in the tree-stump, twined with ivy, at the opposite edge of the picture. Malignancy is built into even Claude's ideal world, which is only ever almost ideal and the more affecting for it.

The artist's last picture, *Landscape with Ascanius shooting the Stag of Silvia*, departs as fruitfully from its own source, the *Aeneid*. Virgil has become Claude. Across a narrow ravine, a gully leading to a bridge peopled with tiny figures and, beyond, to the blue distance that has increasingly replaced the golden distances of his earlier painting, a man aims an arrow at a stag. What is the subject of the picture? Beauty, and life, under threat; a sense of wonder, and a sense of loss, held in perfect suspense. Myth and feeling combined, poignantly, in Claude's valediction to the world.

5th February 1994

Goya

'IT IS WHEN GOYA abandons himself to his capacity for fantasy that he is most admirable,' proclaimed Théophile Gautier, in 1842; 'no one can equal him in making black clouds, filled with vampires and demons, rolling in the warm atmosphere of a stormy night, breaking up a caval-cade of sorcerers on a strip of mysterious horizon.' To the Romantics, Goya was a lonely, obsessive figure, a genius condemned by his own vivid unfettered imagination to experience life as a perpetual dark night of the soul. The Romantic myth of an alienated, solitary Goya stretched on the rack of his own genius has persisted. Its most recent manifestation was a predictably dreadful Spanish mini-series dramatizing Goya's life which was shown earlier this year on the BBC. But this is an age of art-historical revisionism, and a large exhibition currently at the Prado in Madrid sets out to reveal the Goya that Gautier and his countless followers chose to overlook. 'Goya and the Spirit of the Enlightenment' is a world first: meet Goya the man of reason, Goya the idealist, Goya the artist impassioned by his vision of a better, purer world.

The main thesis of the Prado's show is that Goya, far from being some proto-modern apostle of unreason, was very much the product of his age. He was born, it reminds you, into the Age of Reason – the age of Diderot and Rousseau, when prevailing thought held that advances in science, technology, philosophy and morality heralded a brave new dawn for the human race.

The core of the exhibition is an extended demonstration of Goya's close links, in the 1780s and 1790s, with the leading figures of the Spanish Enlightenment. In his portraits of such people, Goya seems keen to demonstrate the sort of affinity with his sitters that rarely, if ever, surfaces in the rest of his commissioned portraiture. Goya paints the stern Conde de Floridablanca – reformer of the economy and agricul-ture, protector of the arts and long-time prime minister of Spain during

the reign of Charles III – surrounded by the attributes of his industriousness and enlightened philosophy, maps and papers documenting good work in progress. He is the hero, in effect, of an allegory of good government.

This section of the show strikes few of those discordant notes that modern criticism has come to prize in Goya – none of the odd, jarring details, for instance, that give a subversive, caricatural twist to Goya's more famous portraits of the Spanish royal family. When Goya painted the venal, arrogant fat cats of the Spanish royalty, he contrived to turn official portraiture into a vehicle for mordant satire (the miracle was that the royal family was too vain and stupid to notice and Goya ended up First Painter to King Charles IV). The royal portraits in the show are cunningly scattered signposts to the contrasting sincerity of Goya's Enlightenment portraiture. When Goya paints *King Charles IV in Hunting Dress*, he zeroes in on his subject's mix of feebleness and stupidity, getting the weak, vacant grin to a T, stranding him in a stage-prop landscape and giving him all the grace of a shop-floor dummy. The painting manages to imply that the king's gaudily bemedalled regal finery is, itself, a theatrical imposture on the part of a man who has no business running a country. The pendant to this portrait, Goya's depiction of Queen María Luisa, is if anything even less complimentary: while Charles IV is simply stupid, his queen seems downright evil, a maenad in a mantilla. It is easy to imagine, in this sullen harridan, with her hard, coarse face, the woman whose adulterous affair with the upstart prime minister Manuel Godoy (she was behind the appointment) plunged Spanish politics into chaos for much of Charles IV's reign.

The Enlightenment exerted its greatest influence on Goya in the form of Caspar Melchor de Jovellanos, a magistrate and politician who preached the beliefs that would later inform many of the satirical prints in Goya's series, *Los Caprichos*. Jovellanos campaigned actively and vocally against, among other things, the parasitic indolence of the Spanish nobility, the sloth and acquisitiveness of the clergy and the excesses of the Inquisition. Goya painted him in 1798, when Jovellanos had just been appointed minister of religion and justice. The extraordinary painting that resulted – extraordinary because so exuberantly un-Goyaesque, both in mood and in the light, feathery handling of paint – documents the high point of the Spanish Enlightenment, the moment

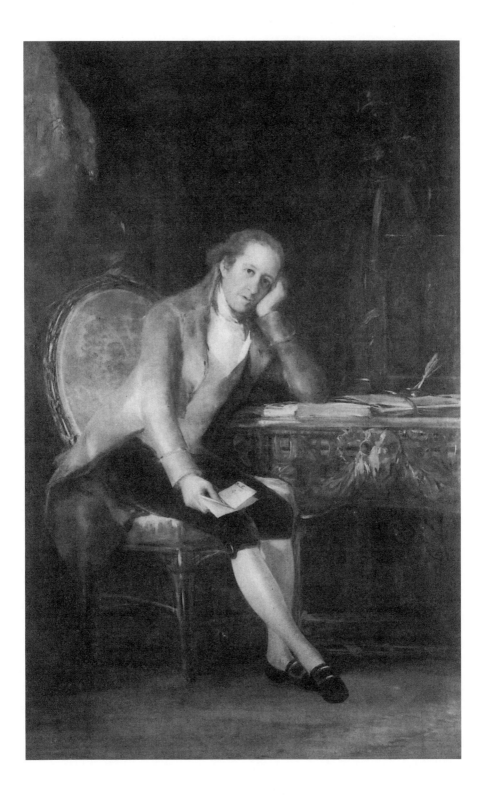

when its millennial hopes seemed, at last, to have been backed up with political substance. Goya's Jovellanos sits at his desk, head propped up on one hand, and gazes meditatively out of the painting like an Hispanic Rousseau.

The reason why this painting, like many of the other Enlightenment portraits, appears so anomalous in Goya's *oeuvre* is that the sitter seems to belong in the position of power that he occupies. His finery sits comfortably on him, in contrast to the glad rags that hang so limply and, by implication, unjustly, from the gross, corpulent figures of Goya's royals. The portrait suggests the presence of a man who is actually capable of living up to the responsibilities invested in him, an alternative to the petty intrigues of a despotic monarchic regime. The moment of optimism was short-lived. Jovellanos occupied his ministerial post for nine months, after which time he fell from favour with the queen and Godoy and was banished to the provincial town of Gijón.

The slow extinction of liberal ideals that followed Jovellanos's removal from office must at least partially explain the increasing bitterness and mordancy of Goya's pictorial assaults on the rulers of Spain. Goya has been remembered, rightly, as the greatest and most subversive of 'official' painters, precisely because he found a way to paint the gap between the heroic self-image of the Spanish powers-that-were and their flawed, human reality. Goya was the product, not just of the Enlightenment but of an age that saw, in the French Revolution, the virtual collapse of faith in the monarchic traditions of the West. Post-1789, there was a visible, radical and dangerous alternative to the doctrine of the divine right of kings.

Goya's most vivid dramatization of Spain's royal family is in Madrid, but not in this exhibition. Cross the road, go to Gallery 32 in the main Prado and you will find the unquestioned masterpiece of Goya's royal commissions, his massive group portrait, *The Family of Charles IV* – an assembly of vacant poseurs, all dressed up with nowhere to go. For the Baroque *gravitas* of Velázquez, whose paintings of an earlier, more secure monarchy hover like ghosts behind his own, debased regal portraits, Goya substitutes a mood of staged over-elaboration, peopled by a cast of moral and intellectual lightweights. Such were the controllers of his Spain.

On 6 February 1799, the *Diario de Madrid* carried an advertisement

for the publication of a set of eighty etchings. 'The artist,' it declared, 'persuaded that the censure of human errors and vices may be the object of painting, has chosen as appropriate subjects, from the multitude of extravagances and follies which are common among our civilized society, those he has believed most suitable to provide an occasion for ridicule as well as for the exercise of his imagination.' The etchings were Goya's savage, accusatory *Caprichos*.

While the tone of the announcement might suggest Goya's continuing faith in the cool, rational ideals of Enlightenment thought, the prints themselves seem almost hysterical, wild discharges of fantasy. They might have satirical intentions, but these are satires that exhaust themselves in rage, shot through with a morbid, fantastical imagination that seems convinced of its own impotence. In the context of what preceded them, they seem to mark the first stages of Goya's depressed acceptance of the Enlightenment's eclipse – they presage the advent of that new, dark age of unreason which he would explore, in deepening isolation, for the rest of his life.

The catalogue that accompanies the Prado exhibition does its best to recover the kinds of moral significance Goya's enlightened contemporaries might have extracted from the *Caprichos*. Outright weirdness is reclaimed, by the book's lengthy exegeses, as rational polemic. The mother (*Capricho* 3) who seems to have hypnotized herself and her screaming, snivelling infants with the terrifying image of a bogeyman – lit on Hammer Horror principles, he looms out of the darkness like an emanation of pure, inexplicable evil – is apparently the target of a satire on irresponsible education. The curious, bald human chickens (No. 20) that scuttle out from under the legs of Goya's busty young women are emblems of dissolute Spanish manhood; fleeced and plucked by prostitutes, their baldness would also have been recognized by Goya's audience as a sign of primary syphilis. Clothed asses reading up on their family tree, or men swaddled like infants, in nappies covered with heraldic devices (Nos 39, 50), symbolize a vain and self-satisfied nobility obsessed with its own inbred history.

Yet Goya's images are not simply texts ripe for interpretation. The compelling strangeness of his imagery – the ugly vitality of the monsters that swarm and cluster in the inky blackness of these etchings, itself surely a metaphorical cloud blotting out the Enlightenment's sun of reason –

suggests Goya's fascination with the dark mental landscape he charted.

Following his struggle with the illness that, in 1793, nearly killed him and left him entirely deaf, Goya seems already to have begun the retreat into a private, phantasmagoric art that marked his later development. He painted, among other things, the series of cabinet pictures of witches and their sabbaths that plunge you into the characteristically illogical, swirling space that would finally issue, during Goya's self-imposed exile from Madrid in the 1820s, in his terrible, lightless visions of a panic-stricken humanity – the 'Black Paintings', in the main Prado galleries, with which he daubed the walls of his country retreat, the Quinta del Sordo (Deaf Man's House).

The early cabinet paintings (three of which are included in 'Goya and the Spirit of the Enlightenment') are ostensibly related to contemporary literature – plays, broadsides – condemning popular superstition. But they are a little too convincingly horrific, too genuinely scary – these airborne, vampirical figures, these screaming clerics, horned devils and wrinkled, malign witches – to read as enlightened satires of ignorant devil-worship. Goya was never cut out to be the spokesman of Reason. When he attempted high-flown allegory – as in the curious, misconceived *Truth Rescued by Time, Witnessed by History* that he worked on between 1797 and 1800 – he succeeded only in conjuring up a trio of weird, ghostly figures in a cavernous interior that might just as easily illustrate some bizarre rite of witchcraft. Setting out to emulate the *grandes machines* of the Baroque, Goya merely demonstrated that their kind of grand philosophical statement was beyond him and his age, an anachronism in a post-revolutionary Europe whose natural language had become doubt and uncertainty.

Maybe it was precisely because Goya confronted his own irrationality, recognized the seeds of violence in his own, vivid fantasy, that he became the recorder of a world from which all reason seemed to have fled; a world mismanaged by the enfeebled representatives of a degenerate and discredited monarchy; a world that would fall so bloodily prey to the ambitions of Napoleon, whose invasion of Spain in 1808, and the Peninsular War, would prompt Goya to the darkest of all his visions of humanity, *The Disasters of War*.

This is a terrifying catalogue of horrors, which presents the world with a new and radical vision of its history. Gone, for ever, is the

evolutionary Enlightenment belief in the perfectibility of man; gone, too, is the heroic vision of history which sustained the old Western monarchies' myth of the king and his generals as invulnerable, giants striding the field of victory. Instead, Goya presents war as a string of meaningless acts of atrocity, a brutal collision between one anonymous mass of humanity and another.

A nameless figure is tied to a post and shot by his equally nameless assassins, represented only by the three gun barrels. In the background the figure of another man, shot point-blank by three more soldiers, hints at the grim production-line efficiency of this life-taking – you can

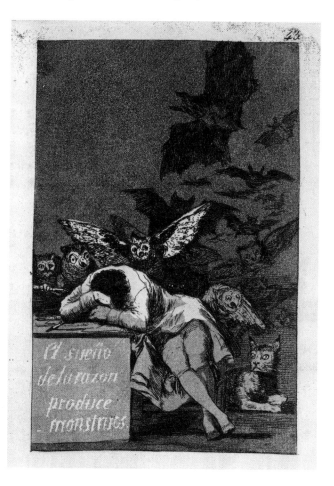

GOYA *The Sleep of Reason Breeds Monsters from 'Los Caprichos'*

imagine countless other victims, queuing up in relays to die. 'There is no remedy' is Goya's simple inscription to this, the fifteenth in the *Disasters* sequence. He piles on the horror: a gaggle of stiff, garrotted corpses; bits and pieces of a dismembered human body tied to a tree. There are no heroes in this art, only villains and unidentifiable sufferers. He evenhandedly records the atrocities carried out by both sides, Spanish and French, in the conflict. He translated the same vision into his painting, with *The Colossus* – a vast, brutish giant presides over a darkening landscape in which all is panic and rush, hordes of tiny figures, possessed by collective insanity, fleeing from this towering vision of evil.

'The sleep of reason breeds monsters' says the inscription to the most famous of all Goya's *Caprichos*, No. 43. It still reads as it always has done, as the most fitting epigraph to Goya's art. A man lies slumped on a desk, while the darkness around him is thick with owls and bats – a bleak, hopeless image whose mood of numb, terminal depression is emphasized at the Prado by the inclusion of Goya's preliminary sketch. Here, at least, Goya hinted at the possibility of reason's awakening, in the brilliant sun which, placed above the sleeper's head, seems to dissolve and scatter the monstrous visions with its radiance. In the published etching, all is thick, impenetrable night.

Goya's sleeping, nightmare-ridden figure has usually been identified with the artist himself – a reading that is strengthened by the empty chalk-holder on the desk before him. Yet what also emerges from the Prado show is that the figure seated cross-legged at his table is an almost exact transcription of Jovellanos's pose in Goya's bright, optimistic 1798 portrait. It is as if Jovellanos, exiled representative of all the aspirations of the Spanish Enlightenment, has become the slumped, despondent symbol of a failed ideal. The fact that Goya chose to identify himself with Jovellanos at this moment, when his art finally and decisively acknowledged a world in which reason had no place, seems significant. In the end, 'Goya and the Spirit of the Enlightenment' will probably fail to revolutionize modern perceptions of Goya. His art does deal in nightmare, with its overriding vision of man plunged into a world that has lost all sense of meaning or hope. But, by setting Goya's cynical, disillusioned vision in context, by giving it a history, this show can only help to deepen our understanding of his achievement.

26th November 1988

Géricault

THEODORE GERICAULT DIED YOUNG, at just thirty-two years of age, but not before he had created one of the great bodies of work in western painting. He has been remembered, chiefly, for his *Raft of the Medusa*, that vast, darkly secular Last Judgement. It is missing from the magnificent Géricault exhibition currently at the Grand Palais in Paris (a ticket to the Louvre, where the painting must stay for reasons of conservation, is included in the price of admission), yet this turns out to be a positive advantage. The *Medusa*'s absence might be said to confirm his genius, the evidence for which is not to be found in any one painting but in nearly everything that he touched. His *oeuvre* is a memorial to the mysterious ability of certain (very few) artists to invest tremendous emotion in the stubborn, refractory medium of oil paint on canvas and, somehow, to ensure that it lodges there. Géricault's art is, often, almost unbearably moving.

Born in 1791 into a fairly prosperous family, Géricault conducted his brief career as an independent artist. This in itself made him something of a rarity in the France of his time, when most art was produced in response to public or private commissions. Personal and political circumstances combined to produce, in Géricault, the first great French artist of modern times: a chronicler of disillusionment, whose tragic personal history was so interwoven with that of his country that it can be hard, sometimes, to determine which accounted for the compelling power of his art.

Alfred de Musset, in his *Confessions of a Child of the Century*, wrote the most telling description of the mood of rootlessness and alienation which came to possess a whole generation of Frenchmen following Napoleon's defeat. 'Behind them,' he wrote in a passage whose metaphors uncannily recall Géricault's *Medusa*, with its image of man adrift on a hostile sea, 'a past for ever destroyed, moving uneasily on its ruins

with all the fossils of centuries of absolutism; before them the aurora of an immense horizon, the first gleams of the future; and between these two worlds – something like the ocean which separates the old world from young America, something vague and floating, a troubled sea filled with wreckage, traversed from time to time by some distant sail or some ship breathing out heavy vapour . . . Napoleon dead, human and divine power were re-established, but belief in them no longer existed.'

Géricault was extraordinary, not simply because he captured in his paintings this new mood of national despondency – but because he seems to have *predicted* it. His first ambitious work, which was painted for the Paris Salon of 1812, while Napoleon was still waging his doomed Russian campaign, was an essay in battle painting strangely at odds with the genre's patriotic requirements. Géricault painted war, in the form of his charging chasseur, as a kind of red inferno, without logic, apparent motive, or justification. (This is particularly clear in the sketch for the painting, where the faceless chasseur is even more battlesmoke-shrouded than he is in the finished picture.) No other artists of the time – with the exception of the Spaniard Goya, whose work Géricault is unlikely to have known – dared to present war in such a way.

Géricault did not only paint the heat of war but also its aftermath. His portraits of dejected solders, standing or on horseback, isolated against heavy, leaden skies, are among the most poignant documents of the early nineteenth century: images not so much of political upheaval, but of its human consequences. Just what gives them their charge of suppressed emotion is something in the quality of the paint itself, its slow, dense application translating into a form of profound melancholy.

Géricault's paintings of horses are equally affecting. Like Stubbs, Géricault was no mere *animalier*. Sometimes, as in his wonderful *Head of a White Horse*, he manages to imbue his equine subjects with a remarkable, anthropomorphizing nobility. This is a portrait rather than an animal painting: an image of grave, immeasurable sadness, which seems to extend the emotions invested in those military portraits.

He had a remarkable ability to introduce, into the supposedly 'lower' branches of art, a weight of feeling normally only associated with the grandest forms of painting. Géricault painted horses, unsaddled, in their

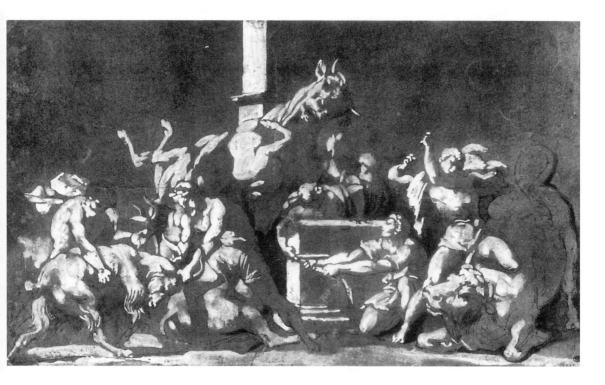

natural environment, but did so with such intensity that you never for an instant imagine that these are merely genre paintings of animals at pasture. Illuminated by flashes of lightning, possessed by a weird, almost electrically charged nervousness, his horses become images of a feeling, a sense of self in the world, that Géricault was one of the first artists to develop. Painting horses, Géricault was really painting his sense of aloneness as the defining characteristic of life. No artist – and certainly no modern artist – has painted with such feeling the awfulness of solitude. Only Picasso, of the artists to have come after Géricault, would manage to make animals – in particular the bull, and the horse, both among Géricault's favoured subjects – the vehicles of such a compelling personal mythology.

Géricault is a fascinating artist to modern eyes, because he predicts so many of the emotions and devices that would become the clichés of the modernists. He is the first painter of alienation; he is the first painter to challenge, in everything he did, the notion that art exists to make sense of the world. The world, in Géricault, becomes something that art cannot make any sense of. This is why it is such a mistake to consider the *Medusa* as his only masterpiece and everything else he did as a sequence of unsatisfying fragments.

The *Medusa*, that terrifying image of marine despair, is itself a large fragment, a history painting that has no moral, no ethically enlightening story to relate. The subject that Géricault chose to illustrate was a tawdry real-life tale of incompetence, maladministration, corruption and man's inhumanity to man: the tale of how a third of the crew of the French frigate *Medusa*, their vessel having run aground in a hostile sea, found themselves left to die on a makeshift raft while their fellows escaped in the few available lifeboats. The way in which he painted it seems designed to extinguish any optimism, even in those among his audience who knew that at least some of the crew were later rescued.

The other large-scale history painting that Géricault was planning exists only in the form of a few sketches and drawings. *The Race of the Barberi Horses* would have recorded a primitive ritual, still enacted annually at festival time in Rome during Géricault's time, which dated back to pagan antiquity. What did Géricault make of it? An image of strife, of struggle between man and beast in an isolated setting, lit by a strange, uneven light – very characteristic of Géricault – that makes his images

GÉRICAULT *The Gallows*

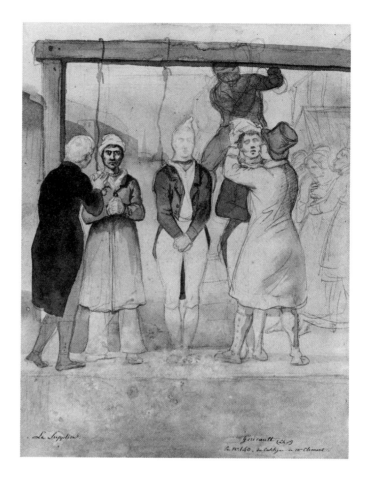

look even more disconcerting than they otherwise might. The variant
of neo-classicism that Géricault evolved in Rome in 1817 is troubled
and convulsive: designed to evoke the exact opposite of the 'calm nobil-
ity and grandeur' counselled by Johann Winckelmann, neo-classicism's
great theorist.

Géricault made all the forms, the genres, and the subjects that he
adopted his own, shaping them with the force of his own compulsions.
In London in 1820, he produced a series of lithographs that effectively
initiate the tradition of melancholy urban realism which would prove

one of the most enduring strains of nineteenth- and twentieth-century art: images of down-and-outs and drunks and the hopelessly poor that are animated, however, by none of the cosy sentiment brought to such subjects by Géricault's contemporaries and followers. He drew quickly and on the spot, it would seem, *The Gallows*, a public hanging in London: an image of men on the brink of annihilation, their expressions set in masks of desperate resolution or despair. Aloneness was always Géricault's great theme, and he made it the subject of his last and perhaps finest works: the portraits of the insane that he painted shortly before his death, possibly at the request of a specialist in the study of 'monomania'. They are as solitary, in their disturbed worlds, as any of the figures who suffer in Géricault's more muscular narrative works: but their aloneness has become stilled and grave. They are not even portraits of lunatics in any conventional sense. They are just portraits. Life, Géricault seems to be saying, is like this. See them, see yourself.

No biographical evidence for the sadness at the heart of Géricault's art existed until relatively recently, when the discovery of documents in a French archive revealed the fact that the artist had had an unhappy love affair with his young aunt, Alexandrine-Modeste Caruel. Shortly before Géricault began work on the *Medusa*, she gave birth to his illegitimate son and the affair was discovered. These upheavals must inevitably have coloured Géricault's work, and the sense of isolation and frustration manifest in so many of his paintings may well stem from these events.

Géricault died young, but there is perhaps an even sadder postscript to his death. Alexandrine-Modeste was sent away and lived the rest of her long life in disgrace, sequestered on the family estate near Versailles. Their son, Georges-Hippolyte, was sent for adoption. Until recently, very little was known about him, but Lorenz Eitner, in his brilliant 1983 monograph on Géricault, provided a short account of his life. After apparently planning to commit suicide in 1841, he pursued unfruitful architectural studies before leaving Paris for the quiet coastal town of Bayeux. He spent the remaining forty years of his life there, quite isolated, in the cheapest room of a small hotel near the beach; a curious, tragic figure with nothing to do but gaze across the empty sea.

9th November 1991

VI

MODERN LIFE

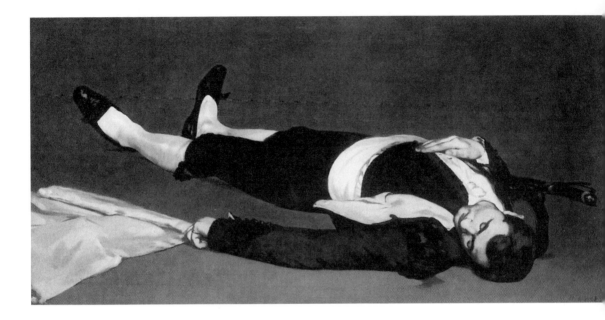

Manet

HE IS THE MODEL OF sartorial elegance, in his sleek black jacket and knickerbockers, his knee-high white stockings and his shiny black shoes. One hand is folded neatly across his chest; the other lies by his side, clutching the matador's cape that gives away both his nationality and profession. The ring on his little finger gleams, a muted highlight. He is, indeed, elegant. He is also dead. At first sight he looks as though only sleeping, but there are fresh bloodstains on the sand and more on his crisp white shirt.

Death does not come any more beautiful than this. Edouard Manet painted *The Dead Toreador* a year before he visited Spain for the one and only time in his life – he was there in 1865 and stayed a mere ten days, as his friend Théodore Duret tells us, because he could not abide the food – yet it is a painting that already testifies to Manet's immense admiration for the great Spanish masters. There is a hint of Zurbarán, in the dulled range of background colours, earthy and dark. There is Velázquez's focus on the single figure. But there are touches, too, of Frans Hals, in the crisp contrast between black and white that is the leitmotif of the painting, and almost as much its subject as the dead man himself.

The Dead Toreador is owned by the National Gallery of Washington, but it hangs for the moment in a toplit, neo-classical gallery adjoining a secluded mansion in one of the grander suburbs of Copenhagen. Ordrupgaard, built for a Danish art collector in 1918, has been a municipal art gallery since 1951. 'Edouard Manet', a temporary exhibition of some fifty paintings borrowed from all over the world, is an unlikely demonstration of the fact that it is still – just – possible for a small museum with tiny resources to put on a grand loan show. It is also almost certainly the last great Manet exhibition we are likely to see for many years.

Manet is the most enigmatic and in many ways still the most controversial French painter of his generation. Was he, as Clement Greenberg insisted, 'the first modernist'? Or was he, as others have preferred to see him, one of the great masters of painting as reportage, the artist who, more than any other, captured the realities of Second Empire France?

The Dead Toreador is in many ways a shocking painting, and must have been still more so when first seen: a representation of death that finds no room for drama or consoling morality, that leaves out the raging bull, the gasping crowd. It is a painting that looks like an excerpt from a painting (more of that later), painted in a style that seems detached from the death that it registers.

Nearby you find the roughly contemporary *Peonies*, one of the products of Manet's mid-career fascination for still life. Again, there is the startling contrast of black and white, pearly blooms on a dark ground; again there is the emphasis on mortality, secateurs barely visible in the shadows reminding you that Manet's peonies are fading fast. Both pictures bring you up close to the painter's own body, offering the kinds of experience perhaps more readily associated with abstract painting. You sense the rhythms of Manet's hand, as he applied these fat, lathery sweeps of paint.

Elsewhere you find a small lively sketch on a theme that preoccupied Manet in the late 1860s and early 1870s, *The Execution of Emperor Maximilian*. Here, if anywhere, you can expect to find Manet the reporter of the great events of his time. Manet's subject was the stuff of modern history. A puppet monarch who had been placed on the Mexican throne by Napoleon III, Maximilian's fate was sealed by the withdrawal of French troops from Mexico in 1867. He was left to the mercies of his unwilling subjects, betrayed – as Manet's painting suggests – by the callousness of his imperial masters.

Manet's Maximilian is a ghostly figure, his face an illegible flurry of paint which merges with the smoke from the executioner's muskets that fire at point-blank range. The cursory brushwork evokes the snuffing out of a life, makes Maximilian the nonentity that death itself has made him, yet it also deprives the painting of pathos since it obliter-

ates the victim's face. There are vestigial references to earlier art, hinting that Manet conceived the painting – as Goya had conceived his *The Third of May 1808*, Manet's immediate prototype – as a modern martyrdom. Maximilian stands flanked by the two generals that died with him, like Christ flanked by the good and bad thieves. His sombrero is a halo.

But the painting, as so often the case in Manet's *oeuvre*, reads as more than one painting. There is the death itself, and then there is the jarringly fastidious painting of the executioners, lined up like a fashion parade. Manet revels in the light/dark contrasts made possible by their uniforms (white belts on ash-grey tunics) and by the shadows that they cast on the sandy ground. To one side, as if he had been included as an emblem of the artist's own detachment, a soldier nonchalantly cocks his rifle.

Théodore Duret explained Manet as the product of a contradiction between his aesthetic ambitions and his social background: on the one hand Manet 'the exponent of a brutal and vulgar realism', on the other 'the Manet who preserved throughout his life the polished manners of the class to which he belonged by birth'. Manet the realist versus Manet the dandy? Perhaps, but Manet's very inconsistency is consistent. Manet answered Baudelaire's call for a 'painter of modern life', one who would express in his art 'the transient, the fleeting, the contingent' qualities of contemporary experience. He expressed his sense of a world where impressions arrive haphazard and will not submit to order by making paintings that fall apart before your eyes.

Take his *View of the World's Fair 1867*, painted to commemorate the *Exposition Universelle*, part of Napoleon III's propaganda campaign for the new Paris – the Paris of Baron Haussmann, with its grand, radial symmetries, the Paris of logic made visible. What has Manet painted? Paris from the Trocadéro, a hillside vantage point overlooking the city. This is a place where the grand ordering ambitions of Haussmann are given the lie by the true, fragmentary nature of modern life. The painting is at least eight or nine paintings, maybe more. A lady rides her horse, its prancing hooves a blur of motion. A boy walks his dog to the right, on the sandy path that tilts the perspective towards flatness – a favourite tactic of Manet's, enhancing his art's tendency to make people and objects look like stranded, incidental details on the flattened plane of the painting. Other groups cluster in solitary, unconnected huddles while the city spreads before them in misty illegibility.

Manet, complained Joseph Péladan – one of his more perceptive contemporary detractors – was 'a painter of fragments'. Where composition traditionally proceeded from part to whole, Manet's pictures went in the opposite direction. Even his greatest paintings are conglomerations of *details*. When he wasn't contriving his decentred, bitty compositions, Manet actually cut his paintings up (he cut up other people's too, most famously Degas's portrait of Manet and his wife). He exhibited paintings that were fragments of other paintings. *The Dead Toreador* was once part of a larger picture of a bullfight. Excerpting this fragment, Manet intensified the sense of disconnectedness that must have been strong in his original. 'On waking up,' ran one sardonic critic's account of the first, whole version, 'a bullfighter sees a bull some six miles away; undisturbed, he turns over and falls asleep.'

There is sadness too in Manet's shattered world. Manet, the painter of fragments, painted everything as if it were still life. He saw the world as a random accumulation of matter, everything isolated from everything else.

26th September 1989

Degas

THE MASSIVE DEGAS exhibition at the Grand Palais rescues a revolutionary artist from the coffee-tables of the world. Today, it is perhaps harder than ever to appreciate Degas's revisions of the art of his time: his multiple reinventions of painting, his redefinition of ways of seeing. Degas has been perpetually misunderstood as a rather charming portraitist and genre painter – a *petit maître* who recorded days at the races, *café-concerts*, nudes at their *toilette* and ballet dancers, cute in tutus.

At first sight Degas's 1865 *La Femme aux Chrysanthèmes* seems an innocuous, if extremely pleasing, picture. At its centre, you see a virtuoso, brushily executed still life of a vase of flowers, standing on a table in what is evidently a bourgeois interior. To its left, you notice a pair of gloves and a jug of water; to the right, a young woman, half cropped by the picture's edge, leans one elbow on the table and stares out to the side.

Simple enough. But, in the context of art in Paris in the mid-1860s, this is a highly unusual painting. Degas has collapsed the old, generic categories of art and produced an image that defies classification. It is not, strictly, speaking, a still life: the enigmatic presence of the woman (whose expression, on close examination, seems tense, nervous) sees to that. It is not a portrait. What portrait painter, at the time, would have pushed his sitter so far to one side of the frame? It is not a narrative painting, in any conventional sense. There is no anecdote, no moral to be extracted from it, no hint as to what this woman is doing here.

Degas's picture breaks down the old orders of looking and painting and proposes a new, fractured vision. His theme, prefigured in *La Femme aux Chrysanthèmes*, is the refractory randomness of the world, its anarchic resistance to interpretation. Gone is the old, generic hierarchy of painting, which ranked subject matter on a rising scale of significance – from the still life and landscape up to the history painting, the great

affirmation of humanist morality or religious belief. Woman, flowers, jug, gloves compete for your attention in a shallow pictorial space calculatedly arranged so as to give none priority. This is a true image of how we experience the world, Degas implies – as a random coming-together of the human, the organic and inorganic, voided of significance. Twenty years earlier Baudelaire had called for a 'painter of modern life', defining 'modernity' as 'the transient, the fleeting, the contingent'. Degas answered the call.

Degas is often said to have been influenced by photography. That is only partially true. His paintings do often look as though they have been almost accidentally framed, rather like what you might get if you took a photograph with your eyes shut. But in Degas's day, photographers were more interested in being 'pictorial' than in exploring their medium's subversive potential, its ability to record the world in a series of arbitrary glimpses. While photographers copied the look of Beaux-Arts painting it was, paradoxically, Degas the painter who investigated, in his own medium, photography's anarchic capabilities.

The masterpieces of Degas's middle career are his paintings of the Paris ballet. Unsettling, flattened perspectives telescope near and far; oddly angled compositions make the peripheral central and what would conventionally be the focus of interest a stranded, incidental detail. In *L'Orchestre de l'Opéra* the ballet is in full swing, but the dancers themselves are mere attenuated presences occupying a thin band at the top of the painting – bright, gauzy *anonymes*, decapitated by the top of the picture frame. Degas has focused, instead, on the players in the orchestral pit, who loom large and dark in the foreground.

Degas always opts for the inadvertent over the posed or prearranged. He rarely paints actual ballet performances, preferring rehearsals or glimpses backstage. Degas's ballerinas, straining to make their bodies live up to the rigorous demands of the classical dance repertoire, are forever stretching, bending, willing themselves to suppleness. Their endless rehearsing is mirrored in Degas's practice: he was himself an inveterate rehearser, repeating the same composition in different media (oil, drawing, pastel, monotype), constantly experimenting with slight changes of viewpoint and arrangements of the figures.

These paintings are also implicitly melancholic. Degas has a genius for catching dancers unawares, in moments of awkwardness and

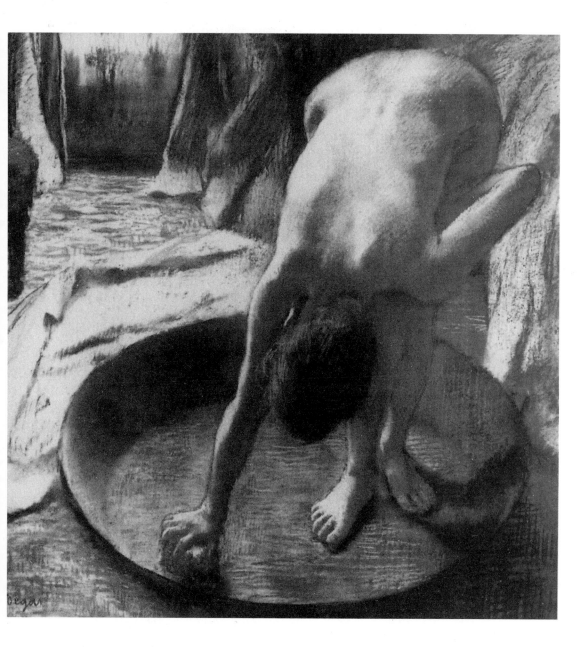

ungainliness. In *Examen de Danse* a stern ballet master stands centre stage, putting a ballerina through her paces. She is graceful enough, but all around the ballerinas at rest serve as frumpy reminders of how ungraceful the body at rest can be. They yawn, they slouch, they loosen their corsets or simply stand there squatly, wearily grounded after their exertions. One of the prime subjects of Degas's art is art's own inadequacy. The ballet dancer can only hope to cheat reality for a brief moment, her grace a hard-won evasion of physical realities. There is nothing cruel (as has sometimes been said) about Degas's portrayals of these dancers in moments of awkwardness or lassitude. He seems infinitely sympathetic, finding in their predicament an emblem of his own. Degas was, after all, a lapsed classical artist who made no secret of his lifelong admiration for Ingres, the last great French painter in the classical tradition. His sense of the world's arbitrariness, its unregenerate chaos, always coexisted uneasily with a yearning for the anatomical grace, the moral certainties of the grand tradition.

The early history paintings are revealing failures. It is as if the young Degas is trying out the formulae of the classical tradition and finding them wanting – or, at least, inappropriate to his vision. *Sémiramis Construisant Babylone* sandwiches a frieze-like group of classically draped figures into the centre of a large canvas, the rest of which is occupied by a ghostly, mistily panoramic cityscape. The painting is unfocused, directionless, its moral unclear. In history painting, everything is supposed to make sense, to take its place in the iconographic order of things. Degas's art, which deals in fragments rather than wholes, which sees the world in bits and pieces, was manifestly incapable of developing in this direction.

Establishing his credentials as a painter of modern life, Degas painted laundresses, aching, stretching and drinking their way through days of unrelieved tedium; alcoholics (as in the famous *L'Absinthe*); and, above all, prostitutes. His brothel-scene monotypes of 1879–80 are dark, smudgily rendered images of the Parisian sexual marketplace. Prostitutes sprawl or lie carelessly across sofas in dim, seedy interiors; their clients are sheepish, guilt-ridden gents in suits, or brutish gawpers, like the fatuously beaming chap who leers up at the nude taking a bath in *L'Admiration*. The brothel is more than a topical milieu, for Degas. A place of sad, brief encounters, it comes to stand for the modern world itself.

The melancholy nature of Degas's art is constantly heightened by its distant echoes of the art of the past. 'It is odd to think,' he remarked in old age, 'that in another era I would have painted Susannah and the Elders.' *L'Admiration* is his late, debated version of Susannah and the Elders. The horses in his racecourse scenes, frequently arranged in processional bands across the middle ground, evoke faded memories of the Parthenon frieze.

Degas's magnificent late pastels of the female nude are a fitting climax to one of the most memorable shows of the decade. These women, who give no sign that they know they are being watched, who make no display of their nudity, are at their toilette. The significance of their constant attention to hygiene often escapes the modern audience. The only women who washed this frequently in late nineteenth-century Paris were prostitutes. These nudes are insistently modern. They adopt unclassical, unconventional poses – ungainly squattings, vigorous under-arm scrubbings, awkward steppings in and out of the bath. But they have none of the tawdry, sad feel of the earlier monotyped prostitutes. They are images of a matter-of-fact, unconcerned intimacy. Perhaps they are wistful images of the kind of intimacy that Degas himself, who formed no lasting emotional attachments, never enjoyed.

But they are, above all, the final expression of the tension between the modern and the classical in Degas's art. They are modern pictures, in that Degas's nudes take their place in no discernible narrative, express no high ideals, embody no moral philosophy. They simply exist. But at the same time, they possess an extraordinary air of calm, a kind of late, late classical serenity. They are Degas's Venuses – the final evidence of his obdurate, classicist's desire to forge art, to salvage some consolation, from the flux of modern life.

22nd March 1988

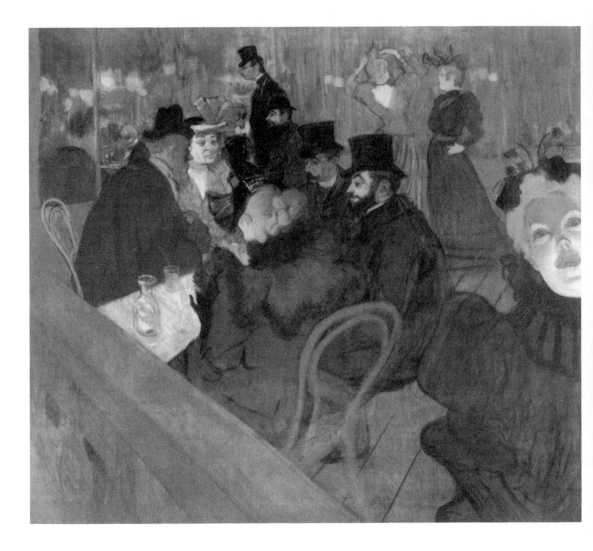

Toulouse-Lautrec

THE ESTABLISHMENT OPENED in October 1889, and, according to *Le Figaro*, quickly attracted a fashionable crowd. The clientele was said to consist of *les artistes peintres, sculpteurs, littérateurs, danseurs . . . enfin le Tout Paris, joyeux*'. One of those *artistes peintres* was Henri de Toulouse-Lautrec, who recorded his impressions of Montmartre's newest night-spot in the famous painting *Au Moulin Rouge*. Exhibit 75 in 'Toulouse-Lautrec' at the Hayward Gallery, it serves notice that Lautrec was much more than the gifted but essentially superficial celebrant of the late nineteenth-century *demi-monde* preserved in popular legend.

The painting presents a disorientating vision of a night on the town. The famously nocturnal Lautrec, who included himself in the background, is in his element. But there is no hint that he is happy to be there. He is a pallid figure lurking in the scene's margins, while the interior is itself a weird and disconcerting place, a bad dream made fact. The painting's uneven light – ranging from gloom to abrupt, bright illumination – contributes powerfully to its effects. The faces of Lautrec's subjects are either sunk in a shadowy half-light that enhances the sense (strong here) of premature decrepitude; or they are irradiated by a harsh, artificial light, tinged with green, that gives them the appearance of sinister cosmetic masks.

None of the people here seems to be communicating with another. Even the odd, truncated woman who stares out from the right edge of the painting – Lautrec often attempted to bridge the fictional world of the painting and the real world of the viewer – looks through or beyond, rather than at us. In a style tuned to the discontinuities of an evening spent in this world, forming and dissolving a multitude of temporary alliances, Lautrec painted an image of seeming conviviality coloured with melancholy. He painted, not the relations between people, but the distances that separate them.

The exhibition opens with a sampling of Lautrec's juvenilia, which adds up to a reminder of what sort of painter, had his personal circumstances been slightly different, he might well have become. The earliest works are lively sketches of horses and horsemen. An aristocrat by birth, Lautrec might, had not illness intervened, have become a sportsman with a taste for drawing. The victim of a congenital bone disorder which arrested his growth, Lautrec came to feel isolated from his own social class.

He was not the most revealing of letter-writers, but there is one particularly poignant passage in the new edition (OUP) of his correspondence. It was written while the thirteen-year-old Lautrec was recovering from his first long illness: 'When it gets dark, I wait to find out whether Jeanne [a cousin] will come near my bed. Sometimes she comes, and I listen to her speak, not daring to look at her, she is so tall and beautiful and I am neither tall nor beautiful.' His decision to immerse himself in the seedy world of Montmartre has been interpreted as an attempt to find and define his *own* world – a place where deformity might, perhaps, be reinvented as distinctiveness. These are among the received ideas that the current exhibition seeks, not entirely successfully, to challenge. Lautrec's virtual obsession with deformity, with alienness, cannot easily be separated from his art.

Neither tall nor beautiful, he developed an alertness to the peculiarities of others and a talent for their graphic abbreviation. He had the gift of the caricaturist, yet tempered it with sympathy and employed it not for the purposes of satire – or at least, not often – but rather in the creation of enticing graphic spectacle. You know the faded stars to whom Lautrec granted a measure of immortality by their attributes. There is Jane Avril, probably Lautrec's favourite, with her distinctive red mop, her infinities of petticoat and flashed expanses of stockinged leg. There is Yvette Guilbert who, in her most simplified incarnation, does not even need to be present at all, embodied by proxy in the form of the elbow-length black gloves that were her most distinctive stage prop.

In his posters, Lautrec adapted the visual language of the *avant-garde* art of his time – the telescoping of near and far and the odd conjunction of details framed with calculated, seeming arbitrariness, found in Degas – and made it the language of *popular* art. No painter before the advent of the Pop Artists would prove so willing to collapse the barriers

between high and low, between fine art and commercial illustration. This may partly explain Degas' famous sneer: 'He wears my clothes, but tailored to his size.'

Yet, inventing his mass-produced likenesses of Jane Avril and company, Lautrec transfigured them. His fascination with the cosmetic powers of art – with his own ability as a creator of images to armour his subjects with artifice – may well have been a sublimated expression of his desire to transform himself. The performers celebrated in his graphic art have been freed from the troubles, the truancies of the body. They have been turned into objects of design, as carefully wrought as Hector Guimard's entrances to the new Paris Metro of the 1890s.

The art historian Richard Thomson argues, in the Hayward's catalogue, that Lautrec's images fail critically to address 'the problematics of the modern city: class, gender, ambiguity, exploitation, alienation.' This seems a singularly odd claim to make in the light of a show which includes so many works – and *Au Moulin Rouge* is not the only one – that suggest the contrary. Lautrec emerges as an artist who could be strongly aware of a sadness at the centre of his gaslit world. In his paintings, as opposed to his commercially reproduced images of the music-hall stars, he caught them off stage and off their guard. He depicted *Jane Avril Entrant au Moulin Rouge*, in civvies, as a shrivelled, prematurely middle-aged woman huddled against the cold of the street. Such paintings seem to register neither satire nor ridicule, but an appalled recognition of facts.

His paintings of the brothels of Montmartre are remarkable for their complete absence of prurience or ribaldry. This is apparent in Lautrec's choice of subject, the *salons* where the prostitutes awaited their clients. Lautrec saw the *ennui* of prostitution. The sense of stasis, of fixity, that is so strong in his graphic work, is present here, but given a different emphasis. Lautrec has painted a modern limbo, a place whose slouched inhabitants seem condemned to wait until the end of time. The vacantly staring, spiritless, depleted women of the brothels are the mirror images, sadly reversed, of Montmartre's *vedettes*. Lautrec saw the cruelty as well as the glamour of a certain female predicament: the condition of having nothing to sell but oneself.

The pictures of lesbians that Lautrec painted in the 1890s are simple and beautiful works in which it is equally difficult to recognize the

louche voyeur of *fin-de-siècle* legend. These images represent a form of renunciation on the part of Lautrec, for in them he abandons the graphic virtuosity for which he is so well known. The women lie in bed together, they look into each other's eyes. The gaze, for once in Lautrec's art, meets a human response, and a warm one. Maybe it is appropriate that he should have found in such furtive, illicit liaisons his only images of uncomplicated affection. His sense of his own otherness may have amounted, for Lautrec, to a personal tragedy, but it was also responsible for his finest art.

15th October 1992

Seurat

GEORGES SEURAT DIED QUITE SUDDENLY, of diphtheria, at thirty-one. Few artists of comparable stature had briefer lives, but he somehow failed to qualify as a Tragic Figure. Irving Stone never wrote the novel and Kirk Douglas never played him in the movie. Georges Seurat was a deliberate, methodical man, whose chief pictorial innovation – the technique with which he is famously associated, known most commonly as 'pointillism' – had decisively influenced the course of modern art by the time of his death. If few mourned his passing it was because he had already made his point.

A number of major paintings are missing from the Seurat retrospective currently at the Grand Palais in Paris. *A Bathing Place, Asnières* has remained at the National Gallery; *A Sunday Afternoon on the Island of La Grande Jatte* at the Art Institute of Chicago; *Le Chahut* at the Rijksmuseum Kröller-Müller, Otterlo. This matters far more in the case of Seurat than it might in the case of Monet. Seurat structured his *oeuvre* around a sequence of ambitious studio paintings. He made innumerable studies for such works; but to see the studies without the end product is to witness the rehearsal without the performance.

Looked at in isolation, Seurat's oil sketches – many done on cigar-box lids – can suggest that he was an artist in the Impressionist mould. In those for *La Grande Jatte*, the sun-dappled, riverside promontory is handled in a free, broken manner. Figures are rapidly noted, indicating that these works were painted *en plein air*. Seurat, here, might be mistaken for an improvisatory painter.

In fact, *La Grande Jatte* is one of the most calculated paintings in existence. It is ten feet by seven, far bigger than any Impressionist work. The assorted Sunday afternoon strollers who people it have been placed with a watchmaker's precision, and there is something oddly mechanical about the entire painting. Seurat's people are not the transient human

presences of Impressionist painting but a strange blend of fashion–plate silhouette and tin soldier: clockwork figures in a brightly artificial Arcadia.

La Grande Jatte was also Seurat's first grand demonstration of 'pointill-ism', which he preferred to call 'divisionism'. The Grand Palais show might have its lacunae, but it does allow for an assessment of this technique – countless examples of which are present – and its implica-tions. For the rest, the spectator is left to use his own knowledge to supply the gaps and, so to speak, join the dots.

The theory behind Seurat's divisionism has a reputation for being both more difficult and more comprehensive than it actually is. By 1886, the date of Seurat's *The Hospice and Lighthouse at Honfleur*, the dot of paint, applied to the canvas in many separate touches like the tesserae in a mosaic, had become Seurat's signature. Literally, in this painting of the Channel coast landscape that was so much to Seurat's taste, the artist has spelt out his name, bottom left, in tiny lentils of alternating colour, light blue and orange.

Seurat derived his ideas about colour from a number of nineteenth-century aesthetic theorists. Eugène Chevreul, author of *The Law of Simultaneous Colour Contrast*, was the most influential of these. Accord-ing to Chevreul, colour as perceived is always mixed. A spot of pure colour always gives the retinal impression that it is haloed by its comple-mentary: orange by blue, purple with yellow, and so on. Furthermore, the colour of any object is altered by the reflected colours of those objects adjacent to it in the field of vision. The human experience of colour, therefore, is not of single, determinate, hues, but of a complex, shifting process of interaction; colour, as seen, is always composed of a virtually infinite admixture of reflections and complementaries.

Seurat's divisionist technique was intended to do justice to the com-plexities of colour perception. Seurat's dots, so the theory went, enabled him to present compounds of colour in a more precise and analytical way than any previous painter. Viewed at the correct distance, his cunning orchestrations of colour would resolve into the most deceptive, most truly mimetic paintings in the history of art. Seurat was the heir to the tradition of positivist thinking that had also contributed to the Impressionists' creed of fidelity to visual experience (he might have argued that he was simply better informed than they). When the Eiffel

SEURAT *Study for* Un Dimanche à la Grande Jatte

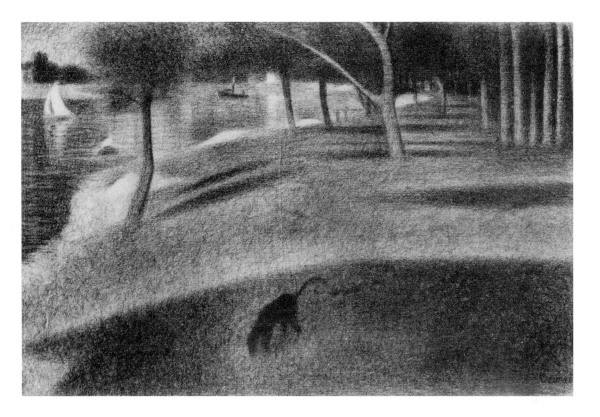

Tower was erected for the World's Fair of 1889, Seurat was one of the first artists to paint it, dashing off the small oil that can be seen near the end of the Grand Palais show. He thought of his works as Eiffel Towers of art: monuments, in effect, to the progress of empirical thought. The news from the Grand Palais is that Seurat was wrong. He was a fascinating painter, but not the definitive realist.

Divisionist painting is founded on a paradox. Seurat's technique, greatly rigorous and disciplined, is fundamentally architectural: he builds each painting brick by brick, through the painstaking addition of one tiny patch of colour to another, slowly walling up the canvas. Yet it also implies a way of seeing the world that is anything but stable. Divisionism was a style of painting which explicitly acknowledged that matter is atomistically divisible and, therefore, inherently volatile. Seurat's landscapes, particularly his paintings of the Channel ports of northern France, offer an unsettling spectacle to the eye. Seurat's technique creates extraordinary effects of shimmer and glare; he paints a world which, atomized, has lost rather than gained in definition.

Seurat, the arch positivist of late nineteenth-century painting, ended up by painting a world that seems as mysterious, as indeterminate, as any in art. It may be revealing that the later modern painters whose work approaches most closely to the mood of Seurat's landscapes – De Chirico, and Magritte – should have been associated with the Surrealist movement. Seurat's art was never quite as straightforwardly empirical as the original propaganda of divisionism asserted.

His drawings also contradict the myth of Seurat as artist-scientist. When he was twenty-two, Seurat invented a new method of drawing – passing Conté crayon, with varying degrees of pressure, over a highly textured paper – which was a graphic prefiguration of his divisionist painting style. The surface of a Seurat drawing is broken into a multitude of discrete marks thanks to the regular, minuscule interruptions of every gesture effected by the hooked tufts of the paper used. The result is a constellation of needlepoint blacks and greys, which Seurat used to model form through light and shade with a subtlety that still seems barely credible.

Many of the figures in Seurat's drawings seem on the point of disappearing into the space that surrounds them. He drew his mother, emerging from thick, velvety darkness, as a spectre. These images speak

of transformation and instability. He frequently envisages thin air as a kind of ether, crackling with mysterious static. Seurat's drawings picture a dim, phantasmal alternative to the bleached-out world of dissolved form you find in the paintings.

Seurat died young, but not before his art had gone into crisis. The crisis, which began as early as 1887, with *The Sideshow*, and extended to his last year, when he painted *The Circus*, manifested itself stylistically. In these works Seurat went against his greatest gift. He became an apostate from his own virtuosity.

Later Seurat abandons the dense, shimmering grids of his earlier divisionism for surfaces marked by an altogether heavier touch. The dots become thicker and eventually metamorphose into shapes more like hyphens. This is interesting because it signals an absolute reversal of priorities: forms are no longer modelled, but – because Seurat uses his new and more linear vocabulary to give shapes hard edges – contained. The chromatic complexity of his earlier work disappears. He becomes, in effect – and this is clearest in *The Circus* – a kind of illustrator.

There are two possible explanations for this. Perhaps Seurat recognized that divisionism, which had led him to create images of such mystery and instability, conflicted with his own positivist ambitions for clarity. Perhaps this parody of his earlier manner was the only way he could get a sense of solidity, of stability, back into his art. If so, his later paintings mark a sad decline.

Or perhaps Seurat was striking out for something altogether new. His later paintings – and this is foreshadowed in *La Grande Jatte* – envisage an odd, mechanical world, peopled by robots: the cast of *Le Chahut*, present in Paris only in sketch form, are a bunch of high-kicking automata who seem as mechanically cheerful as a team of synchronized swimmers; the musicians in *The Sideshow* are strange, bowler-hatted clones of one another; the performers in *The Circus* look like wind-up toys. Seurat, here, may predict the machine-age painting of Léger and the automated nightmare of Chaplin's *The Great Dictator*. This would give his late style a certain logic. A banal world, painted banally: Seurat turns himself into an automaton, blandly outlining shapes and simply filling them in, a dot-and-dash-producing apparatus.

Seurat's later paintings might even mark the first attempt by an artist to reproduce, by hand, the effects of mass reproduction. These pictures

bear a certain resemblance to the cheap colour reproductions with which printers first began to experiment in the 1880s. Seurat as the father of Lichtenstein, pioneer of Ben Day dot art? Seurat as the father of Warhol, the first artist-as-machine? Maybe Pop Art started, with Seurat, in the 1880s – way back, you might say, in the year dot.

23rd April 1991

Sickert

WALTER SICKERT'S habit of basing paintings on news photographs shocked some people in the early decades of this century but now it makes him look proto-modern, or even proto-Post-Modern – one of the first painters to register the second-hand, mediated quality of so much urban twentieth-century experience, of lives lived out in front of TV screens or the turning pages of newspapers. But on the evidence of the Sickert retrospective that opened last week at the Royal Academy in London, he saw the news photograph more as a challenge than as a subject in its own right. It was a test of his own powers as a painter to reconstruct, from grainy black and white images in newspapers like the *Daily Sketch*, the realities that lay behind them.

Sickert sifted through photographs like a private detective looking for incriminating evidence. Pretty often, he found it. Two of the last paintings to be seen in the current exhibition are his pair of portraits of *HM Edward VIII* based on a single photograph taken by Harold J. Clements (Sickert always acknowledged his sources). Seen together, they add up to a snapshot of the painter at work, homing in on the salient details of the image. Sickert's second *Edward VIII* is a masterpiece, a daringly enlarged painting of a photograph in which the frailty and loneliness of a human being are suddenly and simply reincarnated.

The King steps forward hesitantly into the public eye, clutching his bearskin defensively like a shield and glancing uneasily to one side. Sickert's handling – sketchy, incomplete – seems calculated to match his subject. His picture of Edward VIII was painted, with irony, on the scale of a state portrait; in fact, it is an anti-state portrait, a picture of a king involuntarily revealing, in the glare of a flashbulb, his incapacity to rule. He stands revealed as a man crushed by the burdens of public responsibility.

Lord Beaverbrook recognized the summary brilliance of Sickert's

painting when he advised future writers on the King and Mrs Simpson to 'look carefully upon the artist's labours before undertaking their own tasks. Everything is explained and all is excused in a painting on a piece of canvas six feet by three.'

Sickert had studied under Degas in Paris and, like Degas, he valued the inadvertent quality of photographs, as well as the cruelty with which they reveal the gap between how we imagine things to be and how they are. They provided him with an escape from pictorial conventions, from taste ('taste is the death of a painter,' he snarled) and took him elsewhere. They gave him the unexpected. Presumably that is why he was drawn to Clements' photograph of a king not really looking like a king: and why he was drawn to the photograph of Amelia Earhart, the first woman to fly the Atlantic singlehanded, reproduced on the front page of the *Daily Sketch* on 23 May 1932.

The newspaper's headline ('Welcome "Lady Lindy"') trumpeted her arrival at the Hanworth Aerodrome in no uncertain terms, but the accompanying photograph was pure bathos. Surrounded by a crowd of soaked bystanders Earhart is barely visible under the wing of her plane, reduced to a beaky profile obscured by sheeting rain. Sickert cropped his source photograph and made the most of the appalling weather and near-invisibility of the news story's heroine. Sickert was always quick to seize on events that did not turn out as planned.

In late life Sickert posed as an abrasive old buffer with a talent for the one-liner. The year before he painted *Miss Earhart's Arrival*, he visited a Henry Moore exhibition at the Leicester Galleries. Moore was there, gesturing to one of his Polo-mint nudes and telling Sickert earnestly that he 'had to use a very special tool to do her'. Sickert considered the sculpture. 'I think I would need one too.'

His bluffness was a mask for a permanent, if thoroughly unsentimental, form of melancholy. This was expressed most overtly in the paintings of drab, ordinary people leading drab, ordinary lives which Sickert produced in the second decade of this century. *Ennui* is the most famous of them: another Sickert snapshot, this time of domestic misery, of the home as a place of emotional and spiritual confinement. A glassy-eyed husband sits at the table before his nearly empty pint-glass, puffing at his cigar while his wife lounges against a chipped chest of drawers and gazes absently at a glass dome full of stuffed birds.

Virginia Woolf has described Sickert's down-at-heel world better than anyone else, writing about this painting: 'It is all over with them, one feels. The accumulated weariness of innumerable days has discharged its burden on them . . . The grimness of that situation lies in the fact that there is no crisis; dull minutes are mounting, old matches are accumulating and dirty glasses and dead cigars; still on they must go, up they must get.' Persistence was a favourite Sickert theme. The show must go on.

Painting the performers in establishment's like Gatti's Hungerford Palace of Varieties, or the Old Bedford Hall, Sickert created extraordinary images of spotlit isolation – of frail waifs like Minnie Cunningham or Katie Lawrence belting out their stuff in the dark, plush-and-gold ornamented voids of London's Victorian music halls. Turning to the audiences who watched them, he focused on sociable loneliness, on the stark isolation of people in crowds. The rapt faces up in the gods at the Old Bedford, barely illuminated by the glow of the spectacle beneath them, turn especially grotesque in *Noctes Ambrosianae*.

Sickert saw ineffable melancholy but also courage and even a faith in life in most forms of popular entertainment. In 1915, painting *Brighton Pierrots* performing at dusk to rows of empty deckchairs, he distilled the sadness and bravery of the world to the uneven contours of a be-trousered leg profiled against a scarlet sky. A pair of gulls rendered as white blurs fly off into the encroaching darkness.

The Royal Academy retrospective feels like a show designed to make Sickert seem more respectable, more Old Masterly than he ever truly was, despite his amazing (and still underrated) virtuosity with the brush. The symmetrical, stamp-album hang of the exhibition (big picture, little picture, big picture, little picture) does Sickert a disservice by implying that he was, himself, as consistent and logical in his approach to making art. But he was not. Sickert was a constant self-saboteur, a constant underminer of his own formulas.

Despite the hang, his adventurousness shines through. He reinvented the conversation picture in his paintings of prostitutes and their clients in Camden Town bedsits, those visions of arrested, dead-end lives whose clotted textures and liverish colouring and appalling claustrophobia predict (and considerably outdo) the later paintings of Frank Auerbach, whose entire *oeuvre* comes to look more and more like a misconceived

homage to Sickert. He reinvented the genre of cityscape and found a potent alternative to most modernist painting of the urban scene – the fractured, enthused visions of the modern metropolis of the Cubists and Futurists – in visions of Dieppe or London or Paris suffused with an extraordinary, twilit intensity. In these paintings of cities as empty as stage sets, Sickert struck a new note in art. He invented the morose sublime.

Sickert was not a great painter because he was an innovator, but because through all his innovations he managed to achieve one thing. He painted with immense feeling, without ever turning lachrymose. He was an expressionist who never descended to the self-pitying, sentimental extremes of Expressionism. He kept finding new ways of communicating his sense of life's sadness, awkwardness and poignancy.

24th November 1992

Guston

'AMERICAN ABSTRACT ART is a lie, a sham, a cover-up for poverty of spirit. A mask to mask the fear of revealing oneself. A lie to cover up how bad one can be.' That was Philip Guston in the last decade of his life, scribbling down his angry thoughts. There were more to come. 'It is laughable, this lie. Anything but this! What a sham! Abstract art hides it, hides the lie, a *fake*! Don't! Let it show! It is an escape from the true feelings we have, from the "raw", primitive feelings about the world – and us in it.'

Guston had more than earned the right to his misgivings. This was one of the senior American abstract artists talking. By the late Sixties, the date of Guston's apostasy, he was one of the few survivors of that generation of New York School painters to have put America, definitively, on the art-historical map. Mark Rothko was long gone, victim of his own hand; Jackson Pollock, Guston's long-time friend and rival, was dead in a car crash. Pollock, in the course of a drunken argument over who was the finer painter, had once attempted to throw Guston out of a tenth-storey window. All these years later, Guston only had ghosts to argue with – but that did not diminish his fury. As he approached death he painted like an artist forty years younger than he was. There was so much to unlearn, he said, as he embarked on the extraordinary figurative paintings of his final decade.

Musa Mayer, Guston's daughter and only child, has written a spare and moving book about her difficult father. *Night Studio* begins and ends in the painter's large cedar-block studio in Woodstock. Although usually bracketed with the New York School, Guston always liked to stand apart from what were perceived as movements or tendencies in art. 'He was no joiner,' Ms Mayer writes of her father, whose stubborn streak ran deep. She found those angry jottings of his several years after his death, of a heart attack, in 1980. They were stashed away in his

studio, along with the other melancholy remnants of the painter's life: countless tubes of mars black, titanium white, 'and the absurd super-fluity of an entire cupboard full of Bocour and Grumbacher cadmium red medium, hoarded like pints of blood against some feared and imag-ined shortage, still in readiness for the next impassioned run of work.'

Mars black, titanium white, cadmium red medium: the colours of Guston's late work. What strange, unsettling work it was, so oppressive and magnificent in its curmudgeonliness. Guston invented a weird hinterland of the soul in these paintings, a place that was, also, a state of mind: deserts piled high with hobnailed boots, paralysed tangles of legs, knotted pipes, fallen ladders, mean streets patrolled by hooded Ku Klux Klansmen, suspended uneasily between comedy and atrocity; lonely interiors, with bare floorboards and bricked-up windows, lit only by a solitary light bulb, where the artist – Guston painted himself as a huge, bruised, disembodied head from the funny papers, his single comic-book eye fixated on a bottle of booze – keeps up a lonely vigil deep into the night. Laughing in the dark: few modern artists had attempted, let alone managed, anything quite like this awful black comedy, this troubled combination of the appalling and the hilarious. Ross Feld, a friend of Guston's, tells Musa Mayer of a visit to the studio in Woodstock during the painter's last years. 'I hadn't seen these canvases before; I didn't really know what to say. For a time, then, there was silence. After a while, Guston took his thumbnail away from his teeth and said, "People, you know, complain that it's horrifying. As if it's a picnic for me, who has to come in here every day and see them first thing. But what's the alternative? I'm trying to see how much I can stand."'

Guston's late work, one of the most vital and unruly bodies of paint-ing by an American artist in the second half of this century, was a double-edged riposte: a reaction both against the tidy conformity of American abstract painting in the later Sixties (which Guston called 'the soothing lullaby of art') and against the hip cool of the younger Pop and Minimalist generations. 'I got sick and tried of all that purity!' railed Guston. 'I wanted to tell stories.' Stories were the last thing paintings were supposed to tell. Narrative was what New York artists had spent the last thirty or forty years getting rid of. That, and the figure – but here the figure was again, making a terrible comeback, unzipping itself

from the bodybag to which it had been consigned by successive generations of Abstract Expressionists, Colour Field painters, Pop and Op and Minimal artists.

The New York *cognoscenti* were appalled. It was as if Frankenstein had risen in their midst. Musa Mayer remembers going to the opening of her father's 1970 exhibition at the Marlborough Gallery, the first time he showed a group of these disconcerting figurative nightmares, so different from anything in the rest of his *oeuvre*. Guston, 'as usual, was in the centre of a cluster of people, talking and laughing a little too loudly, barely concealing his anxiety'. The anxiety was well-founded. Guston had a few supporters – such as the novelist Philip Roth, who was one of his closest friends in his later years – but most of his audience reacted with horror, bewilderment or petulance. 'Why did you have to go and ruin everything?' was the response of one (unnamed) painter; Lee Krasner, Pollock's widow, studiously avoided Guston, and told a friend that she thought the exhibition was 'embarrassing'. The critics were even more savage in their dismissals. Robert Hughes, in *Time*, wrote that the paintings were 'as simple-minded as the bigotry they denounce'. Hilton Kramer, in the *New York Times*, thought Guston's late paintings proved that 'there is no vitality here to rejuvenate'.

Guston's was an unusual life for a twentieth-century artist, in that he spent so much time readying himself for this late, late shot at greatness. His was a long saga of hesitancy, of anxiety, of agonized creation – the phrase has become a cliché, but agony doesn't seem too strong a word for what Guston, according to his daughter, suffered in the studio during his bad times – followed by the sudden release of certainty which produced the late paintings. At last he could paint, he said, without thinking about it all the time. Willem de Kooning was one of the few to see just what had happened to Guston when he turned figurative. 'Well, now you are on your own!' de Kooning said to Guston. 'You've paid off all your debts!' It had taken long enough; Guston was in his mid-fifties.

The youngest of seven children, he was born in 1913 in the Jewish quarter of Montreal. Guston's mother and father, Rachel and Leib Goldstein, had fled from Russia a decade earlier in order to escape the pogroms in Odessa (Guston changed his name in the Thirties for reasons that are not entirely clear, a fact which caused him tremendous feelings of guilt in later life). Saul Bellow, who was brought up in the same

Montreal ghetto as Guston, has remembered it as a place of 'gloom and frost . . . dung-stained ice, trails of ashes . . .' Guston's family moved to Los Angeles when he was six, but despite better weather the rest of his youth can hardly be described as happy. His father, 'a huge, brooding man', had worked as a machinist for the Canadian Railway, but in California the only job he could find was 'as a junkman, driving a horse-drawn wagon through the streets, collecting refuse, a job he found humiliating'. Guston would describe his late paintings as an attempt to recover the life he had spent so much time excluding from his art. Their gloom may partly recollect his feelings as a young man, aware of his father's misery. The figures in them occupy rubbish-tip wastelands; they are surrounded by patched rags, piled refuse, junk. Guston had had good reason to forget his father for so many years. Leib Goldstein hanged himself in 1923 or 1924 (the precise date is uncertain); his son Philip, aged ten or eleven at the time, found the body dangling from a rope slung over the rafters of a shed. A few years later, Philip's brother Nat had his legs crushed in a car accident and died, in great pain, of gangrene.

In 1930, Guston won a scholarship to the Otis Art Institute in Los Angeles, where he and his friend Jackson Pollock succeeded mostly in annoying their teachers (Guston particularly remembered a ticking off from George Stanley, a minor sculptor whose chief contribution to twentieth-century art was the design of the Oscar statuette). America was deep in the Depression. Guston saw, at first hand, the union-busting and the Ku Klux Klan goon squads – more of the memories that would be resurrected in his later work. By 1934, Guston was in Mexico, where he went to see the vast revolutionary paintings of the muralists Rivera, Siqueiros and Orozco. They gave him and a friend, Reuben Kadish, a 1,024-square-foot wall in Morelia to paint: the result, a forty-foot-high demonstration of angry young mannishness, was called *The Struggle Against War and Fascism*. Returning to America, Guston moved to New York, where the Works Progress Administration employed him to paint large, patriotic murals: *Maintaining America's Skills* was a typical commission.

Guston's conversion to abstract painting came late (his earliest abstract works date from the early Fifties), a fact which partly explains why he has never quite been considered a mainstream Abstract Expressionist.

His abstract paintings were marked by a light and hesitant touch, by innumerable erasures and startings-over: close-hatched brushstrokes gather in clusters at the centre of the canvas, suspended in an indeterminate haze of rubbings-out. At their most lyrical and evocative, they were often compared to Monet's later waterlily paintings. 'I recall a strong preoccupation with the forces of nature,' he said. 'Sky and earth, the inert and the moving, weights and gravities, the wind through the trees, resistances and flow.' A special term was coined for Guston's work of the Fifties and Sixties: 'Abstract Impressionism'.

This naturally made the shock of the late work seem all the greater. After these harmonies, such appalling, klutzy discord – such grotesqueness. 'I have metamorphosed,' Guston said, 'from something in flight into some kind of grub.' But there was a certain logic behind Guston's late shift. As a young man he had dreamed of an art capable of commenting on the larger human issues of his times. The later paintings resume such an ambition. They were Guston's way of commenting on the absurd, awful century he had lived through. Even during his most abstract periods, Guston had always been fascinated by the literature of the absurd – by Beckett, by Kafka – but he had never, until now, found a way of articulating his deeper feelings in paint.

Unexpectedly, he may have found his method by combining aspects of the two kinds of art he despised most. From Pop, he took the demotic iconography of the funny papers: Guston's Cyclopean head comes from Bald Iggle, a character in Al Capp's Forties strip Li'l Abner; the clown-like gloved hands and the skinny legs in hobnailed boots come from Gottfredson's version of Disney's Mickey Mouse. And from Abstract Expressionism, Guston took the painterly high seriousness that makes these images resound with more than merely comic-strip resonance: those aching black grounds, lovingly impasted, those dense, material voids that set the scene for his absurdities, are as richly and weightily painted as anything in Newman or Still or Kline. This combination, of the ludicrous and the momentous, establishes the tone of late Guston. It is a contrast central to his vision of the world: a mean and violent comedy played out in a darkening wasteland. Guston did not paint specific atrocities (although some of his paintings, with their sad piles of human refuse, those heaps of legs or clusters of boots, suggest genocidal aftermaths); he painted, rather, a generalized sense of atrociousness. It

is hard not to be reminded of another artist who, a century and a half earlier, had created his own blackly comic vision of a world gone awry. Poised between absurdity and tragedy, between eloquence and cack-handedness, late Guston staked his claim to significance. He hoped he had done enough, he said, to enter art history, to become 'a good heavy foot in the door of this room'. His hopes were justified. He was a Goya for the twentieth century.

23rd February 1991

Warhol

ANDY WARHOL WAS as boring as he set out to be, but he was also one of the most penetrating artists of his century. Warhol's career was built on paradox. He became the greatest art-world star of his time, a celebrity whose fame rivalled that of the celebrities, the Marilyns and Elvises, whose images multiplied across his silkscreened canvases – yet his art was consecrated to cool impersonality. He set out to abolish the old notion of the artist as a privileged, inspired creator, the possessor of a special and precious sensibility – yet that, in these *post mortem* years of Andy's Apotheosis, is precisely how he is being sold.

'Andy Warhol: A Retrospective', at the Hayward, opens with a multitude of Maos, silkscreened in a variety of brash colours and hung on a modern recreation of the Chairman Mao wallpaper which Warhol devised for one of his exhibitions in the 1960s. Wallpaper may be said to represent the *ne plus ultra* of Warhol's art. Painting is replaced by replication and reduplication. Art becomes mass-production, and vice-versa. Based in the New York studio he christened The Factory, Warhol became an impersonal personality. He was the artist who established his identity by removing himself from his art. He did not sign his pictures, and he did not need to; he made anonymity his signature.

Most major exhibitions return the viewer, with a sense of freshness and discovery, to original works of art known too long and too exclusively through reproduction. Renewed acquaintance with Warhol's work is peculiarly and significantly dispiriting. Whether you are looking at row on row of Marilyns or Elvises, dollar bills or soup cans, the overwhelming impression is of an art that has been made redundant by its own reproductions. Warhol's silkscreens dingily evoke the infidelity of colour registration in sub-standard reproductions, so in reproduction the effect is, if anything, enhanced. In the flesh, you tend to notice the singularity of images – the difference, say, between one Campbell's

soup can and the next – the very point of which was their numbing uniformity. 'I want to be a machine,' Warhol famously proclaimed, and in reproduction, where irregularities are touched out or easily overlooked, Warhols achieve themselves in spectral, production-line perfection.

Reproduction was both Warhol's strategy and his theme. He defined it as the spirit of his age – the age of mass-production and mass-marketing, ruled by the twin deities of Sign and Package. Where the artists of the past had cherished or celebrated or at least affirmed the significance of what they depicted, Warhol did the exact opposite. Even when he depicts celebrities like Marilyn or Elvis, he makes a point of their ordinariness; he does not paint them so much as their conversion into sign and product. Marilyn, as Warhol's titles for his various Monroe multiples make clear – *Six-Pack Marilyn, Turquoise Marilyn, Gold Marilyn* – has become as potentially plural, as unexceptional, as a Brillo box.

Warhol matters because Warhol, more than any other modern artist, fingered the mood of alienation bred by life in the media age – the sense that life is not something to be experienced directly but at second hand, through the technologies of television, newsprint, film. This is the point of the Disaster series, with its grainy repetition of silkscreened photographs recording crumpled suicide victims and car crash aftermaths. 'During the Sixties,' Warhol said, in one of the epigrammatic insights that punctuated the bland drone of his conversation, 'I think people forgot what emotions were meant to be. And I don't think they've ever remembered.' Warhol's genius lay in his ability to find visual equivalents for the numbed absence of emotion he set out to record, an art whose formal emptiness and repetitiousness mirrored its vacancy of spirit. For his 'Disaster' series, Warhol chose photographs which had been deemed too horrific for newspaper reproduction. Yet the cumulative effect of his silkscreened repetitions is not sensational but anaesthetic. 'When you see a gruesome picture over and over again,' said Warhol, 'it doesn't have any effect.'

The son of a Czech-born immigrant coalminer, Andrew Warhola became Andy Warhol became Andy Warhol Enterprises, Inc. Warhol's career followed the pattern of the American success story, a parable of self-betterment. But his standardized art, homing in on the standardization of taste in post-war America, directly contradicted America's myth

of itself as a continent where every man was in charge of his own destiny, where freedom of choice and expression were the hallmarks of democracy. Warhol's repeating Maos, placed alongside his repeating Coca-Cola bottles, hint subversively at a covert alliance between Communism and capitalism. Communism, Warhol said, is making 'everybody think alike . . . under government. It's happening here all by itself.'

Warhol pursued boredom with a philosopher's rigour. He sought its Platonic essence, Boredom Resplendent. His films succeed, in this respect, where his paintings could not. You can glance at a painting and look away, but *Empire*, Warhol's eight-hour silent film of the Empire State Building, subjected the viewer to unbearable *longueurs* of banality (Warhol had one member of its first audience tied to his chair). Warhol commented that since most Americans spent their lives watching effectively the same film – 'they're essentially the same plots and the same shots and the same cuts over and over again' – he was merely being more honest than most film-makers. 'If I'm going to sit and watch the same thing I saw the night before, I don't want it to be essentially the same – I want it to be *exactly* the same. Because the more you look at the same exact thing . . . the better and emptier you feel.'

It is hard not to suspect that Warhol's dandyish posture of *ennui* masked a genuine melancholy, a *horror vacui*. Warhol's cool is shot through with morbidity. Death takes many forms in his art: death by glamour, a conversion of individual life into serial anonymity; death by disaster; the death of art itself, its exhaustion by parody or its replacement by the slick imagery of the consumer society. Warhol, the artist as mortician, seemed to celebrate the spiritual void of his times, but his art can suggest, too, that he felt the loss of religious faith (he attended church regularly until his death as a sadness of a kind). His tacky *Gold Marilyns* are icons painted by a gay Roman Catholic of uncertain belief.

Warhol has been characterized by his detractors as a visual illiterate, an indiscriminate plunderer, an opportunist who laughed all the way to the image-bank. Yet this does not take into account his considerable sophistication, nor the sheer range of his iconoclastic ambitions. Warhol set out, with a thoroughness unmatched by any artist in this century bar Picasso, to rewrite art history. He redefined, in his own affectless terms, every genre. Portraiture, traditionally the unique record of an

individual, became serially monotonous. Grand narrative painting was telescoped to the narrow repetition of events as seen on TV (one thing you don't get from reproductions of his work is a sense of its sheer scale, which also reads as a parody of the history paintings of the past, their declaration of the image's significance that is nullified in his art). Landscape and still life, held ever since the advent of Romanticism to be the covert index of the artist's emotions, became the pretext for colour-by-numbers repetitiousness in Warhol's 'DIY' series: numbered diagrams that the artist did not even bother to fill in. The list could be extended.

The Hayward retrospective, with its heavy emphasis on the art of the 1960s, reaffirms that Warhol said all he had to say in under a decade. A career that was planned as meticulously as an advertising campaign ended like one that had run out of steam. By the 1980s, Warhol was producing stale résumés of ideas more than twenty years old – slack pastiches of Raphael or Leonardo overlaid with advertising logos – or producing slick, vacuous portraits of the likes of Liza Minelli. 'I wanted to be an Art Businessman or a Business artist,' Warhol once said. He held his first exhibition in the Bonwit Teller department store in 1963. His last culminates, on the Hayward's top floor, in 'The Andy Warhol Shop', a cornucopia of consumables. The Andy Warhol Marilyn badge is a snip at 70p.

12th September 1989

VII

MOTHERS

Whistler

RUSKIN'S RATHER TOO FAMOUS attack on Whistler for, as he put it, 'flinging a pot of paint in the public's face', is an insult which can easily be turned into a compliment. How bravely and aggressively modern it makes Whistler sound – and that, rather than its presumed philistinism, is what is really wrong with the remark. It is an indictment that credits Whistler with a recklessness and an abandon which he never actually possessed (and which would have made him a more considerable painter). Whistler did not fling. Whistler arranged.

The most celebrated of his 'arrangements' may also be the most revealing of his pictures because it is the only one in which he confronted his own most pronounced emotional characteristics as an artist: a profound and slightly debilitating fear of things, a wary distrust of the world, of life and light and colour, which both made him who he was and held him back all his life. He called it *Arrangement in Grey and Black*, but the world now knows it as 'Whistler's Mother' and it is currently to be found at the centre of the Tate Gallery's beautiful, exemplary but in the end somewhat dispiriting retrospective of this intriguing artist's work.

The most common misreading of Whistler's best-known picture assumes it to reveal a gap between the painter – the sophisticate and aesthete, the art-for-art's-sake dandy – and his plain old homespun Ma. In fact it demonstrates a secret alliance between mother and son; and there may be a sad and accurate prophecy locked up in the demonstration. Whistler would never quite release himself from the attitudes of the woman who gave birth to him. This tired but alert and deeply Protestant old lady is not only the mother of Whistler but of almost all that he did. She is not a merely quaint misfit affectionately included in his elegant world, she is its only begetter.

Whistler's eternal preference for low tones, his love of monochrome

effects, are seen to have been foreordained in her stern and puritanical dress sense; his nervous, guilty asceticism to have been predicted in her similarly black-and-white resolve not to enjoy anything too much. His reserve and his silence, so much the hallmarks of his mature painting, are shown to have had their origins in her. Whistler was interestingly irritated by those who persisted in seeing *Arrangement in Grey and Black* as the depiction of a person rather than as a pleasing disposition of forms. 'What can or ought the public to care about the identity of the portrait?' he exclaimed, protesting a little too much. Perhaps he found his own picture a little too confessional for comfort.

Whistler remains an enigmatic artist partly because it is so difficult to get to the heart of him – to separate his experiments, with any great degree of confidence, from the works in which he seems most completely himself. The impression given by the Tate's retrospective is, time and again, of an undeniably gifted draughtsman, painter and etcher reluctant to settle to anything for long enough to make it his own. This almost certainly reflects the great difficulty Whistler had in establishing his identity as an artist, which may have been partly the product of his unusually peripatetic early life. He was born in a manufacturing town in Massachusetts, a fact of which he was always rather genteelly ashamed. He first studied art in St Petersburg, where his father worked for a time as a railway engineer; he later moved to Paris where he was a pupil of the minor academic painter Charles Gleyre; and at twenty-five he went to London where he spent most of the rest of his life. Whistler is an artist who still seems for ever caught between things: not really a French painter, not altogether English, somewhat but by no means entirely American. This could have been a strength but it became a weakness.

A contemporary and acquaintance of both Manet and Degas, the young Whistler is conventionally credited with having introduced the British to the new and powerful realism of early modern art in France. What is most striking about the earlier pictures at the Tate is their curious impassivity in the face of what they record. Whistler, an astute observer of the painting of his time, clearly understood as Degas did the tremendous originality and power of Manet's cropped and often almost accidental-seeming habits of composition. His early etchings of Paris and London have precisely that glancing, snapshot quality which

would produce so much of the most extraordinary art of the early modern period – that sense of the city as a disconcerting patchwork of lives being lived, in every corner, too intensely to be ignored and too variously to be comprehended. But somehow Whistler's etchings of unsafe tenement buildings and their occupants, of grim meals eaten in grubby cafés, of backstreet or dockland low-life seem more historically significant than morally or emotionally engaging.

Manet and Degas were never sentimental, but they painted the fragmented urban world of their times like men who were genuinely affected by the mysterious lives of those among whom they moved. Whistler seems indifferent, and perhaps that is what the oddest of all his paintings in the urban realist vein, *Wapping*, betrays. He paints the face of the prostitute, lost in her thoughts while her two male companions talk on, as a blur of boredom and depression. But he does not seem truly concerned by her predicament. There is, if anything, something fatally vague about his rendering of her. Most of the painting is no more than an excuse to linger, with a naturalism that is just as effete as it is attentive, on criss-crossed rigging and creamy sailcloth and all the rest of the dockside's picturesque paraphernalia.

Perhaps to say this is to say no more than what everyone already knows about Whistler, namely that he was an aesthete. He insisted on the fact himself, and the Tate's exhibition demonstrates how quickly he moved away from the painting of the real lives of real people – as if to confirm that he knew he was temperamentally unsuited to their depiction. Whistler, who never could bear too much reality, was much more comfortable painting people as disembodied ghosts, and his most characteristic portraits are *The White Girl* and *The Little White Girl*, those spectres in wedding dresses dreamily regretting lost love and lost virginity. The former once looked radical enough for it to be hung next to Manet's *Déjeuner sur l'Herbe* (at the 1863 *Salon des Refusés*). But now we can see that Whistler's white girl is really just a Greuze girl in Aesthetic disguise, her vanished maidenhood symbolized by fallen flowers instead of a broken pitcher. The fact that Whistler probably meant the reference as a joke (the white girl of the picture was his mistress, Joanna Hiffernan) makes the picture, if anything, even worse.

Perhaps the uneasy mixture of aestheticism and genre painting in *The*

White Girl begins to get to the bottom of what was wrong with Whistler – not that he became an aesthete, exactly, but that he did not become an extreme enough one. His greatest failing as an artist was that he did not pursue far enough any of the various directions he took during his life. He was for ever complicating and diluting things and he never (or only very, very rarely) cut loose and dared to invent a kind of painting that was entirely his own. In fact, he did it only once, during the relatively short period which saw the creation of his most nearly abstract *Nocturnes*.

These are hung, asymmetrically, with loving spareness at the Tate – and they are certainly Whistler's monument. Gradually, he purifies these pictures of symbolical distractions (ships of life and the like) and irritatingly hamfisted *japonismes*, to achieve a form of painting which is genuinely original and which begins to feel compelled, shaped for the first time by some kind of pressing internal necessity. Dark, imposing shapes loom up out of blue or emerald depths, lights twinkle in the fog and the world, purged of people, turns nearly abstract. The pictures also begin to achieve, at last, an unembarrassed sensual character, a melting, trembling, dark-toned liquidity.

Then, inexplicably, Whistler stops painting these pictures and reverts to being a less than convincing jack-of-all-trades. He paints tasteful parodies of a lot of other painters' work and indeed of his own. He creates some magnificent, completely decisive decorative designs – although his best work in this vein, for Aubrey House, and for the Peacock Room, coincides with the *Nocturnes* – but as a painter he is really finished. The last room in the exhibition, in which his attempts to revive English grand manner portraiture produce a series of terminally dull and laboured pictures, seems almost desperate: a sad and painful fade to black.

Why Whistler should have stopped painting his most interesting pictures just when they had become most interesting is a mystery that can never be solved. Perhaps the answer lies partly in their very subject matter. Fog could become Whistler's preoccupation because he was always too nervous to look at the world straight on. He could paint screens of mist and vapour with the rapture that can be sensed in the handful of his best *Nocturnes* precisely because they *were* screens between Whistler and things. But once his preoccupation became an obsession,

it seems he felt compelled to abandon it. We cannot know what made him live his life in such strong and almost continual fear. I think his mother probably knew. But of course it is only a theory.

18th October 1994

Moore

1927: MARY MOORE, huge, heavy hands clasped in her lap, sits and waits for Henry to finish his drawing. There is a hint of impatience in her expression – she fixes her son with a gaze that implies he had better get on with it and no slacking – tempered by definite, proprietorial affection. Henry dwells in some detail on the face and hair. The rest of her, a craggy, considerable bulk swathed in a high-necked, sack-like dress, is accomplished in broad washes of pen and ink.

In Henry's eyes, Mary is both statue and – predicting most of his art – Woman as Landscape. Her shins, joined by taut drapery, are a precipitous climb, her lap a gentle rise. He follows the line of her arms and shoulders with almost topographical fidelity, less portraitist than cartographer, studying the lie of the land, capturing every irregularity of the terrain.

Later, Moore would declare that 'The sculpture which moves me most is full blooded and self-supporting. It is static and it is strong and vital, giving out something of the energy and vitality of great mountains.' *The Artist's Mother* – exhibit 55 of 239 in the Royal Academy's celebration of what would have been Moore's ninetieth birthday – meets all those criteria. She is the original Moore monument.

Moore did not mind admitting he had 'a mother complex . . . She was to me the absolute stability, the whole thing in life that one knew was there for one's protection. If she went out, I'd be terrified she wouldn't return.' Even at its most abstract, the undulating roundness of his sculpture speaks of protection and nurture – a sluggish, monumental softness that was Moore's antidote to the hardness, the angularity, the rush and mechanization of the century in which he found himself.

His sculptures thrive on landscape associations. That puts the RA's 'Henry Moore' at an instant disadvantage. Take his 1938 *Recumbent Figure*, commissioned for a garden in Sussex: Moore conceived the long,

softly rising plateau of her torso and thighs, the rounded bump of her knees and sharp declivity of shins as a response to the rolling vista of the South Downs. Shorn of the landscape context that reinforces Moore's basic premiss – we are part of the world, and it of us – his sculpture loses much of its point.

The RA does its best to stage outdoorness, particularly in the galleries where assorted stately madonnas and bronze abstracts are accompanied by aerosoled simulations of cloud and sky on the walls. The effect, we are assured by exhibition designer Ivor Heal, is based on patterns that adorned Moore's own studio walls. It still looks tawdry.

More damaging, though, this exhibition manages to give the impression of doing justice to Moore while, at the same time, diminishing his reputation. It is certainly not intentional – the organizers have chosen to omit virtually all examples of his more outrageous delegations of responsibility, the studio-assisted, Moore-the-merrier inflations of old ideas to meet civic demand. Even so, he emerges as a distinctly one-track artist. It is all there, effectively, in that drawing of his mother.

Early Moore is resolutely modern, in the post-Cubist, primitivizing sense. In the first room of the show there is a wall-full of stone *Masks*, grim, inscrutable totems based on Mexican, Aztec and Cubist sources. Here, too, you find the earliest of Moore's *Reclining Figures*, the earth mother in prototype – a stern figure, hewn from brown Hornton stone, most remarkable for the treatment of the body as geology, the horizon-line silhouette, the emphasis on mass.

Moore wrote, in 1930, of the 'removal of Greek spectacles' from his eyes. Turning to non-Hellenistic sources, he allied himself with the greatest of the moderns – Picasso of the *Demoiselles d'Avignon*, the chthonic 'bone drawings' and bathers of the 1930s. Yet Moore always swam against the tide of the modern movement. Picasso found in tribal art a brutalist, overpoweringly sexual repertoire of images. His dislocated female anatomies were fraught with sexual threat. They spoke of human aloneness, of fear and incomprehension in the face of sexuality unleashed. Moore's self-appointed task was to salvage a sort of meaning, a sense of spiritual community from such wreckage.

The chief strength of the RA show – which arranges Moore's work, for once, chronologically rather than thematically – is that it allows you a sense of the struggle this involved. At first, in sculptures like the

Four-Piece Reclining Figure, the influence of Picasso lies heavy. Four separate pieces of carved alabaster add up to a sprawling anatomy. The head, a simple globe with crescent slice removed, suggests a scream. It offers a glimpse of the gloomy existentialist that Moore – unlike Francis Bacon – refused to become.

As you move down the years, Moore's sculptures bloom into roundness. Even when they continue to be formed of discrete units, as in the recumbent figures that also recall arrangements of human vertebrae, the impression is of overall harmony. Moore becomes practised in looking on the bright side: in late life, commissioned to commemorate the splitting of the atom, he produced what most commentators have read as a mushroom-cloud-as-skull. But within the sculpture's recesses, Moore couldn't resist offering a measure of comfort, a place of refuge which he talked of as doing justice to 'the positive aspect' of nuclear energy.

'To be an artist is to believe in life . . . In that sense an artist does not need any church and dogma.' Moore was a religious artist living in secular times. Even at its most abstract, his work is rife with Christian overtones: the almost-but-not-quite touching metal spikes of his *Three Points* recall Michelangelo's divine and human finger from the *Creation of Adam*; the totem-like *Three Upright Motives* make up his version of the crucifixion, a modern Golgotha. They are sorrily lumpish, inarticulate sculptures, but they serve as a reminder of Moore's huge ambition. Precision was never his strong point: when called on to carve a genuine madonna, for St Matthew's, Northampton, in 1943, he responded with a lifeless, faintly poignant Mary nestling the Christ child on her lap.

The central icon of Moore's self-invented church was never the biblical madonna, but the biological mother of birth and nurture. It is the *leitmotif* of his art, from the early *Two Forms* – an abstracted pelvic girdle and infantile head, in lustrous Pynkado wood – to the beautiful, late drawing *Mother and Child on Seashore*. In wartime London, Moore consoles himself by sketching in the Underground. His tunnels are wombs, sheltering relays of foetal sleepers.

Later, no longer having an experience as tough as war to work with, Moore often – too often – succumbs to a wishy-washy, well-meaning form of pantheism. It becomes enough to note the resemblance between human forms and landscapes, or between the rump of a grazing sheep and a worn pebble. All Is One, Moore's art declares, with a mixture of

naïvety and portentousness. Spotting, or forcing, equivalences becomes a kind of obsessive hobby. Freely adapting Dürer's great *Portrait of Conrad Verkell*, Moore contrives to turn even this into a landscape, trees sprouting from the bridge of the nose.

Moore's principal failure was his tendency to vagueness. He tended to repeat the same, generalized formulae – shelter and shelterer the favourite – as a form of retreat, a version of pastoral. Get too specific, and uglier truths might emerge. There is something compulsive about his need to people a hostile, threatening world with mothers.

20th September 1988

VIII

CHILDREN

Miró

APART FROM PROVIDING ONE of his more expansively surreal titles, Joan Miró's *Half Brunette Half Red-headed Girl Slipping on the Blood of Frozen Hyacinths on a Blazing Football Field* signals the artist's determination to respond – however circuitously – to desperate times. It is an abrupt, coarse-textured work, in which Miró's characteristic stick-figures and chirpy, effervescently metamorphic creatures have given up their past frolics and become enmeshed in grim, ugly conflict.

A gaggle of Miró biomorphs watch, helpless and amazed, while what you take for the girl of the title – a sort of daddy-long-legs with human characteristics – does the splits and is simultaneously assailed by a large black blob. Even the patchy white ground is a far cry from the consoling, limitless expanses, the vibrant fields of pure colour, that were Miró's characteristic *mise-en-scène* just a decade earlier.

Miró painted the picture in 1937, the same year in which he and Picasso drew international attention to the atrocities of the Spanish Civil War – Picasso with *Guernica*, Miró with a lost mural called *The Reaper* – at the Spanish Pavilion of the International Exhibition in Paris. In the same year, Miró wrote that 'everything that is happening in Spain is terrifying in a way that you could never imagine . . . we are living through a hideous drama that will leave deep marks on our minds.'

It left deep marks, too, on his canvases, to judge by 'Joan Miró: 1929–41', at the Whitechapel. Among other things, this survey of mid-period Miró testifies to his willingness to depart from the precedents he had set himself. Previously, the now-familiar creatures of Miró's invented bestiary – the friendly, bewhiskered squiggles, the animated vegetation, the wriggling hairs – danced to the rhythms of a beneficent, fecund nature. At the Whitechapel, by contrast, his imaginative antennae are tuned to discord.

Nocturne IV, of 1938, pictures a desolate landscape, Miró's Waste

Land. A leafless tree turns predator, trunk arching like a scorpion's sting. At the bottom of the picture, a diagrammatic bird lies prone, felled, presumably, by the boomerang that spins through the painting's dark sky. Elsewhere, in the succinctly titled *Man and Woman in front of a Pile of Excrement*, of 1935, a pair of haunchy, grotesque figures occupy a similarly barren landscape and gesticulate wildly in the direction of an oddly monumental turd on the horizon.

There is something peculiarly archaic about much of this art. Its vision of a harmonious natural order disturbed suggests a much earlier world, every upheaval a portent – the world of Macbeth, with its 'Lamentings heard i' th' air, strange screams of death,/And prophesying with accents terrible/Of dire combustion and confused events.' Misshapen, deformed anatomies abound; Miró's bestiary harks back to its mediaeval origins and turns satirical, implying – most spectacularly in his drawing of a *Nude Woman Climbing the Stair*, with her toothy snarl and massive, Cyrano proboscis – that humanity has turned beastly.

Formulating this art of darkness, Miró gave lasting form to his belief, expressed in 1939, that 'if the powers of backwardness known as fascism continue to spread, if they push us any further into the dead end of cruelty and incomprehension, that will be the end of all human dignity.' His art of the 1930s seems unresolved, incapable of truly coherent protest. He was no Picasso, but there is still something touching about his attempt to make an art so geared to happy-go-lucky inconsequence – and so used to speaking in the vague, oneiric terms encouraged by his contact with the Surrealists – responsive to political realities.

In 1937, when Miró was forty-four, he started attending life classes in Paris; 'Perhaps the events of the time,' he later suggested, 'made me feel the need to get to grips with reality.' He painted the heightened, almost over-attentive *Still Life with an Old Shoe*, which, with its soggy apple impaled by a fork under a lurid, hallucinogenic sky, has been remembered as his *Guernica*. This was about as specific as Miró would ever get. 'The fork attacks the apple,' he said, 'as if it were a bayonet. The apple is Spain.'

The radical changes in Miró's art of the 1930s are not simply down to the force of circumstance. He always resisted settling into the security of a fixed style; he railed against 'artists who begin their shameful decline at the age of thirty'. Seeking to reinvigorate his art, Miró went out of

his way to make things difficult for himself. At the Whitechapel, you find paintings on masonite, scraps of cardboard and ragged, tufty asbestos; Miró's *Head* of 1937 is done, according to the catalogue, in 'oil and turkish towel glued to celotex'. Rudimentary graffiti, scrawled symbols and signs wriggle across these rough, mottled surfaces.

These works are the clumsy, barely articulate fruit of what Miró called his 'attraction to anonymous things, graffiti, the art of the common people'. Miró was, at heart, a primitivist; he believed primitive or tribal art (he included urban graffiti) to be the expression of some primal, irreducible common humanity. It is a little disconcerting to find his slightest effusions – the stick-figures he painted on a housebrick, the mock-Egyptian Miroglyphs on waste-paper – cherished in perspex boxes or housed in tasteful gilt frames. The whole point of them was, originally, their humble anonymity, their mauled appearance a rejection of fine art values. They have survived as trophies, made precious by the Miró label. The primitivist philosophy that went into their creation now seems faintly disreputable, a kind of intellectual laziness that ignores cultural difference and opts for Family of Man simplifications. It is no coincidence that Miró would, later, make murals for UNESCO.

Miró painted his way out of crisis in the late 1930s, in a series of pictures he called his 'Constellations'. On light, diaphanous grounds, a spidery network of lines knits together astral dots, star-shapes and the simplified creatural forms of his original bestiary. Miró transplants his vision of a happy, thronging commonwealth of mingling shapes and forms to the heavens; perhaps it is an admission of just how frail that vision had been in the first place. He saw them as 'shapes and arabesques projected into the air as cigarette smoke which would go up and caress the stars, fleeing from the stink and decay of a world built by Hitler and his friends'. The 'Constellations' are touching but slight, reminders of how simple, not to say banal, Miró's work is at base. As he pieces each 'Constellation' together, linking the biomorphs, joining the dots, you sense Miró returning to the past, repairing the fabric of what had, always, been a childish notion of the world.

7th February 1989

Klee

'IN THE RESTAURANT run by my father, the fattest man in Switzerland,' Paul Klee remembered in his autobiography, 'were tables topped with polished marble in slabs, whose surface displayed a maze of petrified layers. In this labyrinth of lines one could pick out human grotesques and capture them with a pencil. I was fascinated with this pastime; my bent for the bizarre announced itself (nine years).'

In 'Paul Klee' at the Tate Gallery the artist's bent for the bizarre announces itself in *Pierrot's Persecution Mania*, 1924. A barrel-chested doodle of a clown is pursued across ghostly towers and stairways by a cartoon maenad in a tutu. Stranded between one castellation and another, he is, clearly, about to plummet to earth (just beneath his feet Klee has drawn a thick black arrow, pointing downwards, to indicate his fate) but he hovers for a moment, hopelessly defying gravity like Wile E. Coyote over the Grand Canyon.

Oddity prevails in Klee's universe. In another watercolour, a man – the title tells you he is a ventriloquist – walks the gangplank in a landscape of chequerboard abstraction, his see-through body filled with odd, writhing biomorphs. *In Memory of an All-Girl Jazz Band* memorializes the Jazz Age by depicting a Surrealistic trio of musically inclined furies. Rendered in Klee's characteristic smudgy, spider-gone-walkabout line, they look as though they have been drawn in smoke.

Klee's bizarreness naturally endeared him to the Dadaists and, subsequently, the Surrealists, but over the years it has counted against him too. He has been remembered as an influential but incorrigibly slight figure, a cartoon modernist who indulged the least whim of his antic imagination. He compounded the supposed felony of eccentricity by working mostly on a small scale which, along with his preference for the supposedly secondary media of pencil and watercolour, has tended to encourage the idea that he was essentially a *petit maître*.

At the same time, the artist has always had his devotees, a small circle of avid collectors and admirers one of whose number, Heinz Berggruen, has given a large part of his collection to the Metropolitan Museum of Art in New York. Berggruen's Klees, on loan to the Tate until mid-August, add up to a superb and refreshing exhibition which challenges one of the most pervasive and wrongheaded orthodoxies of the contemporary art world. It proves that you do not have to paint big to *be* big; further, it establishes Klee as something of a rarity in the history of modern times, an artist who preserved his sense of humour intact.

Klee was not unambitious for his art. 'Formerly we used to represent things visible on earth,' he wrote, 'things we either liked to look at or would have liked to see. Today we reveal the reality that is behind visible things, thus expressing the belief that the visible world is merely an isolated case in relation to the universe and that there are many more other, latent realities.'

The transition from what Klee called 'visible' to 'latent' realities is dramatized in the early stages of this show. Its first image is a triumph of miniaturization, a fetishistically detailed line-drawing of a row of houses in old Bern which Klee drew in 1893, at the age of 13, on a scrap of paper two inches high by five across: the well-heeled residential world of the Swiss bourgeoisie writ small. It is a drawing that indicates a certain consistency on Klee's part, declaring his commitment to the small-scale, but its neat, orderly picture of the way things are would be shattered by his encounter with the Cubism of Braque and Picasso, and his discovery of the vivid, heatstruck colours of Tunisia.

Hammamet with its Mosque, of 1914, announces a new, shimmeringly dissolved image of the world, a collision of planes and colours where buildings become rough-edged areas of watercolour wash and fields and gardens are remade as a dazzling patchwork of earth-red triangles, yellow stars and green blobs. *Untitled* of 1914 takes Klee's new vision to abstract extremes, setting its quilt of splodgy, abutting rectangles of translucent colour dancing in indeterminate space, as if the tight-knit, angular forms of the Cubists had been shaken loose. Suggesting a bird's-eye-view across fields seen through half-closed eyes it is, also, a paradisial image, the world transmuted by art into a new Eden.

Klee wanted to restore art to a state of innocence. In his own way,

he reactivated the Romantics' old faith in the child's purity of vision –
which so many of his drawings or watercolours seek to emulate – while
pointing the way for the later developments of *art brut* and the calculated
naïveties of Jean Dubuffet. 'I want to be as though new-born,' he pro-
claimed, 'knowing absolutely nothing about Europe, ignoring facts or
fashions to be almost primitive.'

That was, by now, virtually a commonplace of European aesthetic
thought, but for Klee it was more than a received idea. It was his peculiar
achievement to translate the grandest aspirations of the Romantics –
the recreation in art of an earthly paradise, the exploration of sublime
landscape vastnesses or realms of cosmic ethereality – into an art conse-
crated to the childlike. *Libido of the Forest,* with its swirl of scratchy,
scribbled abstract hatchings that still read vestigially as foliage, marries
the naïve and the grandiose – small-scale pantheism, a rough envisaging
of the world as a fertile, writhing flux. Its mobile whorls and coils are
oddly reminiscent of Turner's natural vortices. Caspar David Friedrich's
dark Germanic copses are brought to mind by *Forest of Beauty,* a small
oil which enlivens a gridded chequerboard of colour planes with tiny,
fir tree ideograms, Friedrich's enchanted forest refracted through post-
Cubist space, rendered in jewel-like, enamelled miniature.

Minuteness always suited Klee, partly because he perceived the infi-
nite inherent in 'the visible world' proceeding in two directions at the
same time. On one hand he conjured images of blurred expansion, the
world melting into radiance or repeating itself, *ad infinitum,* in colour
swatch geometry; on the other, taking his cue in part from contem-
porary advances in microscopy, he created a world that crawls with
detail. This is where Klee's line – which he once described as 'my most
personal possession' – takes over from colour, breeding lively, graphic
subcultures of surpassing weirdness.

In *Drawing Knotted in the Manner of a Net,* Klee's join-the-dot whacki-
ness evokes the intricacies of a world invisible to the naked eye: the
long-legged, popeyed things that live in a drop of water, or tiny germin-
ating seeds. His *Abstract Trio* looks like a threesome of dancing microbes.
Klee was nothing if not eclectic, but even his images of the modern
metropolis can suggest a similarly microscopic vision. *Cold City,* which
the Nazis confiscated from an exhibition in Mannheim in 1937 on the
grounds that it was 'degenerate', sets abstracted buildings adrift in space

like settling snowflakes: the city, seen through the Klee-doscope, turns crystalline.

Klee took his art seriously but not too seriously. He often sent up the preoccupations of an era most of whose celebrated figures devoted themselves to *angst* or trauma. The bearded gentleman engaged in his *Analysis of Various Perversities* – who has rigged up a number of peculiar contraptions to measure, among other things, a bird's flow of urine into an angler's keepnet – is presumably Sigmund Freud. Klee's art was always resolutely anti-monumental, preferring to phrase tragedy in the terms of the naïve artist, letting pathos emerge from scrawled effusion rather than six-foot canvas. *Dance of the Mourning Child* – a balloon-headed scribble-girl waltzes melancholically with a peacock feather – is a sorrowful graffito to set against the century's grander statements of human misery.

Klee could, too, dramatize his own quest for higher realities as farce or cartoon caper. In *Tale à la Hoffmann*, the little stick-figure running up a ladder, lost in a labyrinth of odd, Heath Robinsonish plumbing and mechanics, is surely Klee himself. The Hoffmann tale the artist was illustrating tells the story of Anselmus, a young man who tries to gain entry to the heaven of poetry. Klee's heaven is typically, a realm given over to idiosyncrasy, inviting and bizarre – an airy expanse of smudged paper inhabited only by an umbrella on a very long stalk and an ungainly bird.

23rd May 1989

SIX TYPES OF ALIENATION

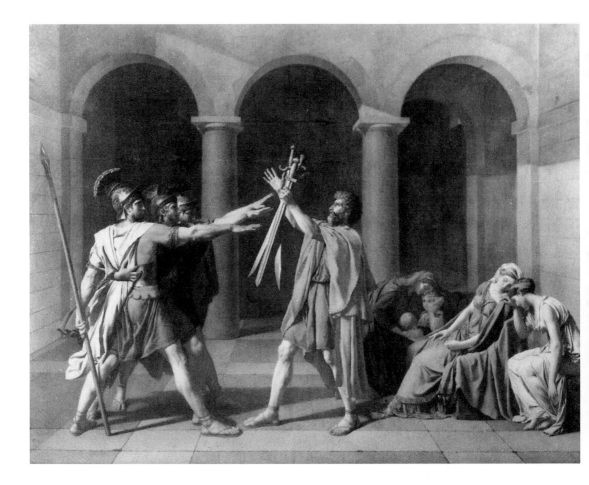

David

SIMPLICITY IS THE KEY – the sudden, stunning clarity of a picture that seems, at a stroke, to do away with the old order of painting and inaugurate the new. In a cold, forbidding atrium, three Roman youths are making a pledge to their father. The physical act that seals their oath looks to the modern viewer like a prototype of the Nazi salute. The embodiment of martial valour, they are presented as a frieze.

The salute is also a reaching out: those three hands, groping in space, await with evidently itchy fingers the three swords that the father holds aloft. To the side, a trio of women swoon or cower with their children, the feminine antithesis to this display of steely masculine resolve.

The Oath of the Horatii, centrepiece of the Louvre's 'Jacques-Louis David', bore no more than a coincidental relationship to the French Revolution, which this show is meant to celebrate. David, brilliant propagandist as he was, would later claim a political significance for the painting, as a proto-Republican manifesto, that it never originally possessed. The *Oath* is, rather, a brilliant, summary image of the Enlightenment, the product of a secular age much preoccupied with the definition of secular virtue. A response to the ethical climate of the times, it is, too, a subversive, difficult picture, and it is this – rather than its status as revolutionary harbinger or supposed invocation to virtue and *amor patriae* – that accounts for its power, its shocking singularity.

Consider the tale that it illustrates. It is not pleasant, nor does it score high on the scale of moral edification. The warring kingdoms of Rome and Alba, embroiled in a trivial dispute over cattle grazing rights, have elected three champions to do battle for each side: for Rome, the brothers Horatii, for Alba, the brothers Curiatii. Matters are complicated by the fact that one of the Horatii is married to Sabina, sister to the Curiatii (the middle of David's three languishing women), and one of the Curiatii is betrothed to Camilla, sister to the Horatii (the woman

closest to the viewer). The whole shoddy story would end in a sequence of bloodily pointless events. The Horatii would kill their three opponents, and when Camilla curses her eldest brother for slaying her betrothed he promptly runs her through with his sword.

David's picture is many things, but it is not the lofty morality painting that it might at a glance appear. It is a picture riven by the moral dilemma it embodies, a painting that opens on to a void. Its subject is, as much as the oath itself, the gap between the men, and the women in it, an awful split between the genders. The men are all action, no feeling; the women, by contrast, have been poleaxed by the strength of their emotions, reduced to a nearly animal state of torpor by the lassitude their role in this senseless tragedy has assigned to them. The *Oath* can, just, be read as an elegy to patriotism, but it is a strangely unpleasant form of heroism that it celebrates – one that demands the absolute suppression of sensitivity, the surrender of personality suggested by that repeating salute. To be a hero, David implies, is to be a clone.

David was fascinated by the seamy side of Roman history. In the last of his pre-revolutionary masterpieces, *Brutus receiving the Bodies of his Sons*. David has again seized on a bloody and unsympathetic character for his hero, if hero he is: the murderous Brutus (not to be confused with Julius Caesar's nemesis), assassin of the king of Rome, Tarquin the Proud, and the man who had ordered the deaths of his own sons for plotting a royalist restoration. Again, the painting centres on a void that dramatizes a breach between the sexes – the gap that separates Brutus, who sits in the shade, brow furrowed, his feet twisted together in what may be an agony of conscience, and the figures of his hysterical wife and swooning, horrified daughters.

The void area that divides the male and female worlds is punctuated by one of the most marvellous passages of painting in David's *oeuvre* – a still life of a sewing basket, painted as beautifully, with as much weight and density as anything in Chardin, which is also a pathetic reminder of the peaceful domestic life that has been so summarily terminated.

David was an almost exact contemporary of Goya, and he is usually cast as the cool, rational antithesis to the Spanish master, painter of darkness and unreason. The Paris retrospective, which gathers together virtually every existing David, conclusively demonstrates the wrongheadedness of such a view. David, at least the pre-revolutionary David,

was an artist plagued by doubts, a would-be Enlightenment moralist whose ethical pronouncements nearly always end in fragmentation and uncertainty.

The tendency shows itself early, in the vast and brooding altarpiece of *St Roch Interceding for the Plague-Stricken* that David painted for the public health bureau of Marseille in 1780. It is a disturbing picture, like the *Oath*, because it focuses attention on the unbridgeable gap between the two halves into which it divides. The upper half contains a dull, workmanlike madonna after Poussin. The lower half contains the figures of the plague-stricken and is dominated (as is the whole picture) by a full-length male nude who glowers out at you with implacable, incurable despondency. It is a picture that signals David's complete lack of religious faith (there is no suggestion that his unreal, cut-out madonna can do anything to help those who exist in such a different world from her) and also an emblem of the painter's own doubt, the tensions he so often sets up within his official iconographical schemes.

David was liberated from uncertainty by the French Revolution. 1789 gave David a cause in which he could believe unquestioningly and he embraced it with what a mixture of crazed enthusiasm and relief. The Revolution enabled David to revisit the theme of the *Oath* and purge it of ambiguity by omitting the troubled female half of the equation. He sketched *The Oath of the Jeu de Paume*, depicting the oath-taking members of the Third Estate as the Horatii multiplied. As pageant-master of the Revolution, he devised elaborate festivals in which multitudes of newly Republican Frenchmen struck the pose of the Horatii. While reality resolved the doubts in his art, he felt confident enough to remake reality in the image of his own painting. During his revolutionary years, David acquired a new certainty and confidence. His masterpiece is the funerary portrait of *Marat*, in which he managed to turn a leprous maniac stabbed in his bath into a marble-skinned martyr, a secular *pietà*.

After his denunciation and imprisonment, in 1794, there was something missing from David. He adapted, indeed became first painter to Napoleon, but both the tension and the fervour left his art. He fulfilled his Napoleonic commissions with what seems like a stunned, mechanical obedience exemplified by his picture of Josephine's coronation, a vast group portrait muffled in the red velvet of Napoleon's imperial

style, the *style troubadour*. It seems significant that his great project of these years should have been the *Leonidas at Thermopylae*, a parable of stoic fortitude in the face of certain defeat (Napoleon, predictably, hated it) and his last transformation of the *Oath*, whose saluting figures turn philosophical, pledging only their calm acceptance of impending death.

David had one last, strange trick up his sleeve. Exiled to Brussels after the fall of Napoleon, he painted a series of truly weird mythological paintings. They culminated in *Mars Disarmed by Venus and the Graces*, a quite ludicrous confection in which a gaggle of marmoreal maidens cavort around a bedridden god of war in front of what looks like an airborne Empire fireplace. David, tense and humourless David, seems at last to be cracking a weary smile. Having spent his life puzzling over or fabricating myths of one sort or another – the Enlightenment myth of absolute virtue, the Revolutionary myth of social transformation, the Napoleonic myth of omnipotence – David turned his attention to mythology itself. He made a joke of it – and a joke, this garish, sublimely horrible painting suggests, in the worst possible taste.

12th December 1989

Sisley

PISSARRO CALLED SISLEY 'the typical Impressionist', but this has come to seem more of a weakness than a strength. While his colleagues in the movement experimented with other styles, other subjects, Sisley remained the solid, reliable club secretary of Impressionism. His life sometimes seems to have been one long riverbank excursion, devoted to the memorializing of one transitory 'impression' after another. Sticking to his *plein air* strategies, Sisley continued to register strength of breeze, agitation of foliage and water, disposition of clouds, right to the end.

Thirty years after Sisley's death, H. R. Wilenski wrote an article called 'The Sisley Compromise' in which he rested the case for the prosecution: 'Sisley was never sensational or vulgar. He kept the tones and planes in excellent relation. He had sensibility, good taste and pictorial tact. But he was not a great and original master; he was not a Monet, a Seurat, a Degas or a Renoir.' It is hard to think of a better demonstration of how to damn someone with faint praise.

'Alfred Sisley', at the Royal Academy, sets out to reopen the Sisley case, to prove that he was a more complicated artist than his reputation might suggest. Sisley's preference for pastoral over urban subjects, it is argued in the catalogue, gives his art 'a particular relevance for us today'. He is cast as an artist whose concerns foreshadow those of the contemporary environmentalist lobby. You could as plausibly (or implausibly) argue the case for just about every landscape painter in history but Sisley *is* a fascinating artist, precisely because he is the most typically Impressionist of the Impressionists. His painting demonstrates, with unusual clarity, the peculiar problems and anxieties implicit in such a reputedly carefree approach to painting.

The earliest works in the RA's exhibition show Sisley starting out as a painter of lyrical, wistfully poetic landscapes in the manner of Corot,

and as a painter of densely worked scenes of village life patently indebted to Courbet. The tonality of these works is almost overbearingly dark and their mood is equally sombre and austere. *Village Street at Marlotte, near Fontainebleau* is a dour little painting of a labourer chopping wood under a cloudy sky. The woodcutter, whose face has been left blank, is painted more as a thing than a person, and he seems hemmed in by the flinty world of stone walls and squat, heavy houses that he occupies.

There are no people at all in another early work, *Avenue of Chestnut Trees near La Celle-Saint-Cloud*, in which the artist contemplates the dark vista down an overgrown woodland track with only a nervous deer, in the middle distance, for company. This is a sullen, late Romantic painting, which pictures a natural world that seems hostile or at best indifferent to man. Sisley's melancholia may seem to have been dissipated in his later work, where the vigour of his Impressionist technique can easily pass for a form of happy-go-luckiness. But maybe it did not, ever, entirely go away and merely took a different form.

The Bridge of Villeneuve-la-Garenne is one of Sisley's best-known Impressionist paintings of the early 1870s. It is a sunny, apparently untroubled picture of just the kind that has made Impressionist art so enduringly popular, so appealing to the escapist sensibility. Under a blue sky across which a few wispy clouds are scattered, Sisley notes the sun-struck creaminess of the white house on the riverbank opposite him, the pair of women on holiday taking a boat trip down river and, in the shade of the stone and cast-iron bridge next to which he has set up his easel, a couple enjoying a picnic.

Yet this exhibition also suggests that Sisley's concerns ran deeper than the merely literal. As you progress through the show, you begin to notice how often Sisley places himself at a distance from the scenes which he observes, how frequently he interposes a barrier of one kind or another – sometimes a river, sometimes a patch of waste ground, sometimes a stretch of empty road – between himself and his subjects. It could be argued that this habit is merely the manifestation of Sisley's compositional preferences, that distance enabled him to frame a view as he pleased. But there may be more to it than that.

Throughout Sisley's *oeuvre*, there is a strong sense of the artist as someone peculiarly aside or apart from his own subject matter. Physical distance reads as a metaphor for emotional distance. This is most

apparent in his many paintings of light industrial labour set along the canals and rivers near Paris. In *The Seine at Port-Marly: Heaps of Sand*, Sisley's view of the men in their boats, dredging the river, is partially obscured by two mooring poles, while the right side of his painting is occupied by the object of their labour, the heaps of sand of the title. The painting sets up an implicit contrast between the useless activity – art – of which it is the result, and the busy scene of labour which it records. You wonder quite what the artist was doing here, and why he felt impelled to paint the subject. How, exactly, does the painter fit in?

That question is never quite answered. The involuntary subject of Sisley's art might be said to be the artist's own sense of his own root-lessness, and a consequent uncertainty of purpose. Sisley's freshness of response, reflected in the dabbed, flickering skeins of paint with which he improvised his visions of the world, can seem wearying, precisely because of this. Sisley gets the job done, over and over, but still you are left wondering what it all adds up to, what purpose these views of riverbank idylls, of parks and gardens and fields might have. Optical truth to the facts of nature, the usual Impressionist justification, will not quite do.

If Sisley is the quintessential Impressionist, the lesson of his art is that Impressionism naturally creates, in its practitioners, an uncertainty of purpose and a sense of never quite belonging in the world. The idea that art should consist of an infinitely sustainable sequence of 'impressions', relayed in paint, is implicitly alienating. It defines the artist as a kind of mechanical sensorium whose job it is to record the optical phenomena which he encounters; and it means that the artist will always be con-fronting a world which his own activity (which is to look and note, rather than to participate) separates him from.

It is no coincidence that Impressionism's favoured subjects are the picnic and the daytrip. These are the leisured, respectable forms of Impressionism's true subjects, which are transience and vagrancy. Impressionism condemns its artists to be constantly on the move, con-stantly seeking out new, ephemeral 'impressions' to paint. Many of Sisley's pictures covertly acknowledge this by focusing on roads or bridges, paths or rivers: emblems of the Impressionist's own activity, which is perpetual travel, a constant uprooting of the self in search of subject matter.

Despite the general sunniness of the scenes Sisley painted, his art is permeated by an unusual, subtle form of melancholy, a sense of sad abstractedness from the world re-created in paint. Just occasionally, this comes to the surface in works that have an almost Symbolist undercurrent of mystery and alienation. *Snow at Louveciennes*, which pictures the small, distant figure of a woman walking away from the painter down a snow-muffled village street, is a work the subject of which seems to be, precisely, *not knowing* another person, not knowing where she is going or why. But much the same sense of incomprehension and distance is implicit in more cheerful works like *Villeneuve-la-Garenne*, where you find the painter, on one side of the river, all alone, contemplating a number of large and graceful summer residences lit by afternoon sunshine on the riverbank opposite. Figures wander up and down, but far away. The painter is a voyeur, peeping through the keyhole of lives he cannot share.

This may explain Sisley's anxious habit of thoroughness, his tendency – manifest, most conspicuously, when he visited Hampton Court in 1874 – to paint series of pictures that amount to visual catalogues of entire locales. Sisley, here, is like the tourist who compensates for the knowledge that he has not really known a place by taking photographs of everything in sight. Painting, for Sisley, becomes a retrospective proof of presence, a confirmation that, yes, he actually was there. But the paintings also betray, whether involuntarily or otherwise, the loneliness of the solitary tourist which Impressionism makes of the painter. *Hampton Court Bridge: the Castle Inn* is predicated on a void, a large area of sand-coloured path whose emptiness is relieved only by a few, self-possessed pedestrians studiously ignoring the artist.

Impressionism, in the work of its most typical practitioner, could even be said to be existentialism before the fact. After all life, according to Impressionist theory, is converted into a disconnected sequence of meaningless visual experiences. But maybe it is more accurate to say that Impressionism is existentialism in disguise, since if it presents a world that is merely an agglomeration of optical facts, unburdened by religious or moral or social significance, it also pretends not to worry about the implications of such a conception of things.

This may, in a roundabout way, explain the intensity of what are among Sisley's last paintings, his sequence of views of *The Church of*

Notre-Dame at Moret-sur-Loing. They are directly comparable with Monet's famous series of paintings of Rouen Cathedral, although what they attempt is, in fact, the precise opposite. Monet famously remarked that 'the motif for me is insignificant – what I want to reproduce is what there is between the motif and myself', and he painted the façade of the cathedral accordingly, registering it not as substance but as a kind of infinitely malleable, almost molten plasma, subject to infinite variability according to the weather, the season and the time of day.

But although Sisley also painted the church at Moret on many different occasions and under very different conditions, what comes across most vividly from his pictures is not the volatility and mutability of the motif but its tremendous, craggy solidity, its presence as an unchanging physical fact. Sisley even reneges, here, on his characteristic style, developing a technique much heavier, more substantial and impasted. The associations of his subject may not be irrelevant. Perhaps the church represented, for Sisley, everything that his Impressionist precepts denied him: a sense of firm purpose in the world, a sense of community, a sense of continuity and, above all, of enduring, and belonging, in just one place. The church at Moret, painted by Sisley, becomes more than itself. It is a compensating fantasy of permanence, of inhabiting rather than touring the world.

14th July 1993

Gauguin

NEAR THE END of the superb, once-in-a-lifetime Gauguin exhibition, currently at the Grand Palais, you find the artist's *Christ in the Garden of Olives*. Despite the title, it is a self-portrait (that long, uneven jaw-line, that crooked blade of a nose are unmistakable), an image of the artist as a misunderstood genius. Downcast, he crouches alone in a landscape of desolate simplicity, its windblown olive trees flattened patches of colour on an empty horizon.

Gauguin painted *Christ in the Garden of Olives* in 1889. Fourteen years before his death, in desperate circumstances, in the South Seas, he is already making out his itinerary. 'There is a road to Calvary that all we artists must tread,' he wrote to Van Gogh, as a gloss on this painting.

Gauguin happily contributed to the myth of Gauguin – the man with a one-way ticket to tragedy, crucified by the intensity of his desire for a life and art of primitive simplicity – which would feed the kind of bio-pic sensationalism through which the twentieth century has had its perception of so many great artists filtered. But the 250-plus exhibits at the Grand Palais – including many loans from the USSR which have not been seen in the West for years – suggest that the truth about Gauguin was both more complicated and more interesting. He emerges as an artist whose brilliance was always shot through with doubt, whose quest for the unspoiled Eden of his imagination led him, in fact, to a place and an art that proved far less simple than he had hoped.

Early Gauguin is characterized by the kind of derivativeness, the reliance on a *mélange* of precedents, that you might expect in an artist still struggling to find his position. *Apple Trees in the Hermitage Neighbourhood of Pontoise* is characteristic – Gauguin-Pissarro, a sun-dappled orchard rendered in a flickering network of feathery brushstrokes that pays homage to Gauguin's first mentor both in its style and in its setting, a favourite Pissarro haunt.

The chronological display of the exhibition suits the nature of Gauguin's art, which is marked by sudden, dramatic advances, generally stimulated by changes of scene. In 1886, Gauguin moved to the remote village of Pont-Aven, near the southern coast of Brittany, which he liked because 'it is savage and primitive. The flat sound of my wooden clogs on the cobblestones, deep, hollow and powerful, is the note I seek in my painting.' Gauguin painted what he thought (wrongly) was a pre-industrial paragon of the simple society, with its quaintly coiffed peasantry, its folk superstitions – but his style remained, essentially, that of late Impressionism.

The real catalyst for Gauguin's breakthrough to a 'savage and primitive' style was not Brittany, but Martinique, which he visited briefly in 1887. His *Tropical Vegetation* is a landmark painting, Gauguin's first true break with assumptions from which he had already begun to dissent. He paints the Caribbean answer to Europe's Bay of Naples – a coastline that curves, in brilliant blue outline, to the horizon, seen through a foreground thicket of vegetation – and he does so in a way that is quite new in the history of painting. There are vestigial traces of the Impressionist manner, in the dabs and flicks of paint that capture the play of light and shade in the foreground, but most of the picture registers the landscape in those flat, patchy areas of unmodulated colour that have been Gauguin's most abiding formal contribution to the art of this century.

Back in Brittany, Gauguin consolidated his apostasy from Impressionism – an art 'without freedom, retaining the bonds of verisimilitude' – by evolving a style and a subject matter that were increasingly detached from perceivable realities, and increasingly mystical in their orientation. Paintings of the late 1880s, like *The Vision of the Sermon (Jacob Wrestling with the Angel)* and *Yellow Christ*, amount to an assault on post-Renaissance tradition.

The subject, in both cases, is meant to demonstrate primitive Breton faith, a scene – the wrestling Jacob and the angel, on a shocking field of red; the stark, yellow figure of Christ on the cross – which exists not in reality but in the inflamed imagination of the Breton peasants who crowd the foreground of each painting. Art, Gauguin suggested, should stop trying to capture the minutiae of perception and explore, instead, the primitive heart of mankind. Pissarro, whose Impressionism

was always allied with a positivist faith in precise observation, was shocked. 'This is a step backward,' was his terse verdict.

Yet Gauguin's art was always paradoxical, in that its evolution towards a supposedly pure, primitive style was immensely culturally sophisticated. Gauguin got his linear simplifications, flattened perspectives and areas of pure colour bound within a tight linear structure from a vast repertory of sources: the Japanese print, popular graphic art, and the presumed primitives of the Western tradition, the Byzantines and, after them, Giotto. He dreamed of creating an art that would be 'Japanese, but seen through the eyes of a Peruvian savage'; he seems to have felt, for a while at least, that such a multi-cultural hybrid of styles and sources could isolate some primitive essence of Man. He painted several (Japanese-ish) pictures of a female figure plunging into frothy surf, embodying his dream of a return to primal origins.

The story of Gauguin's attempt to live that dream – his voyages to Tahiti, separated by a brief, glum interlude back in France – is well known. He becomes the painter of dusky Tahitian Olympias, the transplanter of Christian mythology (as in *Ia Orania Maria*, where Tahitian natives stand in for the Holy Family) to foreign climes. These paintings represent Gauguin's most lasting achievement; in them, you sense Picasso and Matisse waiting to happen. Yet what impresses most about the later, mature Gauguin, is the mood of doubt that creeps into his vision of a putative Eden. If Gauguin is a great artist, it is because he has the courage to face up to the false premisses of his original primitivism. In Tahiti he finds, not Man (and Woman) stripped to some original essence, but something less comfortable and certain.

Gauguin went to Tahiti, he told a journalist before he left, to make 'simple, very simple art . . . to immerse myself in nature, see no one but savages, live their life'. Yet Gauguin's South Sea paintings come to dramatize the gap between his dream and what he found. Gauguin's mythological transplants – his Tahitian Holy Family, or the riders that prance along a violet beach like fragments of the Parthenon frieze – seem to symbolize what he came increasingly to see as a failure of fit between European myth and tropical reality. Gauguin tries to sustain his faith in the idea of Tahiti as a simple, primitive culture, but the strain shows. There turns out to be virtually no indigenous art there, so he makes his own, carving idols in wood, creating his own, 'savage' *mise-en-scène*.

Gauguin's numerous paintings of his various Tahitian concubines are never, merely, images of exotic sex-objects – rather, these are brooding, melancholy, silent figures whose interior life remains a mystery to the painter. Their crises, the sudden accesses of superstition to which they are subject (depicted most famously in *Manao Tupapau*, its recumbent figure paralysed by fear of the evil spirit in her imagination), are painted as mysterious emotional events that the painter himself cannot hope to partake in or understand. In retrospect, even Gauguin's earlier paintings of Breton Christian mysticism seem tinged with the artist's sense of exclusion from the experience he records – they are paintings of *other* people giving in to the urges of faith.

At the same time, Gauguin's increasing radiances of colour, his near-abstract treatment of sky, sea and land, merely heighten the sense of mystery, of the impenetrably exotic. The sheer, irresistible gorgeous-ness of these paintings is, also, poignant – a melancholy luxuriance, Gauguin's palliative to incomprehension.

One painting, of Gauguin's first Tahitian mistress, Tehamana, seems especially significant. She is surrounded by the attributes of her alien-ness – a frieze inscribed with indecipherable glyphs, and carved with Buddhist figures. She wears a starched, high-necked missionary dress, a Western garment that merely increases the distance between her and the West – and, by implication, Gauguin himself. He called the painting *Tehamana Has Many Parents*, which amounts to an admission that the people Gauguin found on the rim of the world were just as freighted with cultural history, just as complicated, as Gauguin himself. Half-smiling, she's the symbol of the enigma that the South Seas, in the end, posed for Gauguin – a Tahitian Mona Lisa.

24th January 1989

FILLE NÉE SANS MÈRE Picabia

Picabia

FRANCIS PICABIA WAS NEVER your average modernist revolutionary. He was extremely rich, for one thing, the son of a Cuban-born Spanish aristocrat, and irritated most of his contemporaries in Dadaist and Surrealist circles by leading a dual existence, artistic anarchist and big-spending socialite rolled into one. Picabia collected fast cars (he is said to have owned over a hundred, including several Hispano-Suizas and a 40hp Rolls-Royce) and women with an almost absurd, Don Juan-like profligacy, which was mirrored in the free-wheeling vagrancy of his art.

Always a natty dresser, he once remarked that 'If you want to have clean ideas, change them as often as your shirts.' 'Francis Picabia, 1879–1953', the main exhibition at this year's Edinburgh festival, is bewilderingly varied – a series of quick-change routines so frequent and radical as to make it scarcely credible as a one-man show.

Picabia's first change of direction was triggered by his trip, with Marcel Duchamp, to New York in 1913. The only pre-New York painting in Edinburgh is *La Source*, a Cubo-Futurist orgy of forms, half human, half mechanical. Sex and machines always fascinated Picabia; in America he was roused to combine his twin concerns in a more radical, less derivative fashion. In New York, he later wrote, 'it flashed upon me that the genius of the modern world is in machinery and that through machinery art ought to find its most vivid expression.'

Picabia, a confirmed nihilist, used machine imagery to express his lack of faith in mankind's moral or spiritual dimensions. His work came to consist, largely, of crude mechanical diagrams with overt sexual connotations: doing away with fine art, he abandoned painting as such for the mock-blueprint, designing a *vagina dentata* of grinding cogs, or engineering amorous couplings of piston-rod and cylinder. At around the same time, Picabia made his famous *Portrait of a Young American*

Girl in a State of Nudity – a drawing of an Ever Ready spark plug. It is easy to forget, after this century's multitude of 'radical' gestures, the shock value such images must have had in its early decades. With Duchamp – creator of the most famous mechano-sexual art work, *The Bride Stripped Bare by Her Bachelors, Even* – Picabia junked the whole humanist tradition of art, casting man and woman as unreflecting sexual mechanisms, mere slaves of desire.

In the mid–1920s, while Duchamp gave up art and devoted himself to chess, Picabia – after a brief involvement with the Dada movement in Zürich – drove off, with a toot on the horn of his Hispano-Suiza, to the South of France. There he led an increasingly detached and eccentric existence. At one time he had a racing car attached by a rotating arm to the top of a tower on his estate in the Midi, a customized fairground attraction in which he whiled away the time by whizzing round and round in mid air. He made art only sporadically, in moments snatched from the whirl of his other activities.

Picabia's later work – dismissed, until now, by most art historians – was a series of arrogant, tossed-off gestures of contempt for the modernist mainstream. The Surrealists' use of *objets trouvés* is parodied in *Plumes*, in which twigs, bits of pasta and feathers are bad-tastefully arranged to form an anodyne landscape with palm trees. Adopting the self-proclaimed 'revolutionary' tactics of doctrinaire Surrealism, Picabia enlisted them in the service of a knowingly vacuous, sinking-to-kitsch realism. In *The Three Graces*, he targets Picasso's cult of the demonic *femme fatale*, producing a haunchy trio of Picasso-like maenads, less graces than goofy, caricatured versions of Macbeth's witches.

Later Picabia is unashamedly slapdash. In the late 1920s he announced his desire 'to achieve something quickly and out of control . . . of poor quality, that glitters. Much later, his art became something of a *cause célèbre* among Pop Artists, equally enamoured of trivia, of kitsch tackiness.

From the vantage point of the late 1980s, Picabia's most up-to-the-minute creations seem his 'Transparencies', paintings that look like X-ray photographs of paintings, in which layered images, loopily mingled, compete for precedence. Saint Sebastian, pincushioned martyr, coexists uneasily with an Ingresque nude in one of Picabia's characteristic marriages of sanctity and voluptuousness; in another Madame Picabia,

painted as a saint *à la* Murillo, eyes tilted heavenwards, is demeaned by the ghostly, overlaid hands that fondle her neck and bust.

These pictures account for the recent resurgence of interest in Picabia's later work. They make him, it is argued, the natural ancestor of the modern 'appropriationists', the image-scrambling brigade of Sigmar Polke, Julian Schnabel, David Salle *et al.* (Salle has even had a two-man show with the extremely late Picabia.) It is a convenient reading, in commercial terms, since it boosts the marketability of all artists concerned. Picabia becomes, not the solitary eccentric of old, but father of a school, while his younger followers become worthy heirs to an overlooked modernist tradition.

For all that, the comparison – made, several times, in the catalogue to this show – seems forced. The new 'appropriationists' go about their business, magpie-like, in order to point out the collapse of a dominant visual tradition, its replacement by the mass media's errant, channel-hopping Babel of images. Picabia's superimpositions and defacements seem to reflect, rather, the workings of his antic imagination; the 'Transparencies' are exercises in free-association, irreverent send-ups of, for the most part, church iconography. Picabia's 'Transparencies' show him to have been rather closer to the Dadaists and Surrealists than he liked to let on.

In the last decade of his life Picabia's stylistic inconsistency seems to have become even more manic and unpredictable. He painted garish, come-hither nudes on B-movie poster principles, tailor-made for the walls of some greasy taverna in the Mediterranean? He painted the vaguely sexual curves and bulges, the unmistakably phallic protuberances that emerge from dense, clotted abstract grounds? He painted still more clogged abstractions that immediately precede his death, with only the odd astral configuration of dots relieving their impasted mono-chrome. Satirical intentions may be assumed: Picabia crashing through the gears, accelerating from one modernist pastiche to another; having a go at, in turn, the figurative art of the 1940s, the biomorphic and subsequently interstellar abstractions of the New York School, of Gottlieb, Newman, Pollock and company.

Style is an artist's rationale, his way of imposing form on the world's chaos. Near the end of his life, Picabia, the styleless artist *par excellence*, wrote a short poem in which he declared 'My life has passed / I searched

and did not find / It was grief and error.' Devoting himself to parody, Picabia turned himself into the modern movement's court jester, a knowing Fool who saw the business of making art as, in the end, plain ridiculous. 'You die as a hero or an idiot,' he said, a nihilist to the end, 'it's the same thing. The only thing that is not ephemeral is the word death.' It seems entirely appropriate – at a moment when much art seems to dwell, obsessively, on the idiocy, the vacuity of contemporary culture – that Picabia, the self-confessed idiot, should be rediscovered as a hero.

23rd August 1988

Giacometti

A WONDER THAT they can stand at all, let alone stand to attention as they do. Thinner than anorexic, their defiance of their own frailty is what impresses: their eyes-forward, chin-up determination simply to exist. Bits of them are missing – part of a leg, or an arm – but that is no surprise under the circumstances. They have been through a lot. They are graduates of one of the most punishing physical regimes of modern times: the Alberto Giacometti Total Fitness Programme. They might only be works of art, but other sculptures would have crumbled under the strain.

Standing Women prove that the G-Plan diet was nothing if not demanding: slim, slim again and then slim some more, until there's almost nothing left of you. More than twenty of these almost nothings can currently be seen at the Tate Gallery, Liverpool, in what is itself a slimmed-down display of the artist's later *oeuvre*.

Alexander Libermann, who visited Giacometti in Paris in 1960, described the single room where the artist lived and worked as a monastic retreat, its walls stained a dispiriting grey by a lifetime's chain-smoking. Libermann was particularly disconcerted by a multitude of 'long, narrow, life-size figures of white plaster' which seemed to him 'like apparitions from another planet'. There are some photographs of Giacometti's studio in the current show, but what counts now is the work rather than the milieu in which it was created.

Giacometti's figures look like survivors, figures persisting on the brink of extinction. The tiniest of them, the *Four Figurines on a Base*, are almost miraculously attenuated. Blink and they might disappear altogether. They are the products of what can seem a bizarre notion of figurative sculpture, the chief preoccupation of which is not, in fact, the human figure, but the space that envelops it.

No one has ever made figures that seem more alone, or more

threatened by the condition of solitude, than Giacometti. Like a lot of artists, he admired the work of others when it seemed most nearly to address his own concerns.

He liked the engravings of Jacques Callot on account of their 'multitude of minuscule people emerging from white space', and for their creation of 'a great gaping void in which gesturing figures are exterminated and abolished'. Giacometti was describing his own work.

Few artists have worked on quite such a tiny scale as Giacometti. At one point in the early 1940s, he recalled, 'All my figures stubbornly shrank to one centimetre high. Another touch with the thumb and whoops! no more figure.' He worked in Switzerland, his country of birth, during the Second World War, and in 1945 found he was able to take his entire output of four years back to Paris in his trouser pockets.

Giacometti made larger works too, but his smallest and frailest works are his most ambitious. The poses struck by the *Four Figurines* suggest that they are meant as anything but slight. Their erect bearing, arms by their sides, gives this work a sense of momentousness quite at odds with its size. It is as if you are being invited to inspect a monument – though to what, or to whom, remains unclear – through the wrong end of a telescope. The sculpture might easily be mistaken for a model for a much larger project – and indeed Giacometti's handling of material, his pinched and kneaded forms cast in bronze from the most fragile of plaster originals, is reminiscent of the maquettes of heroic monumental sculptors like Rodin or Giacometti's own master, Bourdelle.

But it is a finished work. Giacometti's distressed, miniaturized monument is a reproof of the tradition it occupies. Monuments commemorate people and enshrine civic ideals. They crystallize the past, freeze it into a series of historic moments and by doing so make sense of it. They tell us comforting stories about the world and its main actors. But for Giacometti history is an irrelevance and so there can be no main actors.

His memorials to unknown, unnamed people are democratic and at the same time curiously unconsoling: his figures are dwarfed by the world rather than masters of it; they play no vital role in any heroic narrative. This is as true of his larger works as it is of the tiniest: none of his emaciated crew, even the taller, gesticulating men, can be said to

be doing anything to much purpose. But this is why his work came to seem so meaningful to Giacometti's contemporaries, and to subsequent generations.

Giacometti gave visible form, and a new consequence, to modern man's sense of his place in the order of things – or, rather, he gave form to modern man's sense of placelessness. It has become a cliché to speak of Giacometti as an existentialist sculptor. But the facts remain that his mature work was created in existentialist Paris, and that his closest friends – Jean-Paul Sartre and Samuel Beckett, for whom Giacometti worked on the first set for *Waiting for Godot* – were the creators of the philosophy and literature of the absurd. Sartre wrote one of the most acute appreciations of Giacometti's later work: 'between things, between men, connections have been cut; emptiness filters through everywhere, each creature secretes his own void'.

Yet Giacometti's art is at least as rooted in art as it is in philosophy. The figures in Giacometti's portrait paintings, which emerge like spectres from murky grounds, represent a draughtsman's reinterpretation of Cézanne. Cézanne's jostling planes are translated by Giacometti into a corresponding uncertainty of line. Giacometti's dense, scribbled physiognomies are, famously, the products of month upon month of reworking, and what this suggests (Giacometti has this too in common with Cézanne) is an artist deeply aware of the paradox of his enterprise – of the fact that something as mobile as a human being can never be captured in paint.

Existential man, as conceived by Giacometti, is a frail creature, but he is not an entirely new invention. Giacometti's figures, which seem eaten away by the air that surrounds them, contain dim reminiscences of Rembrandt's paintings. Meant as *mementi mori* – Giacometti once said that he saw people as 'skeletons in space' – their handling recalls the extreme chiaroscuro of Rembrandt, a device which implies the malleability of flesh, its vulnerable softness. Giacometti's figures also evoke the memory of Baroque grotesques and of the metamorphic statuary still commonly encountered in Italian gardens like the Boboli. Giacometti's stalagmitic figures seem mineralogically unstable.

What is most memorable about them, though, is their extraordinary thinness. Their thinness was Giacometti's signature, but it was also his way of giving expression to his one insight. In Giacometti, more

completely than in any other modern artist, we find an old western conception of space finally replaced by its opposite.

Think of those spaces furthest removed from the voids of a Giacometti exhibition. A Gothic church interior might be a good example. There, everything is ordered; everything takes its place within a theological structure – evident in paintings, carvings, stained glass windows – that leaves no room for doubt about man's place in the universe. Now think of a room full of Giacomettis. No stories, no iconography; just these skinny, divining-rod figures, stranded in an abyss of thin air. When we exchanged faith for faithlessness we exchanged one way of thinking about space for another. Claustrophobia gave way to agoraphobia. Fear, in the end, was Giacometti's theme: the fear of open spaces.

16th April 1991

Freud

JUST WHO DOES LUCIAN FREUD think he is? A bit of a devil, on the evidence of his most recent self-portrait. *Painter Working, Reflection* is Freud turning the tables on Freud: the observer observed; the painter of nudes painted in the nude. It is not a pretty sight.

Freud looking at his own reflection sees a pallid satyr getting on in years, palette in one hand, palette knife in the other. Self-observation is tinged with self-mockery. Painting himself, the painter acknowledges his own mortality. Under the glare of an electric lightbulb in a barely furnished interior he looks himself in the eye.

Freud's self-portrait (like all self-portraits) is not just a painter's record of his appearance but a statement, for the record, of how he would like to be remembered: an artist who did not flinch from reality, not even the reality of his own encroaching decrepitude; a man who faced facts. Freud is often said to be a deeply reclusive man but he may not be quite as shy of publicity as his reputation suggests. *Painter Working, Reflection* is a subtle exercise in self-promotion and although it might ostensibly be a *vanitas* there is nonetheless a kind of vanity behind it.

The picture is by some distance the most remarkable work in 'Lucian Freud: Recent Works', at the Whitechapel Art Gallery. It is one of those singular paintings that artists sometimes paint: an oddity, a freak – which, precisely because it departs so radically from the norm of a painter's practice, makes the qualities of the rest of his *oeuvre* suddenly more apparent.

Comparing Freud's painting of himself with Freud's paintings of other people you notice the extent to which he has, here, relaxed the conventions of the Freud portrait. Freud by Freud differs vigorously from the nude men and women in his other pictures, those listless and saddened creatures who stare, for the most part, blankly into space. The only form of sentience allowed to them is a perpetual stultification

shot through with a deep and implacable melancholy. The people Freud paints take refuge in, or are seen to have regressed to, a mute and animal form of existence. They stand, heavy-footed, as patient as cattle; they slump in chairs, overcome by tedium; they sprawl on beds and sofas, hopeless prisoners of the studio.

Freud by Freud, however, is a picture not of the tyrannized but of the tyrant himself. Not for him the dejected passivity of his other sitters, their hangdog resignation to the terrible *longueurs* of inactivity to which his scrutiny has condemned them. He paints himself as a mischievous deity, the artist as shaman-cum-showman, waving his palette knife like a wand. There is truculence and a kind of satanic good humour in his gesture and his expression. His body is lithe, sinewy, wirily active. He is the only person in the long, long gallery of Freud's portraits who seems to have much spirit.

Painter Working, Reflection is a tough act to follow, because it implicitly sets the rest of the paintings in this exhibition the task of living up to the claims that it makes for Freud's capacities. It casts Freud in the role of artist-god, a painter who is also a magician, a conjuror of life from inanimate matter. Freud is known to admire Velázquez above all other artists, and when asked to explain that admiration he is in the habit of quoting Ortega y Gasset's remark about *Las Meninas*: 'not art, but life perpetuated'. Freud clearly harbours similar ambitions for his own paintings. This may explain his intense dislike for metaphorical interpretations of his work. Meaningfulness is not (or at least not primarily) what he is after. His art aims for something more primitive and incantatory: the conjuration of real human presence in the unreal field of art.

Freud is undoubtedly the giant of contemporary realist figure painting. But he is a giant in a land of pygmies, and the fact that he has no serious competitors for mastery in his chosen field means that his version of realism is liable to seem rather more convincing, more masterful and assured than it actually is. This exhibition is clearly meant as a celebration, a homage, something like the apotheosis of Lucian Freud. Catherine Lampert, the director of the Whitechapel Art Gallery and author of the catalogue that accompanies the show, places Freud's portraits rather glibly on the same level as those of Rembrandt and Degas. But he is not quite the artist that those who have organized this exhibition would have him be. Freud's recent paintings are uneven

and often almost cackhanded. They are full of anxiety and uncertainty.

Freud's art seems increasingly full of pictorial devices designed to mask or compensate for the ways in which he fails as a traditional painter of the figure. He is working within a tradition of studio-bound painting whose greatest exponents were all trained according to Renaissance and post-Renaissance academic precept, but Freud taught himself to paint and it shows. He has difficulty in giving his standing figures the weightiness, the groundedness of (say) figures painted by David or Géricault, and he attempts to make up for this in various ways. He makes ankles thicker than they really are and he places heavy emphasis on widely splayed feet (this is particularly apparent in *Two Men in the Studio*), which he paints in a more vivid and meaty register than much of the rest of the body.

The intention, presumably, is to conjure the illusion of physical weight by concentrating attention on the load-bearing parts of the anatomy. But the real trouble lies higher up the body, specifically in the area around the thighs, where Freud's figures often become peculiarly two-dimensional and weightless, like flesh-toned silhouettes. This is true even of the self-portrait – and the peculiar, heavy, unlaced boots that Freud has given himself in that painting may be another of his compensatory devices. Like gravity boots, they serve to anchor a weightless body to the ground.

The problem is less apparent when the figure is lying down, which may partly explain why so many of the people in Freud's pictures are prone. This allows Freud to concentrate on flesh rather than anatomy, which is not his strong point, because when someone lies down their muscles are relaxed and the body can be painted reasonably convincingly in terms of its surface. *Lying by the Rags* is a good example, a picture where Freud's close focus on the model's skin, its colour and texture, almost (but only almost: the arms, for instance, are like spaghetti) makes up for the limp and boneless anatomy of the figure. Freud may have been so attracted by Leigh Bowery, the model for a lot of the pictures in this show, because of his sheer bulk, which allows the painter the pretext of painting great acres of flesh without bone.

Freud is something of an oddity: a painter who has been lauded to the skies for his uncompromising realism, despite the fact that his realism is so frequently unconvincing. He is constantly struggling to make things

seem real, seem present, in his pictures, but the struggle is so evidently a struggle (as it never is in the paintings of Rembrandt, or Velázquez, or Degas) that the paintings end up looking extremely artificial. Freud's realism is rhetorical, over-insisted upon: something the paintings desire rather than achieve. His pictures are full of elements that are code for 'real' – Freud's colours are low-toned and murky, the colours of excrement and dust; the texture of his paint is thick, a kind of gritty paste – but they do not conjure up reality.

This is not necessarily a criticism of Freud's paintings (although it may suggest some of the tensions and conflicts within them), but it is certainly a criticism of those who admire them for the wrong reasons. The truth is that Freud is much less of a realist and much more of an expressionist than he is usually made out to be. He is not a master of observation but a painter obsessed by a particular view of people and of the world. This explains the extreme repetitiveness of his work. Freud does not paint (as a true realist might) the differences between people. He paints what he sees as the terrible similarity between them: *Bruce Bernard* is *Leigh Bowery* is *Frances Glory*, Freud's sitters united by Freud's vision of the human lot. His achievement is to have made the milieu of the artist's studio, a place of waiting and contemplation and boredom, into a model of the world as he sees it through his own, disconsolate temperament: a place of limited possibilities, where all there is to do is to paint or wait, glassy-eyed, for death. The extent to which Freud has attempted to pull back from his own melancholy, to withdraw into something more objective and dispassionate ('realism') is interesting. It suggests that he may be embarrassed by his own perpetual sadness.

4th September 1993

X

AT HOME

David

SHORTLY BEFORE LOSING the battle of Waterloo, Napoleon visited the painter Jacques-Louis David in his studio. The Emperor arrived in a dark mood which was not lightened by contemplation of the vast canvas to which David had devoted fourteen years of his considerable but intermittent energy, *Leonidas at Thermopylae*. Napoleon had never liked the painting because he considered its theme, the stoical acceptance of a military defeat, an unlucky one. But he produced an elegant compliment none the less: 'Continue, David, to illustrate France with your works. I hope that copies of this picture will soon be hung in military academies; it will remind cadets of the virtues of their calling.' The two men parted amicably, and never met again.

Shortly afterwards, David linked his own fate inextricably with that of Napoleon by subscribing to the *acte additionnel*, which denied the right of the Bourbon monarchy to rule France. Following Napoleon's defeat and the Bourbon restoration, David was made to feel the full force of the new and precarious regime's displeasure. All those who had supported the *acte additionnel*, it was announced, 'are exiled in perpetuity from the kingdom which they must leave within one month, under penalty of Article Thirty-two of the penal code.' He left Paris at once and chose to spend the remainder of his life in the uneventful obscurity of Brussels.

Once the most celebrated painter of France's most turbulent years, once the intimate of Robespierre, once the pageant-master of the Revolution and creator of the cults of its martyrs Marat and Lepelletier, once the propagandist of the First Empire and the unrivalled *chef d'école* of French neo-classicism, David would occupy much of his last eight years in painting bourgeois Belgians. Having spent the previous four decades of his life at the epicentre of history he found himself suddenly consigned to its margins, living in a town whose most conspicuous feature, he

noted, was the spotlessness of its streets. Brussels was David's St Helena.

The National Gallery recently acquired a painting by David which sheds new light on this little studied, little regarded period of the artist's life. It is a work which, previously almost unknown, may help to revise the standard but ill-considered art-historical view that his last years were marked by decline and melancholy, a dispirited and uninspired moping towards death.

David's *Portrait of the Vicomtesse Vilain XIIII and Her Daughter* is a masterpiece of frank and unaffected tenderness that may, too, have subterranean depths of meaning. It is one of the least strident pictures that David ever painted, this picture of a young woman and her five-year-old daughter posed, but not too formally, in a plain well-lit interior. The painter is almost exclusively absorbed by the substantial presence of his two sitters, whom he has portrayed in a style which seems more Flemish or Dutch than French. These are not the hard marmoreal beings of David's neo-classicism, but warmer and more palpable creatures, flushed and vital.

No attempts have been made to idealize, the style of the painting implies, to smooth out the bump of a nose or improve the contour of a cheek. The mother sits patiently, gazing mistily into the distance of her own thoughts. The little girl is curiouser and more self-conscious. She wonders what the painter is doing, behind his easel, and concentrates on holding her smile in place.

The Vicomtesse Vilain XIIII, who was, like David, a Bonapartist exile from France, seems to have found the process of having her portrait painted singularly dull. Her letters, recently discovered in a Belgian archive, testify to the tiringly methodical thoroughness with which the artist set about her likeness. 'I am beginning to think that my portrait will be quite good, but I admit that the whole thing is extremely boring. The day before yesterday the sitting lasted from 11 to 3.30, and was for the forehead and eyes; yesterday's sitting lasted from 11 to 2.45 for the nose and cheeks. Today he will do the chin and the mouth.' How straightforward she makes it sound. Having decided on his composition and roughed it on to the canvas, David proceeded, part by part, to assemble his images of mother and daughter. Yet the finished painting is nothing like the laborious inventory of detail suggested by the method. Two different human beings – David has painted them in

different focus, the mother slightly sharper and the more statuesque, her child softer and more potentially mobile – have been granted that form of perpetual life which is a great portrait.

The picture seems charged not merely with life but with a significance that goes beyond a painter's record of what two particular people looked like on a certain week in May 1816. David's portrait is too assertive in its realism to be read as an allegory, but it does have a muted allegorical dimension, which is to be found in the emphatic contrast between mother and daughter. This is a picture of innocence and experience, youth and an older and wiser condition of life that seems tinged with melancholy; and a picture of the bonds of affection that join the two. It is a picture of nurture, whose most affecting detail and most subtle invention is the twined arms and softly touching fingers of mother and child. The child draws her mother's arm and fluid orange shawl around her. Comfort is unthinkingly sought and instinctively given.

Few painters have been as hardily adaptable as David and to see this portrait is to see him, late in life and in unpromising circumstances, devising an entirely new style and perhaps an entirely new moral base for his painting. Just a year after his last appearance on the world stage, that curious and emotional meeting with Napoleon, we find him creating a quite new sort of art for himself. Its style may be appropriate to exile since it is a style of renunciation, implying valediction to one world and embrace of another.

The background to the painting is part of its meaning and may partly explain the almost unsettling intensity of its realism, the sense of an artist releasing himself into the everyday world of people and things. It is the work of a painter who has spent almost his entire life in the service of one or other political cause or ideal and the world of his painting has been, overwhelmingly, an idealized martial and masculine world; a world of heroic action, of dangerous moral enthusiasms, of Revolutionary zeal or imperial hubris. But here we see David turning his back on all that and sympathizing, simply but profoundly, with a mother and her daughter.

There had been other moments of moral or political disillusionment when David had rediscovered his humanity by painting portraits, but perhaps none when he had felt so terminally disenchanted as this. He had lived through the Terror and through Napoleon's long years of

blood and he was tired. These two still people may, perhaps, stand in for the silent victims of all the bloody heroics of French history that David had seen. They may be David's archetypes of the people who, generally unnoticed, are left to count the cost of men's aggression. All women and children may be implied in this picture of one woman and her child.

David's didactic pictures are full of busy, gesticulating hands and arms and when they have, occasionally, been stilled, their stillness is portentous and heroic, like that of Marat's limp arm in perhaps his most famous painting of all. Now, however, David has found another kind of stillness, the stillness of affection. Having spent his entire life attempting to define and picture the nature of human heroism, he finds it staring him in the face in a room in Brussels. The discovery has the air of a revelation. His picture celebrates, not an active or impulsive form of heroism, but one that is slow and instinctive: not the sudden heroics of action, but the calm and persistent heroics of love.

1st February 1994

Vermeer and de Hooch

RUSKIN HAD A LOW OPINION of Dutch art: 'The patient devotion of besotted lives to delineation of bricks and fogs, cattle and ditchwater.' 'Brief Encounters: Vermeer and de Hooch', the latest in the National Gallery's series of displays bringing together a pair of closely related paintings, proves him right at least about the patient devotion and the bricks. Pieter de Hooch's *The Courtyard of a House in Delft* of 1658 and Jan Vermeer's *Street in Delft* of 1658–60 each feature lots of bricks, very patiently painted. But they also show that paintings of ordinary things need not be ordinary.

De Hooch's painstaking recreation of the courtyard at the back of a house in Delft pictures an uneventful scene. Outside, within the confines of a brick courtyard, a maidservant leads a smiling little girl by the hand. In the hallway of the main house, open both to the courtyard and to the street, another woman stands, with her back to the viewer, looking away. Nothing much, maybe – yet de Hooch's painting of an ordinary scene in an ordinary home contains its own small drama and is imbued, throughout, with a subtly domesticated form of symbolism.

The Courtyard of a House in Delft is a testament to the Dutch seventeenth-century preoccupation with the home as both seat of private virtue and as microcosm of the well-run commonwealth. The painting stands at the opposite pole from those other, livelier scenes of drunkenness and affray also common in Dutch art of the time. It is an image not of the tavern, with its sensual and moral temptations, but of a place where stillness and security are charged with ethical value. Its theme, emphasized by the painter's tight, narrow framing of his image, is enclosure – which is presented, here, as a state of grace.

De Hooch's courtyard is the setting for a gentle conflict between the virtues of domesticity and the forces ranged against them. The stone

DE HOOCH *The Courtyard of a House in Delft*

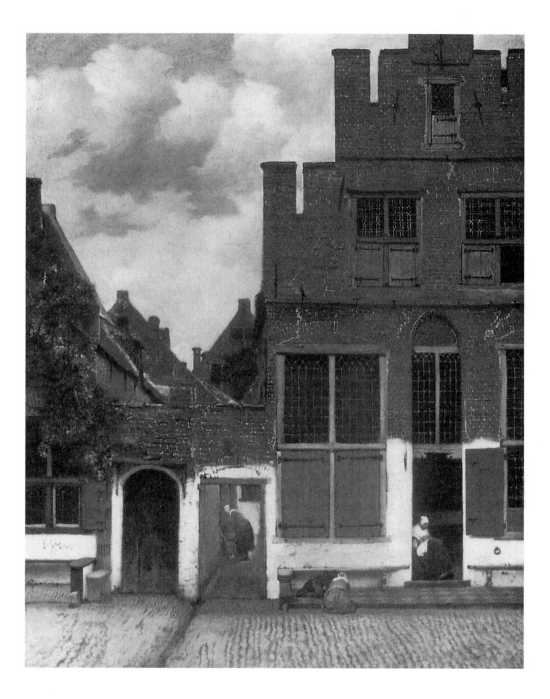

VERMEER *Street in Delft*

floor of the passageway has been polished to a dull shine. The foreground is filled by an expanse of brick paving that has also, evidently, recently been swept. In the bottom right-hand corner of the painting, a well-made broom of bound twigs looks as though it has just been set aside. In distinction to this fantastically clean (and fanatically carefully painted) expanse of floor, the rest of the courtyard seems only precariously ordered, threatened – albeit in a modest way – by the unruly incursions of nature.

Plants sprouting from a strip of earth that runs along the right side of de Hooch's courtyard have begun to creep over the edge of the border. A knot of branches and foliage has begun to spill down from the ramshackle bower under which the maidservant and the little girl stand. Above the archway over the passage, a stone tablet bearing a moralizing inscription that preaches the virtues of the retired life has been half obscured by the tendrils of a creeping vine. The child might herself be meant to represent a potentially unruly being, who needs to be led along the path of righteousness.

De Hooch's painting may be taken as a visual summary of the Dutch Calvinist mythology of cleanliness and domestic order, the legacy of which is the uncanny, toy-town pristineness of much of modern urban Holland. That broom, lying innocently to one side, has nevertheless something of the emblem book about it, the aura of a symbol carefully placed – and indeed old Dutch emblem books contain many images of brooms and mops, reminders of the symbolic potency which this household utensil came to acquire in the youth of the Republic.

'Look also to subtle things,' runs the legend accompanying a broom in one such book, 'that seem but slight to lazy eyes, and mop them up with your own hand. The cobweb of the vile spider that hangs and sits in all the senses, where dirt and base matter gather.' This might seem merely to prefigure the modern cult of hygiene, of whiter-than-white germ-free living, but in Holland 300 years ago housework and its tools were invested with a range of civic and political overtones alien to the age of Daz and Flash.

Simon Schama, whose study of Dutch culture in the Golden Age, *The Embarrassment of Riches*, is especially revealing on the subject of hygiene and housework, makes some interesting remarks about what he calls 'the militant cleanliness of the Dutch' in the seventeenth century.

Commenting on one Dutch admiral's gesture of tacking a broom to the bowsprit of his flagship, Schama comments that 'The brush stood as a heraldic device for the new commonwealth, cleansed of the impurities of the past. To have been slaves was dirty. To be free is to be clean.' The broom was not merely, then, a means to cleanliness, but the symbol of freedom from Spanish rule: of the new, purified Holland of the Republic. In de Hooch's painting, it may even acquire another symbolic dimension. A broom is not unlike an artist's paintbrush, and perhaps de Hooch saw a parallel between his own activity, that of registering the bright, clean world of Dutch domesticity, and that of those to whom the task of maintaining it fell. De Hooch's art is itself a form of housework – the work of understanding the house, in all its significance, and of making it clear.

The safe enclosure of the home becomes an image of the safe enclosure of the state. But the outside world is not absent from his picture since he offers us a view into that world, through the front door, and even includes a figure contemplating it. This figure (who is probably the mistress of the house and the mother of the child) might seem to pre-figure other, later figures seen from behind in painting – common presences in Northern European art, and most famously incarnated in the melancholy *Rückenfiguren* of Caspar David Friedrich, who seem to be yearning for contact with other, larger worlds than their own.

But there is nothing melancholy about de Hooch's figure, who is rather proprietorially vigilant. And the view which she confronts is only another image of the private, sealed world which she inhabits. She is placed along a vista delimited, at the near end, by the archway of the passage that she occupies and, at the far end, by its mirror image, the arch over the window of the house opposite.

This visual rhyme is also a closure, suggesting that the world beyond the home is identical to the world within it. To look out is to see, not difference, but sameness; and by opening out his picture de Hooch suggests an entire city of safe havens, an urban organism made up of such healthy, single cells as the one he has happened to paint. Art becomes a form of civic self-assurance.

Vermeer's *Street in Delft* is a greater painting than de Hooch's, but less amenable to explication. Where de Hooch is essentially a moralizing painter, an artist for whom images define correct or incorrect social

behaviour, Vermeer's ethical credentials have always seemed somewhat suspect. Reticent, for ever withholding or obstructing easy reading of his pictures, Vermeer remains an enigmatic artist.

He appraises the houses that are his subject in *Street in Delft* not from the back but from the front, and at a greater distance than de Hooch in his *Courtyard*. Although Vermeer's picture includes genre-like details – the two children in front of the gabled house to the right, playing knucklebones; the woman sewing in the doorway; the other woman, seen through the open doorway to the right, bending over a tub - their diminished scale robs them of the aura, so strong in the de Hooch, of role models, figures meant in some way to instruct. Their faces, moreover, are left blank. Vermeer's painting differs most fundamentally from de Hooch's: in the daring quality of its realism, its intermittent, inconsistent, variable nature.

For de Hooch's somewhat plodding manner, in which every last brick is painted with perfect clarity, Vermeer substitutes a much less determinate repertoire of effects that range from the precise to the audaciously generalized. He paints mortar between bricks as a skein of lively, darting brushstrokes, a vivid shorthand. He paints red and green shutters by applying the paint in thicker, more buttery layers (an emphasis on the tactility of paint which is appropriate since he is here painting surfaces that have themselves been painted). He translates the cobbled street into a mass of painted wriggles.

Vermeer's illusionistic virtuosity carries with it the knowledge that all illusionism, in painting, is a lie. No other realist has ever presented the real in so many different, competing registers, so variably faithful to fact. To see this even more clearly than in *Street in Delft*, consult the National Gallery's later *Woman Seated at a Virginal*. This is a painting which, in its varyingly achieved treatment of different illusionistic surfaces – the *faux marbre* of the virginal, the painting on the wall behind the young woman, the patterned curtain to one side – seems devoted to a demonstration of the partial correspondence of all painted illusions to the realities they mimic.

To be conscious of this – as Vermeer evidently is, too, in *Street in Delft*, although there he parades it less overtly – is to be profoundly conscious of the gap between art and its subjects. It is to know that the world cannot be replicated in paint, only reinvented. And maybe this

is what Vermeer's *Street in Delft*, in the end, has to declare: the way in which the world withholds itself from the artist-as-observer, the way in which it retains its mystery. The most forceful visual elements of his design, the dark oblongs of closed doors and empty windows that punctuate the surface of the city's houses, are also powerful images of blankness – of interior spaces that cannot be interrogated by the painter, whose art has to deal with surfaces. Where de Hooch moralized privacy, Vermeer was content to respect it; to leave it impenetrable and intact.

28th July 1992

Spencer

IN 1937 PICASSO PAINTED *Guernica*, Mondrian started work on a picture called *Composition with Red Yellow and Blue* and Stanley Spencer, a world away from the avant-garde, painted his *Beatitudes of Love*. Three of the *Beatitudes* are in the Barbican's centenary celebration of his work, variations on a favoured Spencer theme: the Matron and the Weed. Spencer's misshapen lovers, kitted out in floral-print dresses and worn tweeds, leer at one another in mutual infatuation. The *Beatitudes* might easily be mistaken for satire but that is the last thing they were meant to be. Spencer's subject was the transfiguring power of Love.

There is a telling photograph of him on the back cover of Kenneth Pople's new book, *Stanley Spencer: A Biography*: a bespectacled gentleman in a stained jacket, he is trundling his easel and paints along a wet country lane in a pram. It is hard to imagine a painter to whom the formal and philosophical doubts which characterized so much of the art of the first half of this century could have seemed less important. The painter with the pram; the artist who found heaven in Cookham; Stan, Stan, the visionary man – whatever else he was, one thing is for sure. He was no modernist.

Maybe this is why people in Britain so often use Spencer to define their sense of the proper forms and subjects of art. Last week, at the private view of the Barbican show, I overheard one elderly visitor insist to his companion that 'Young abstract painters today have no ideas. They have nothing to say. Look at this though [pointing at one of Spencer's *Marriage at Cana* pictures]. It's so full, so rich.' Earlier in the day, I had been interviewing a young abstract painter. He felt genuinely sorry for me when he heard I had to review the Spencer show: such pointless, dreary, parochial painting, after all.

Spencer's defenders use him as the prime example of all that they consider English art to have lost – narrative invention, the old hard-won

technical skills of the figurative painter – in its reckless attempts to be up-to-date. Spencer's attackers use him as the prime example of all that English art should purge itself of – provinciality, eccentricity, quaintness – if it is ever to be taken seriously. But the idea that Spencer might be an example – for better or worse – to later generations seems extremely dubious. Spencer's art is not something that can be copied or revived. It is too personal for that. He painted the way he did from compulsion, not principle.

Spencer was, as is commonly asserted, a visionary artist, yet his is a vision rooted in ordinary things. It is a vision of heaven, but entirely naturalized: a heaven on earth, Cookham Village. The mundane and the divine are co-extensive in Spencer's vision, a fact responsible for his bizarre conjunctions of subject and setting: *The Baptism of Christ*, for instance, set in the Odney Bathing Pool, where the Son of God is regarded with faint curiosity by commuters taking an early morning dip.

Spencer's idea of sacredness is tinged with pagan lusts and longings. Compare his idea of heaven with that, say, of Milton. Milton's is the Puritan version, constructed on the principle of exclusion: a place emptied of all human desires and fantasies; a place where literally nothing happens. But Spencer's is vital and bustling, crammed – like the chests of drawers he loved to paint – to bursting. It is the village green of *Love on the Moor*, thronged with hugging and snogging couples, where a man (Spencer?) proffers a peeled banana to a gaggle of smiling women. The gesture seems lewd and innocent at the same time. Spencer's is a childish idyll, but that accounts for its attractiveness. In his heaven, appetites – whether for women or hot buttered toast – exist to be satisfied.

Spencer felt his sexual desires to be sacred and allowed himself to be governed by them. This is why he left a woman whom he loved, Hilda, for a woman he lusted after, Patricia Preece, in the vain hope that he might enjoy them both. His painting is equally appetitive, voracious. The pictures have the quality of lists: things I have found beautiful; women I have desired. *Promenade of Women* is typical, sacrificing composition – what you see is simply a line of women, all shapes and sizes – for the sake of maximum inclusiveness.

The distortions in Spencer's art are another result of this voracity. His fish-eye perspectives are a way of opening the picture up, of getting

as much as possible *into* it and the alterations to which he subjects the human figure serve a different but related purpose. His women are often compared to those of Giotto, whose bulk they share, but there is something else in Spencer too – a kind of lumpiness, which makes certain parts of them look as though scanned through a magnifying glass while the rest remains at normal scale. This is why he can be mistaken for a satirist. But Spencer thought that, for the artist, 'Distortion arises from the effort to see something in a way that will enable him to love it'.

The Barbican's catalogue contains several quotations from Spencer's voluminous (and hitherto unpublished) writings. He was, it turns out, a remarkable writer. In the narrative which he wrote to explain one of the *Beatitudes*, Spencer imagines sex between the man and the woman in his picture: 'When she sits to take her old boots & stockings off, her lank and ghastly buttocks emerge & protrude from the drawers as they ooze and spread themselves on the seat . . . he holds on to the two old remnants of her breasts. He loves these two old lumps. Their bellies touch and press.' This manages perfectly that redemption of grotesqueness through love which the paintings often leave ambiguous. It is the best account of what love meant to Spencer: the complete acceptance of another person, and the sense that such acceptance is touched with holiness.

It is not just love, in Spencer's art, that offers such redemption, but any form of absorption. The most remarkable thing about his imagination is its almost complete lack of a dark side. Even the carpenter nailing Christ to the cross in Spencer's *Crucifixion* seems an innocent sort of lout, taking a childish (and therefore redeeming) pleasure in his woodwork. His mouth is full of nails.

Spencer's prose favours the ampersand, because the world seems so vital and immediate to him that enumeration of its pleasures seems the only possible response. It is the same in the paintings: this woman & that woman & the overflowing dustbin & those boots in the hall & every single brick in that building. So much, always, to include, that often it counts against the painting itself. The need to inventorize everything in the vision produces a kind of dull efficiency in the completion

of the task. The composition, sketched out on the canvas, is simply coloured in (you see this clearly in the unfinished *Apotheosis of Love*), rendered in paint sunk flatly into the weave of the canvas.

All the pictures in the Barbican's show date from after 1932, when Spencer first dreamed of creating what he called his 'Church-House'. Never built, this was where Spencer hoped to unite a large number of his 'spiritual' paintings. The Barbican exhibition, designed as a model of what such a place might have been like, demonstrates how wide was Spencer's definition of 'spiritual': his 'Church-House' would have included paintings ranging from the domestic to the biblical. The result, with its sudden shifts from the ordinary to the supernatural – from *Patricia Preece* to *Christ in the Wilderness* – is fascinating: an architectural simulacrum, as it were, of the artist's mind.

'A man raises a woman's dress,' wrote Spencer, 'with the same passionate admiration and love for the woman as the priest raises the host on the altar. 'Few men could have said this and convinced you that they meant it. But Spencer really *did* mean it. He is separated from his modernist contemporaries like Picasso or Giacometti as much by the innocence of his sexuality as by the styles in which he painted. It was one of the great misfortunes of his life that the woman with whom he most desired sex, Patricia Preece, was so unattracted to him. Yet this was a blessing to his painting, since it is only in the nude portraits of Patricia that his paint – the stuff itself, oil on canvas – comes to life.

Perhaps it is because Patricia's body was so rarely available to him in life that he felt this aching need to know it in paint. The human figure, here, appears in a quite new and different style: painted, for once, with the fantastic immediacy that is there in his descriptive writing. Spencer's fantasies of sexual fulfilment – which are always, as in *On the Landing*, of a diminutive male smothered in acres of female flesh – seem lifeless and abstract in comparison.

These paintings convey, too, Spencer's sense that even when this body is given to him its owner has somehow absented herself from it. Her body is full, voluptuous; her expression frosty, removed. Kenneth Pople's biography includes Spencer's description, in a letter to his ex-wife Hilda, of sex with her replacement, Patricia. 'She removed all of

herself up into her head which she buried in a pillow, and sub-let the rest of her shifting body at high rental.' He has been remembered as a visionary painter, but his finest paintings are those in which he is least visionary. Spencer painted best when he was facing facts.

29th January 1991

Whiteread

NUMBER 193 GROVE ROAD used to be an unexceptional Victorian house in the East End of London. 'Mile End, E3 – 3-storey end of terrace Victorian house, 4 beds 2 receps, original features,' an estate agent might have described it. Extensively remodelled, improved beyond habitability, it has become both monument and memorial. It has become Rachel Whiteread's *House*: a strange and fantastical object which also amounts to one of the most extraordinary and imaginative public sculptures created by an English artist this century.

193 Grove Road is no longer a home but the ghost of one perpetuated in art. It has no doors, no windows, no walls and no roof. It was made, simply (although the process was complicated, the idea itself was simple) by filling a house with liquid concrete and then stripping the mould – that is, the house itself, roof tiles, bricks and mortar, doors and windows and all – away from it. The result could be described as the opposite of a house, since what it consists of is a cast of the spaces once contained by one.

Facing *House*, on the other side of Grove Road, stands the Kingdom Hall of Jehovah's Witnesses. Now the Witnesses can knock on the door of number 193 until kingdom come but there will be no one home. Rooms that were once lived in have become blocks of stone, megaliths piled one on top of another like an infant giant's building bricks. Foursquare sash windows that once looked out on to the world have become blind, heavy, cruciform reliefs. Doors that once opened have become sealed panels of rock. The house has, itself, become a giant sarcophagus, a mausoleum containing (but also concealing, as mausoleums do) the lives and memories of all the people who once lived there.

Whiteread's *House* (1993) expands on Whiteread's *Ghost* (1990), which was an exact plaster cast of a bedsitting room in an abandoned house on

the Archway Road, cut into blocks and reconstituted in the Chisenhale Gallery, London. *Ghost*, a monument to cramped living conditions in N6, was bought by Charles Saatchi but *House*, being the size of a house and heavier than one, will be going nowhere. The terrace that 193 Grove Road once occupied has been demolished, and *House* itself is scheduled for demolition at the end of this month. Whatever happens to it, it will live a long time in the memory.

To visit *House* or (as many will do) simply to come across it, isolated in a scrubby patch of parkland at the corner of Roman Road and Grove Road, is to be suddenly and disconcertingly transported elsewhere. It is to be taken to another world, like and yet completely unlike this one: the world of the photographic negative, with its phantom-like reversals of known fact; the world that Alice enters through her looking glass; the world that lurks behind the molten silver mirror in Cocteau's *Orphée*, where normal relations between objects have been summarily suspended. Denatured by transformation, things turn strange here. Fireplaces bulge outwards from the walls of *House*, doorknobs are rounded hollows. Architraves have become chiselled incisions running around the monument, forms as mysterious as the hieroglyphs on Egyptian tombs.

House may seem perverse to those who persist in the belief that a work of art does not really count, as art, unless it looks like an easel painting or hand-carved sculpture. But it is in many respects an extremely traditional work. The artist has taken something very ordinary (but no more ordinary than the traditional painter's oil and ground pigment, or the traditional sculptor's piece of wood or stone) and made of it something extraordinary. The artist has asserted her right to construct her own world out of the materials of this one, to make a fantasy real and palpable. Like much of the most compelling art, *House* has the quality of a thing that had to be made to exorcize the compulsions of its maker.

Looking at *House* is temporally as well as spatially distorting. It is like looking at an object from the present that has suddenly been pitched far into the future or far into the past. An English terraced house has been remade as an archaeological find, and what an oddly simple thing it turns out to be. Just a squat arrangement of spaces to inhabit, a stack of caves honeycombed together. *House* contains the traces of late

twentieth-century living habits and technology, which survive in odd details like the impressed patterns of a fossil caught in its surface: the zig-zags of a wooden staircase running up one of its walls, the indented relics of plug sockets. But the overall effect is one of extreme, primitive simplicity.

To solidify the interiors of a house may be to conceal them, to seal them off, but it is also to reveal how basic our needs and our lives have remained down the centuries. There is a pathos in the revelation. Our houses are places that we like to think of as containing the evidence of our own unique sensibilities, repositories where we store the evidence of our sophistication and impeccable tastefulness. *House*, being a house without furniture, a house reduced to the shape of the air that a house contains, serves as a reminder that we are all the same: creatures that have always sought shelter, a roof over our heads.

House is a sculpture that memorializes, in its transfiguration of an ordinary home, the ordinary lives of ordinary people (ordinariness, it suggests, is one thing we all have in common). Unlike other kinds of monumental statuary – Nelson's Column, say – which suggests that history is made by the great and merely lived by the rest of us, *House* is stubbornly unheroic and democratic. Whiteread has made an image of how we all live, caught between solitude and sociability, out of the separate but abutting cells of the rooms in a house in London E3.

House is a paradox made concrete since it is a monument made out of void space, a thing constructed out of the absence of things. Being a dwelling in which it is not possible to dwell, a building that you cannot enter, it has the character of a tantalus. It is both a relic and a prompt to the imagination (Who lived here? What did they do? What did they feel?) as well as a sculpture that is charged with a sense of loss.

All houses (and many works of art, too) are tombs of a kind: most of the people whose memories they contain have gone, have surrendered their tenancy of the world. *House* is about the past and it is also about the unrecoverability of the past, about the fact that what has gone cannot be revived. The sculpture has a peculiar, almost anthropomorphic quality, or at least the traces of humanity that it bears are so strong that it ends up feeling oddly human for such an evidently non-figurative work of art. Something that was once full of life, open to light and sound

and movement, has been terminally stilled, made dumb and blind and inert. *House* is monument, memorial, and *memento mori*.

2nd November 1993

On 11 January 1994, the house was demolished by a Fiat–Hitachi earth-mover as demanded by Bow neighbourhood council.

XI

A LITTLE PIECE OF HISTORY

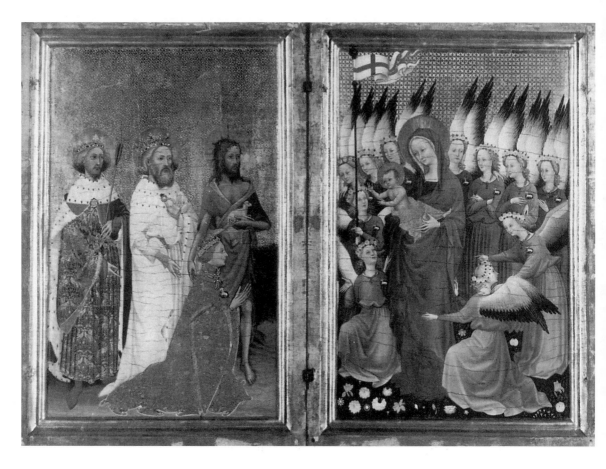

The Wilton Diptych

PAINTING CAN TAKE YOU instantly elsewhere, plunge you into an alien and distant world. The Wilton Diptych, the most enigmatic painting to survive from the English Middle Ages, is a vivid demonstration of the transporting capacities of art. It is also an object lesson in just how much – how much emotion, belief, aspiration and failure – can be contained on no more than a couple of tablets of painted wood.

The Wilton Diptych has been a mystery for centuries. The painting's blend of naturalism and other-worldliness is both subtle and slightly puzzling. Its most famous figures, those faintly insouciant long-necked angels with the most famous angels' wings in art, are a strange and compelling hybrid of real people and real birds, supernatural beings formed from a blend of observation and imagination. But they are just one part of an intricate symbolic scheme that has never been satisfactorily deciphered.

What, exactly, is the nature of the encounter which the picture depicts? What is the relationship between the kneeling King Richard II, flanked by three saints in a wild and wooded landscape, and the Madonna and Child in a paradise garden crowded with angels? Some momentous event is taking place. That much is clear from the busy gesticulation of four of the angels, who are pointing at the figure of Richard; and also from the strange, open-handed gesture of the king, who appears to be waiting for some sign (approval? benediction?) from the Virgin and Child. Something is happening, a transaction that bridges the two abutting hinged panels, worldly and heavenly, of which the diptych is made – but just what that might be has escaped us, separated as we are from the picture by a distance of six centuries.

This year may, however, mark a watershed in the history of the painting's interpretation. Recent cleaning of the picture has revealed a tiny detail, no more than a couple of centimetres across and previously

obscured by dirt. The stave of the red and white banner held by the angel on the extreme left of the right-hand panel is crowned by a minute orb, previously thought to be blank. Restoration has revealed a tiny picture within the circumference of this orb: the image of a green island with trees on its horizon and a turreted white castle at its centre, floating in a dark sea which – according to the National Gallery's team of restorers – was originally painted silver but is now permanently tarnished.

This image, discovered in the finest surviving painting of Richard II, inevitably calls to mind lines in the finest piece of literature about him: John of Gaunt's description of England, in Shakespeare's *Richard II*, as 'this little world,/This precious stone set in the silver sea'. Shakespeare may have known the Wilton Diptych, or at least an image of an island very like the one that has been found in the picture. This may also provide the key to unlock some of the meanings of the painting.

The banner in the Wilton Diptych has until now been regarded as a conventional symbol of Christ's Resurrection. How this might have related to Richard II has never been entirely clear. But if the banner was meant, as now seems likely, to symbolize 'this realm, this England', the red and white flag of St George rather than of the risen Christ, then the picture becomes suddenly more intelligible. It becomes a subtle piece of royal self-invention: an assertion, by Richard, of his divinely sanctioned right to rule. The king, kneeling and empty-handed, has given his realm into the power of the Virgin in the form of the banner. She has accepted it, and it is about to be passed back to the king by the attending angel (a fact signposted by that angel's pointing finger, directed at Richard). The King will rule England under the protection and with the blessing of the Virgin.

The Wilton Dyptych seems to have been painted around 1397, near the end of Richard's troubled reign, but the symbolic link which it proclaims between the King and the blessed Virgin (the picture has the quality of a mystic marriage, a betrothal in which Richard presents the Queen of Heaven with the dowry of his kingdom) may go back some sixteen years before that to one of the most dramatic incidents in English history. The painting may refer to Richard's (and the Virgin Mary's) involvement in the Peasants' Revolt.

In 1381, more than 40,000 peasants marched on London under the

leadership of Wat Tyler to protest against the Statute of Labourers, which fixed maximum wages during the labour shortage that followed the Black Death. Before negotiating with them, according to Sir John Froissart's contemporary account, the fourteen-year-old Richard II 'went to Westminster, where he and his lords heard Mass in the abbey. In this church there is a statue of Our Lady, in which the kings of England have much faith. To this on the present occasion King Richard and his nobles paid their devotions and made their offerings.' Richard and his men then proceeded to put the rebellion down, the king silencing Tyler's hordes with the famous words: 'Gentlemen, what are you about? You shall have me for your captain: I am your King, remain peaceable.'

The Wilton Diptych may be a memorial to the contract which Richard believed the Virgin to have made with him back on that day in 1381: he had prayed to her image and she had rewarded him with victory over those who had threatened his sovereignty. Although the picture was painted in the late 1390s, it depicts Richard II as he might have looked in 1381: the king in the painting is a beardless, fresh-faced adolescent.

The picture might be described as a form of propaganda – an image which deliberately harks back to virtually the only incident in Richard's reign that could be described (from his point of view) as a political success – but without, perhaps, the cynicism of most propaganda. The painted Richard's faith in his own blessedness seems entirely genuine.

This image of royal piety contains within it an entire world of popular mediaeval piety that has long sunk from view in this country, sub-merged by the great tide of the English Protestant Reformation: a world where people believed, fervently, in the power of prayer to incite divine intercession in the affairs of men; a world where not only kings but common people would plead with images of saints or of the Virgin to deliver them from their troubles. The Wilton Diptych seems very likely to have been painted as a devotional image for the private use of Richard II, a portable altarpiece to be set up and prayed before whenever he chose. This lends it a peculiar but affecting self-referential quality – looking at it, we see a painting of a king praying, before which a real king once kneeled and prayed.

This may partly explain why the figure of Richard in the Wilton Diptych seems so moving. In this frail and porcelain-skinned adolescent

we can see an extinct English religious culture, firm in the faith that heavenly intercession was a real possibility – that beings in the other world that is Heaven, the picture's rich and tapestry-like garden, might help them in the wilderness of the real world.

History has given the Wilton Diptych additional poignancy, because we know (as Richard did not, when he commissioned the painting) that heaven would eventually let the boy king down. On 29 September 1399 Henry IV seized the throne. Richard was confined in one of Henry's fortresses in Pontefract, deep in the Lancastrian heartlands. And there he was murdered: starved to death in a castle probably not unlike the one we can now, once again, make out in the middle of the island in a silver sea which occupies two square centimetres of mediaeval England's greatest painting.

5th October 1993

Canaletto

IN 1746 ANTONIO CANALETTO came to London from Venice and many of the pictures he painted during the nine years he spent in the capital suggest an artist uneasily acclimatizing himself to new surroundings. *London Seen Through an Arch of Westminster Bridge*, one of the most instantly memorable pictures in 'Canaletto and England', at the Gas Hall in Birmingham, is a case in point: a painting of one city (London) so suffused with memories of another (Venice) that it represents neither, but rather a fantastical hybrid of the two. The result is deeply ambiguous, stranding anyone who looks at the picture in a place, neither entirely Italian nor entirely English, that seems suspended between fantasy and reality.

The great curving arch of a bridge frames the prospect of a busy metropolitan river alive with commercial activity. The right-hand riverbank is dominated by a single landmark, the vast proud dome of a great church towering over the other buildings. But where are we, exactly? The bridge is said to be Westminster Bridge but it could be the Rialto; the river is the Thames but it could be the Grand Canal; the church is Wren's St Paul's but it could be Palladio's San Giorgio Maggiore. The sense of double-take even extends to the blue, blue sky, which looks as if it has been imported from Italy to England for the day.

Canaletto's father was a stage scenery painter and Canaletto would always treat topography with a certain degree of theatrical licence. He saw buildings as stage flats and often rearranged them at will, moving churches this way and that, modifying skylines and relocating monuments to serve his own purposes.

Owen McSwiney, the theatrical impresario and alcoholic who acted as an intermediary between Canaletto and his English patrons, was wrong when he said that 'Canaletto's excellence lyes [*sic*] in painting things which fall immediately under his eye.' The diminutive people

who inhabit his civic *mise-en-scènes*, whether English or Italian, are treated with wonderful cursory abstractedness, often just rendered as two or three tiny swipes and dots of colour. They are twinkling ciphers in boats that bob on rippled fields of green, painted with the same freedom that Vermeer (the two painters have more in common than might be thought) brought to art, and carrying the same, muted undertone of insolence: a painter's way of saying, albeit quietly, that he makes up the rules in his own painted world.

Art historians have tended to divide Canaletto's work into topographical paintings (pictures of the real) and *capricci* (pictures of the imaginary). This has obscured the fact that *all* his pictures are fantasies of one kind or another. But Canaletto's departures from the truth are also windows on to certain truths about the world which he inhabited, fantasies that reflect on the real.

Canaletto's visionary blend of the English and the Italianate serves as a reminder that mid-Georgian England, the England of Stowe and Stourhead and of architectural neo-Palladianism, liked to see itself through a haze of Italianate metaphor – and a reminder, too, that mid-Georgian London was beginning to formulate a myth of itself as a Venice *redivivus*, a Venice for modern times. It is well known that the main patrons for Canaletto's views of Venice were English, and had always been, long before he came and worked in this country. But just why the Grand Touring milords of Georgian England should have developed such a fondness for pictures of La Serenissima (the legacy of which is, still, the sheer quantity of Canalettos in England) is a question that has been infrequently addressed.

Canaletto's Venice exerted such a powerful hold on the English aristocratic imagination in the mid-eighteenth century precisely because it represented a model of their own aspirations. Venice, isolated and embattled centre of a powerful empire, a vital (and extremely wealthy) culture set, like a jewel, in the sea – the parallels, to a Georgian Englishman, were seductively powerful. And it is this ambition, to rebuild England on the model of Venice, that is surely the true subject of Canaletto's *London Seen Through an Arch of Westminster Bridge*.

The painting's most apparently playful detail, the little bucket that dangles in mid-air from a rope slung down from the bridge in the upper right-hand corner of the picture, is also the key to its meaning. What

CANALETTO *London seen through an Arch of Westminster Bridge*

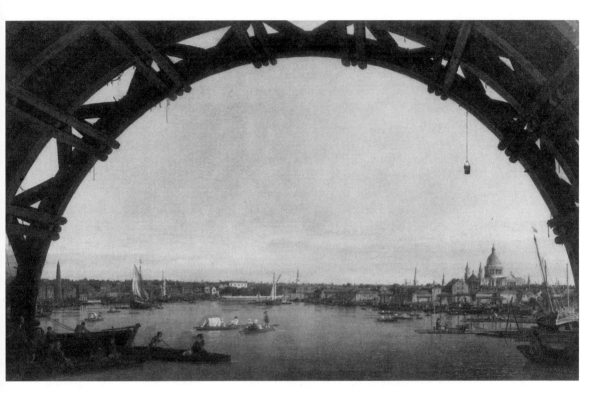

it says is that this is a bridge (and, by implication, a city; and, by further implication, an entire nation) *under construction*. What it says is that London, the new Venice, differs from the old one in that it is not a place of crumbling and decay but one of humming activity, with its eye on the present and the future rather than the past. What it says is: Men (Englishmen) At Work. It is an image of Georgian England's fantastic confidence in its own ability to remake eighteenth-century London along Venetian imperial lines.

Canaletto's greatest legacy to the English and to English art may have been a certain idea of Venice (which he did not necessarily invent but to which he certainly painted the most lasting memorials) as an object of emulation. The potency of the idea of Venice as a metaphor for England would be enhanced still further in the late eighteenth century, when the Venetian Republic was invaded by the Napoleonic armies. The suppression of the Venetian Republic and the final crushing of Venetian imperial ambitions by the French became, to the English, a fantastically powerful symbol of their *own* democracy under threat. A wonderfully eccentric painting by William Marlow, one of Canaletto's more intriguing English followers, makes this point. Painted fifty years after Canaletto had painted London as Venice, Marlow's *Capriccio of St Paul's Cathedral on the Grand Canal* reverses the trick and paints Venice as the image of London. The political implication is clear: the invasion of Venice is a surrogate invasion of England, so closely have the two places become allied in the English imagination.

Venice in peril had come to equal London in peril, and this may suggest some of the ways in which J. M. W. Turner's great and much later paintings of the Italian city were so subversive. Nearly one hundred years after Canaletto came to England, Turner went to Venice and painted the city as a molten chaos of light and almost indeterminate form. Doing so, he took an iconoclast's hammer to the Venice of Canaletto. He even included the figure of Canaletto in one of these pictures (*The Bridge of Sighs, Doge's Palace and Customs House, Venice: Canaletto Painting*) as a barely recognizable blob of a figure daubing an unreadable blob of a canvas.

Painting this picture, Turner not only announced his own apostasy from Canaletto's clear-eyed, poised form of visionariness but also his apostasy from the *idea* of Venice that Canaletto represented. Canaletto

gave the English Venice as an ideal to be aspired to, a great symbol of an embattled but stubbornly empire-building culture. For Turner, however, great painter of flux and fallenness, all empires (all things) are doomed to decay and atrophy.

Turner remade Venice as an emblem of inevitable cultural disintegration and turned the city into a symbol of the fate that awaits all human empires. And he did so at precisely that moment, just a few years before the accession of Queen Victoria, when the British Empire was about to become the most powerful political machine on earth. Painting once-imperial Venice as meltdown, Turner painted his disdain for the very idea of empire. He also, incidentally, predicted the future of Britain.

16th November 1993

XII

FRIENDS AND RIVALS

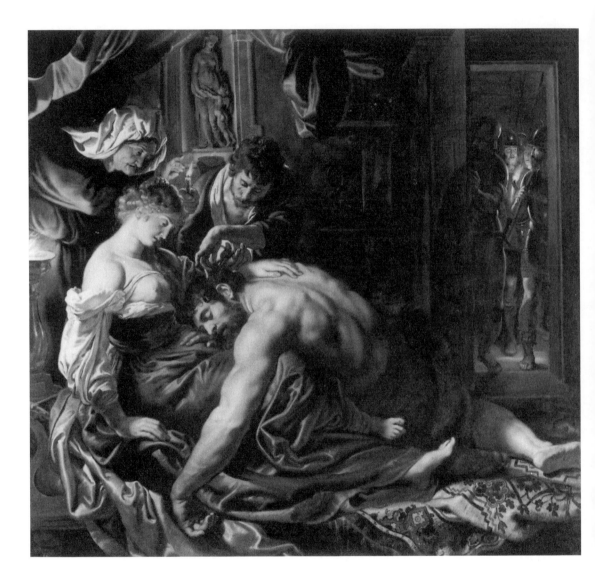

Rubens and Van Dyck

THE FIRST IN A NEW SERIES of displays at the National Gallery, 'Brief Encounters', must be the smallest exhibition in London. It consists of just two paintings, one by Rubens, the other by Van Dyck, both treating the same subject matter: the most famous haircut in history.

Rubens painted his *Samson and Delilah* in 1609; Van Dyck painted his *Samson and Delilah* just ten years later, while he was an assistant in Rubens' Antwerp studio. By offering this rare opportunity to compare two great painters' handling of a single theme, the exhibition proves wonderfully revealing of the differences in temperament and talent between them.

When Rubens painted his *Samson and Delilah* he had just spent eight years in Italy. Back in Antwerp, at the age of thirty-two, he was out to establish himself as the leading painter in his native city. This was his demonstration piece, and one of the things which it demonstrates is just how much knowledge and technical facility Rubens had acquired on his travels. Samson's back, with its impressive musculature, carries memories both of classical statuary (the *Farnese Hercules*) and of the heroic male anatomies of Michelangelo. The most dramatic feature of the painting is its nocturnal lighting scheme, with its pools of candle- and torch-light, handled with absolute assurance. Rubens was almost certainly inspired to attempt his nocturne by the example of Adam Elsheimer – a German-born artist active in Italy when Rubens was there and whose dramatically lit *Judith and Holofernes*, now in the Wellington Museum, London, Rubens once owned – and also, inevitably, by that of Caravaggio.

Rubens' *Samson and Delilah* carries its learning lightly. His subject had been commonly treated in the art of Flanders and Holland in the

previous century. The theme of the hero brought low seems to have appealed to a certain morose streak in the Dutch and Flemish soul. He who thinks he has everything is deceiving himself; he has nothing, for all worldly power is vanity. This is the message, not merely of much Dutch and Flemish narrative art, but also of its other great tradition in painting, the *vanitas* still life. Rubens, however, elevates this theme to a level of rhetorical grandeur previously unmatched in the art of his countrymen. His Samson, this great slumped hulk of a man, introduces a new kind of hero into Flemish art – a hero whose fall is not merely contemptible, but tragic.

The tale of Samson and Delilah as inherited by Rubens from the Bible and the apocrypha is fairly sordid. It is the story of a gullible meathead undone by his drunkenness (which explains Samson's deep slumber) and by his infatuation with a whore. Rubens indicates Delilah's profession unambiguously, in the figure of the wizened procuress holding the candle. The scene is set, as the lavish spread of fabrics in this small, dark room implies, in Delilah's boudoir. Yet Rubens was not remotely interested in the potential tawdriness of his chosen story. All his efforts seem devoted to extracting, from this unpromising subject matter, a painting of the highest moral seriousness. (Van Dyck would attempt something altogether different, as we shall see.)

Rubens' *Samson and Delilah* is essentially a drama of heads and hands. The bodies of its cast are all frozen: by sleep, and by a kind of troubled inertia (Samson, and Delilah); by concentration on a delicate task in hand (the procuress and the barber); by anticipation (the soldiers peeking through the doorway). The keys to the painting are Delilah's face and her left hand, which is given tremendous emphasis by the contrast between its fairness and the swarthiness of Samson's back, where it rests in a way that suggests a mixture of affection and nervousness. Delilah's expression is melancholic. She regards Samson, not with pride in her victory but, rather, with what looks like guilt tinged with sadness.

Delilah represents the one unfixed, indeterminate point in Rubens' tightly organized scheme. She is the only character whose role is not absolutely defined: Samson, asleep, is the heroic victim, while the procuress and barber, whose heads and hands are completely taken up by the work of shielding candle and cutting hair, are the main aggressors. Delilah does not seem sufficiently agonized to be a victim, nor suf-

ficiently whole-hearted to be an aggressor. She is the moving centre of a stilled world. This makes Rubens' painting a work whose primary focus is moral. It is a painting of Delilah's dilemma, frozen for all eternity. Of course we all know how it will be resolved: Samson's eyes will be put out, and he will 'grind in the prison house'. Yet Rubens reminds the viewer that there was a moment – *this* precise moment: as the elegantly contorted hands of the barber find just the right degree of purchase on Samson's locks; as the scissors begin to close – when she could still have chosen a different end to the story. A moral choice presented itself; the wrong choice was made; tragedy ensued.

'The best of my disciples' is how Rubens presciently described Van Dyck in 1618. It would be interesting to know how he felt about his 'disciple' after seeing his *Samson and Delilah*, an impudently original version of a subject so closely associated with Rubens himself.

It has been said, by those art historians who prefer the Rubens to the Van Dyck (and they are in the majority), that Van Dyck fatally diluted his master's dense, concentrated composition – and in doing so lost that sense of momentousness, of high moral tension that was the older artist's great achievement. This is true, but Van Dyck does it with such thoroughness – replacing Rubens' claustrophobic interior with his own, open loggia, increasing the number of actors from four to five and spreading them much more widely across the canvas – that it cannot have been anything but deliberate. Van Dyck did not paint a youthful mistake; he painted a carefully phrased reproof to his master.

Van Dyck's painting has been criticized for its lack of drama. This objection is invalid, but it leads straight to the heart of what it is that makes the paintings so different from one another. Van Dyck's painting is no less dramatic than Rubens'. But, it prefers one kind of drama to another.

If Rubens' painting is a drama of heads and hands, Van Dyck's is a drama of bodies – and bodies, not frozen, but clumsily mobile: the lumbering barber, the anxiously craning procuress, holding back the straining, horrified handmaid; the frantically shushing Delilah, raising a finger to her mouth while with her other hand she attempts to remove an awkward fold of drapery from Samson's head. It all looks as if it

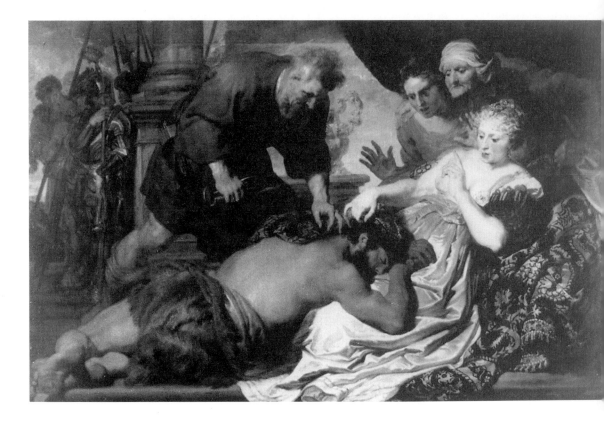

could go terribly wrong: the barber will trip over Samson's body, the procuress and handmaiden will topple into Delilah's lap; Samson will wake up and lay the lot of them out cold.

Rubens painted *Samson and Delilah* as tragedy. Van Dyck painted it as comedy. Van Dyck outpainted Rubens, conspicuously, in the depiction of fabrics, rendered here with a liveliness and dash that makes their equivalent in the Rubens seem ponderous and inert. Van Dyck's worldliness, which declares itself here as a positive love of the world, a luxuriance in the sheer stuff of it (this predicts his talents as a portrait painter), expands into the rest of the painting as well. There, it translates into a wider sense of tolerance, of forbearing to the story's ludicrous participants.

Van Dyck, rendering *Samson and Delilah* as, in effect, a domestic farce, its hero absurdly entrapped in acres of spreading silk, encourages a kind of forgiveness of those involved. His painting sacrifices the momentousness of Rubens' (which is a way of insisting, with the grim finality of the tragedian, on the irreversibility of events) and gains a playful indeterminacy. Perhaps it will not all turn out so badly; and anyway, aren't the failings of Samson and Delilah merely human, merely the biblical prefiguration of those trivial infatuations and betrayals played out in the perennial comedy of human existence? Rubens uses the stasis of the painted image to imply inevitability. Van Dyck – and even the space of his painting, with its bright blue sky beyond the drapes, suggests the possibility of escape – uses it to grant all concerned the permanent reprieve of uncertainty.

9th March 1991

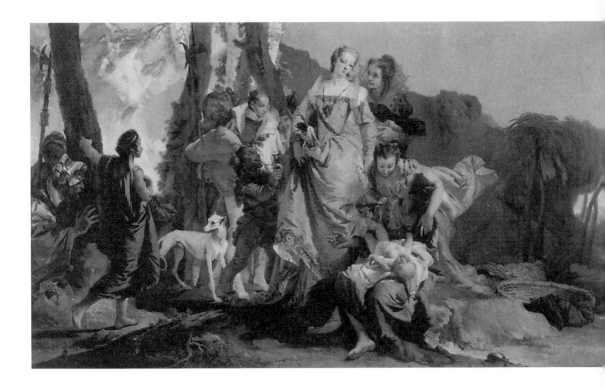

Tiepolo and Piazzetta

WHEN GIAMBATTISTA TIEPOLO painted *The Finding of Moses* he turned Egypt into a place that looked suspiciously like home. The Nile has been shrunk to the proportions of the Grand Canal. The Pharaoh's daughter has become a courtesan in yellow silks and pearls with a brittle, yapping lapdog, attended by a grinning dwarf and procuress. She looks down at the bawling, red-faced baby Moses, not with the conventional compassion but a distant frostiness that gives the game away. This is a satire in disguise: Tiepolo's way of insinuating, circa 1740, that innocence does not belong in Venice. Even his paint seems touched with cynicism, uncharacteristically coarse and garish, as if in mimicry of Cleopatra's own cold gaudiness.

'The Glory of Venice: Art of the Eighteenth Century', at the Royal Academy, commemorates a self-consciously decadent culture on the verge of dissolution. La Serenissima, in the last years of its influence, contemplates its own gradual corruption. Retrospectively, the art of the Venetian eighteenth century, particularly of the later eighteenth century, seems moved by a prescient fatalism. Domenico Tiepolo, son of Giambattista, painted scenes of carnival gaiety that now look strained, like dreams that have begun to turn into nightmares or Watteaus that have begun to turn into Goyas. (His drawings are stranger still, the oddest of them presenting the image of five men, a clown and a dog, their backs turned to us, holding umbrellas, waiting for something inexplicable, while four cursory birds dart about in a wet sky.) But it was Francesco Guardi who, disdaining the workmanlike clarity of Canaletto's potboiled souvenirs, created the most enduring images of Venice in decline.

Guardi concentrated on the dilapidation of the city and dotted his pictures with those emphatic white highlights which were his shorthand for raggedy sailcloth, the raggedy shirts of gondoliers and raggedy

laundry hung out to dry – but which were above all signs for the raggedness of the place as Guardi conceived it. Guardi also imagined Venice in the future, ruined like ancient Rome, and in his *The Fire at S. Marcuola* the buildings of the city have become a mirage suspended between fire on the ground and smoke in the air. Guardi's drawings are even more extreme, turning people into coils and wisps of line, as evanescent as smoke.

The real heart of this exhibition, however, lies elsewhere, in the encounter – which turns out to be a kind of argument – which it skilfully engineers between the two greatest Venetian painters of the first half of the century: Giambattista Tiepolo and Giambattista Piazzetta. Their work and the tensions that animate it so overwhelm almost everything else in the exhibition that the entire exercise comes to feel like a pretext for comparing their distinctive, contrary geniuses.

Tiepolo is justly famous as the giant of eighteenth-century Venetian painting, though less famous than he was in his own lifetime, when he earned a somewhat dubious reputation as the artist who, in the words of one of his contemporaries, could paint a picture faster than most others could grind their colours. But Piazzetta, slightly older and quieter – a slower, more morbid and more darkly imaginative artist – is almost unknown in this country. In some respects, he puts Tiepolo to shame. Piazzetta has been called Venice's Courbet. That is not a bad description, since his work exhibits a kind of brutal realism, but it is also allied to a most un-Courbet-like spiritual intensity – neither being qualities many people associate with Venetian painting in the eighteenth century. His breathtaking *Supper at Emmaus* is a picture which, among other things, contains what may be the finest painting of a plate of asparagus (Manet's included) in the world. An appropriately ghostly Christ, watched tensely by two coarse-featured disciples in the tenebrous half-light that so often illuminates his pictures, is breaking bread. He looks up, his expression an enigmatic mixture of sadness and hope. The still life elements in the picture are both intensely immediate and subtly allusive: the wine in the carafe a muted suggestive red, the asparagus stalks a morbid white and green the colour of dead flesh, the tablecloth a wind-ing sheet in miniature. The silent, serious intensity of Piazzetta's painting is moving and more than a little disturbing.

There is a tremendous sense of weight in Piazzetta's pictures, almost

of an obsession with gravity, which is an important part of what makes them so compelling. His *St James Led to Martyrdom* is one of the most remarkable pictures of the eighteenth century (partly because it feels much closer in spirit to the seventeenth, to the art of Rembrandt and Caravaggio) and much of its power derives from the sheer grounded substantiality of the figures: St James, painted as if he were an ageing but powerful hobo, pulls against the rope with which his loutish executioner has lassoed him, as if determined to walk away, up out of the picture and into the light of God. Transcendence is a struggle, however, and no one flies in Piazzetta: even his levitating St Francis is a terrible, heavy burden for the supporting angel. The mystery of Piazzetta's painting is sustained and deepened in his last and most affecting pictures, which seem to look forward to the nineteenth century: strange, melancholy pastorals, in which vagabonds and heavy-limbed women, prostitutes perhaps, loiter among rocks and trees under skies dark with threat.

Tiepolo can easily seem a frivolous artist, when compared with Piazzetta, and in some respects that is what he was – although he was so brilliantly frivolous, and his art was so perfectly adapted to the tastes of the age in which he lived, that this hardly counts as a criticism. In contrast with his rival, Tiepolo was a painter of weightlessness: the inventor of vast and teeming airborne worlds whose splendid unreality can only be hinted at, in any exhibition, in the form of the artist's sketches for his enormous decorative schemes. Where Piazzetta was a solemn, melancholic realist, Tiepolo was a daring fantasist, a painter of risqué mythologies rustling with the sound of shot silk the point of which is often no more – see his *Rinaldo and Armida in Her Garden* – than the perfect flash of the perfect thigh.

The most awkward and head-on collision between the two artists in the present exhibition, however, occurs between Piazzetta's *St James Led to Martyrdom* and the picture which Tiepolo painted, for the same church, in an evident attempt to upstage it. His *Martyrdom of St Bartholomew* is a bizarre, low-toned pastiche of Piazzetta's masterpiece, which replaces its sinister chiaroscuro and *gravitas* with gaslit melodrama. Tiepolo's saint, a flailing geriatric, is held down by one executioner while the other, preparing to flay him alive, feels his flesh with his fingers. But even when his theme is this morbid, Tiepolo finds

it impossible to give due weight to his figures. Overstressing their anatomies, he produces curious expanses of weightless, too-fleshy flesh, which predict the work of Salvador Dali with amazing if quite accidental accuracy.

But the exhibition also restores to Tiepolo some of the seriousness that two centuries of being labelled a Rococo artist (with all the disapproval which that implies) have taken away from him. His secular allegories are not always entirely light-hearted and they become more morbid with age. There is pain in the gaze that the wizened Time fixes on the young and indifferent figure of Venus in his *Allegory with Time and Venus*. The most moving Tiepolos in the exhibition, though, may be his two small late paintings of *The Rest on the Flight to Egypt* and *The Entombment*. Mary and Joseph sit slumped under a tree in a rocky landscape while a vulture circles above them; the body of Christ is lowered unceremoniously into the tomb in a dark cave. They are religious pictures but they feel too personal to be *only* religious: one a painting about waiting to die, the other a painting about the event itself. Piazzetta painted like a man who could not forget about death, while Tiepolo painted like a man who could not bear to think about it. Or not until it was almost upon him – perhaps here, finally, we can see the great Promethean artist of his age, the artist who could create his own worlds on any wall or ceiling, no matter how large, finally conceding his own mortality.

20th September 1994

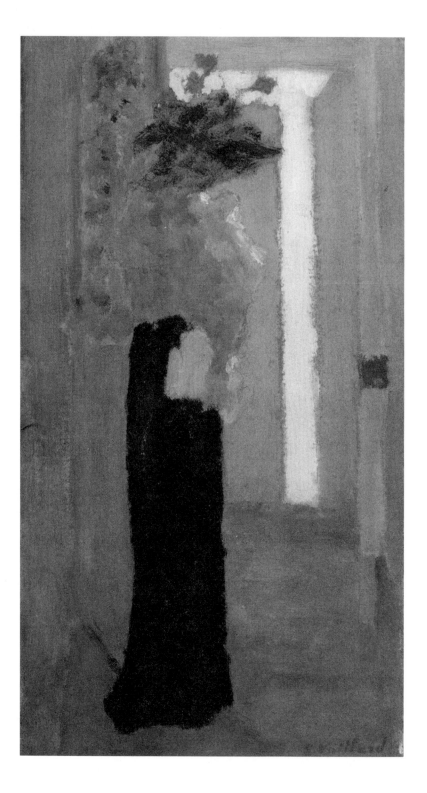

Vuillard and Bonnard

A WELL-DRESSED PARISIENNE stands in a bourgeois domestic interior and finds herself suddenly confronted by the unknown. Rapt, in pink blouse and long black skirt and an extravagant flower-sprouting example of the *fin de siècle* milliner's art, she is an unlikely and involuntary witness to the mystery of things. Edouard Vuillard's *L'Elégante*, painted circa 1891, has been made to seem on the brink. But of what, exactly?

She seems casual but also transfixed, hypnotized by the spectacle of sunlight, which has been rendered by the artist as a solid column of bright, fatty, butter-coloured paint filling the crack between a pair of half-opened orange shutters. Silhouetted, almost dissolved by the radiance that surrounds her, she stands on the threshold of a bright and weird nothingness. Wraithlike, barely substantial, made of paint that seems itself to hover and tremble, she is nevertheless a monument, the image of what we all know ourselves to be: matter poised on the edge of its own dissolution, that final unbecoming which, the beautiful ominousness of the picture suggests, can seem both a promise and a threat.

L'Elégante is exhibit 153 in the huge survey at the Grand Palais, Paris, of the work of Les Nabis, a group of young, mostly French painters who decided some time in 1888 that they had enough in common to declare themselves an art movement. United by admiration for Van Gogh and Gauguin, as well as by certain vaguely formulated spiritual values inherited from some of the more eccentric sects of their times such as Theosophy, the Nabis took their name from the Hebrew word for prophets. But they were not all blessed with visionariness. Sérusier and Denis, Ransom and Roussel, Maillol and Vallotton and Rippl-Ronai – they were all, on occasion, capable of painting intriguing and affecting pictures. But there were only two truly great Nabis: Edouard Vuillard and Pierre Bonnard.

The chief revelation of this show, apart from a number of wonderful and rarely seen pictures by those two artists, might be said to be its proving of a paradox. The Nabis were much preoccupied with the spiritual potential of art, and many of them painted religiose or grandly Symbolist subjects which they clearly believed were appropriate to their aspirations. Painting muses or wood nymphs in sylvan glades rendered as broad, cloisonnist expanses of pure saturated colour, artists such as Denis and Maillol hoped to create windows on to other, higher orders of spiritual being – and to counter what they saw as the damagingly materialist-positivist sensibility of their times by proposing mythical, otherworldly alternatives to it. But now their painted dreams of spiritual otherness tend to look painfully dated. The rooms of the Grand Palais contain rather too many sinuous Art Deco goddesses enacting mysterious but fundamentally unengaging allegories.

Bonnard and Vuillard, by contrast, whose paintings would always remain rooted in real things and real people, achieved genuine and intense visionariness. They, alone, managed to make painted equivalents to the intangibles all the Nabis wanted to paint. Focusing on the material world, they found themselves miraculously enpowered to transcend it and, in painting the domestic or metropolitan milieux of bourgeois Paris, they also made some of the most remarkable pictures of states of mind – of aspiration, foreboding and many other barely articulable feelings – ever created. To see their pictures of the 1890s side by side and in depth is to realize that they were, as Picasso said of himself and Braque during their Cubist years, roped together like mountaineers.

Vuillard painted many of his pictures on a modest scale, but although they are physically small they are morally and emotionally enormous. They are also full of portents. The wavering zip of yellow splitting a plane of orange that occupies just a few square inches of *L'Elégante* contains, latent within it, a pictorial idea that at least one later twentieth-century artist would devote his entire life to. The *oeuvre* of the New York School painter Barnett Newman, constructed around the notion that a split field of purely abstract paint might somehow conjure visions of the ineffable, is implicit in just one corner of just one painting by Vuillard.

Part of Vuillard's genius consisted in the daring with which he trans-figured the real world as he painted it. In *L'Elégante*, he paints the things

we assume to be solid (a person, walls, a floor) as if they are intangible phantoms; while he reserves for the things thought to be most fugitive and transitory (sunlight) his most blatant, insistently solid passages of paint. This freedom is also a form of licence insisted upon: Vuillard's way of declaring his right to paint the world not necessarily as it is but as it can, sometimes, seem – as weird and as unreal, indeed, as an apparition.

Vuillard, and Bonnard too, are constantly attempting to capture the apparitional quality that real places and people occasionally assume. The most daring strategy they adopt to convey this may be the way in which they allow slippages of attention to occur between one passage of paint and another, so that some forms seem almost cursorily treated, thrown away in pigment that abandons them to murky indistinctness, while others are rendered in vivid detail. Bonnard can paint a woman and a horse as almost unrecognizable silhouettes sliding across the view of a street; Vuillard can paint people in an interior but pay such calculatedly abbreviated attention to them that they seem swallowed up, absorbed, even obliterated by décor. Their pictures represent both the world and the ways in which, inattentively, partially, filtered through obsession or emotion, we experience it.

Bonnard's *Omnibus* emerges from this show as one of the masterpieces of the 1890s, and it is a perfect example of the technique carried to an extreme: like a fragment of experience snatched from the memory, it pictures the head of a young woman haloed by the radiant yellow wheel of a horse-drawn wagon. It is a wonderfully distinct image of the way we remember things or people that may suddenly strike us: a distinct image of vivid indistinctness.

The moments and places which the paintings reflect differ greatly – there are interiors and exteriors, portraits and animal paintings and street scenes and still lifes – but what the best of them have in common is the heightened, epiphanic quality of the waking dream. Bonnard, painting two friends and himself smoking, allows portrait and interior and the whirling patterns of smoke curling in the still air of a room to merge and coalesce as if all the discrete elements of an experience that took time to unfold have been condensed into the single moment perpetuated that is a picture. This is not art that aims to depict experience so much as to distil the memory of an experience, to preserve the idea of it.

Painting a white cat, its back impossibly arched (but in just that exaggerated way that cats do arch their backs), Bonnard gives you an image that seems, somehow, even more palpable than a reality. Perhaps Picasso had the painting in the back of his mind when he made his well-known remark about wanting to create, in art, a goat that was more like a goat than a real one.

Bonnard once took a photograph of Vuillard in Italy, himself caught in the act of taking a photograph. One painter's snapshot of the other taking a snapshot is, also, a reminder of the important role that photography played in the evolution of their form of visionariness. Photographs taught Vuillard and Bonnard (as they had taught Manet and Degas) to keep on taking themselves unaware, to note and preserve the insistent oddity with which real life, left to its own devices, tends to be framed. The world snapped by the snapper, like the world as we see and remember it, is not neatly framed, and both Bonnard and Vuillard would devote much of their immense skill as artificers to recreating the impromptu effect of quickly taken photographs.

Vuillard derived from photography a tremendously powerful sense of the unfathomability of the world, its nature as a strange agglomeration of things and people in a condition of permanent and inexplicable flux. This may be the real theme of *L'Aiguillée*, ostensibly a painting of his mother at work dressmaking in her Paris flat. A woman sewing, her arm at the apex of the needle-pulling gesture, is frozen in silhouette. Before her sits an almost faceless assistant while behind her bolts and swatches of fabric have become a vivid heaped pile of brushstrokes accumulated at the lower edge of the painting. A portrait on the wall of the room presents the vague and blurry ghost of someone. Life is a patchwork, Vuillard is saying, a never-finished sampler with an unknown message. The only thing to do – like his mother in this quiet room, as patient and obdurate as Penelope awaiting Ulysses – is to go on, unknowing.

23rd November 1993

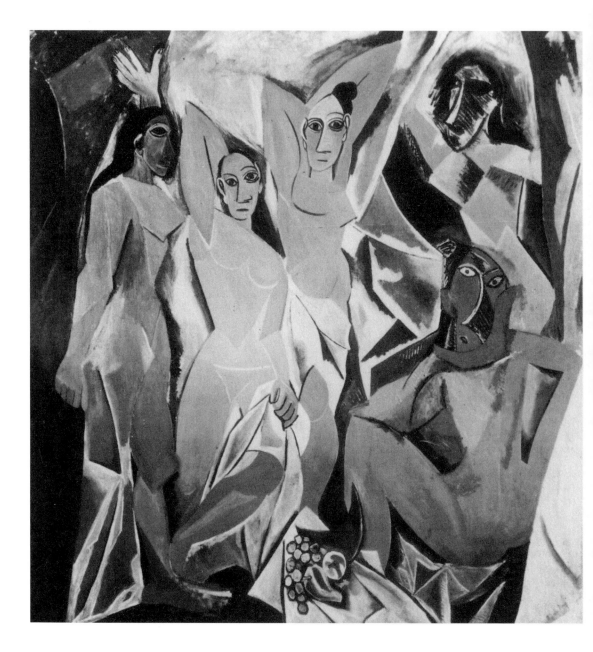

Picasso and Braque

'PICASSO AND BRAQUE: pioneering Cubism', at New York's Museum of Modern Art, gathers together more than 350 paintings, sculptures, collages and *papiers collés* produced between 1907 and 1914. Cubism, which developed with the irresistible momentum of a great philosophical argument, is well suited by such blanket coverage. It was never about this or that masterpiece (although it produced many), but about changing the way we see the world.

For Picasso and Braque, Cubism was also a way of life, an adventure, and the miracle of it is that the excitement of that adventure has not been dulled by the passage of time. It *has* been dulled by the carving up of the Cubist *oeuvre* among private collectors and museums. Curator William Rubin has managed, for a brief, extraordinary moment, to set Cubism's shattered bones, to restore it to something like wholeness. At MOMA, until January, the jigsaw puzzle comes together. All those small, mostly monochrome canvases that museum visitors tend to hurry past ('Oh, Cubism') come to life.

Cubism began, as this exhibition begins, with the savage outburst that was Picasso's *Demoiselles d'Avignon*. It is one of the masterpieces of world art, but that is not to say that it has become respectable. Its savagery survives intact: those five harpies still fix you with basilisk stares, a glowering parade of accusatory whores (Picasso's original title for the painting was 'The Avignon Brothel'). The ghosts of the past are present in the *Demoiselles* – Poussin's bacchanals, the Venuses of the Hellenistic tradition, Michelangelo's 'prisoners' – but they are there only to be exorcized. The angular geometries that literally squeeze the space out of the picture, flattening the five maenads to its surface, do away at a stroke with the inheritance of Renaissance perspective. The masks that the figures have for faces are based on ancient Iberian and African sculpture, a way of announcing – by way of means that Picasso

undoubtedly thought of as both savage and primitive – the exhaustion of the Western tradition of easel painting.

But as Picasso and Braque embarked on their joint enterprise, the problems that they chose to consider were simply too difficult, too knottily theoretical, to allow for the physiological and narrative complications that the figure brings to painting. The first phase of Cubism – Analytic Cubism, as it has been dubbed – would proceed by exploring, not the figures in the *Demoiselles* but the spaces between them: those extraordinary passages of painting where air itself, depicted as a kaleidoscope of criss-crossing, hard-edged planes, assumes the properties of solid matter.

'*Notre avenir est dans l'air*' ran a newspaper cutting Picasso affixed to one of his later collages. His nickname for Braque was 'Wilbourg', a reference to pioneering aviationst Wilbur Wright. Cubism's prime subject was air, or more precisely space. Braque would later say that Cubism was an attempt to 'materialize the new space', and it was he who took the lead in Cubism's earliest phase. His 1908 *Houses at L'Estaque* is one of the most cubistic of Cubist paintings, reducing its subjects to solid geometry whose solidity is simultaneously undermined by Braque's characteristic herringbone shading and multiple, contradictory light sources. The perspective is illogical; Braque has made it virtually impossible to determine whether one plane is before or behind another. Art's subject is no longer the thing that it depicts but the multiplicity of viewpoints from which a thing *can* be depicted, the infinite positions that you can occupy when you look at an object. This is Braque's new space, and it is the space of relativism.

Cubism, it has often been said, represented a new, alternative brand of realism in art. It was, according to this view, a way of painting things in the round, an attempt to capture the sense of solidity that you get when you circle an object, taking it in from many angles. But to think that is fundamentally to misunderstand Cubism which sought, rather, to demonstrate that the very concept of realism is based on a false premiss. Looking at the key examples of high Analytic Cubism, those difficult, hermetic paintings of 1910 to 1912, you encounter dense skeins of paint in which it has become impossible to identify anything like the subject of a conventional representational picture.

These paintings, with their dense weaves of criss-crossing lines, their

mosaics of indeterminate painterly tesserae, throw up clues to real things – fragments of words, O-shapes that suggest the sound holes of guitar or mandolin – but little more. They are difficult, and were meant to be. They do not set out to picture the world but to create a visual equivalent to a *theory* about the way it is. These busy, flickering areas of paint come to look like metaphors for the secret, pulsating, molecular life of things. The subject matter of Cubism – tables and chairs in cheap street cafés, newspapers, bottles – was clearly selected for ordinariness, a way of pointing out that *what* was being painted was beside the point, that Cubism's true subject was vision itself.

What Analytic Cubism represents, paradoxically, is the unrepresentability of the world – or at least all those aspects of it, spatial and structural, that old-fashioned, illusionist art left out. Braque made this clear in his magnificent *Violin with Pitcher* of early 1910: a wall of fractured shards in which you distinguish the broken forms of pitcher and violin, absorbed into the Cubist geometry of dissolution, while at the top Braque has included – a perfect example of his dry sense of humour – a single nail and its shadow painted with exemplary illusionism. It is a detail that gives the painting the status of a summary, a declaration of just where, in 1910, Cubism stood. The nail and its shadow are there to post a reminder of all that Cubist space was not, of the old order of vision that it had set out to destroy.

The Cubists seem to wonder what the world might look like seen through X-ray eyes (solid objects turn transparent, dissolving into complex layers of intersecting planes), or under extreme magnification (air itself thickens, full of mysterious atomic energy, traversed by lines that look like sound- or radio-waves literalized). The connection between the Cubist revolution and contemporary scientific revolutions – Picasso and Braque painted in the wake of Einstein's Theory of Relativity and on the eve of the age of radio – has probably been overstressed, but it is intriguing none the less.

Picasso initiated Cubism's second and final phase (Synthetic Cubism) when he stuck a piece of mass-produced oilcloth printed with the image

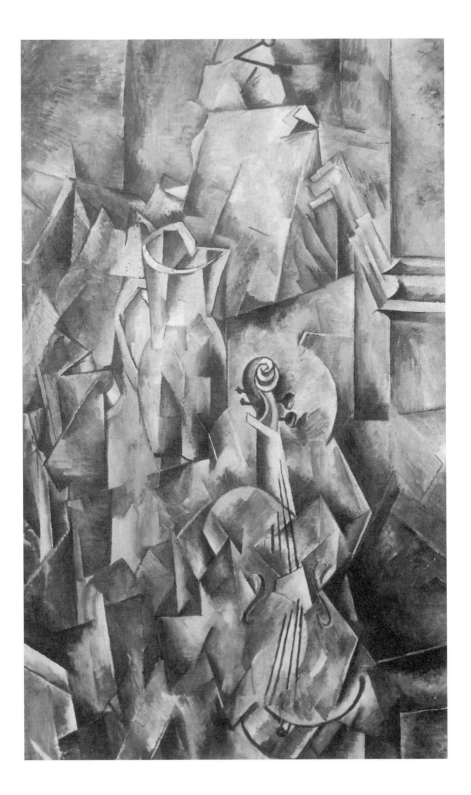

of chair-caning to his 1911 painting *Still Life with Chair Caning*. Collage – the implications of which were swiftly grasped by Braque and explored in his great series of *papiers collés* – looks with hindsight like a natural development of Analytic Cubism. Picasso and Braque had already begun to envisage the texture of life as a form of collage – a rushing influx of images and sensations, overlaid one upon another – before they hit on their cut-and-paste technique. Picasso painted *Landscape with Posters* in 1912 in oil on canvas, but his vision of the city as a place of abstracted architectural planes, enlivened by sudden apparitions of vast, colourful logos ('Pernod Fils', 'Leon'), defines the modern metropolis as a vast three-dimensional collage, a place characterized by overlapping signage. As Synthetic Cubism gets under way, it develops into the first great art of the twentieth-century city. This is art that has found an equivalent for the fragmented, quickfire succession of experiences, the bombardment of visual imagery that characterized (and still does) modern urban life.

'Pioneering Cubism' offers among other things many a crash-course in telling Cubist Picasso and Cubist Braque apart. Theirs was a marriage of opposites. Picasso was always more interested in dissonance, in quirkiness, in what would later emerge as the surreal potential of Cubist fragmentation: it shows, even in the period of his greatest affinity with Braque, in the extra vehemence with which his planes tend to intersect, the attack of his brushstrokes, the suggestion that his structures are poised on the brink of violent collapse.

Synthetic Cubism marked the moment when the partnership – finally brought to a close when Braque was drafted to the Front in 1914 – began to dissolve. Picasso becomes ever more confident, as if he feels positively liberated by the sense of anarchy that is inherent in later Cubism. Synthetic Cubism's bitted world suits the nature of his imagination, which is essentially that of the fetishist – one who is classically transfixed by certain body parts at the expense of others – and it is significant that at this point Picasso finally feels able to translate Cubism back into an art of the figure. The figures that he creates are mad, demonic concoctions, such as *Woman in an Armchair*, her breasts a pair of torpedoes fixed by a pair of illusionistic tacks to the broad planes that make up the rest of her body. Already you begin to sense the possibility of late Picasso. Those extraordinary, dislocated female

anatomies of the late 1950s and 1960s are made possible by Cubism's assertion that we can only ever know the world in fragments.

Braque, on the other hand, seems troubled by the very anarchy he has helped to unleash. His works of 1912–14 gain their power – which amounts, in the end, almost to a form of moral fortitude – from the tension between his sense of an exploded world and his determination to forge from it artistic structures of poise and lucidity. Braque's Synthetic Cubism is an art of rigorous control, governed by a system of compositional checks and balances, alignments of line and form to the rectangle of the picture plane, offering a classicist's reproof to Picasso's fertile eccentricity.

Cubism is still challenging, and it is some measure of the achievement of Braque and Picasso that their works – even at the end of a century whose artists have been virtually obsessed with the notion of radicalism – should still look more radical and extraordinary than any that have succeeded them. We may have only begun to understand the implications of the Cubist revolution.

21st November 1989

XIII

CRITICAL REMARKS

Mengs

ANTON RAPHAEL MENGS was the most famous painter of the eighteenth century for about fifteen minutes. In 1761 he painted his presumed masterpiece, a large but flaccid canvas, conflating hints adapted from Raphael and Poussin, which he entitled *Parnassus* and which was, briefly, one of the most highly regarded pictures in the world. On the strength of what now seems a stunningly dull mythology, with its wooden Muses and mannequin-like Apollo, Mengs was acclaimed by the first great arbiter of neo-classical taste, Johann Joachim Winckelmann, in terms which any artist at any time in history might have had trouble living up to: 'He is the greatest artist of his time and perhaps of succeeding times, reborn like the phoenix from the ashes of the first Raphael, to teach the world beauty in art, and to achieve the greatest flight committed to human powers in the same.' But within a few years Mengs and his works would abruptly disappear into obscurity. Winckelmann's phoenix turned out to be nothing of the kind, but a dodo of the neo-classical age.

Conclusive evidence comes in the exhibition devoted to Mengs that currently occupies the upper galleries of Kenwood House. This is something of a rarity: a show consecrated to the talents of a hopelessly mediocre painter that is none the less fascinating; an exhibition of irredeemably bad art that also amounts to a study in ephemeral artistic celebrity.

Mengs was not only the victim of Winckelmann's wild overenthusiasm – although, had Winckelmann not damned him with such strong praise, he might never have attracted the venomous dislike that has characterized most later descriptions of his work and would, probably, have been remembered as a merely competent practitioner of a style of painting that became briefly fashionable in Rome in the third quarter of the eighteenth century. But it seems that he was doomed

from birth to carry a weight of expectation that he could not support.

Mengs' father was an embittered, frustrated minor painter of portraits who lived out most of his life catering to the vanity of the court circle of the Elector of Saxony. Clearly desperate to see his son succeed as he had never done, he condemned him at baptism to a lifetime of hopeless dreams and inappropriate aspirations. Mengs' given names – Anton after Antonio Correggio, and Raphael after the Renaissance prodigy – amounted to an albatross around a baby's neck.

Mengs senior brought up Mengs junior to believe that he was destined for great things. He took him to Rome, introduced him to Cardinal Albani, the influential connoisseur and collector for whose private gallery the *Parnassus* was commissioned and, for a while at least, the desperation that lay behind his urge to impress carried him through. But in the end his tragedy may have been that he was no more and no less than the son of his father: a moderately talented portrait painter whose almost complete lack of feeling and imagination fatally unsuited him to the genres of mythological or biblical narrative painting which he saw as his route to greatness. His proper domain was the world of fashion-conscious *cognoscenti* and *dilettanti*, of English milords dallying with classical culture while on the Grand Tour, of which he left several records in the form of dutiful but uninspired portraits. It was not Mount Parnassus.

The self-portrait that Mengs painted in 1774 is a more confessional picture than, perhaps, it was intended to be. Mengs probably meant it as a document of his supreme self-confidence, an image of himself as Winckelmann's phoenix. The artist, soberly dressed and simply lit against a plain background, gestures to the canvas beside him on which he has traced out several classical figures in flowing draperies. The painting is Mengs' way of spelling out, in no uncertain terms, that he is the new heir to the Renaissance – that in him, as in no other painter of his day, the spirit of classical antiquity still lives. But although Mengs' self-portrait clearly occupies a long-established tradition of pugnaciously self-propagandizing artists' paintings of themselves, there is, none the less, something slightly unconvincing about it. The man at the centre of the charade seems conscious, after all, that it is a charade. The expression that he has given himself (and whether this was involuntary or not, the *Self-Portrait* is by some way the most expressive painting

Mengs ever painted) is the giveaway. There is fear, and sadness, in his eyes, the look of a man who knows that one day people will see through him.

In Rome Mengs married the daughter of a dustman, and she is said to have posed for the figure of the Virgin in his *The Holy Family with St Elizabeth*. This seems unlikely, to judge by the painting itself, one of his most shameless attempts to follow in the footsteps of Raphael. Nothing remotely as robust as the likeness of a real person has been

MENGS *The Holy Family with Saint Elizabeth and Saint John the Baptist*

331

allowed to intrude into this monument to Mengs' pained academicism, a painting made up entirely of magpie-like borrowings from the work of the High Renaissance master he sought to rival but could only parody. Each of the figures, whether the overly solicitous Virgin or the daftly beatific, ludicrously ill-proportioned infant Christ, looks like the shadow of a shadow of an art-historical source, as if ineptly copied from some inept engraving of a Raphael original.

The puzzle of Mengs' sudden and temporary celebrity, to modern eyes, is that it could ever have happened – that anyone, looking at this painting (or the *Parnassus* which now loiters, dark and unseen, in the Villa Albani in Rome; or the equally inert *Augustus and Cleopatra* which hangs, universally ignored, at Stourhead), could ever have believed that Mengs was anything other than a painter of the third rank with pretensions. The minor dramatist and amateur art historian Richard Cumberland, writing three years after Mengs' death, put the seal on his posthumous reputation. 'Mengs,' he wrote, 'was an artist who had seen much, and invented little. He dispenses neither life nor death to his figures, excites no terror, rouses no passions, and risks no flights. By studying to avoid particular defects, he incurs general ones, and paints with tameness and servility in all or most of his compositions, in which a finished delicacy of pencil exhibits the Hand of the Artist but gives no emanations of the Soul of the Master; if it is beauty, it does not warm, if it is sorrow, it excites no pity.'

Yet Cumberland's damnation of Mengs may also account for his momentary apotheosis. Mengs' dull and lifeless paintings clearly answered a need, even if their virtues were negative. The neo-classicism that Winckelmann espoused in the second half of the eighteenth century was itself underpinned by a negative aesthetic, an aesthetic in opposition to all that the Rococo style seemed, to him, to embody: decadence, frivolity, the unashamed carnality of Boucher and Fragonard, those painters of airborne brothels. Mengs' academic, by-rote method of painting, the pallidity and bonelessness he imparted to human flesh and his confinement of all human activity to the feeble gesturing of figures halfheartedly enacting morally uplifting narratives from the Bible or classical myth – these were all, to Winckelmann, virtues of the highest order.

Mengs appealed to Winckelmann for exactly the same reason that the

bleached fragments of surviving classical statuary appealed to him. They allowed him to indulge his fondness for looking at the nude human body while rendering it harmless by presenting it unsexed, made marmoreally frigid, taken out of the domain of real life, real (and dangerous) passion. Winckelmann, one of the first of art history's long line of shamefaced closet homosexuals, was terrified of his own urges and required art to act on his nervous system like a form of sedative, or purgative. 'Beauty,' he wrote, 'should be like the best kind of water, drawn from the spring itself; the less taste it has, the more healthful it is considered.' It was Mengs' good and bad fortune that, through sheer cultural accident, his art happened to fit the devious prescription of the most influential writer on aesthetics of his age. He became famous, quite simply, because his art was so thoroughly unengaging, so cold and emotionless, so unrelieved by virtuosity and so without sensual appeal that it met Winckelmann's peculiar needs. He became famous because Winckelmann found in his painting the cold shower that he felt his overheated sensibility required. No wonder that the temporary fame of Anton Raphael Mengs, which depended precisely on all his worst qualities as an artist, did not last.

17th August 1993

Danby

FRANCIS DANBY'S *The Upas, or Poison Tree in the Island of Java*, the smash sensation of the annual British Institution exhibition of 1820 and one of the most ambitious narrative paintings of its time, has languished in the obscurity of the V&A's basement for more than a century. Recently restored, it is the focal point of the Danby retrospective that has been mounted jointly by the Bristol City Museum and Art Gallery and the Tate Gallery. *The Upas Tree* marked Francis Danby's London début, and in some style. Measuring 66in by 99in, Danby's gloomy canvas was an enormous calling-card, his way of announcing that here, from provincial Bristol (via Ireland, his place of birth), was a young painter to be reckoned with.

The painting's subject was fashionably exotic, if a little obscure. In a barren landscape of towering, craggy outcrop and plunging ravine (Java imagined by a Bristolian, the Avon Gorge disguised for effect), and littered with the odd skeletal remains, a figure holds its head, reeling away from the poison tree of the title. Richard Redgrave, in *A Century of Painters of the English School* (1866), explains the story: 'The fabulous tree was said to grow on the island of Java, in the midst of a desert formed by its own poisonous exhalations. Its poison was considered precious, and was to be obtained by piercing the bark, when it flowed forth from the wound. So hopeless . . . and so perilous was the endeavour to obtain it, that only criminals sentenced to death could be induced to make the attempt, and as numbers of them perished, the place became a valley of the shadow of death, a charnel-field of bones.'

The Upas Tree, as far as its early nineteenth-century audience was concerned, had the lot: a touch of the East, a grandly sublime landscape in the Turner mould, a *frisson* of horror and even a moral in its parable of greed getting its come-uppance, a seeker after gain stranded in his own just desert. Even Danby's dour tonalities seem to have struck a

chord in those reared on the dark sublimities of Ossian and, subsequently, the Romantic poets. 'The dinginess of colour in this picture,' noted the critic for the *London Magazine*, 'came over us like the darkness of a thundercloud.'

The trouble was, Danby's painting rapidly got darker. By 1857, a few years before the painter's death, one observer noted 'its defective technical treatment' and concluded that within a few years it would have degenerated altogether. Now, thanks to conservation, Danby's painting, darkness visible epitomized, is, once again, visible, although much of its left side, almost indecipherably bitumenized, and its ubiquitous crazy-paving of *craquelure* are reminders that Danby's technique was indeed fatally flawed. Many of his other paintings have not made it into the twentieth century.

Danby has been remembered, rather unfairly, as an irredeemably minor follower of John Martin ('Mad Martin'), the master of awe-inspiring upheaval, of zig-zagging lightning flashes, splitting boulders and multitudes overwhelmed by the forces of God and nature. Danby's position has long been symbolized by the hang at the Tate, where his version of *The Deluge* hangs opposite Martin's trio of perennially popular Tate-owned biblical epics, *The Plains of Heaven*, *The Last Judgement* and *The Great Day of His Wrath* – outnumbered and outfaced. Yet *The Upas Tree* shows that, well before he had encountered the work of Martin, Danby had dark and awesome leanings. His relationship to Martin was complicated in more ways than one. Danby always maintained that Martin stole the idea for his own version of *The Deluge* from a painting he saw in Danby's studio, *An Attempt to Illustrate the Opening of the Sixth Seal*.

Martin was, undoubtedly, the high priest of apocalyptic art, whose Bible-bashing portrayals of furious geological and historical convulsion would later inspire the megalomaniac cinema of Cecil B. De Mille and D. W. Griffith. But Danby was, in his own right, a master of the grand apocalyptic spectacular, even if his decision to paint such subjects seems to have been made with an eye to profit. 'The subject is not one after my own heart,' he wrote to his patron John Gibbons, concerning *An Attempt to Illustrate the Opening of the Sixth Seal*. But, he added, it was 'the sort of picture I am at present most likely to sell'.

He did sell it, to the fabulously wealthy and somewhat cracked

William Beckford, who, as creator of the massive, ill-fated Fonthill Abbey in Wiltshire, must have felt some affinity with Danby's grandiose, megalomaniac picture. John Constable noted the sale, somewhat rancorously, in a letter of 1828 that suggests his grudging interest in, and ultimate contempt for, the art purveyed by Danby and Martin: 'There is a grand and murky dream by Danby. It is purchased by Beckford – the subject is from the Revelations but might pass for the burning of Sodom – 500gns . . . I only wish you could see the work which has elicited all this.'

Danby threw down the gauntlet to Martin with works like *The Delivery of Israel out of Egypt* (a multitude of foregrounded Israelites praise the Lord, Moses raises his staff and the waters of the Red Sea close over the hapless Egyptian army) and the depiction of lurid, mountainous cataclysm that was his *Attempt to Illustrate the Opening of the Sixth Seal*. These were the most successful of his full-blown, wide-screen entertainments. Painted in not-so-glorious Danbycolor – 'I think I am almost cured of painting dark pictures,' he would write in 1825, 'but I shall ever like them best' – such paintings nevertheless represent his greatest attempts at high seriousness and, in retrospect, his finest hour.

Danby led a chequered life. Having left Ireland to seek his fortune as an artist, he settled for a while in Bristol – where he painted calm, idyllic landscapes and genre paintings of sugary, Biedermeier charm – before making his calculated assault on London. Danby's subsequent success may have annoyed Constable, but Constable would have his revenge – in 1829, he defeated Danby by one vote in the annual election to the Royal Academy. Sickened by this, heavily in debt and estranged from his wife ('a little red-faced bare-footed wench' he had met in Somerset, who ran off with another Bristolian artist) Danby fled to the Continent with his pregnant mistress. Once there, he lived the life of an indigent itinerant, perpetually in debt, with, on occasion, as many as eleven children to support (the 'bare-footed wench' had shipped out their seven children to Danby when he left for Europe).

Danby made a comeback, of sorts, with *The Deluge* that hangs opposite the Martins in the Tate. Painted in 1839, at the prompting of a dealer-cum-entrepreneur who originally planned to tour it round the country, its 130sq. ft of hostile weather and writhing, diminutive bodies put Danby briefly back in the limelight. But Danby was, by this time,

disillusioned with the Martinesque *grande machine* by which he had earned his reputation. He went to live in Exmouth, where he devoted himself to his hobby, boat-building, and painted vaguely Claudian pictures of becalmed three-masters basking in the glow of a late evening sun.

Some of Danby's finest works are the small and unpretentious landscape studies, in watercolour or oil, that he produced throughout his career – his studies of Irish landscape, or of London from Primrose Hill, are far more convincingly and freshly worked than many of his drier, more ambitious subject pictures. Even in some of his most calculatedly 'sublime' paintings, Danby can seem more interested in meteorological effects than dire consequences. His extravagant *Sunset at Sea after a Storm*, its tiny raft-borne figures adrift in unpromising circumstances, was meant to be Danby's answer to Géricault's famous *The Raft of the Medusa*. But the figures feel irrelevant, an unnecessary narrative graft on to a pure seascape, ragged clouds lit by the glare of a red-eye sun.

In Bristol Danby had painted Arcadian landscapes, and his patron, John Gibbons, always maintained that Danby's early Claudian landscape *An Enchanted Island* was his finest painting. 'I have a landscape by Danby,' he wrote, 'that is Claude all over, but I like it none the less; if a man can pull the bow of Ulysses, to me he *is* Ulysses.' Living out his days in Exmouth, Danby seems to have found, at last, some kind of tranquillity. He had always been an eclectic painter, working in any of the three categories recognized by contemporary aesthetics – the sublime, the beautiful or the picturesque – seemingly at will, and probably in order to conform with whatever was fashionable or expedient. His last known creative act was not the painting of a picture but, some four months before his death in February 1861, the invention of 'a new kind of single-fluked anchor', for which he took out a patent. A small thing, but his own.

11th February 1989

Modigliani

'HE WHO LOOKS TO A POISON in order to think will soon be unable to think without it,' Baudelaire once wrote. 'Picture if you will the appalling fate of a man whose paralysed imagination would be unable to function without the help of hashish.' Amedeo Modigliani appears to have modelled himself, during his short and unedifying life, on this cautionary figment of a poet's imagination.

Dead at thirty-six, killed by his almost religious adherence to a diet of drugs, cheap brandy and absinthe, Modigliani's entire adult life amounted to a suicide committed by degrees. He may have believed too literally in a certain romantic notion of what it is to be an artist, widely current in *fin-de-siècle* and early twentieth-century Paris, and have mistaken disorientation of the senses for inspiration.

Surprisingly little is known about him. He emerges from various accounts as a kind of caricature early Modernist, the supreme *peintre maudit*. His friends even nicknamed him 'Modi', pronounced *maudit* ('damned'), a fact of which he seems to have been singularly proud and which he did his damnedest to live up to. In the stories told about Modi he is a cartoon character, invariably manic and absurd: pawning his clothes for drink or drugs to dance, naked and intoxicated, through the streets of Montmartre in midwinter; demolishing one of the walls of his studio in a drunken rage; abruptly terminating an argument with his lover, Beatrice Hastings, by throwing her through a window.

He cannot always have been quite so stereotypically crazed, and Picasso, intriguingly, suspected him of playing up to his image, noting that he always reserved his worst behaviour for public occasions – but there is almost no evidence of what he might have been like in his quieter moments. The relationship between Modigliani's personality and his most admired art – those beatifically calm, elongated stone heads with inscrutable almond-shaped eyes – has never been clear. He has

been submerged by his own myth and become, merely, a colourful character, almost entirely devoid of human characteristics.

'The Unknown Modigliani', which opened last week at the Royal Academy, is a promisingly titled exhibition. It suggests disclosure, a fleshing out of the bones of the Modigliani myth, a revelation (or at least a glimpse) of the private man. The show consists almost exclusively of drawings from the collection of Paul Alexandre, a doctor and friend of Modigliani's said to have supplied him liberally with opium in exchange for works of art. Although the show offers no deep insight into Modigliani's personality, it is possible to read between the immaculate lines of the artist's drawings and to guess at some of the conflicts that were played out in his sad, short life.

The earliest drawings in the exhibition reveal an artist fashionably fascinated by the subject matter of the Parisian *fin-de-siècle*, producing stylish impressions of essentially the same *demi-monde* painted by Toulouse-Lautrec. Sketching a gawping clown or a dancer lifting her skirts to an appreciative audience in a Montmartre music-hall, Modigliani reveals an entirely conventional avant-garde determination to find the subjects of his art in low rather than high life. Much the same impulse lay behind his contemporary Picasso's melancholic pictures of circus troupes and the urban poor, the sad harlequins and emaciated laundresses of his Blue and Rose Period pictures.

Modigliani's drawings of this time are shot through, too, with an uneasy and somewhat forced mysticism. He draws a pair of spiritualists, rapt and entranced during a seance, clearly attempting to endow his subjects with a sinister and sacerdotal intensity but sabotaging the effect with his characteristically elegant, dandyish draughtsmanship. The resulting awkwardness is characteristic of much of Modigliani's work: the sense of a split between subject and manner, of an artist working the wrong genre like a comic actor trying to play Macbeth or a novelist of social manners attempting to write epic poetry. Elegance may, in retrospect, have been Modigliani's greatest shortcoming, as well as what came to him most naturally.

There is a scrap of paper behind glass, encountered early in this show, on which he has written a manifesto for his art: 'What I am searching for is neither the real nor the unreal, but the Subconscious, the mystery of what is Instinctive in the human Race.' Not much of a manifesto,

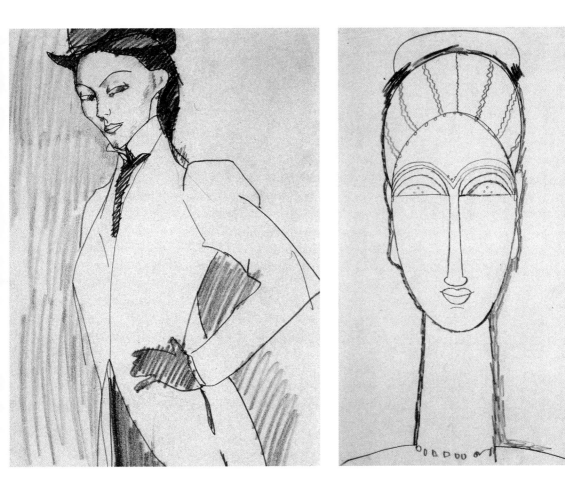

perhaps, and it does not even make much sense, but it does give a clear sense of what Modigliani was after: something *profound*; something *powerful*; something *universal*.

This explains why, like many other artists of his time, Modigliani began to work in ways indebted to non-European art. The elongated oval heads and the solemnly expressionless caryatids that he drew and sculpted were his stab at timeless, tribally powerful art. But unlike Picasso's work in a similar vein, which manages genuine modern savagery, Modigliani's primitivist work remains curiously and perpetually effete.

This is particularly apparent in his many drawings of caryatids in the current exhibition. They have the character of stage props, or of architectural decorations, and to note the difference between one drawing and another is often to see an artist working on the irreproachably stylish embodiment of a preconceived formula – adjusting the fine line of a profile, say – rather than responding to the urgings of a dangerous and unfettered creativity. Modigliani may not have been quite the wild man of his myth.

Modigliani's primitivism, which lies behind the works for which he has been most often remembered – his sculpted heads, his portraits of people transformed into mute and sightless totems – has a distinctly odd character. It uneasily combines two vastly different traditions of art. His sources might be the Buddhist statuary of India or Cambodian temple sculpture, but his visual sensibility is thoroughly Western European, infused with a kind of bravura seemingly derived from Italian High Renaissance and Mannerist art. Modigliani's caryatids and his long-necked Buddhas with their mysterious smiles owe as much to Leonardo da Vinci and Parmigianino, painter of long-necked madonnas, as they do to the art of the East. The collision of these various influences and affinities with the artist's avowed intent to confront 'the mystery of what is instinctive in the human race' produces something of a freak: art that is torn between immense spiritual ambition and facility; art that marries the atavistic and the chic.

In another life, Modigliani could have been a talented painter of society portraits. His various drawings of the so-called *Amazone*, an unnamed Baroness in riding costume, demonstrate his considerable talents for characterization (almost caricature) as well as his desire to

transcend such talents. She is a haughty socialite, on the brink of meta-
morphosing into one of Modigliani's fey and theatrical temple god-
desses. Modigliani might have been happier if he could have admitted
that it was to her polite and well-mannered world that he really
belonged. Narcotics and alcohol may have been his way of trying to
induce, in himself, frenzies that he could not naturally feel; and Modi's
tragedy may have been that he expended his life in an attempt to live
up to a nickname that did not really describe him.

18th January 1994

XIV

LOVE LETTERS

Matisse

MATISSE PAINTED THE FIRST, experimental version of his great mural, *La Danse*, in 1931, when he was sixty-two. It then disappeared for sixty years before it was found, rolled up in a warehouse in Paris, in April 1992. I saw it last month, on a clear, cold day, at the Musée d'Art Moderne de la Ville de Paris, where it had gone on exhibition for the first time. As virtually everyone else in the city appeared to be waiting to see 'La Collection Barnes' at the Musée d'Orsay or 'Les Nabis' at the Grand Palais, or the Louvre's newly opened Aile Richelieu, I had the museum, and this particular Matisse, to myself.

The experience of art is often disappointing because so often there is something distractingly, nigglingly wrong. The pictures may be badly hung or badly lit. The rooms in which they are exhibited may be over-crowded. You may have a headache, or an upset stomach, or a sore tooth. But sometimes, very, very occasionally, everything seems just right.

I arrived, early, at the museum. I was not expecting much. I knew almost nothing about the painting and had seen only one rather poor reproduction of it. I remember an attendant fumbling with the door, unlocking it but not opening it, and then indicating that I could go in. I opened the door with difficulty (it was sticking), and what happened next may sound embarrassing and extravagant, but it seemed, at the time, true: I left time and space behind and crossed the threshold from one world into another.

Memories of art are often fickle and deceiving, but this particular memory, of this particular work of art, still seems as clear and vivid to me as the experience itself. I am in a blindingly white space – floor, walls and ceiling are all white – at the top of a broad and shallow flight of stairs. Opposite me hangs an enormous triptych. Vast painted bodies, some whole, some fragmented, dance and tumble across a field of

indescribable blue: a blue that only Matisse has ever painted, somehow bluer than the bluest sky or bluest pool of water in the real world. Nothing has prepared me for the sheer scale of it, for the fantastic monumentality of these almost abstract, faceless dancers, nor for the vast, spreading void which they occupy.

The painting is described as being unfinished, although no modern painter has done more than Matisse to blur the distinction between the unfinished and the finished work of art. The manner of this work's incompleteness seems essential to the grandeur of its effect and to the profundity of its feeling. The dancers are painted, from left to right, with increasing abstractness and, correspondingly, the blue void within which they dance is itself increasingly intermittently realized, eventually petering out altogether in the extreme right-hand panel, fading to the whiteness of the primed canvas. The effect is both strange and beguiling, as if Matisse's dancers are dancing themselves into the air – dancing

themselves out of this world and into another. Perhaps Matisse meant the picture to be read as multiple images of one, single dancer, whose destiny it is to dance himself or herself (the figures in the painting are androgynous) away to nothing, to become a spirit or an angel.

Perhaps all that has happened when you have been moved by a certain painting is that your own emotional peculiarities have been temporarily and obscurely heightened by an object which will signify precious little to others. But I noticed that other people, too, gasped when they entered the room. It is possible that my experience before Matisse's painting was not merely some freak of feeling brought on by the weather or a sense of well-being, or the peculiar suddenness with which the fumbling attendant and the sticking door had revealed it to me. Matisse's long-lost painting made me feel as though I had, momentarily, entered some Utopia, some strange idyll or heavenly space, perhaps because the yearning for just such a form of transcendence was what had inspired Matisse

MATISSE *The Dance*

when he painted it more than sixty years ago. I now think that that is the case, although I have no way of proving it: just a few scraps of fact and a vague, half-formed hypothesis.

Matisse embarked on his mural, *La Danse*, in 1930 in response to a commission. Dr Albert Barnes, the American collector, wanted a decorative triptych to fill the somewhat awkward space provided by three arch-shaped lunettes in his large, neo-Renaissance-style mansion in Philadelphia. The subject was of Matisse's own choosing, and it took him almost three years of trial and error to bring it to completion. During that time he rejected the first version (the one that moved me) and nearly finished a second version before realizing that he had painted it to the wrong dimensions. Finally, he completed a third version, which Barnes accepted and installed in his house. All three versions have been gathered together in this current exhibition (the first two will remain there when the third goes back to Philadelphia). Each is different, and each differs, too, from Matisse's various other images of dancers.

'Dance is an extraordinary thing,' wrote Matisse, 'life, and rhythm.' He could have been describing his own painting. The dance, or more properly the idea of dance, was an almost talismanic theme for Matisse, one that he seems to have chosen to paint at key moments, when he felt the need to define or redefine himself and the nature of his art.

The first time the theme appears is in *Le Bonheur de Vivre* (1905–06). Within a landscape of Arcadian artifice – an unreal world of bright and soft patchwork colours inhabited by dreamily self-absorbed bodies, lounging and embracing – a ring of dancers circulates hypnotically in the middle distance. The painting presents the first and the least troubled of Matisse's Utopias. It is a paradise garden, an image of the mythical Golden Age (the image of dancers in a circle recalls Mantegna's *Parnassus*, many paintings by Poussin, and Ingres's *L'Age d'Or*). The dance signals a perfect, and perfectly unreflective, condition of humanity, where simply to be is to be whole, content and in perfect harmony. The painting, and the ring of dancers within it, represents a dream of perfection that Matisse could not (or would not, or knew too much to) revisit. *Le Bonheur de Vivre* is the self-created Eden from which Matisse

had to expel himself in order to continue painting: an image of perfection that could only, subsequently, be complicated or dissented from.

'This dance,' Matisse said, when he was working on the various versions of the Barnes mural in the Thirties, 'this dance – I have had it inside me for so long.' He had returned to the theme just once before, in the two enormous paintings of *La Danse* which he executed for the Russian collector Sergei Schukin between 1909 and 1910. By then, the dance had become more frenzied, more Dionysiac, less untroubled. Those famous, enormous figures, cavorting on vast grounds of flat colour, became Matisse's way of defining the joyful and painful struggle not just of being alive but of making art, of wresting something – energy, exuberance, a moment of release – from the daily round of experience. This dance is tinged with desperation, and the circle which the dancers form is crucially broken (as it is also, but less emphatically, in *Le Bonheur de Vivre*): two of the hands are separate, as if to emphasize that perfection, the unbroken circle, can only ever be a dream to strive for, and can never become a reality.

In the three versions of the Barnes *Danse*, Matisse is still scratching the same itch. The first version (the 'unfinished' version, 'my' version) is perhaps the most extraordinary because it combines such lucidity, such disembodied calm, with a strange and powerful frenzy. Matisse seems to have yoked together the two extremes of monumental painting, the despairingly gesticulative with the serenely transcendent. It is an image of apparently hopeless aspiration – those figures at its left-hand edge could be stranded on some seashore, waving at a distant sail for rescue – which gives way, in the form of the figure weightlessly ascending at its opposite pole, to an image of salvation. It may be the most universal of all Matisse's paintings, the one in which the guiding tension of his art – between sadness and hope, melancholy and pleasure, the earthly and the divine – is most simply stated. Why did Matisse not present Dr Barnes with this first version? Perhaps because it was too nakedly emotional, too radical, or because he felt it worked so well 'unfinished'.

The second and third versions mark the moment when Matisse reinvented himself, yet again, in later life. He zoomed in ever closer on the same single motif, magnifying it to the point where its coherence dissolved and the dancers became fragments – but each time he painted

it, it meant something different. When he came to make the second and third versions of the Barnes mural he used a new technique, the *papier collé*. Instead of painting his composition on to three canvases, he cut out huge sheets of paper in the form of the various dancers, or anatomical fragments of dancers, and experimented with placing them in different positions.

What did it produce? Paintings that look oddly impersonal (although Matisse's cut-outs are always 'drawn', with the scissors, unmistakably in his hand), and paintings in which the artifice of art, and the artist's relationship to his own work, is spelled out in a new way. Matisse's second version of the Barnes mural, now known as *La Danse de Paris*, ceases to present the figures as a circle and envisages them as a frieze, like the fragmented dancers you might see on shards of Grecian pottery. The last dance, *La Danse de Mérion*, is more like battle than ballet, pitting pairs of Amazonian nymphs against each other in successive panels. The dancer might change, but it remains metaphorically charged, an image of more than itself: Matisse's way of distilling the serenity or violence of the world to a single image.

Matisse's second and third versions of the Barnes *Danse* seem strangely provisional, and lack the salutary, inventive vigour of the first, where serenity and violence coexist. They have, however, their own special significance. These shapes declare that they could have been placed in many other positions. The dance is not fixed and can never be fixed; the painting can never be finished; the dream of perfection can never be realized. The world itself, Matisse's later art says, is just provisional. 'Painting', he said, 'is never complete.' That is – just like life, and just like the dance – until the living, and the dancers, cease to breathe.

After painting the Barnes *Danse* murals, Matisse turned increasingly, and eventually entirely, to the medium of the cut-out. He ceased to be a painter and became, instead, a choreographer of the forms which his hands both cut out and caused to dance. The greatest example of Matisse's youthful old age is in the Tate Gallery in London, and he called it, mischievously, *The Snail*: what could be less earthbound than that enormous collage of floating aerial forms, those great slabs and slices of vibrant colour choreographed in space? Before he died, Matisse made himself lithe and young again.

8th January 1994

Turner

WILLIAM HAZLITT ONCE remarked that Turner's paintings were 'pictures of nothing, and very like'. He meant those vortices of light or primal oceanic upheavals that swirl in the roomful of late Turners at the Clore – and he meant what he said as an insult.

Since then the twentieth century has intervened, and pictures of nothing are labelled abstract art. Recent years have seen a series of critical attempts to enlist late Turner as a modern artist stranded in the nineteenth century, a revolutionary whose visionary ideas – hampered by the prevailing pictorial and iconographic conventions – initiated a tradition that would culminate in the abstractions of Jackson Pollock and Mark Rothko.

The new arrangement of the Turner Bequest reads like an extended argument against his modernity. Both in the hanging of the paintings and, perhaps surprisingly, in the design of the exhibition space (it feels like a cross between Soane's nineteenth-century Dulwich Art Gallery and the Yale Centre for British Art). In this classical, academic setting the pictures are accompanied by brief essays which explain Turner's often arcane iconography, point out his self-conscious imitations of the Old Masters, and quote the lines of poetry which he originally appended to his works when he showed them at the Royal Academy. *The Bay of Baiae, with Apollo and Sibyl* invites you to gaze past its two diminutive human protagonists into the lucid depths of an ideal landscape, the world turned to honey by Turner's sun, the sails of distant ships reflected in the clear expanse of a sea that stretches to infinity. The text on the wall transforms the picture from wistful travelogue into allegory, a moralizing contrast between the unfading beauty of nature and the folly of human ambitions for permanence. Turner's painting tempts you to put on sunglasses and bathe in its warm glow; his didacticism, backed to the hilt at the Clore, tells you to put on your reading glasses and pay attention to his references.

The exhibition never allows you to forget the paranoid literariness of this Cockney made good – the symbolic, mythological or historical associations with which he freighted his art. Facing each other down the central spine of the gallery, separated by some fifty yards, hang his 1818 *Field of Waterloo* and the 1842 *The Opening of the Walhalla*. The first is Turner's grim reflection on the horrors of war – the foreground is littered with dead or grieving figures, examples of his characteristically floppy, boneless humanity (he never could paint people), lit by the lurid glow of a burnt-out landscape that flashes with the sporadic detonation of cannon fire. The second is his celebration of the resurgence of European culture, a gooey mess of paint in which you can just discern a congregation of worthies and the Bavarian temple of arts the picture was meant to commemorate. (Turner sent it to the Congress of European Art in Munich, where it was taken as a satirical insult, returned damaged, and was partly responsible for the fact that no public institution in Germany would purchase his work for over a hundred years.) Neither is a particularly fine painting, so you suspect they have been placed so prominently to make a point: to stress Turner's intellectual seriousness, to underline his lifelong engagement with the history and culture of his time.

There is a case for this approach. Turner might have approved of the Clore's scholarly glosses on his pictures, and its eager promotion of minor works with grandiose intellectual pretensions. When he first entered the Royal Academy Schools in 1789, at the precocious age of fourteen, the pictorial hierarchy of the late eighteenth century still held sway. This was a kind of points system that ranged subject matter in a scale of descending importance, from 'history' painting (narrative works treating religious or mythological subject matter) down through portraiture to still life and landscape, the lowest of the low. Throughout his life Turner sought to revise the hierarchy, to raise the status of landscape painting. His texts, his frequently awkward symbolism, all served to exculpate his art from the charge of being mere topography, mere depiction of the effects of nature. Turner might have been horrified by the suggestion that he was an Impressionist *avant la lettre*.

'Damn the man! how various he is,' said Gainsborough of Reynolds, and so is Turner. Not just in the variety of moods and styles of which he was capable – anything from picturesque to sublime, from Titian to

Ruysdael (you sometimes feel he wanted to be a one-man National Gallery, which, in a sense, he has now become) – but also in quality. Among the scores of genuine masterpieces at the Clore you find equivalent mediocrities, works that are only there because Turner couldn't sell them, and some outright failures. One scarred but beautifully painted seascape, its label explains, looks the way it does because Turner used it for years as a cat-flap. But one of the greatest arguments for having a whole gallery devoted to the work of a single artist lies in its ability to accommodate the lesser works – paintings which are often as revealing as the accepted masterpieces.

One great failure at the Clore is his late *Interior at Petworth*. A failure, that is, as a depiction of a patrician dwelling, which Turner has painted instead as the site of some extraordinary, churning act of creation. In its infernal chaos of melted forms you can just make out the ghostly traces of architecture: the salon as super-nova. In the same room, you find a more conventionally representational Petworth scene, the magnificent *Petworth Park, Tillington Church in the Distance*, with its plunging perspective leading into the heart of a majestic sunset. Pastoral English landscape is transformed by Turner's ecstatic suffusions of glowing incandescent light, into an uncannily stilled vision of Eden. Turner relocates divinity, hitherto the prerogative of religious painting – from Byzantine art to the Renaissance and beyond – in the secular tradition of landscape. Whether he actually said so or not, in his art the sun *is* God.

Turner's perennial theme is *vanitas*. Through all the avalanches, biblical deluges, snow- and sea-storms, blinding lights and darkling shades of his art, what comes through in the end is his elemental perception of the world – his sense that fire, earth, air and water are all that will endure. This is clearest of all in his supposedly unfinished works, the Rothko-like 'colour beginnings' and those works-in-progress that hang (deliberately unframed) next to his completed Venetian paintings. The exhibition reminds you that these quasi-abstract works *are* incomplete, but by placing them next to finished paintings, it suggests his modernity. Turner would finish them – described by one of his contemporaries as 'without form and void, like chaos before the creation' – on the walls of the Royal Academy, hours before the opening of the annual exhibition. Stepping in to create new worlds out of their indeterminate

TURNER *Petworth Park, Tillington Church in the Distance*

ether, Turner – in hubristic contrast to his theme of human insignificance – played God. He became the first action painter, predicting the improvisatory, and likewise cosmically ambitious, paintings of Pollock.

In Turner's supposedly unfinished works – shifting veils of paint, glowing and translucent at once – you find him freed from his cumbrous allegorical machinery, exploring an amorphous universe. In the late twentieth century, it is perhaps inevitable that they should appeal more than some of his more self-conscious finished works – like *War: the Exile and the Rock Limpet*, with its clumsy cartoon-transfer Napoleon that turns a glorious sunset into the backdrop to a moralizing aphorism.

Turner was a divided artist, torn between his eloquence with paint and a compulsive, official need to fill his raging storms and becalmed voids with words. The Clore Gallery sides with the man of letters, but no amount of cross-reference and beetle-browed explanation can destroy the revolutionary evidence that has been left by his brush.

10th April 1987

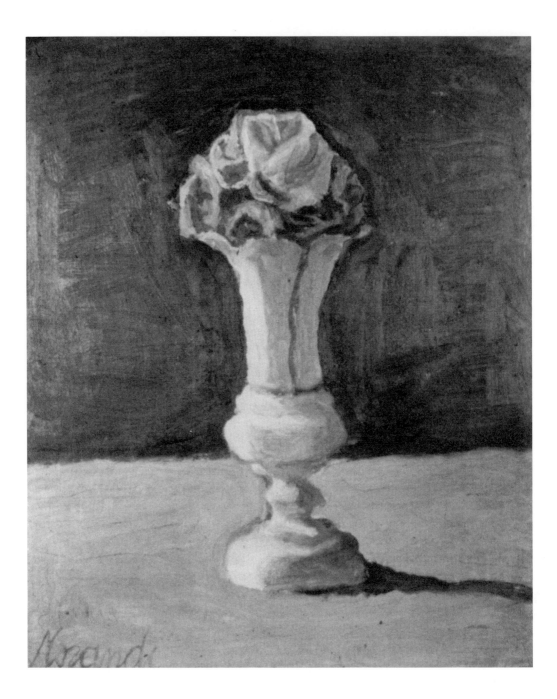

HIS NICKNAME WAS '*Il Monaco*' (The Monk) and he spent a lifetime painting simple things: old bottles and cups and bowls and vases arranged in different configurations on a rugged wooden table-top in the flat that he shared in Bologna with his three sisters, Anna, Dina and Maria-Teresa.

Giorgio Morandi (1890–1964), a bachelor with a reputation for reclusiveness, was the least hysterical of all twentieth-century Italian artists. He knew the Futurists but never joined their maniac iconoclastic cult of modernity. He contributed, but only briefly, to *Pittura Metafisica*. Movements came and went, but Morandi just got on with the slow business of painting masterpieces and forged, out of his Franciscan devotion to poor and ordinary objects, an art that transcended the plainness of its subject matter.

'Giorgio Morandi: Five Paintings for Contemplation', at the Accademia Italiana in Rutland Gate, is the smallest and quietest art exhibition in London at the moment. It is not controversial or topical. No anniversary, of birth or death, is being spuriously celebrated. It is not An Event, nor does it pretend to be one. No tombstone catalogue, no merchandise, no rhetoric; just five pictures by a great painter hung simply and sparsely in a large white daylit room.

Morandi painted his pictures slowly, and they require the slow viewing that this show encourages (the white room contains chairs to sit on as well as paintings to look at). They do not yield much to the casual glance because to look at them quickly is only to see their mundane subjects, the glass or the cup or the vase. What counts as much is the way they are painted. Morandi's table-top ensembles are endlessly mobile, their surfaces worked and reworked to emphasize all the subtle slippages that occur between observation and the transcription in paint of what has been observed. One of their themes is the transfiguration

of ordinariness. The paintings also propose their own subtle code for real things and create their own alternate worlds in order to reflect on this one.

Flowers, painted in 1950, is a small picture that strands a single vase containing roses on a light table-top against a dark wall. The knobbly vase could be made of cheese but it also has the scale of something enormous, a tower or a lighthouse. The flat bands of wall and table-top are painted both pastily and abstractly and they evoke the enormity of a long empty beach and a long empty sky. Morandi made large art out of small things and one of the ways he did so was by making small things seem physically vast, metaphorically charged. A room containing a vase on a table becomes a landscape containing a monument.

Painting makes up its own version of the truth. To the right of the vase a shadow falls and trails away, a dwindling river of darkness running off the edge of the canvas. Fugitive, it bears no relation to a real shadow and has become instead a thing in its own right. The shadow that looks as if it has leaked out of a thing like a fluid is a Morandi hallmark, announcing the bold self-sufficiency of his art and the necessary liberties that all art always takes with facts. In *Flowers*, the curving, uneven line of the shadow is taken up in the thin blue lines that run up and girdle the vase: decorative motifs that, remade in painting, have become wonky and tremulous.

The hesitancy of those blue lines is important, because Morandi's art as a whole invests hesitancy with tremendous significance. Hesitant painting – and the texture as well as the line of Morandi's art speaks of hesitancy, full of undisguised retouchings and alterations – becomes a model for hesitant looking and a way of saying that things can always be looked at differently. The moral of Morandi's painting is: take nothing for granted. Even the simplest things (just a bunch of flowers on a table lit by the afternoon sun) can become, looked at for long enough, an image of the mute mysteriousness of all things.

Objects lose their individuality and become part of a continuum of change, or at least Morandi's equivalent for the idea of constant change; they become absorbed into the busy shifting field of artifice that is the picture. Air is made as present to the eye in *Flowers* as solid objects. Move in close and you see the whiplash scribble of brushstrokes that is the artist's way of painting nothing at all; not thin air, exactly, but air

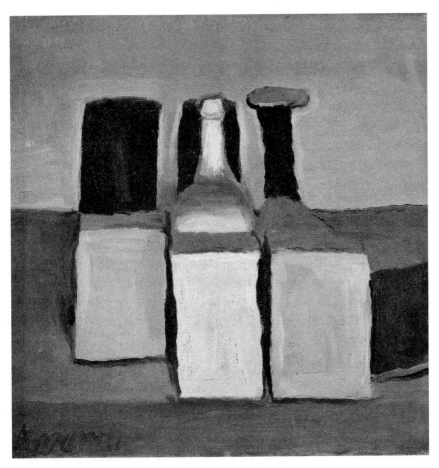

MORANDI *Still Life*

that has been thickened, like the heat haze that rises off tarmac in high summer, blurring the edges of things seen through it so that they appear as if viewed through half-closed, tearful eyes.

Morandi makes the static image eloquent of volatility and mutability and he creates a world where everything literally flows and seeps into everything else. Background becomes foreground and foreground becomes background; air solidifies and solid things liquefy. While his vase has the soft fatty quality of cheese left out in the sun, the roses

that it contains, stemless and bunched together, look like soft scoops of melting ice-cream.

Morandi uses the molten quality that paint, itself a liquid medium, can so readily impart to representation. There are many hints of this in earlier painting – the creamy surfaces of Chardin; the thick dribble of paint that Jacques-Louis David allowed to trickle down the top left-hand edge of the crate upon which the dead Marat rests his hand – but Morandi uses the liquidity of paint to speak of transience even more insistently. He uses it to propose a congruence between the unreal world of painting and the real world – to suggest that things really are as fluid and as unfixed as his images of them, even if they do not always seem so.

Still Life, 1956, is a painting of three opaque, square wine carafes that also makes objects seem far bigger than they are, although its monumentality seems invested with a different significance from that of *Flowers*. They look like three houses huddled next to one another and perhaps this is intentional. Perhaps the painting is meant to offer up an image of inanimate things transformed into an image of society, of human contact or the lack of it.

Morandi's characteristic wavering line – the line of hesitancy that he inherited in part from Cézanne – is most apparent here in the way that he has unevenly traced the thin gaps that separate these objects. Here, line acquires a different form of pathos. The forms in the painting touch, barely, only to separate again. If *Flowers* is about merging and mingling, opposites turning into one another, this is a picture about the gaps between objects (and maybe people too: there is something anthropomorphic about these flesh-coloured long-necked carafes), about sad separateness. Unexpected poignancy is found in the simple distinctness of things.

Morandi's art has a reputation for calm and orderliness that the paintings in this show contradict. They are as intense as the sharp stab of an emotion and their apparent composure turns out, on extended viewing, to be nothing of the kind.

The objects on Morandi's table-tops are precarious, tipped forwards by a flattened perspective that recalls trecento painting, or pitched sideways by a horizon line (in *Flowers* particularly) that is subtly out of true. The object monuments and object cities teeter and tilt, the

surfaces of the paintings churn like seas of butter. Morandi's world is not still, but for ever in motion. The Monk practised a form of violent contemplation.

1st June 1993

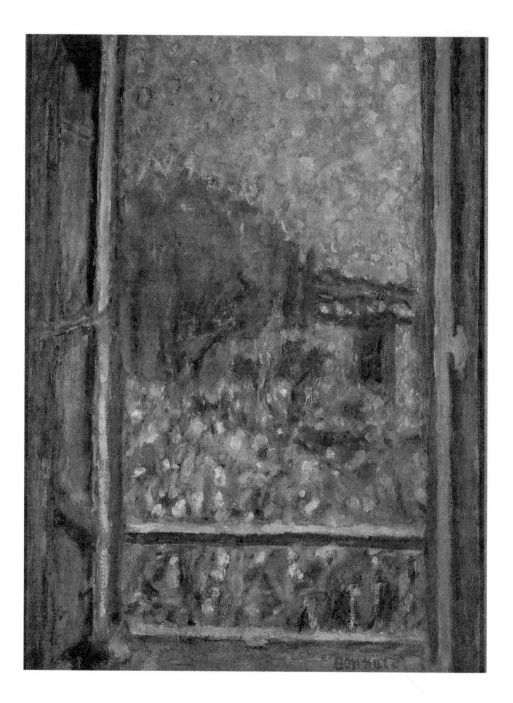

Bonnard

THE VIEW FROM THE BEDROOM WINDOW of his villa at Le Bosquet, on a summer's day in 1946, was the pretext for one of the smallest and most glowing of Pierre Bonnard's late pictures. The artist looked out, perhaps through eyes half closed against the summer glare, and he saw an orange tree and an almond tree and a thick mass of green and yellow vegetation. He saw the tiles on the roof of a small jerry-built outhouse shining with orange vividness in the heat of the sun. He saw the humid thickness of the air.

But as Bonnard worked on *The Little Window (View from the Painter's Bedroom)*, he did not really paint those things, or not those things alone. He painted the inexplicable intensity of his own feelings before them. His picture offers to the eye an image of the world transfigured. Using paint to create a gold-green sparkle shot through with passages of shadowy blue he made a surrogate for what he saw that seems tinged with the memories of other things seen. He might have been looking down, not across: not through a window at a landscape but through the floor of a glass-bottomed boat at fish and coral, gleaming and twinkling under the sea.

'Bonnard at Le Bosquet', a lovingly and sparingly selected display of the pictures which the artist painted during the last twenty years of his life at his villa in the South of France, is the most shiningly beautiful exhibition seen at the Hayward Gallery for many years. It is also confirmation that Bonnard was one of the great visionary painters of his century – and, indeed, of any other.

Bonnard never descended to the grandiose. He painted interiors. He painted views from windows. He painted still lifes, things on tables and shelves and in cupboards. He painted landscapes. He painted his wife, Marthe, and after her death he painted his memories of her. But out of these ordinary things he created pictures charged with glory and wonder.

A street near his home became *The Pink Road*, a mauve lake in which two diminutive figures and a dog have been marooned beside a house made of ice-cream with, beyond them, a skyline made of bright blue trees. The picture's oddity also strikes a chord of recognition, evoking the kind of day when heat and haze dissolve everything and when trees backlit by the sun do, indeed, look blue. The world through Bonnard's eyes may often seem to melt and deliquesce, to take on strange and apparitional qualities. But the nervous vitality of his touch and the trembling incandescence of his colour also represent truth to experience.

The nearly unreal vividness of this art is a form of insistence, Bonnard's way of emphasizing that things did look this way to him. Objects in his paintings often seem more powerfully actual than merely real things, in the merely real world, do to most of us most of the time. Bonnard was a great painter of heat and light and of the heavy penumbra with which sunshine can surround things. The bowls and baskets of fruit that he depicted on tables in the sun are so simply painted that they could easily have seemed insubstantial. But they do not. Haloed by light, they are also anchored in reality – just as, transfigured by art, they are also weightily present. These pictures are Bonnard's sacraments.

He has been labelled an Intimist, but he was really a religious painter in a secular age: a man who saw the real world as a blessed place and re-created his perceptions of it in the form of painted worlds that have the quality of benedictions. There were not many visitors at the Hayward when I saw the exhibition but they were all smiling the same slightly stunned, beatific smile. They looked like people walking in sunshine for the first time in a long while, or the recipients of some sudden, unexpected, generous gift.

Bonnard's disposition was not uniformly or simply optimistic, and this show also contains pictures that speak of loss and melancholy and of the knowledge that life must come to an end. In his 1938 *Self-Portrait* (*In the Mirror*) Bonnard paints himself, with sad but unsentimental foreknowledge, as a quizzical slope-shouldered ghost. His radiant epiphanies are themselves substantiated by the sense, within the mobile brushwork and evanescent colour that has been used to conjure them, of the transitoriness of those moments that they celebrate.

The mechanisms by which Bonnard invested his pictures with the

quality of numinousness remain beyond articulation because they are not a matter of symbolism or allegory but of technique. There are, occasionally, hints of a leaning to mystical symbolism, of a kind, in his art. He depicts Marthe, the tutelary deity of so many of his pictures, in ways that make of her a mute goddess, an unspeaking figure with an aura about her of ancient myth. He makes much of doors and windows as framing devices, so they become metaphors for the way in which his is an art suspended at the threshold of the worldly and the otherworldly. But it is in the paint itself that Bonnard accomplishes the magical act of transformation that such small and understated pieces of symbolism announce as the ambitions behind his pictures.

No other modern artist – perhaps not even Matisse, although it is a form of heresy to say so – has ever made paint look quite so unlike itself, so nearly immaterial or so strangely possessed with living qualities, as Bonnard did. The trees in his landscapes catch fire, his skies heave, the air in his interiors pulses with mysterious energies. Inspect his pictures really closely and it is still not quite clear how the feat was managed. Even from a few inches away, Bonnard's surfaces seem not like surfaces but like electrically charged ether or moving water. His tiny dabs and streaks and blotches of paint are almost alive and they seem to shift around as you look at them.

Bonnard is a much loved artist but the true magnitude of his achievement has been insufficiently recognized. He was too bourgeois to be great, it has been said. He did not paint the large themes of life, it has been said. But how inattentive and small-minded such objections are – and how irrelevant they are rendered by his finest work.

Take the tersely titled *Nude in Bathtub*, which Bonnard worked on for five years, between 1941 and 1946. It is a truly astonishing work, not least because in it we can see so clearly how Bonnard has, in his surreptitious and soft-spoken way, invented a new language of painting: a way of painting which is so mobile and fluctuant, in the shifts and moves of light and colour across its animated mosaic of a surface, that it becomes an almost tragically potent analogue for experience; a way of re-creating, in the texture of art, the texture of life itself. It is an endless picture, such is the delicacy and hesitancy of the marks which form it, the way in which touch and colour and form bleed into and melt into one another. The wonky rectilinear grids of tiles on the wall

and the floor of the bathroom contain, like a dim memory, recollections of the fractured world of the Cubists, but the Cubist project of attempting to picture the unstill and moving essence of things has been resumed in a painting that surpasses Cubist art in the accomplishment of the ambition. A room has become a world, a paradise sensorium of light and colour that celebrates what it can be to be alive but which also contains its own *memento mori* in the form of Marthe, lying in her bathtub like a body in a sarcophagus. This exhibition reminded me of the young Delacroix's description of how he felt when he saw Géricault's *Raft of the Medusa* for the first time. He tried to walk home but found himself instead running and whooping, like a madman, with involuntary and unconfined delight.

5th July 1994

Picture Credits

HOLBEIN *A Lady with a Squirrel and a Starling*, 1526–8, oil on oak, 56 × 38.8 cm. Courtesy of the Trustees, The National Gallery, London.

POUSSIN *The Triumph of David*, oil on canvas, 118.4 × 148.3 cm. By permission of the Trustees of Dulwich Picture Gallery.

VELAZQUEZ *Mother Jerónima de la Fuente*, 1620, oil on canvas, 160 × 110 cm. Museo del Prado. Photograph © The Bridgeman Art Library.

VELAZQUEZ *Garden of the Villa Medici*, 1630 or 1650, oil on canvas, 48 × 42 cm. Museo del Prado. Photograph © Scala.

REMBRANDT *Bathsheba with King David's Letter*, 1654, oil on canvas, 142 × 142 cm. Musée du Louvre. Photograph © R M N.

REMBRANDT *Portrait of the Artist*, 1665, oil on canvas, 114.3 × 94 cm. Kenwood, The Iveagh Bequest. Photograph © English Heritage.

CONSTABLE oil sketch for *The Leaping Horse*, 1824–25, oil on canvas, 129.5 × 187.96 cm. Photograph © The Board of the Trustees of the Victoria and Albert Museum.

SASSETTA *A Miracle of the Eucharist* (detail), tempera and gold on wood, 24.1 × 38.2 cm. Courtesy of the Trustees, The National Gallery, London..

GOYA *Saint Francis Borgia Attending a Dying Impenitent*, 1787–88, oil on canvas, 38 × 29 cm. Valencia Cathedral. Photograph © MAS.

VAN GOGH *Still Life with Open Bible, Extinghished Candle and Zola's Joie de Vivre*, 1885, oil on canvas, 65 × 78 cm. Vincent Van Gogh Foundation, Van Gogh Museum, Amsterdam.

REINHARDT *Black Painting Being Executed by Ad Reinhardt*, 1966, oil on canvas, John Loengard/Life Magazine. Photograph © Time Warner/Katz.

RAPHAEL *Sistine Madonna* (detail), 1513, oil on canvas, 265 × 196 cm. Gemäldegalerie, Alte Meister, Dresden. Photograph © AKG, London.

MICHELANGELO *The Entombment* (unfinished), 1504, wood, 161 × 149 cm. Courtesy of the Trustees, The National Gallery, London.

POUSSIN *Tancred and Erminia*, oil on canvas, 75.5 × 99.7 cm. Photograph © The Barber Institute of Fine Arts, The University of Birmingham.

POUSSIN *Tancred and Erminia*, oil on canvas, 98 × 147 cm. The Hermitage, St Petersburg. Photograph © The Bridgeman Art Library.

MANET *Olympia*, 1863, oil on canvas, 130 × 190 cm. Musée d'Orsay. Photograph © RMN.

CEZANNE *The Modern Olympia*, 1873, oil on canvas, 46 × 55 cm. Musée d'Orsay. Photograph © The Bridgeman Art Library.

SCHIELE *Girl Kneeling, Resting on Both Elbows*, 1917, black chalk and body colour on paper, 28.7 × 44.3 cm, inscribed lower right: Egon Schiele, 1917. Leopold Museum, Private Collection, Vienna.

MASSON *L'academie de Dessin*, 1940, pencil, 48 × 43 cm. Photograph courtesy of Galerie Louise Leiris, Paris. © ADAGP, Paris and DACS 1996.

PICASSO *Seated Nude*, 1959, oil on canvas, 146 × 114 cm. Courtesy Private Collection, Switzerland. © DACS 1996.

DE KOONING *Woman III*, 1952–53, oil on canvas, 172.7 × 123.2 cm. Private Collection. Courtesy of Thomas Ammann Fine Art, Zurich. © ARS, NY and DACS, London 1996.

CASSIANO *Ammonites*, 1630s pen and brown ink over black chalk, 175 × 239 mm. Royal Library, Windsor Castle. © Her Majesty Queen Elizabeth II.

CASSIANO *Three Studies of the Bound Left Hand of a Pugilist*, from the Paper Museum, Vol. II, 1630s, pen and brown ink with brown wash. Royal Library, Windsor Castle. © Her Majesty Queen Elizabeth II.

The Badminton Cabinet, Florentine pietra dura, ebony and ormolu cabinet, 386 × 232.5 × 94 cm. Made for the 3rd Duke of Beaufort. Sold at Christies in July 1990. Private Collection. Photograph © The Bridgeman Art Library.

RICHMOND *John Ruskin*, 1843, Chalk, 43.2 × 35.6 cm. Courtesy of the National Portrait Gallery, London.

REMBRANDT *Portrait of an Eighty-Three-Year-Old Woman (Portrait of Aechje Claesdr. Presser)*, 1634, oil on oak, oval, 71.1 × 55.9 cm. Courtesy of the Trustees, The National Gallery, London.

REMBRANDT *Portrait of an Eighty-Three-Year-Old Woman (Portrait of Aechje Claesdr. Presser)*, (detail). Courtesy of the Trustees, The National Gallery, London.

REMBRANDT *Portrait of an Eighty-Three-Year-Old Woman* (Portrait of Aechje Claesdr. Presser), (X-Ray). Courtesy of the Trustees, The National Gallery, London.

CARAVAGGIO *The Supper at Emmaus*, c. 1596–1602, oil on canvas, 141 × 196.2 cm. Courtesy of the Trustees, The National Gallery, London.

GERICAULT *The Raft of the Medusa*, 1819, oil on canvas, 490.8 × 715 cm. Musée du Louvre. Photograph © RMN.

MANTEGNA *Madonna and Child*, oil on canvas, 43 × 32 cm. Gemäldegalerie, Berlin. Photograph © Giraudon.

MANTEGNA *Triumphs of Caesar – The Little Bearers*, c. 1483, oil on canvas, 278 × 268 cm. Hampton Court © Her Majesty Queen Elizabeth II.

CLAUDE *The Embarkation of the Queen of Sheba*, 1648, oil on canvas, 148.6 × 193.7 cm. Courtesy of the Trustees, The National Gallery, London.

CLAUDE *Landscape with Ascanius Shooting the Stag of Silvia*, 1682, oil on canvas, 120 × 150 cm. Photograph © Ashmolean Museum, Oxford.

GOYA *Caspar Melchor de Jovellanos*, 1798, oil on canvas, 205 × 134 cm. Museo del Prado. Photograph © MAS.

GOYA *The Sleep of Reason Breeds Monsters* from 'Los Caprichos', etching and aquatint, 21.5 × 15.0 cm. Bequest of William B. Babcock, courtesy, Museum of Fine Arts, Boston. Photograph © Museum of Fine Arts, Boston.

GERICAULT *Ancient Sacrifice*, 1817, pen and brown ink, white gauache on oiled paper, 28.5 × 42.2 cm. Musée du Louvre. Photograph © RMN.

GERICAULT *The Gallows*, pencil and ink washes on grey paper, 40 × 32 cm. Musée Rouen. Photograph © RMN.

MANET *The Dead Toreador*, probably 1864, oil on canvas, 75.9 × 153.3 cm. Widener Collection, Photograph © 1995 Board of Trustees, National Gallery of Art, Washington.

DEGAS *The Tub*, c. 1886, pastel, 69.8 × 69.8 cm. Courtesy of Hill-Stead Museum, Farmington, CT 06032.

TOULOUSE-LAUTREC *At the Moulin Rouge*, 1893–95, oil on canvas, 123 × 141 cm, Helen Birch Bartlett Memorial Collection, 1928.610. Photograph © 1994 The Art Institute of Chicago.

SEURAT *Study for Un Dimanche à la Grande Jatte*, 1886, black chalk, 42.5 × 62.8 cm. Courtesy of the Trustees of the British Museum.

SICKERT *H.M. King Edward VIII*, 1936, oil on canvas, 183 × 91.5 cm. Beaverbrook Art Gallery. Photograph © The Bridgeman Art Library.

GUSTON *Strong Light*, 1976, oil on canvas, 204.5 × 175.3 cm. Courtesy of McKee Gallery, New York. Photograph © Steven Sloman.

WARHOL *Triple Elvis*, 1964, aluminium paint and printer's ink silk-screened on canvas, 208 × 180.5 cm, unsigned. Gift of Sydney and Frances Lewis, Virginia Museum of Fine Arts, Richmond, VA. Photograph © Virginia Museum of Fine Arts. © ARS, NY and DACS, London 1996.

WHISTLER *Arrangement in Grey and Black*, (The Artist's Mother), 1871, oil on canvas, 144.3 × 162.5 cm. Musée d'Orsay. Photograph © RMN.

MOORE *The Artist's Mother*, 1927, pencil, pen and ink, 27.3 × 19.1 cm. Courtesy of The Henry Moore Foundation.

MIRÓ *Nude Woman Climbing the Stair*, 1927, coal pencil on cardboard, 77.9 × 55.8 cm. F.J.M. 4679. Courtesy of Fundació Joan Miró. © ADAGP, Paris and DACS, London 1996.

KLEE *Dance of the Mourning Child*, 1922, water-colour, sprayed ink, transferred printing ink on woven paper, mounted on paper with brown water-colour, mounted on light cardboard. Signed in black ink, lower right: Klee; on the secondary support, in brown ink: 1922/11 Tanz des trauenden Kindes, 29 × 27.5 cm. Private Collection, New York. © DACS 1996.

Index

Page numbers in *italics* refer to illustrations

377

Andrew Graham-Dixon is the art critic for the *Independent* in London, where the essays in this book were first published. The author of a biography of Howard Hodgkin, he has been awarded the Hawthornden Prize, Britain's top prize for writing about art, and the BP British Arts Journalist of the Year Award three times, in 1987, 1988 and 1990. A documentary film he wrote and presented for the BBC on the subject of Géricault's painting *The Raft of the Medusa* (a related essay appears in this book) won first prize in the reportage section of the Montreal International Film Festival in 1992. He is also the writer and presenter of BBC2 television's *A History of British Art*. Graham-Dixon is currently Associate Professor of the History of Art at the London Institute.

A NOTE ON THE TYPE

This book was set in a version of the well-known Monotype face Bembo. This letter was cut for the celebrated Venetian printer Aldus Manutius by Francesco Griffo, and was first used in Pietro Cardinal Bembo's *De Aetna* of 1495.

The companion italic is an adaptation of the chancery script type designed by the calligrapher and printer Lodovico degli Arrighi.

Composed in Great Britain

Printed and bound by Quebecor Printing,
Martinsburg, West Virginia